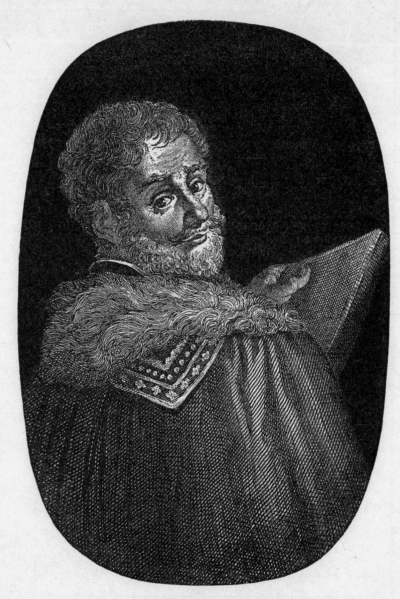

BENVENUTO CELLINI

THE AUTOBIOGRAPHY

OF

BENVENUTO CELLINI

A FLORENTINE ARTIST

CONTAINING A VARIETY OF
INFORMATION RESPECTING THE
ARTS AND THE HISTORY OF
THE SIXTEENTH CENTURY.

THE SPENCER PRESS

MANUFACTURED IN THE UNITED STATES OF AMERICA
BY THE CUNEO PRESS, INC.

THE SPENCER PRESS

The avowed purpose of the Spencer Press is to publish classics which have survived the test of time. In the quest for enduring titles more than fifty famous lists of the finest books ever written were consulted. The findings were then tabulated and the list was found to include more than one thousand titles, some of which have been mentioned in the recommendations of as many as thirty-five different authorities. The first hundred titles which were most often mentioned by the critics, were selected on the assumption that any book which had been chosen so often and by so many eminent authorities must be exceptionally fine. Upon considering these titles, thirty books were discarded because they were either too heavy in style or subject matter to find popular favor.

The next problem was to select those twenty books which would form the cornerstone of a fine home library for people of discriminating taste; books with a cultural and educational background that would tend to broaden the vision and develop the inner resources of the reader . . . books that were sufficiently thrilling and popular in their appeal to capture the imagination and interest of every member of the family.

It seems significant to mention here that when the final list of twenty volumes was compiled it contained books which had been mentioned on almost every list of worthwhile reading. The titles of this set are submitted with the confidence that each and every volume merits the label "World's Greatest Literature."

The next problem of importance was the designing of a format worthy of the name "Spencer." The services of Mr. Leonard Mounteney, a master craftsman who had served for twenty years as a binder in the studios of Robert Riviere & Sons of London, England, were engaged for this artistic undertaking. Mounteney has in the last

ten years won for himself considerable acclaim as one of the world's most eminent binders. He approached the task of designing these books with all the fervor and interest of a skilled artisan who loves his work, applying the same thought to these volumes as is usually accorded the bindings of museum masterpieces, incunabula and priceless first editions. Mounteney was well aware that the name "Spencer" had become identified with handsome illustration, fine printing and exquisite binding and he was most anxious to create books of surpassing beauty.

"The Spencer Press" is named in honor of and as a tribute to the memory of William Augustus Spencer, the son of Lorillard Spencer and Sarah Johnson Griswold. Spencer was born in New York, was educated in Europe and made his home in Paris, frequently visiting the United States. Spencer became an inveterate book collector, specializing in fine French bindings. He soon became a patron of the fine binders of his day and his collection, now on permanent exhibition at the New York Public Library, is rated as one of the finest of modern collections. Unfortunately, Spencer perished in the sinking of the Titanic in 1912 cutting short a career of great promise.

The books collected by Spencer were mostly nineteenth century works. These volumes represent a definite advancement in many spheres of book production. The authors, publishers, printers, engravers and bookbinders are all representative of what is modern in their several arts, for Spencer was a true collector who insisted upon a high state of perfection in every creative phase of the bookmaking art.

This type of publishing depends more than anything else upon patronage for its existence. The history of fine bookmaking is linked with the social history of the countries where it is practised. The wealthy nobility were usually the patrons of this fine art. The Kings of France were notable collectors forming libraries of considerable merit. Jean Grolier, Viscount d'Aguisy (1479-1565), Treasurer-General of the Duchy of Milan, friend of Francis I, and ambassador to Pope Clement VII, friend of

Aldus, the great printer, was perhaps the most lavish patron of the art of binding and collecting books. To Grolier is accorded the first place among all the great names in book collecting history, and to him is owed the dignified standing in which book collecting is esteemed among the gentler arts. To Grolier also goes the honor for creating a most important and fundamental style in the decoration of book covers.

From Grolier to Spencer we find the names of many illustrious notables who have fostered and patronized the advancement of this art. Jean Baptiste Colbert, statesman and minister of finance under Louis XIV, was the founder of the Academy of Inscriptions which concerned itself greatly with book decoration. Then there was Mazarin, Italian and French cardinal and statesman, who founded one of the great libraries of the world which bears his name. During the intervening years there have been thousands of collectors who have patronized the art. In America one thinks of such great names as Weidner, Morgan, Huntington and Hay in this connection.

Such affluent patronage has given aid to many different interpretations of beauty. Books have been handsomely bound in paper, in wood, in parchment, in cloth and fine leathers. They have been inlaid with materials of contrasting colors, hand painted, encrusted with rare and valuable jewels. They have contained gorgeous end papers and fancy doublures. Men have spent years in the binding, tooling and decoration of a single volume.

These bibliophiles collected not only fine titles, bindings and illustrations but fine printing as well. Gutenberg, the father of fine printing, set an early standard which has been difficult if not impossible to excel. The books created by Gutenberg still rank as among the finest examples of book ornamentation ever produced. Then came the handsome volumes of the East with their arabesques, graceful lines and fleurons which found many an eager collector among the gentlemen of Venice. Aldus, the printer, patronized by Grolier, created many examples of fine printing influenced by these same Eastern designs.

The history of fine binding and bookmaking is a long

and interesting one filled with many glorious stories of exquisite books. In the creation of this set of the "World's Greatest Literature," Mounteney has copied the designs of Roger Payne, the one truly great English binder of the nineteenth century. Payne's work was known to have a French influence, a delicate decorative scheme of dots, lines and simple designs. Mounteney has added certain elegant refinements of his own and has endeavored to create a set of books that would be a credit to the memory and name of one of the greatest of all modern collectors . . . a set of books within the reach of the true book-lover so that the appreciation of fine and beautiful books need no longer be a kingly prerogative alone.

The publishers do not claim or even dare to hope that these books are to be compared for richness of binding or makeup with the volumes in the Spencer Library, for some of those books cost thousands of dollars and occupied many years in the lives of master craftsmen. It is true, however, that Mounteney in his careful designing has created books possessing rare beauty of design and exquisite good taste which vie in appearance and handsomeness with the Spencer masterpieces. It should be remembered that the original Spencer volumes were designed by hand, tooled by hand, and often printed by hand, whereas these books were created by one of the world's greatest printers employing every advancement of modern science and efficiency to bring to you books you will treasure over the years . . . books that will add to the richness and fullness of your life.

Reading, Pa. 1936.　　　　　Leonard S. Davidow.

CONTENTS

CONTENTS

CHAPTER I.

It is a duty incumbent on upright and credible men of all ranks, who have performed any thing noble or praiseworthy, to record, in their own writing, the events of their lives; yet they should not commence this honourable task before they have passed their fortieth year. Such, at least, is my opinion, now that I have completed my fifty-eighth year, and am settled in Florence, where, considering the numerous ills that constantly attend human life, I perceive that I have never before been so free from vexations and calamities, or possessed of so great a share of content and health, as at this period. Looking back on some delightful and happy events of my life, and on many misfortunes so truly overwhelming, that the appalling retrospect makes me wonder how I have reached this age, in vigor and prosperity, through God's goodness, I have resolved to publish an account of my life. And although men whose exertions have been crowned with any degree of honour, and who have rendered themselves conspicuous to the world, ought, perhaps, to regard only that personal merit to which they owe their celebrity; yet as in this world it is necessary to live like other people, I must, in commencing my narrative, satisfy the public on some few points to which its curiosity is usually directed; the first of which is to ascertain whether a man is descended from a virtuous and ancient family.

My name, then, is Benvenuto Cellini, and I am the son of Maestro Giovanni, the son of Andrea, the son of Cristofano Cellini; my mother was Maria Lisabetta, daughter to Stefano Granacci: and both my parents were citizens of Florence. It appears from the ancient chronicles compiled by natives of that city, men highly deserving of credit, that it was built after the model of Rome. This is evident from the vestiges of the Colosseum, and the hot baths, near the Holy Cross: the capitol was an ancient market-place: the rotunda, which is still entire, was built for a temple of Mars, and is now called San Giovanni's church. This is so evident that it

1

cannot be denied; but the above-mentioned structures are of much smaller dimensions than those of Rome. It is said that they were erected by Julius Cæsar, in conjunction with some other Roman patricians, who, having subdued and taken Fiesole, in this very place founded a city, and each of them undertook to erect one of these remarkable edifices*. Julius Cæsar had a very gallant officer of the first rank in his army, named Florentius of Cellino, which is a castle within two miles of Monte Fiascone: this Florentius having taken up his quarters under Fiesole, where Florence at present stands, to be near the river Arno for the convenience of his army, all the soldiers and others who had any business with that officer used to say, "Let us go to Florence;" as well because the name of the officer was Florentius, as because on the spot where he had fixed his head-quarters there was great plenty of flowers. Thus in the infancy of the town the elegant appellation of Florence seeming to Julius Caesar appropriate, and its allusion to flowers appearing auspicious, he gave it the name of Florentia; at the same time paying a compliment to his valiant officer, to whom he was the more attached, because he had promoted him from a very humble station, and considered his merit as in some measure a creation of his own. The other name of *Fluentia,* which the learned inventors and investigators of the connexion of names pretend that Florence obtained on account of the Arno's† *flowing* through the town, cannot be admitted; because the Tiber flows through Rome, the Po through Ferrara, the Saone through Lyons, the Seine through Paris, which cities have various names, no way derived from the course of those rivers. I believe the matter to be as I have stated, and am of opinion that this city takes its name from the valiant captain Florentius.

I have also learned that there are some of our family of Cellini in Ravenna, a much more ancient city than Florence, and that they are people of quality: there are also some of the family in Pisa, and in several others parts of Christendom; besides a few families that still remain in Tuscany. Most of these have been devoted to arms. It is not many years since a beardless youth, of the name of Luca Cellini, encountered a most valiant and practised soldier, named Francesco da Vicorati, who had often fought in the lists: Luca, who had only courage on his side, vanquished and slew him; evincing such prowess and intrepidity as astonished the spectators, who all expected a contrary result. So that, upon the whole, I

* Thus far Cellini agrees with Villani, Buoninsegni, Machiavelli, Varchi, and Borghino. Not so in what follows respecting Florence and the flowers.

† Such is the opinion of Lionardo Aretino and Poggio.

think I may safely boast of being descended from valiant ancestors.

How far I have contributed to the honour of my family, which, considering our present condition, arising from well-known causes, and considering my profession, cannot be in any very great degree, I shall relate in a proper place; thinking it much more honourable to have sprung from an humble origin, and laid a foundation of honour for my descendants, than to have been descended from a noble lineage, and to have disgraced or extinguished it by my own base degeneracy. I shall therefore now proceed to inform the reader how it pleased God that I should come into the world.

My ancestors lived in retirement in the valley of Ambra, where they were lords of considerable domains: they were all trained to arms, and distinguished for military prowess. One of the family, a youth named Cristofano, had a fierce dispute with some of their neighbours and friends; and because the chief relations on both sides had engaged in the dispute, and it seemed likely that the flames of discord would end in the destruction of the two families, the eldest people, having maturely considered the matter, unanimously agreed to remove the two young men who began the quarrel out of the way. The opposite party obliged their kinsman to withdraw to Siena, and Cristofano's parents sent him to Florence, where they purchased a small house for him in the Via Chiara, from the monastery of St. Ursula, with a pretty good estate near the bridge of Rifredi. This Cristofano married in Florence, and had several sons and daughters: the daughters were portioned off; and the sons divided the remainder of their father's substance between them. After his decease, the house of Via Chiara, with some other property of no great amount, fell to one of the above-mentioned sons, whose name was Andrea. He took a wife, by whom he had four male children: the name of the first was Girolamo, that of the second Bartolomeo; the third was Giovanni, my father; the fourth was Francesco.

Andrea Cellini, my grandfather, was tolerably well versed in the architecture of those days, and made it his profession. Giovanni, my father, cultivated it more than any of his brothers; and since, according to the opinion of Vitruvius, those who are desirous of succeeding in this art, should, amongst other things, know something of music and drawing, Giovanni, having acquired great proficiency in the art of designing, began to apply himself to music. He learned to play admirably well upon the viol and flute; and being of a very studious disposition, he hardly ever went abroad.

His next-door neighbour was Stefano Granacci, who had several daughters of extraordinary beauty. Giovanni soon became sensible

to the charms of one of them, named Lisabetta; and at length grew
so deeply enamoured that he asked her in marriage. Their fathers
being intimate, and next-door neighbours, it was no difficult matter
to bring about the match, as both parties thought they found their
account in it. First of all, the two old men concluded the marriage,
and then began to talk of the portion; but they could not rightly
agree on that point, for Andrea said to Stefano, "My son Giovanni
is the best youth in Florence, and even in all Italy; and if I had
thought of procuring him a wife before, I might have obtained for
him the best portion in Florence amongst persons of our rank."
Stefano answered, "You have a thousand reasons on your side, but
I have five daughters and several sons; so that, all things duly con-
sidered, it is as much as I can afford." Giovanni had stood some
time listening to their conversation unperceived by them, but on
hearing this he suddenly interrupted them, saying, "Ah! father,
it is the girl that I love and desire, and not her money. Wretched is
he who marries to repair his fortune by means of his wife's dowry.
You boast that I am possessed of some talents: is it then to be
supposed that I am unable to maintain my wife, and supply her
necessities? I want nothing of you but your consent; and I must
give you to understand that the girl shall be mine; as to the portion
you may take it yourself." Andrea Cellini, who was somewhat
eccentric, was not a little displeased at this; but in a few days
Giovanni took his wife home, and never afterwards required any
portion of her father.

They enjoyed their consecrated love for eighteen years; but
had no children, which they ardently desired. At the expiration of
the eighteenth year, however, Giovanni's wife miscarried of two
male children, through the unskilfulness of her medical attendants.
She became pregnant again, and gave birth to a girl, who was called
Rosa, after my father's mother. Two years after, she was once more
with child, and, as women in her condition are liable to certain
longings, hers being exactly the same upon this occasion as before,
it was generally thought that she would have another girl, and it
had been already agreed to give her the name of Reparata, after
my mother's mother. It happened that she was brought to bed
precisely the night of All-Saints-day, in the year 1500, at half an
hour past four. The midwife, who was sensible that the family
expected the birth of a female, as soon as she had washed the child
and wrapped it up in fine swaddling-clothes, came softly up to my
father, and said to him, "I here bring you a fine present which you
little expected." My father, who was of a philosophical disposition,
and happened to be then walking about, said, "What God gives me,

I shall always receive thankfully;" but, taking off the clothes, he saw with his own eyes the unexpected boy. Clasping his hands together, he lifted up his eyes to Heaven, saying: "Lord, I thank thee from the bottom of my heart for this present, which is very dear and welcome to me." The standers-by asked him, joyfully, how he proposed to call the child: he made them no other answer than, "He is WELCOME." And this name of Welcome (BEN-VENUTO) he resolved to give me at the font; and so I was christened accordingly.

Andrea Cellini was still living when I was about three years of age; and he was then above a hundred. As they were one day removing a water-pipe, a large scorpion, which they had not perceived, came out of it: the scorpion descended upon the ground and had got under a great bench, when I, seeing it, ran and caught it in my hand. This scorpion was of such a size, that whilst I held it in my little hand it put out its tail on one side, and on the other darted its two mouths. I ran overjoyed to my grandfather, crying out, "Grandfather, look at my pretty little crab!" The good old man, who knew it to be a scorpion, was so frightened, and so apprehensive for my safety, that he seemed ready to drop down dead, and begged me with great eagerness to give the creature to him; but I grasped it the harder, and cried, for I did not choose to part with it. My father, who was in the house, ran to us upon hearing the noise; but, stupefied with terror at the sight of that venomous reptile, he could think of no means of rescuing me from my perilous situation. But happening just at that instant to espy a pair of scissors, he laid hold of them, and by caressing and playing with me, he contrived to cut off the tail and head of the scorpion. Then finding I had received no harm, he pronounced it a happy omen.

When I was about five years of age, my father happened to be in a little room in which they had been washing, and where there was a good oak fire burning: with a fiddle in his hand he sang and played near the fire, the weather being exceedingly cold. Looking into the fire, he saw a little animal resembling a lizard, which lived and enjoyed itself in the hottest flames. Instantly perceiving what it was, he called for my sister, and after he had shown us the creature, he gave me a box on the ear: I fell a-crying, while he, soothing me with his caresses, said, "My dear child, I don't give you that blow for any fault you have committed, but that you may remember that the little lizard which you see in the fire is a salamander; a creature which no one that I have heard of ever beheld before." So saying, he embraced me, and gave me some money.

My father began to teach me to play upon the flute, and to sing

by note; and though I was very young, at an age when children, generally speaking, are highly pleased with piping and such amusements, I had the utmost aversion for it, and played and sang merely in obedience to his authority. My father at that time made the most curious organs with pipes of wood, the finest and best harpsichords that were to be seen in those days, and most beautiful and excellent viols, lutes, and harps. He was an engineer, and constructed a variety of machines, such as draw-bridges, fulling-mills, &c. He worked admirably in ivory, and was the first artist of his time in that line. But as he was also musically inclined, insomuch that this art had engrossed his whole thoughts and attention, he was requested by the court musicians to join with them; and as he was willing to oblige them, they made him one of their band. Lorenzo* de' Medici, and Pietro, his son, who were very much his friends, seeing afterwards that he attached himself entirely to music, and neglected his business as an engineer, and his admirable art of working in ivory, removed him from that place. This my father highly resented, and thought himself very ill used by his patrons. He therefore on a sudden applied again to his business, and made a looking-glass, about a cubit diameter, of bone and ivory, adorned with carved figures and foliages, with the finest polish and the most admirable elegance of design. It was in the form of a wheel; the mirror was placed in the middle; round it were seven circles, in which the seven virtues were carved in ivory and bone; and both the mirror and the figures of the virtues were balanced in such a manner, that the wheel turning round, all the virtues moved at the same time, and had a weight to counterpoise them at their feet, which kept them in a straight direction. As he had a smattering of the Latin language, he carved a verse round the mirror, the purport of which was, "that on which side soever the wheel of fortune turns, virtue stands unshaken upon her feet."

Rota sum semper, quò quò me verto, stat virtus.

A short time after, his place of court-musician was restored to him. At that period (which was before I was born) these musicians were all eminent artizans; some of them, being manufacturers of wool, and others of silk, belonged to the *Arti Maggiori†*: hence my

* Lorenzo the Magnificent, who died in his 44th year, in 1492, one of the most munificent and intelligent patrons of the fine arts Italy ever possessed.

† In the year 1266, the Florentine people, to resist the influence of the aristocracy, established seven classes, termed "Arti Maggiori," each having a consul or leader. Among these were enumerated judges and notaries, manufacturers of wool, traders in foreign merchandize, brokers, physicians, mercers, silk, and fur dealers, &c. &c. All those entitled to rank in the "Arti Maggiori" were, at that period, considered as gentlemen.

father did not think this profession beneath him; and his first desire with regard to me was, that I should become a great player on the flute. I on my part was never more offended than when he touched upon this subject, and when he told me that, if I had a mind, I might become the best musician in the universe. As I have already observed, my father was a staunch friend to the house of Medici, so that when Pietro was banished from Florence*, he intrusted him with many affairs of consequence. The illustrious Pietro Soderini† afterwards being elected to the government, when my father was in his service in quality of musician, that great statesman, discovering his extraordinary genius, began to have recourse to him in many matters of importance, showing him thenceforward the greatest kindness.

At this time my father, as I was of a tender age, once caused me to be carried upon a person's shoulders to play upon the flute before the senate, and one of their servants supported me all the time. After the music was over, Soderini, then gonfalonier, or chief magistrate, amused himself with my prattle, and giving me sweetmeats, said to my father, "Giovanni, you must teach him your other two elegant arts, as well as that of music." My father replied, that he did not intend I should follow any other business but that of playing upon the flute, and composing; for if it pleased God to spare his days, he hoped to make me the first man in the world in that profession. To this one of the old gentlemen present replied, "Ah, master Cellini, mind what the gonfalonier says; why should the boy aim at nothing higher all his life than being a good musician?"

Thus some time passed till the Medici family was restored. The Cardinal de' Medici, who was afterwards Pope Leo X., immediately upon his recall showed the utmost kindness to my father. While the family was in exile, the balls‡ were removed from the coat of arms in the front of their palace; and the citizens had caused to be painted in their place the figure of a red cross, which was the arms of the republic. But at the sudden return of the Medicean princes

* This happened in November, 1494. Pietro was drowned in passing the river Garigliano, in 1504. His brothers, the Cardinal Giovanni, afterwards Leo X., and Giuliano, returned to Florence in September, 1512, through the intervention of Julius II.

† The only perpetual gonfalonier the Florentine republic ever had. He assumed the office in the year 1502, at a time when the public liberty was in the utmost danger. Though worthy of the trust, Soderini was unequal to the difficulties which presented themselves, and wanted energy to restrain the licentiousness of the citizens. Thus, he at last fell a victim to some of the more daring and ambitious, and was banished, after nine years' administration, from his country.

‡ The balls, called *Palle*, borne in the arms of the Medici.—*Ed.*

the red cross was effaced, and upon the said escutcheon were again painted the red balls, and the golden field was replaced with the most beautiful decorations. My father, who had rather a turn for poetry, with somewhat of a prophetic vein—doubtless, a divine gift, —when the new arms were shown him, wrote the following four lines :—

"These arms, so long interr'd from human sight,
Beneath the image bland of Holy Cross,
Renew their glorious ensigns' proud emboss,
And wait but Peter's sacred mantle bright."

This epigram was read throughout the whole of Florence. A few days after, died Pope Julius the Second, and the Cardinal de' Medici, afterwards known as the magnanimous and liberal Leo X., having repaired to Rome, was elected Pope*, contrary to the general opinion : my father, having sent him the four verses which contained so happy an augury, was invited by him to repair to that capital, which would have been greatly to his advantage, but he did not choose to leave Florence. However, instead of being rewarded, his place at court was taken from him by Giacopo Salviati†, as soon as that nobleman was made gonfalonier.

This was the reason of my applying myself to the goldsmith's business; and while I was learning that trade I was compelled to spend part of my time in practising upon the flute, much against my inclination‡. For when my father spoke to me in the manner above mentioned, I requested him to let me draw so many hours a-day, telling him that I would dedicate the remainder of it to the flute; upon which he said to me, "Do you not take pleasure in playing on that instrument?" I answered in the negative, saying, the profession of a musician appeared to me base in comparison of that to which I aspired. My poor father then, in the utmost despair, placed me with the father of the cavalier Bandinello, who was called Michelagnolo, goldsmith of Pinzi di Monte, a man of great skill in his art. He was not descended from any illustrious race, but was the son of a collier. This I do not mention as a reflection on Ban-

* In 1513. He had been made a cardinal at fourteen, and was then thirty-seven years of age. Like his father, Lorenzo the Magnificent, he seemed to restore the times of Pericles and Augustus, and died at the early age of forty-four, in the year 1521.

† Salviati married the eldest daughter of Lorenzo, and, attaching himself to the party of the Medici, obtained great influence in Florence. But he does not appear to have ever arrived at the office of gonfalonier, or chief magistrate.

‡There is here an hiatus in the Laurentian MS. before-mentioned, by us consulted.

dinello*, who, as the founder of a distinguished family, is entitled to respect, provided his success was merited; and however that may be, I have nothing to say against him. When I had stayed there a few days, my father took me away from Michelagnolo, as being unable to bear me any longer out of his sight; so that I continued, much against my will, to play upon the flute till the age of fifteen. If I should attempt to relate the extraordinary events that befell me till that period, and the great danger to which my life was exposed, I should strike my readers with surprise and astonishment; but to avoid prolixity, having more interesting matter, I shall wholly omit them.

Having attained the age of fifteen, I engaged myself, against my father's inclination, with a goldsmith, named Antonio di Sandro, who was commonly called Marcone. This was an excellent artist, and a very worthy man, high-spirited, and generous in every respect. My father would not have him allow me any wages, as was customary with other workmen; for this reason, that, since I voluntarily applied myself to this art, I might likewise have an opportunity to draw whenever I thought proper. To this arrangement I readily acceded, and my worthy master was much pleased with the bargain. He had an only, but illegitimate son, to whom he often directed his orders, on purpose to spare me. So great was my inclination to improve, that in a few months I rivalled the most skilful journeyman in the business, and began to reap some fruits from my labour. I continued, however, to play, sometimes, through complaisance to my father, either upon the flute or the horn; and I constantly drew tears and deep sighs from him every time he heard me. From a feeling of filial piety, I often gave him that satisfaction, endeavouring to persuade him that it gave me also particular pleasure.

* Baccio Bandinelli, knighted by Clement VII. and by Charles V. was born in 1487, and died at the age of seventy-two. Cellini often speaks of this celebrated sculptor, who approached, perhaps, the nearest of any in his age to Michel-Angelo Buonarroti. Disliking his avarice, as well as his envious and overbearing temper, Cellini always attacked and ridiculed this artist's works. But in the opinion of Michel-Angelo, by no means a friend to Bandinelli, they are finely designed, and would have been as nobly executed, had not his inordinate desire of money led him to adopt too hasty and loose a style.

CHAPTER II.

The Author seeing his brother almost killed in a fray, takes his part; this gives rise to some untoward accidents, and is the cause of his being banished from Florence.—He removes to Siena, and from thence to Bologna, where he improves greatly in playing on the flute, and still more in his own art of a goldsmith.—Quarrel between his father and Pierino, a musician; lamentable catastrophe of the latter.—The Author removes to Pisa, and enters into the service of a goldsmith of that city.—He returns to Florence, and is taken ill; but, upon his recovery, engages with his old master Marcone.

At this juncture an adventure happened to my brother, which was attended with very serious consequences to us both. He was two years younger than myself, of a warm temper and the most undaunted courage, qualities which fitted him for the military school of the illustrious Signor Giovanni de' Medici*, father to Duke Cosmo, where he became an excellent soldier. One Sunday evening, being between the gates of St. Gallo and Piti, he challenged a young man of twenty, though he was but fourteen himself, and behaved

* Giovanni de' Medici, called the Invincible, was descended from a brother of Cosmo, entitled "Padre della Patria." He was born at Forli, in 1498, educated under Jacopo Salviati, and wholly devoted himself to a military life. He commanded in the wars of Romagna for Leo X. and afterwards fitted out a squadron, at his own expense, against the Moors, till the conclusion of the league between Charles V. and Leo X. against the French, in 1521, placed him at the head of the pontifical horse.

In the ensuing campaign, in an action under the walls of Parma, and at the passage of the river Adda, Giovanni greatly distinguished himself. Under his discipline and conduct, the six bands which he commanded soon gained the reputation of being the finest soldiers of the age. After the death of Leo, he took the command of a body of Swiss in the Florentine service, against a threatened attack by the Duke of Urbino, but could not bring the enemy to action, as they did not venture to wait for his approach. He then returned into Lombardy, and entered into the service of Francesco II., Duke of Milan, who was chiefly indebted to him for the signal victory obtained by the Milanese at Abbiategrasso, in 1524.

At length, either through the policy of Clement VII., who dreaded the increasing power of Charles V., or induced by the offer of better pay, Giovanni accepted a command in the French army under Francis I.; but, owing to a wound received in a skirmish, he was absent from the great battle of Pavia. In every subsequent engagement he attracted the admiration of the whole army, till he received a wound, in an affair near Governo sul Mantovano, of which he died in Nov. 1526, being only twenty-eight years of age. Out of grief for his loss, the squadrons he had commanded changed the white ensigns by which they were distinguished for black ones, which obtained for them the appellation of "Le Bande Neri," or the Black Bands. He married the daughter of Jacopo Salviati, by whom he had a son, Cosmo I. Duke of Tuscany.

so gallantly, that, after wounding the youth dangerously, he was upon the point of either killing or disarming him. There was a great crowd present, and amongst others were many of the young man's relations: seeing their kinsman hard pressed, they took up stones and threw them at my brother's head, who immediately fell to the ground. I, who happened to be present, alone and unarmed, cried out to my brother, as loud as I could, to quit the place. But as soon as I saw him fall, I ran to him, took his sword, and, standing as near him as possible, I confronted a great many swords and stones, till some valiant soldiers, who came from the gate of St. Gallo, saved me from the exasperated multitude. I carried my brother home for dead, who was with great difficulty brought to himself, and afterwards cured.

The Council of Eight* condemned our adversaries to a few years' imprisonment, and banished me and my brother, for six months, to the distance of ten miles from the city. Thus we took leave of our poor father, who, having no money gave us his blessing.

I repaired to Siena, in quest of an honest goldsmith, whose name was Francesco Castoro. I was well acquainted with him, as I had worked with him some time before at my trade, when I had eloped, for some frivolous reason, from my father. Signor Castoro received me very kindly and found me employ, offering me a house for the whole time I should reside at Siena. I accepted his offer, and brought my brother to the house, where I followed my business for several months with close application. My brother, too, had made some progress in the Latin language, but, being young, he was not equally capable of appreciating the excellence of moral beauty, and led rather a dissipated life.

Soon after this troublesome affair the Cardinal de' Medici, afterwards Pope Clement VII†, was prevailed upon, by the entreaties of my father, to obtain permission for us to return to Florence. A pupil of my father's, excited by the natural malignity of his temper, desired the cardinal to send me to Bologna, in order to take lessons on the flute of a great master, whose name was Antonio. The cardinal told my father that if he would send me thither he would give me a letter of recommendation: the old gentleman was extremely desirous that I should go, and I was glad of that opportunity of seeing the world.

* A tribunal so called from the number of which it was composed.

† Giulio, a natural son of that of Giuliano de' Medici, who was assassinated in the conspiracy of the Pazzi, in 1478. He succeeded Lorenzo, a son of the unfortunate Pietro, in the government of the republic, in 1519; and in 1523 he was elected Pope by the name of Clement VII. Our author will have much to say of him, and of the events of his pontificate, as he proceeds. He died in 1534.

Upon my arrival at Bologna I undertook to work under a person whose name was Ercole del Piffero, and I began to make money. At the same time, I went every day to receive a lesson on the flute, and soon gained a considerable emolument by that odious profession; but I got much more by my trade as a goldsmith and jeweller. Having received no assistance from the cardinal, I went to lodge with a miniature-painter, named Scipio Cavaletti, who lived in the street of our Lady of Baracani, and there I worked for a person named Grazia Dio, a Jew, with whom I earned a great deal of money.

Six months afterwards I returned to Florence, where Pierino the musician, who had been a pupil to my father, was greatly mortified at my success*; but I, through complaisance of my aged parent, waited upon Pierino, and played both upon the horn and flute with a brother of his, whose name was Girolamo. He was some years younger than Pierino, and was moreover a well-disposed young man, displaying a marked contrast to his brother. My father happening one day to be at the house of this Pierino to hear us play, and being highly pleased with my performance, said, "I am determined to make a great musician of him, in spite of those who would fain prevent such a genius from shining in the world." To this Pierino answered (and what he said was very true), "Your son Benvenuto will acquire more profit, as well as honour, by minding his business as a goldsmith, than by blowing the horn, or any other instrument." My father, finding I was of the same opinion, was incensed to the last degree; he therefore said to him in a violent passion, "I was very sensible that you were the person who thwarted me in my design; and it was you that were the cause of my being deprived of the place I held at court, behaving to me with that base ingratitude, which is but too frequently the return for the greatest favours. I got you promoted, and you were so base as to undermine me; but mark these words: in less than a few weeks you will rue this black ingratitude." Pierino replied: "Signor Giovanni Cellini, most men when they advance in years begin to doat: this is your case; nor am I surprised at it, as you have already lavished all your substance, without reflecting that your children were likely to want. Now I, for my part, propose taking quite a different course: I intend to leave so much to my sons, that they shall be able to assist yours." To this my father replied, "No bad tree ever brings forth good fruit, but the reverse; and I must tell you, that if you be a

* From what appears afterwards, Pierino wished to divert Benvenuto from playing, and from home; perhaps from jealousy in his art, or to injure him in his father's good opinion.—*Editor.*

bad man, your sons will be fools and indigent, and come to beg of my children, who shall be crowned with affluence." At this they parted, murmuring and railing at each other.

I, who, as it was reasonable, took my worthy father's part, said to him at quitting the house, that I intended to revenge the affront he had received from that scoundrel, if he would give me leave to dedicate my talents to the art of design. My father made answer, "Dear child, I have been myself, in my time, a master of that art; but will you not, in your turn, promise me, by way of recreation, after your noble labours are done, and for my sake, who am your father, who have begot you, educated you, and laid the foundation of so many shining qualifications, sometimes to take in hand your flute and cheerful horn, and play for your pastime and amusement?" I made answer, that I would readily comply with his desire. My good father then rejoined, that the virtues which I displayed to the world would be the best revenge I could take for the affronts and abusive language he had received from his enemies.

Before the month was expired, it happened that the above-mentioned Pierino, causing a vault to be made to a house he had in the street *dello Studio,* and being one day in a room on the ground-floor over the vault, which was then repairing, entered into conversation with some company, and spoke of his master, who was no other than my father, repeating the prophetical words which the latter had uttered, concerning his approaching ruin. Scarcely had he ended his discourse, when the chamber in which he then stood suddenly sunk in, either because the vault had been unskilfully constructed, or through an effect of the divine vengeance, which, though late, is only deferred to a fitter season*. Some of the stones and bricks falling with him, broke both his legs, whilst the rest of the company, standing upon the extremities of the vault, received no manner of hurt, but remained in the utmost surprise and astonishment at what they saw; and most of all at what he had said to them a little before in a scoffing mood. My father, having heard of this accident, took his sword, and went to see him; and, in the presence of his father, whose name was Niccolajo da Volterra, trumpeter to the senate, addressed him in these words: "My dear pupil Pierino, I am very sorry for your misfortune; but you may remember that it is but a short time since I apprised you of it; and my prophecy will likewise be verified with regard to our children."

Soon after, the ungrateful Pierino died of the consequences of his fall, and left behind him a wife of bad character, and a son,

* *Virtù di Dio, che non paga il sabato.* Heaven that fixes no precise time for chastisement; but inflicts it when it is most proper.—*Editor.*

who, a few years after, came to me at Rome, asking charity. I gave him alms, as well because I am naturally of a charitable disposition, as because I could not without tears recollect the affluence with which Pierino was surrounded, when my father spoke the words above mentioned.

Continuing to apply closely to my business as a goldsmith, by the emoluments arising from thence I assisted my good father, as well as my brother Cecchino, whom he caused to be instructed in the Latin language; for, as he intended I should be the best player upon the flute in the world, it was his design that my younger brother should be a man of learning, and a profound civilian. He was not, however, able to force nature, which gave me a turn to drawing, and made my brother, who had a fine person, entirely devote himself to the military profession. This brother of mine, having in his early youth learned the first rudiments of war under that renowned commander Giovanni de' Medici, returned to my father's house, at a time when I happened to be out of the way: being very much in want of clothes, he applied to my sister, who, unknown to my father, gave him a new surtout and cloak which belonged to me; for, besides assisting my father, and my sisters, who were virtuous and deserving girls, I had, by the profits arising from my extraordinary application, contrived to purchase this handsome apparel. Finding my clothes gone, and my brother disappeared, I said to my father, "How could you suffer me to be wronged in such a manner, when you see I spare no toil nor trouble to assist the family?" He made answer, "That I was his good and worthy son, but that what I thought a loss, I should find to be true again; adding that it was a duty incumbent on us, and the command of God himself, that he who had property should share it with him who had none; and that, if I would for his sake patiently bear the wrong I had suffered, God would increase my store, and pour down blessings upon me."

I behaved to my poor afflicted father like an inexperienced young man; and, taking with me what little money and clothes I had left, I bent my course towards one of the city gates, and, not knowing which of them led to Rome, I travelled to Lucca, and from thence to Pisa. I was now about sixteen years of age. Upon my arrival in the last-mentioned city, I stopped near the middle bridge, hard by the fish-market, at a goldsmith's shop, and looked attentively at the master whilst he was at work. He asked me my name, and what business I followed: I made answer, that I worked a little in the same branch that he did. The man thereupon bade me come in, and setting before me some tools to work with, he told me that my physiognomy induced him to believe that I was an honest youth;

so saying, he laid before me gold, silver, and jewels, and, after I had finished my first day's task, he carried me to his house, where he lived very respectably with his wife and children.

I then called to mind the grief which my father must feel upon my account, and wrote him word that I was at the house of a very worthy tradesman, one Signor Ulivieri dello Chiostra; and that, under him, I was employed in my profession on many great and beautiful works. I therefore desired him to make himself easy, as I was improving in my business, and hoped soon to procure him both profit and honour by my skill. He immediately wrote me an answer, the purport of which was as follows: "My dear son, so great is the love I bear to you, that I should instantly set out for the place where you now reside, were it not that the laws of honour, which I always adhere to, prevent me; for I think myself deprived of the light of my eyes every day that I am without seeing you, as I did formerly, when I gave you the best instructions. I shall keep it in view to incite my family to virtuous enterprize, and pray lead the way in the attainment of good qualities, for which all I wish is that you would keep in mind those few simple words;— observe, and never once allow them to escape your memory:—

> 'The man who consults his house's weal,
> Lives honest—and lives to work—not steal.' "

This letter fell into the hands of my master Ulivieri, who read it to himself, and then said to me: "Thy good looks, Benvenuto, did not deceive me, as I find by a letter from thy father, which has fallen into my hands. He must, doubtless, be a man of worth, therefore consider thyself as in thine own house, and under the care of thy father."

Whilst I stayed at Pisa I went to see the Campo Santo*, where I discovered a great number of antiquities, such as large marble urns; and, in many parts of the town, I saw other monuments of antiquity, which afforded me constant amusement, whenever I was disengaged from the business of the shop. As my master came daily, with great good nature, to see me at the little apartment which he had assigned to my use, when he found that I spent all my time

* The Campo Santo in Pisa, one of the most singular curiosities belonging to that city. It is surrounded by a vast portico, built as early as 1278, every where richly studded with monumental figures in marble, and exhibiting the oldest paintings of Cimabue, Giotto, and other masters. It is said to be a fact, that the Pisanese were so anxious about their place of sepulture, that in 1189 they set sail in several vessels for Jerusalem, in order to bring back holy soil, of which to compose their "Campo Santo," or burial ground.

in laudable and virtuous occupations, he conceived as strong an affection for me as if he had been my father. I improved considerably, during a year's stay in that city, and executed several fine pieces of workmanship, which inspired me with an ardent desire to become more eminent in my profession. My father, at this juncture, wrote to me very affectionately to come home, and, in every letter, exhorted me not to neglect my flute, in which he had taken so much pains to instruct me. Upon this I entirely lost all inclination to return to him; and to such a degree did I hate that abominable flute, that I thought myself in a sort of paradise during my stay at Pisa, where I never once played upon that instrument.

At the expiration of the year, Signor Ulivieri happened to have occasion to go to Florence, to dispose of some filings of gold and silver; and, as I had in that unwholesome air caught a slight fever, I returned, whilst it was upon me, with my master to Florence; where my father secretly intreated my master, in the most urgent manner, not to carry me back again to Pisa. My fever still continuing, I kept my bed about two months, and my father attended me with the greatest affection imaginable; telling me repeatedly that he thought it a thousand years till I recovered, that he might hear me play upon the flute; but feeling my pulse, as he had a smattering of physic and some learning, he perceived so great a change in it whenever he mentioned the flute, that he was often frightened, and left me in tears. Observing then the great concern he was in, I bade one of my sisters bring me a flute; for, though I had a fever constantly upon me, the instrument was a very easy one, and would do me no hurt. I thereupon played with such skill and dexterity, that my father, entering the room on a sudden, gave me a thousand blessings, assuring me that, during my absence from him, I had made great improvements. He requested, moreover, that I would endeavour to continue my progress, and not neglect so admirable a qualification.

But no sooner had I recovered my health, than I returned to my worthy friend, the goldsmith Marcone, who put me in a way of making money; and with my gains I assisted my father and my relations.

CHAPTER III.

Pietro Torrigiani, an Italian statuary, comes to Florence in quest of young artists for the King of England.—The author gets acquainted with him, but refuses to leave Italy.—He improves in drawing by studying the designs of Michel-Angelo and Lionardo da Vinci.—He repairs to Rome for improvement, accompanied by a young artist named Tasso.—He meets with great encouragement in that capital as well as with a variety of adventures.—At the expiration of two years he returns to Florence, where he cultivates his art with great success.—His fellow artists grow jealous of his abilities.—Quarrel between him and Gherardo Guasconti.—Being prosecuted for beating and wounding his antagonist, he disguises himself in a friar's habit, and makes his escape to Rome.

ABOUT this time there came to Florence a sculptor named Pietro Torrigiani, who had just arrived from England, where he had resided several years; and as he was an intimate friend of my master's, he every day came to see him. This artist, having seen my drawings and workmanship, said to me,—"I am come to Florence to invite as many young artists as I can to England, and, having a great work in hand for the King of England, I should be glad of the assistance of my fellow-citizens of Florence. I perceive that your manner of working and your designs are rather those of a sculptor than a goldsmith: now I have considerable undertakings in bronze, so that, if you will go with me to England, I will at once make your fortune." This Torrigiani was a handsome man, of consummate assurance, having rather the air of a bravo than of a sculptor; above all, his fierce gestures and his sonorous voice, with a peculiar manner of knitting his brows, were enough to frighten every one that saw him; and he was continually talking of his valiant feats among those bears of Englishmen. His conversation one day happened to turn upon Michel Angelo Buonarroti*; a drawing of

* Michel-Angelo Buonarroti, called the elder, to distinguish him from his nephew, Michel Angelo, author of "The Tancia," and of the "Fiera," &c., was born in 1474, and gave the first proofs of his extraordinary genius in the school of Bertoldo. Lorenzo, who had opened this academy at his own house, secured the talents of this distinguished pupil, by inviting him to his table, and conferring a pension upon his father. In addition to the information thus acquired in the first society, he arrived at a practical knowledge of his art, and had full leisure to study the exquisite models of antiquity which Lorenzo had collected with so much care. By visiting Rome, after the banishment of the Medici, he was farther enabled to indulge his passionate admiration of the ancients, until unwearied study, and long familiarity with their works, produced those master-pieces of art which contend for excellence with the models upon which they were formed.

Unequalled in sculpture, in drawing, and in architecture, his genius extended itself also to poetry. He seemed to live only for the perfection of the Arts, and St. Peter's is the right monument for his fame.

mine, taken from one of the cartoons of that divine artist, gave rise to this discourse.

This cartoon was the first in which Michel Angelo displayed his extraordinary abilities, as he made this and another, which were to adorn the hall of the palace where the senators assembled, in emulation of Lionardo da Vinci*: they represented the taking of Pisa† by the Florentines.‡ The admirable Lionardo had chosen for his subject a battle fought by cavalry, with the taking of certain standards, in which he acquitted himself with a force of genius that cannot be surpassed by conception. Michel Angelo Buonarroti, in his cartoon, exhibited a considerable body of foot, who were bathing in summer-time in the river Arno; at this very instant he represents an alarm of battle, and all the naked soldiers rushing to arms, with gestures so admirably expressive, that no ancient or modern performance was ever known to attain to so high a degree of perfection: and, as I have already observed, that of the great Lionardo was also a work of extraordinary beauty. These two cartoons stood, one of them in the palace of the Medici, the other in the pope's hall. So long as they remained there, they were the school§ of the world; and though the divine Michel Angelo painted the great chapel of pope Julius, he never again rose to that pitch of excellence: his genius could not reach the force of those first essays.

Let us now return to Pietro Torrigiani; who, holding the above-mentioned drawing of mine in his hand, spoke thus: "This Buonarroti and I went, when we were boys, to learn to draw at the chapel of Masaccio¶, in the church of the Carmelites; and it was customary with Buonarroti to rally all those who were learning to draw there. One day, a sarcasm of his having stung me to the quick, I was provoked to an uncommon degree, and gave him so violent a blow upon the nose with my fist, that I felt the bone and cartilage yield under my hand as if they had been made of paste, and the mark I then gave him he will carry to his grave." This speech raised

* Respecting this celebrated artist and man of letters, we refer the reader to the very elegant life of him, by the learned Abate Amoretti, inserted in Lionardo's works.

† This painting was never finished.

‡ This was not the subject, as appears from Lionardo's own account. It was a great victory won by the Florentines, near Anghiari, 1440.

§ These are now lost. That by Buonarroti was engraved by Marc Antonio Raimondi. Some part of Lionardo's design appeared in a publication entitled the *Etruria Pittrice*.

¶ Tommaso Guidi, commonly called Masaccio, born in 1402. He studied under Donatello, Brunelleschi, Ghiberti, and Masolino da Panicale, in Florence, and then went to Pisa and Rome, where he acquired such a degree of excellence, that, in the opinion of Vasari, he was the first who gave a natural expression, combined with an elevated style, to Italian painting.

in me such an aversion to the fellow, because I had seen the works of the divine Michel Angelo; that, far from having any inclination to go with him to England, I could never more bear the sight of him.*

Whilst I was in Florence I did my utmost to learn the exquisite manner of Michel Angelo, and never once lost sight of it. About this time I contracted an intimate acquaintance and friendship with a youth of my own age, who, like me, was learning the goldsmith's business: his name was Francesco, son of Filippo†, whose father was Frà Filippo, an excellent painter. Our intercourse gave rise to so great an affection between us, that we were never asunder; his house was full of the admirable performances of his father, which consisted of several books of drawings by his own hand representing the antiquities of Rome. I took great delight in these, and our acquaintance lasted about two years. At this time I produced a piece

The chapel here mentioned was a fine school for Lionardo, Michel Angelo, and even for Raffaello. Masaccio died at the age of 41, in 1443.

Annibal Caro says of Masaccio:

> Pinsi, e la mia pittura al ver fu pari;
> L'alteggiai, l'avvivai, le diedi il moto,
> Le diedi affetto: insegni il Buonarroto.
> A tutti gli altri; da me solo impari.

> My paintings seem to move and live;
> Their truth and nature all discern:
> Let Buonarroti lessons give
> To others; from Masaccio, learn.

* Torrigiani began to study design in his own country, as we have already seen, under Bertoldo already named. He soon became famous in sculpture, and works in clay, but was of such an envious and haughty disposition, that he actually destroyed the productions of his fellow-students, when he thought they surpassed his own. From this cause, and for giving Michel Angelo the above-mentioned blow in the face, which occasioned the remarkable depression in that great man's nose, he was obliged to leave Florence. He then worked at Rome for Alexander VI., and soon after entered into the army and served under Duke Valentino, Paolo Vitelli and Pietro de' Medici, the last of whom he saw drowned in the Garigliano. Returning to his studies, he passed over into England, where he acquired great reputation as a sculptor; and unfortunately proceeded thence to Spain, where he was employed by a grandee in modelling a statue of the Virgin. Not receiving the promised reward, which he expected would make his fortune, in a fit of passion he dashed his work to pieces; for which he was basely denounced by the disappointed Spaniard to the Inquisition. In order to escape being burnt alive for heresy, he starved himself to death in the dungeons of the Inquisition, 1522. Some remnants of that fatal statue are still to be seen in Spain, in particular a hand, which exhibits a perfect model.

† Frà Filippo Lippi, so called from his having been a Carmelite monk in his youth. He was considered the best pupil Masaccio ever had, and his figures are remarkable for their breadth of drawing, and their animated expression. He died in 1469. Filippo, his son, in addition to his other merits, has that of having first studied ancient monuments, with a view of exhibiting vases, thrones, trophies, and other ornaments, in his pictures. He died in his 45th year, in 1505.

Cellini alone speaks of Fran. Lippi, the goldsmith.

of basso-relievo in silver, about as big as the hand of a little child; it served for the clasp of a man's belt; clasps of that size being then in use. Upon it was carved a group of foliages, made in the antique taste, with several figures of youths, and other beautiful grotesques. This piece of work I made in the shop of a person named Francesco Salimbeni; and, upon its coming under the inspection of the goldsmiths' company, I acquired the reputation of the most expert young man in the trade.

At this time I was also acquainted with one Giovanni Battista, surnamed Tasso*, who was a carver in wood, a youth of my own age exactly. He one day began to talk to me about going to Rome, observing that he should like to accompany me thither (this occurred as we sat conversing after dinner), and I having had a new difference with my father about learning the flute, said to Tasso, "You appear to be a man of words and not of deeds." Tasso answered, "I have had a dispute with my mother, and, if I had but money sufficient to bear my charges to Rome, I would never more trouble my head about my little hole of a shop." To this I replied, that if there was no other obstruction to our journey, I had money enough in my pocket to defray our expenses. Then chatting as we walked along, before we knew whereabout we were, we came to the gate of San Pier Gattolini; when I said to my companion: "My good friend, Tasso, it is the direction of God that we should insensibly reach this gate: since I have proceeded so far, I think I have performed half the journey."

Matters being thus agreed, we said to each other, as we were jogging on, "What will the old folks at home say this evening?" We then came to a resolution to think no more of them, till we arrived at Rome: so we buckled on our knapsacks, and proceeded in silence to Siena. When we reached that city, Tasso said that he had hurt his feet, and did not choose to walk any farther, at the same time asking me to lend him money to return home. I answered that I should have none left to bear my expenses to Rome, and that he should have well weighed his project before he left Florence; adding, that if the hurt he received prevented his accompanying me, we should find a return-horse for Rome, and then he would have no ex-

*Tasso seems to have been a very constant friend of Cellini's, and stood high in his own profession, as appears from the testimony of Pietro Aretino and Vasari. By his accomplishments, and the peculiar attraction of his manners, he became a great favourite at the court of Duke Cosmo, deciding upon all the works that made their appearance, to the no small detriment of Vasari, Tribolo, and other artists. Wishing to display his skill in architecture, as well as on other subjects, and being deficient in the requisite attainments, he injured the reputation he had before acquired. Among the letters of painters, we perceive one by this same Tasso.

cuse. Thus having hired a horse, as I saw he did not answer me, I bent my course towards the gate that led to Rome. Perceiving that I was resolved, he came hopping after me as well as he could, at a distance, grumbling and muttering all the time. When I reached the gate I was touched with compassion for my companion, and having waited for his coming, took him up behind me, using these words: "What would our friends say of us, if, after having commenced a journey to Rome, we had not the courage to push any farther than Siena?" My friend Tasso acknowledged that my observation was just, and, as he was a person of a cheerful disposition, he began to laugh and sing, and in this merry mood we pursued our journey to Rome. I was then in the nineteenth year of my age, as I was born exactly in the year 1500.

As soon as we got to that capital, I went to work with a master whose name was Firenzuola of Lombardy, an excellent artist in making vases, and other things of a considerable size. Having shewn him part of the model which I had made at Florence with Salimbeni, he was highly pleased with it, and spoke thus to a journeyman of his named Gianotto Gianotti, a native of Florence, that had lived with him several years; "This is one of the geniuses of Florence, and thou art one of its dunces." As I knew this Gianotto, I had a mind to have some chat with him. Before he set out for Rome, we often practised drawing in the same school, and had been for several years intimate acquaintances. He was, however, so much nettled at his master's speech, that he declared he was not acquainted with me, nor had ever seen me before. Provoked at his behaviour in this manner, I said to him, "Oh, Gianotto! formerly my intimate friend, when we were employed together in drawing, and when we ate and drank in such and such apartments of your native town, I do not desire that you should bear testimony of my abilities to your master, for I hope, by my own hands, to shew what I am, without your assistance." When I had done speaking, Firenzuola, who was a passionate man, turned to Gianotto, and said: "You vile scoundrel, are you not ashamed to behave in such a manner to one that was formerly your intimate acquaintance?" At the same time he addressed himself to me: "Come in, young man," said he, "and do as you proposed: let your own hands prove your abilities."

So saying, he set me upon a fine piece of work in silver, which was intended for a cardinal. This was a small case, in imitation of that of porphyry, which stands before the door of the Rotunda. That which I made, I adorned with so many fine figures, that my master went about showing it every where, and making it his boast

that his shop had produced so admirable a piece of art. It was about half a cubit in circumference, and made in such a manner as to hold a salt-cellar at table. This was the first time I earned money at Rome: part of it I sent to the relief of my good father, and the remainder I kept to support me whilst I studied the antiquities of that city, which I did till my money began to fail, and then I was obliged to return to the shop, and work for my subsistence. My fellow-traveller, Battista di Tasso, made but a short stay at Rome, and returned to Florence. For my part I undertook new commissions, and when I had finished them, I took it into my head to change my master, being enticed away by a Milanese, whose name was signor Pagolo Arsago.

My first master Firenzuola had thereupon a great quarrel with this Arsago, and gave him some abusive language in my presence. I began to speak in defence of my new master; and told Firenzuola that "I was born free, and resolved to continue so; that he had no cause of complaint either against Arsago or me; that I had still some money left to receive from him, and that, as I was a free artificer, I would go wherever I thought proper, not being conscious of injuring anybody thereby." At the same time Arsago made a great many apologies, affirming that he had never persuaded me to leave my master, and that I should oblige him by returning to Firenzuola. I replied, that "as I was not conscious of having wronged my master in any respect, and as I had finished all the work I had undertaken, I was resolved to be at my own disposal, and that he who had a mind to employ me, had nobody to consult but myself." Firenzuola made answer: "I will no longer solicit you, or give myself any trouble about you; and I desire you never more to appear in my presence." I then put him in mind of my money, but he only answered by scoffing and derision. I told him that as I used my tools well, as he was sensible I did, in my trade, I knew equally well how to use my sword in recovering my right. As I uttered these words an old signor named Antonio da S. Marino came up; he was one of the best goldsmiths in Rome, and had been Firenzuola's master: hearing what I had to say for myself, he immediately took my part, and desired Firenzuola to pay me. The dispute was very warm, for Firenzuola was still a better swordsman than a jeweller; however, justice and reason are not easily baffled, and I exerted myself to such purpose, that my demand was satisfied. Some time after Firenzuola and I were reconciled, and I stood godfather to a child of his, at his own request. Continuing to work with my new master Pagola Arsago, I earned a great deal of money, and constantly sent the best part of my gains to my father.

At the expiration of two years, I returned to Florence at the request of my good father, and began to work again under Francesco Salimbeni, with whom I gained a genteel subsistence, taking great pains to become perfect in my profession. Having renewed my acquaintance with Francesco di Filippo, though that odious flute drew me into some pleasurable dissipation, I contrived to dedicate some hours, both of the night and the day, to my studies. About this time I made a silver clasp girdle*, such as were usually worn at that time by new-married ladies. It was three inches broad, and worked in half rilievo, with some small round figures in it; this I made for a person of the name of Raffaello Rapaccini. Though I was very ill-paid for my trouble, the work did me so much honour, that the reputation I acquired by it was of more service to me than a fair pecuniary recompense.

Having at this time worked with several masters in Florence, amongst the different goldsmiths I knew in that city, I met with some persons of worth, as was Marcone, my first master; whilst others, who had the character of honest men, being envious of my works, and robbing and calumniating me, did me the greatest injustice. When I perceived this, I shook off my connexions with them, and looked upon them all as unprincipled men, and little better than thieves. A goldsmith, amongst the rest, named Giovanni Battista Sogliani, was so complaisant as to lend me part of his shop, which stood at the side of the new market, hard by Landi's bank. There I executed many little works, earned a great deal of money, and was enabled to assist my relations materially. Envy began then to rankle in the hearts of my former bad masters, whose names were Salvadore and Michele Guasconti; they had three big shops, and had immense business. Seeing that they did me ill offices with some men of worth, I complained of it, and said they ought to be satisfied with having robbed me, as they had done, under the mask of benevolence. This coming to their ears, they declared loudly that they would make me repent having uttered such words; but I, being a stranger to fear, little regarded their menaces.

As I happened one day to lean against the shop of one of these men, he called me to him, and in the most abusive language bullied and threatened me. Upon which I said, that if they had done their duty with respect to me, I should have spoken of them as persons of fair character; but, as they had behaved in a different manner, they had only themselves to complain of. Whilst I spoke thus, one Gherardo Guasconti, a cousin of theirs, who was in all probability

* It was called a Chiava Cuore, or Heart's Key.—*Editor*.

set on by them, took the opportunity, as a beast loaded with bricks happened to pass by, to push it so violently against me, that I was very much hurt. Upon which I instantly turned about, and seeing him laugh, gave him so violent a blow on the temple that he fell down, and lay upon the ground motionless and insensible. Then turning to his cousins, I said to them, "That is the way I use cowardly rascals like you;" and as they, confiding in their number, seemed preparing to take their revenge, I, in a violent passion, drew a little knife, and vented my anger in these words,— "If any one of you offers to quit the shop, let another run for a confessor, as there will be no occasion for a surgeon." This declaration struck such terror into them all, that not one of them ventured to stir to the assistance of his cousin.

No sooner had I left the place, than both the fathers and sons ran to the magistrates, and told them that I had violently assaulted them with arms, in so audacious a manner, that the like had never been known in Florence. The Council of Eight summoned me, and I, without delay, presented myself before them. Here I met with a severe reprimand, as well in consequence of the appearance of my adversaries in long mantles and robes, whilst I wore only a cloak,* as because they had taken care to prepossess them in their favour, a precaution which I, being inexperienced, and trusting to the goodness of my cause, had neglected. I told them, that "as I had received such provocation from Gherardo, and had only given him a slap on the face, I did not think I deserved so severe a rebuke." Prinzivalle della Stufa, who was one of that court, hardly suffering me to make an end of the words "slap on the face," exclaimed, "You gave him a violent blow with your fist, and not a slap." The bell having rung, and we being all dismissed, Prinzivalle thus spoke in my favour to the rest of the bench: "Observe, gentlemen, the simplicity of this poor youth, who acknowledges himself to have given a slap on the face, thinking it to be a less offence than a violent blow; whereas there is a penalty of five-and-twenty crowns for giving a person a slap on the face, in the new-market; while the penalty for a blow with the fist is little or nothing. This is a very worthy young man, who supports his poor relations by his industry: would to God that there were many like him in our city, which can, indeed, boast but a very small number of virtuous citizens."†

* Varchi, who was contemporary with Cellini, says, that a man was considered in Florence as a ruffian, and a low-lived fellow, if he was seen in the day-time merely in his cloak, unless he was a soldier.

† Prinzivalle della Stufa, of the party of the Medici, in whose favour he formed a conspiracy, in the year 1510, against the Gonfalonier Soderini.

There were in the court some persons in folded caps, who, moved by the importunities and misrepresentations of my adversaries, because they were of the faction of Frà Girolamo*, were for having me sent to prison, and heavily fined: but the good Prinzivalle defeated their malice, by getting me fined only in four bushels of meal, which were to be given in charity to the monastery *delle Murate*. This same judge, having called me into his presence, commanded me not to say a single word, but obey the orders of the court, upon pain of incurring their displeasure. They sent us then to the chancellor, and I muttered the words "slap, and not a blow, on the face;" the magistrates burst out a laughing. The chancellor commanded us all to give security to each other for our good behaviour, and sentenced me only to pay the four measures of meal. I thought myself very hardly used, and having sent for a cousin of mine, whose name was Annibale Librodoro, father to Signor Librodoro, the surgeon, that he might be bail for me, he refused to appear. This incensed me to the highest degree, believing my case desperate, and I exclaimed loudly at his behaviour, as he was under great obligations to my family. Here it may be observed how a man's stars not only incline, but actually compel, him to do their behest.

Inflamed by this treatment, swelling like an enraged asp, and being naturally of a very passionate temper, I waited till the court broke up, and the magistrates were gone to dinner. Finding myself then alone, and that I was no longer observed by any of the officers

* Frà Girolamo Savonarola, of Ferrara, was invited to Florence by Lorenzo il Magnifico, in 1489, on account of the high reputation he had acquired throughout Italy by his eloquent discourses, which he well sustained, on his arrival in Florence. —Early nursed in theological studies and observing the utmost sanctity of manners, his daring and impetuous genius disdained to keep any terms with the splendid and somewhat free style and manners of the age and society in which Lorenzo lived. In declaiming against the vices of the times, and calling for reformation, he took care also to predict numerous calamities.—The people soon became attached to his doctrines, but the nobles regarded him with dislike. That he never, however, directly opposed Lorenzo, is known from the latter sending for him to receive his last benediction.

When Pietro de' Medici deserted Florence, and went over to the French, Savonarola was sent, on the part of the Republic, as one of the mediators to Charles VIII. He afterwards became a busy statesman and staunch republican, and even ventured to attack the Pope, Alexander VI. in his sermons, for being on favourable terms with the exiled family of the Medici. By such conduct he brought down upon himself the vengeance of the Holy See; and his enemies becoming too strong for him, at a favourable opportunity, in 1498, they broke into his convent, seized and imprisoned him, and shortly after, by sentence of the judges, expressly sent from Rome by the Pope, they hanged him up and burnt him as a heretic, with two of his companions, in the 46th year of his age. The persons who distinguished themselves by wearing folded caps were disciples of Savonarola, whom the Cardinal Giulio de' Medici and his friends permitted to be in office in order to flatter the Florentines with the shadow of liberty.

of the court, I left the place in a violent fury, and went in all haste
to my workshop, where I took up a dagger, and ran to attack my
adversaries, who by that time were come home. I found them at
table, and young Gherardo, who had been the chief cause of the
quarrel, immediately flew at me. I thereupon gave him a stab in the
breast, which pierced through his cloak and doublet, without once
reaching his skin, or doing him any sort of harm. Imagining, how-
ever, from the rustling of his clothes, upon my giving the stab, and
from his falling flat upon the ground, through fright and astonish-
ment, that I had done him some great hurt, I cried out, "Traitor,
this day I shall be revenged on you all." The father, mother, and
sisters, thinking that the day of judgment was come, fell prostrate
upon their knees, and, with voices full of terror and consternation,
implored for mercy. Seeing then that none of my adversaries stood
upon the defensive, and that Gherardo lay stretched out upon the
ground like a dead corpse, I scorned to meddle with them, but ran
down stairs like a madman. When I got into the street, I found the
rest of the family, who were about a dozen in number, ready to attack
me. One of them held a ball of iron, another a thick iron tube,
another a hammer taken from an anvil, and others again had
cudgels in their hands. Rushing amongst them like a mad bull, I
threw down four or five and fell to the ground along with them,
now aiming my dagger at one, now at another. Those who con-
tinued standing exerted themselves to the utmost, belabouring me
with their hammers and cudgels; but, as God sometimes mercifully
interposes upon such occasions, it so happened that I neither received
nor did any harm. I lost nothing but my cap, which fell into the
hands of some of my adversaries who at first had fled: being assured
it was only my cap, each of them struck it with his weapon; but,
upon looking about for the wounded and slain, it appeared that none
of them had sustained any injury.

The scuffle being over, I bent my course towards the convent of
Santa Maria Novella, and accidentally met with a friar named
Alessio Strozzi. Though I was not acquainted with the good father,
I intreated him to save my life, saying, I had been guilty of a serious
offence. The friar desired me not to be under any apprehensions,
for that whatever crimes I might have committed I should be in
perfect security in his cell. In about an hour's time, the magistrates
having assembled in an extraordinary meeting, published one of the
most tremendous edicts that ever was heard of, threatening the
severest penalties to whosoever should grant me an asylum, or be
privy to my concealment, without any distinction of place or quality
of the person that harboured me.

My poor afflicted father, appearing before the eight judges, fell prostrate upon the ground, and begged them to show compassion on his young and unfortunate son. Thereupon one of those incensed magistrates, shaking the top of his venerable hood, stood up, and thus angrily expressed himself: "Rise directly, and quit this spot, or, to-morrow morning, we shall send you from the town under a guard!" My father, in answer to these menaces, said, "You will do what God permits you, and nothing more." The magistrate replied that nothing could be more certain than that God had thus ordered matters. My father then said boldly to him. "My comfort is that you are a stranger to the decrees of Providence."

Having thus quitted the court, he came to me with a youth about my age, whose name was Piero, son of Giovanni Landi (we were dearer to each other than brothers); this young man had under his mantle an excellent sword and a coat of mail. My father having acquainted me with the situation of affairs, and what the magistrates had said, embraced me most tenderly, and gave me his blessing, saying, "May the protection of God be with you!" Then presenting me with the sword, and the coat of mail, he, with his own hands, helped to accoutre me, concluding with these words, "My worthy son, with these arms you must either live or die." Pier Landi, who was present, wept without ceasing, and brought me ten crowns of gold. I desired him to pull off a few hairs from my cheeks, which were the first down that overspread them. Father Alessio dressed me in the habit of a friar, and gave me a lay brother for a companion.

I came out of the convent by the Al Prato gate, and walked by the side of the town walls, as far as the great square, ascending the steep of Montui, where I found, in one of the first houses, a person of the name of Grassuccio, natural brother to Benedetto da Monte Varchi.* After I had laid aside my friar's disguise, and resumed my former appearance, we mounted two horses, which there stood ready for us, and galloped away in the night to Siena.

Grassuccio, upon his return to Florence, waited on my father, and informed him of my having reached a place of safety. My father, highly rejoiced at these tidings, was impatient to see the magistrate who, the day before, had rebuked him with such severity. As soon as he came into his presence, he said, "You see at last, Antonio, it was God, not you, that knew what was to befall my son." To which the other answered, "I wish I could see him once

* Varchi, the celebrated poet, one of Benvenuto's most intimate friends, as will farther appear. We have met with no account of Grassuccio.

more before this court." My father replied, "I return thanks to God, that he has rescued him out of your hands."

In the mean time I was waiting at Siena for the Roman Procaccio, or mail, with which I travelled on the rest of my journey; and when we had passed the Paglia, we met with the courier, who brought intelligence of the election of Pope Clement VII.*

CHAPTER IV.

The Author meets with extraordinary success at Rome; he is patronized by Signora Porzia Chigi.—Rivalship between him and Lucagnolo da Jesi.—He plays at a concert before Pope Clement VII., who takes him into his service in the double capacity of goldsmith and musician.—He is employed by the Bishop of Salamanca, at the recommendation of a scholar of Raffaello da Urbino.—Anecdotes of the Bishop.

UPON my arrival at Rome I went to work at the shop formerly of Santi the goldsmith; who being dead, his son continued to carry on the business. The latter did not work himself, but employed a young man, whose name was Lucagnolo da Jesi, whom Signor Santi had taken into his service when a little country lad: he was low in stature, but very well proportioned. This youth was more expert than any journeyman I had ever seen before, possessing great facility and freedom of design; he worked only on a large scale, making beautiful vases, basons, and other things of the same kind. Having engaged to work in this shop, I began to make some chandeliers for the bishop of Salamanca, a Spaniard†; these were wrought with as much art as it was possible to bestow upon a work of that nature. A pupil of Raffællo da Urbino, one Giovanni Francesco, surnamed *il Fattore,* who was an excellent painter, and intimate with the bishop, found means to introduce me to his favour, insomuch that he frequently employed me, and I gained considerably by my business.‡

* In the year 1523.

† Don Francesco de Bobadilla, bishop of Salamanca, arrived at Rome in 1517, to attend the Lateran Council. He was afterwards shut up with Clement VII. in the castle of St. Angelo, when it was besieged in 1527.

‡ Gio. Francesco Penni, called *il Fattore,* was a Florentine. Raffaello, whose benevolence was scarcely exceeded by his talents, invariably treated this worthy pupil as if he had been his own son, entertained him in his house, and left at his death, to him and Giulio Romano, the whole of his effects. They completed together all the unfinished works of Raffaello. Penni then worked with his relation Pierino del Vaga, and succeeded better in design than in colouring. He died at Naples in the 40th year of his age.

About this same period I sometimes went to draw at the chapel of Michel Angelo*, and sometimes at the house of Agostino Chigi† of Siena, in which were several admirable paintings by that great master, Raffaello da Urbino‡; this was only upon holidays, because Signor Gismondo, brother to the said Signor Agostino, was come to live there. The family, however, were greatly pleased when they saw young artists frequenting their house, as a school of painting. The wife of the said Signor Gismondo, a most elegant and beautiful lady, having often seen me thus employed under her roof, one day came to look at my drawings, and asked me whether I was a painter or a statuary: I told her I was a goldsmith. She replied that I drew too well for a goldsmith; and having ordered her waiting-maid to bring her a jewel consisting of some very fine diamonds set in gold,

* The Sistine Chapel.

† It is now called "La Casa Farnesina," in the possession of the King of Naples. Agostino Chigi, a wealthy merchant, distinguished for his liberality to the arts, formerly assembled there some of the most celebrated painters of the age. He employed Raffaello, with the assistance of Giulio Romano, *il Fattore* Gaudenzio, Raffael del Borgo, and his other pupils, to paint for him the entire fable of *Psyche,* and the beautiful *Galatea.* Chigi died in or about 1520.

‡ Raffaello Sanzio, one of the finest geniuses Nature in her most lavish moments ever produced. Every thing seemed to have combined to render him great, whether we consider his talents, their cultivation, the career chalked out for him, the society and the munificent patronage of princes, or the spirit of the age in which he lived. Inferior only to Michel Angelo in a knowledge of the human frame and the art of drawing ideal subjects, he was unequalled by any in the exquisite delineation of real human beauty and living forms, in which the expression of the passions and affections of our nature was carried to its very highest excellence.

Where Buonarroti seizes upon and astonishes the mind by the grandeur and imagination he displays, Raffaello's genius goes directly to the heart, and, with a fascinating power which the most sceptical and indifferent in vain resist, compels them to feel there is a language in the art which even the vulgar can understand. Admitting, then, the equal excellence of both, in their respective works, the preference will be given to Raffaello, because men in general possess more feeling than imagination, and admire nature's living beauties more than the ideal and sublime. Hence Raffaello has for three centuries been considered as the prince of painters; as Michel Angelo would otherwise have been.

Raffaello was also a good architect, and wrote comments upon Vitruvius. That fine letter to Leo X. on the best mode of designing the antiquities of Rome, is likewise, on the authority of Bald. Castiglione, attributed to him: he also directed, and most probably modelled, the statue of Juno, placed near the Madonna del Popolo at Rome. He is said to have tried several different styles; an opinion altogether unfounded: for when he left his master, Pietro Perugino, he adopted those excellent maxims which ever after continued to influence him in the various branches of his art. The *Dispute on the Sacrament* marks the period, when his genius, emancipated from a school, began to see nature with free and unshackled eyes. The "Acts of the Apostles," and the "Transfiguration," show the sublime reach of his maturer powers. He had a noble figure, agreeable manners, and was consequently much admired, and addicted to pleasure. His liberality and other distinguished qualities were such, that his most invidious rivals and enemies were frequently loud in his praise. He was carried off suddenly, in the midst of his fame, and in the very flower of his age, on his birth-day, Good Friday 1520, in the 37th year of his age.

she desired me to tell their value. I estimated them at eight hundred
crowns. The lady declared that I had judged very rightly, and then
asked whether I would undertake to set them properly; I answered
that I would do it most willingly; and began the design in her pres-
ence, in which I was the more successful on account of the pleasure
I took in conversing with so fair and agreeable a lady. When I had
finished my sketch, another most beautiful Roman lady came down
stairs into the room, and asked Porzia (which was the first lady's
name) what she was about, to which the latter answered, smiling, "I
am amusing myself in seeing this young man draw, who is as good
as he is handsome." Though I had acquired some assurance, I yet
retained a mixture of bashfulness with it; I coloured deeply, and
said, "Let me be what I may, madam, I shall always be most ready
to serve you." The lady, reddening a little herself, replied, "You
know I am desirous of your services." She then bade me take the
diamonds home with me, and gave me twenty gold crowns, saying,
"Set these diamonds according to the design which you have drawn,
and preserve me the old gold in which they are mounted." The other
lady then said, "If I were the young man I would go off with what
I had got." Signora Porzia rejoined, "That virtues are seldom
coupled with vices, and that, were I to behave in that manner, I
should belie my honest open countenance;" then taking the other lady
by the hand she turned about, and said to me with a smile of con-
descension, "Farewell, Benvenuto."

I stayed some time after I had drawn the design, copying a figure
of Jove*, the work of Raffællo da Urbino. As soon as I had
finished it, I went away, and set about making a little model in wax,
to show in what manner the work was afterwards to be executed.
This I carried to Signora Porzia, with whom I found the Roman
lady: they were both highly pleased with my specimen, and en-
couraged me by such obliging compliments, that I collected sufficient
confidence to promise them that the work itself should be far
superior to the model. I thereupon began my task, and in twelve
days set the jewels in the form of a fleur-de-lys, as I said above,
adorning it with little masks, figures of boys and animals, and the
finest enamel, so that the diamonds of which the fleur-de-lys was
composed appeared with redoubled lustre.

Whilst I was engaged on this work, the worthy Lucagnolo
seemed much dissatisfied, frequently telling me that it would be
more for my interest, as well as reputation, to help him in working
on pieces of plate, as I had done at first. I made answer, that I could

* In the same fable of Psyche, where the figure of Jupiter is frequently intro-
duced.

always obtain that kind of employment, but that such commissions as that in which I was occupied did not occur every day; and that they were no less reputable, and far more profitable, than large silver vessels. Upon my telling Lucagnolo that they were more lucrative, he laughed at me, and said, "You'll see that, Benvenuto; for by the time that you have completed your job I shall contrive to finish this piece of plate, which I began precisely at the same time when you undertook the setting of the jewels; and experience will convince you of the difference between the profit accruing to me from my piece of plate, and to you for your trinkets." I answered, that I would with pleasure make such a trial of skill with so consummate an artist, that it might appear which of us was mistaken, when both our performances were finished.

Thus, with countenances that betokened some displeasure, we both fell hard to work, eager to finish our several undertakings; and we laboured so industriously, that in about ten days' time we had both of us completed our respective tasks, in an elegant and workmanlike style. That of Lucagnolo was a large silver vase, which was to be placed on the table of Pope Clement, and to receive bones and the rinds of various fruits whilst that pontiff was at his meals,— a work rather calculated for magnificence and ostentation than any real use. This piece of plate was adorned with two beautiful handles, as likewise with many masks of different sizes, and several fine foliages of the most beautiful and ingenious design that could possibly be conceived. Upon seeing this performance, I told Lucagnolo that it was the finest piece of plate I had ever beheld. Lucagnolo, thinking he had convinced me of my error, answered, "Your work appears to me equally admirable; but we shall soon see the difference between them." He then carried his piece of plate to the pope, who was highly satisfied and immediately caused him to be paid the ordinary price for works of that kind.

In the mean time I took my performance to Signora Porzia, who expressed great surprise at my having finished it so expeditiously, and told me that I had far exceeded my promise to her. She then desired me to ask whatever I thought proper in recompense for my labour, declaring that, were she to make me lord of a castle, she should hardly think she had rewarded me in proportion to my deserts; but since that surpassed her ability, she desired me, with a smile, to ask something in her power to bestow. I answered that the most valued recompense which could crown my endeavours, was the satisfaction of having pleased her ladyship. This I said in a cheerful way; and, having made my bow, was departing, assuring her that I desired no other payment. Upon this, Signora Porzia,

turning to the other lady, said, "You see the virtues we discovered in him are accompanied by others, and not by vices;" and they both expressed equal admiration. Signora Porzia then said to me,— "My good Benvenuto, did you never hear it said, that when the poor give to the rich, the devil laughs?" I replied, that since he had met with so many vexations, I had a mind he should laugh for once. But as I was going away, she said she did not intend to favour him so much this time.

Upon my return to the shop, Lucagnolo, who had the money he received from the pope wrapped up in a paper, said to me,—"Now compare the payment I have received for my piece of plate, with what you have had for your jewels." I answered, that we might let the matter rest for that time, but I hoped the day following to make it appear that, as my work was in its kind as exquisite as his, I should be rewarded with equal munificence. The next day Signora Porzia, having sent her steward to the shop, he called me out, and put into my hands a paper bag of money, which he brought from that lady, telling me, at the same time, it was not his mistress's intention that the devil should laugh at my expense; and, that the money she sent me was by no means a reward adequate to my merit, with several other compliments worthy of such a lady.

Lucagnolo, who thought it an age till he could compare his money to mine, that instant rushed into the shop; and in the presence of twelve workmen, and other neighbours, who were come to see how the contest would end, took his paper, laughing with an air of triumph; then having pretended to make three or four efforts, he at last poured out the cash, which rattled loudly upon the counter: it amounted to the sum of five and twenty crowns in silver. I who was quite stunned and disconcerted with his noise, and with the laughter and scoffs of the by-standers, having just peeped into my paper, and seeing it was filled with gold, without any emotion or bustle, held my paper bag up in the air, as I stood on one side of the counter, and emptied it as a miller does a sack. My coin was double the number of his, so that all the spectators who before had their eyes fixed upon me with a scornful air, suddenly turned about to him, and said, "Lucagnolo, Benvenuto's pieces, being all gold, and twice as many as yours, make the grandest appearance of the two." Such an effect had envy, and the scorn shown by all present upon Lucagnolo, that I thought he would have dropped down dead; and though he was to receive a third part of the money, as I was only a journeyman, and he my master, envy prevailed in him over avarice, which one would have expected to have been just the contrary, this Lucagnolo tracing his birth to a native of Jesi. He curst his art, and those

from whom he had learnt it, declaring that from thenceforward he would renounce it, giving his whole mind to these toys, since they were so well paid for. Equally indignant on my part, I said, that every bird considered its own note the sweetest; and that he talked like a rude uncultivated fellow in keeping with the Bœotian soil from which he had sprung. I then told him I would venture to prophesy, that I should succeed in his branch of business, but that he would never be successful in my gewgaws, as he called them. Thus I went off in a passion, telling him I would soon make it appear that I was no false prophet. Those who were present all declared him to be in the wrong, looking upon him as a mean fellow, which he was in fact; and upon me as a man of spirit, as I had shown myself.

The next day I went to return thanks to Signora Porzia, and told her that her ladyship had done the reverse of what she said she would; that I proposed to make the devil laugh, and that she had made him once more renounce God. We both were merry upon the occasion, and she gave me orders for other fine and valuable works.

About this time I contrived, by means of a pupil of Raffaello da Urbino, to get employed by the bishop of Salamanca, in making one of those large silver vases for holding water, which are used in cupboards, and generally laid upon them by way of ornament. The bishop being desirous of having two of equal size, employed Lucagnolo to make one, and me another; but with regard to fashion, Giovanni Francesco, the painter, gave us a design, to which we were to conform. I with great alacrity set about this piece of plate; and a Milanese, whose name was Signor Giovanni Pietro della Tacca, accommodated me with a part of his shop to follow my business. Having begun my work, I laid by what money I wanted for my own private use, and the remainder I sent to the relief of my poor father. At the very time the money was paid him in Florence, he happened to meet with one of those rigid magistrates, who had menaced and used him so roughly in consequence of my unfortunate scuffle. As this fiery magistrate had some very worthless sons, my father took an opportunity to say to him, "Untoward accidents may happen to any body, especially to men of choleric tempers, when they know themselves to be injured; as was the case with my son, when he quarrelled with those jewellers: but it is evident from the general tenour of his life, that I knew how to give him a virtuous education. I pray God your sons may behave to you neither better nor worse than mine has to me; and that I wish for your sake; for as God enabled me to give them a virtuous education, so when my aid was unavailing, he interposed himself and found means to rescue them

out of your violent hands." After he had left the magistrate, he wrote me an account of the whole affair, requesting me to play sometimes upon the flute, that I might not lose that admirable art, which he had taken so much pains to teach me. I now found myself strongly inclined to oblige him in this respect before he died: thus God often grants us those blessings which we pray for with faithful hearts.

Whilst I was going on with the bishop of Salamanca's plate, I had no assistance but that of a little boy, whom, at the earnest request of his relations, I had, half against my will, taken as an apprentice. This boy, named Paulino, then about fourteen, was son to a citizen of Rome, who lived upon his fortune. Paulino was one of the best bred, sweetest tempered and prettiest boys that I ever saw in my life; and on account of his good qualities, his extraordinary beauty, and the great love he bore me, I conceived the strongest affection for him that the human breast can conceive.

One of the effects of this great fondness was, that, in order to diffuse a ray of cheerfulness over his features, which had naturally a serious melancholy cast, I from time to time took in hand my flute: he used then to smile in so graceful and affecting a manner, that I am not the least surprised at the fables which the Greeks have written concerning their deities. Had my apprentice lived in that age, he would, in all probability, have turned the heads of some of the poets of antiquity. Paulino had a sister named Faustina, of so exquisite a form, that she might justly be compared to the renowned Faustina, whose charms are so much vaunted by historians; and as he sometimes carried me with him to his father's, so far as I could judge from observation, that worthy man seemed desirous that I should be his son-in-law. This made me set a much higher value upon music than I had done before. It happened about this time that Giovanni Giacomo, a musician of Cesena, who belonged to the Pope's household, and was an excellent performer, sent Lorenzo Trombone, of Lucca, a person who is now in the service of our Duke, to propose to me to assist them with my flute at the Pope's Ferragosto*, in playing some concert music; as he had selected some of the most beautiful compositions for the occasion. Though I had an earnest desire to finish the fine piece of plate that I had begun, yet as music has a secret charm in it, and as I was in some measure desirous of gratifying my aged father, I agreed to make one at their concert; so that for eight days before the Ferragosto we every two hours had a rehearsal.

* A feast at Rome on the 1st of August.

Upon the first of August we repaired to Belvidere, and, whilst Pope Clement was at dinner, we played those fine compositions which we had long practised, insomuch that his Holiness declared he had never been delighted with more exquisite harmony: then sending for Giovanni Giacomo, he inquired of him how he had procured so able a master of the flute, and ordered him to give a full and circumstantial account of my person. Upon Giovanni Giacomo's mentioning my name, the Pope said, "Is he the son of Giovanni Cellini?" Finding who I was, he added, that he would take me into his service, and make me one of his band of music. Giacomo answered, "As to his joining your Holiness's band, I will believe it when I see it: his business is that of a goldsmith and jeweller, in which he is a complete master, and, by working at it constantly, he makes a great deal more money than he could ever gain by music." The Pope replied, "I am, therefore, the more desirous of having him in my service, since he is possessed of one talent more than I expected. Let him have the same salary with the rest of you, and tell him from me that I desire he would become one of my band, and I will find him constant employment in his other business." His Holiness thereupon gave him a handkerchief, which contained a hundred gold crowns, desiring him to divide them amongst the band, and let me have my share.—Giacomo having quitted the Pope, came to us and repeated word for word all that his Holiness had said. Having then divided the money amongst eight of us musicians, and given me what fell to my share, he added—"I have orders to set you down as one of our band." To this I made answer—"Give me a day to consider of it, and to-morrow I will let you know my determination."

When I had left them, I deliberated within myself whether I should accept the offer, as it was likely to interrupt me so much in the noble study of my own art. The night following, my father appeared to me in a dream, and entreated me, with tears of affection, that I would for his sake accept of the place of musician to the Pope; I thought I replied, that it was my firm resolution to do no such thing. He then appeared to me to assume a form so horrible, that I was shocked to behold him, and he said, "If you do not, you will have your father's curse; but if you conform to my desire, I will bless you for ever." No sooner was I awake, than I ran in a fright to get my name entered amongst the Pope's musicians. I then wrote to my aged father, telling him what I had done; who, upon receiving the intelligence, was, through excess of joy, attacked by a disorder, which brought him almost to death's door. Immediately upon his recovery he wrote me word that he had had exactly the

same dream as mine: I therefore concluded that I had given my father full satisfaction, and that all things would succeed to my wishes. I then exerted myself to the utmost to finish the piece of plate, which I had begun for the bishop of Salamanca.

This prelate was an extraordinary person, and exceedingly rich, but very difficult to please. He sent every day to inquire how I went on; and as the messenger happened once not to find me at work, his master came in a great passion, and said he would take the work out of my hands, and give it to another to finish. This came of my attaching myself to that odious flute. I therefore continued the work day and night with the most assiduous application, till I had forwarded it to such a degree, that I thought I might venture to show it to the bishop; but upon seeing what I had done, he grew so impatient to have it completed, that I heartily repented having ever shown it to him. In about three months I finished this grand piece of plate, which I adorned with a surprising variety of beautiful animals, foliages, and figures. I then sent my apprentice Paulino to show it to the ingenious Lucagnolo. Paulino delivered his message in the most graceful manner imaginable, in these terms; "Signor Lucagnolo, my master Benvenuto has, in pursuance of his promise, sent me to show you a piece of work, which he has made in imitation of your performances, and he expects in return to see some of your little nick-knacks." These words being uttered, Lucagnolo took the piece of plate into his hand, and having examined it sufficiently, said to Paulino: "My pretty youth, tell thy master that he is an excellent artist, and that there is nothing I desire more than his friendship." The lad joyfully delivered his message.

The plate was then carried to the bishop, who wanted to have a price set upon it. Just at this juncture Lucagnolo entered the room, who spoke of my work so honourably, and praised it to such a degree, that he even surpassed my own good opinion of it. The bishop having taken the plate into his hands, said, like a true Spaniard, "By G—I will be as slow in paying him, as he was in finishing the work." When I heard this, I was highly mortified, and cursed Spain and all who belonged to it.

Amongst other beautiful ornaments, there was a handle to this silver vase of the most exquisite workmanship, which by means of a kind of spring stood exactly upon the mouth of it. The bishop one day ostentatiously exhibiting this piece of plate to some Spanish gentlemen of his acquaintance, it happened that one of them meddling indiscreetly with the handle, the delicate spring, ill-adapted to bear his rough touch, suddenly broke; and this occurred after his lordship had left the room. The gentleman thinking this a most

unlucky accident, entreated the person who took care of the cupboard, to carry the vase directly to the artist who had made it, and order him to mend it without delay, promising that he should be paid his own price, in case he proved expeditious. The piece of plate being thus again come into my hands, I promised to mend it without loss of time; and this promise I performed, for it was brought me before dinner, and I finished it by ten o'clock at night. The person that left it with me then came in a most violent hurry, for my lord bishop had called for it again, to show it to other gentlemen. The messenger, not giving me time to utter a word, cried, "Quick, quick, bring the plate in all haste." Being determined to take my own time, and not to let him have it, I said I did not choose to make such despatch. The man then flew into a passion, and clapping his hand to his sword, seemed to be ready to break into the shop by main force; but this I prevented by dint of arms and menacing expressions. "I will not let you have it," said I; "go tell your master that it shall not be taken out of my shop, till I am paid for my trouble." Seeing he could not obtain it by bullying, he began to beg and pray in the most suppliant manner; saying, that if I would put it into his hands, he would take care to see me satisfied. These words did not in the least shake my resolution; and as I persisted in the same answer, he at last despaired of success, and swearing that he would return with a body of Spaniards and cut me to pieces, thought proper to depart. In the mean time I, who gave some credit to what I had heard of Spanish assassinations, resolved that I would defend myself courageously; and having put in order an excellent fowling-piece, I said in my own mind, "He that takes both my property and my labour, may as well deprive me of life."

Whilst I thus argued with myself, a crowd of Spaniards made their appearance with the above-mentioned domestic at their head, who with great arrogance bade them break open the shop. At these words I showed them the muzzle of my loaded fusil, and cried out with a loud voice, "Miscreants! traitors! cut-throats! are the houses and shops of citizens of Rome to be assaulted in this manner? If any thief amongst you offers to approach this door, I will shoot him dead." Then taking aim at the domestic, and pretending that I was going to fire at him, I cried out, "As for you, you rascal, that set them on, you are the very first I shall make an example of." Upon hearing this, he clapped spurs to a jennet, upon which he was mounted, and fled at full speed. The disturbance had now brought all the neighbours out of their houses, when some Roman gentlemen passing by said: "Kill the dogs, and we will stand by you."

These words had such an effect on the Spaniards, that they left me in a terrible panic, and told his lordship all that had happened.

The bishop, a proud haughty man, reprimanded and scolded his servants very severely, both because they had commenced such an act of violence, and because they had not gone through with it. The painter who had been present at the above-mentioned accident, entering at this juncture, his lordship desired him to go and tell me, that if I did not bring him the piece of plate directly, he would leave no part of my body entire but my ears, but that if I brought it without delay, he would instantly satisfy my demand. The proud prelate's menaces did not in the least terrify me, and I sent him word I should immediately lay the whole affair before the Pope.

In the meantime his anger and my fear having subsided, and some gentlemen of Rome assuring me that I should come to no harm, and should be paid for my trouble, I repaired armed with my dagger and coat of mail, to the house of the bishop, who had caused all his servants to be drawn up in a line. There I made my appearance, Paulino following close behind me with the piece of plate. To make my way through the line of domestics, was like passing through the Zodiac; one of them looked like a lion, another like a scorpion, and a third like a crab, till at last we came into the presence of this reverend prelate, who uttered the most priest-like, Spaniard-like words that I ever heard. All this time I never once looked at him, or so much as answered a single word; at which his lordship seemed to discover more resentment than ever, and having ordered pen, ink, and paper, desired me to write him a receipt. I then looked him full in the face, and told him that I would readily do so, after I had received my money. The haughty bishop was then more exasperated than ever; but in fine, after a great deal of scolding and hectoring, I was paid, and afterwards, having written an acquittance, left the place in high spirits.

Pope Clement afterwards heard the whole affair, having first seen the piece of plate in question, though it was not shown him by me. He was highly pleased at what had happened, and said publicly that he entirely approved of my behaviour, so that the bishop heartily repented what he had done; and, in order to make atonement for the past, sent me word by the same painter, that he intended to employ me in many commissions of importance; to which I made answer, that I was very willing to undertake them, but that I should insist upon being paid beforehand. These words coming likewise to the ear of Pope Clement made him laugh heartily. Cardinal Cibo was at Rome when the affair happened; and his Holiness told him

the whole story of the difference between me and the bishop of
Salamanca, with all the disturbances it had given rise to; upon which
he turned to one of his domestics, and bade him find constant
employment for me in my business as a goldsmith. The above
cardinal* sent for me, and after much conversation ordered me to
make him a piece of plate, more considerable than that which I had
lately finished for the bishop of Salamanca. I likewise worked for
Cardinal Cornaro†, and for many other cardinals, especially Ridolfi‡
and Salviati§: I was employed by them all, and earned a great deal
of money. Signora Porzia Chigi recommended me to open a shop
entirely upon my own account. I did so accordingly, and was kept
in constant employment by that good lady, so that it was perhaps
by her means chiefly that I came to make some figure in the world.

At this time I contracted an intimate acquaintance with Signor
Gabriello Cesarini, gonfalonier of Rome, and was frequently em-
ployed by that gentleman. Amongst other works which I executed
for him, one was particularly remarkable, namely, a large gold
medal to be worn upon a hat, and on which was engraved Leda
with her enamoured swan. He was highly pleased with the exe-
cution, and said he would get my work examined, in order to pay
me according to its full value. My medal being a masterpiece of art,
the connoisseurs set a much higher price upon it than he expected;
he kept the medal, and I reaped no benefit from my labour. The
same circumstance, however, happened respecting this medal, as in

* Cardinal Innocenzo Cibo Malaspina, Archbishop of Genoa, was a son of
Leo X.'s sister, and vied with his maternal relations in patronising learned men,
bestowing upon them the greater part of his immense wealth. He died in 1550.

† Marco Cornaro, brother of the Queen of Cyprus, and nephew of the Doge of
Venice, a bishop and cardinal, was a person of great authority, both in Rome and
Venice. He brought about a reconciliation between the Venetians and Julius II.,
and was solemnly eulogized by Leo X. for his skill and assiduity in promoting the
interests of his country and the Church. The works in which Cellini was engaged,
must have been commenced before July 1524, as Cardinal Cornaro had at that time
set out for Venice to avoid the plague, and died suddenly from excessive fatigue
in the journey.

‡ Cardinal Niccolo Ridolfi, a Florentine, nephew of Leo X., collected a splendid
library at an enormous expense, enriched with the rarest works in art and literature.
Sadoleto extols him for his great learning and liberality.

§ Gio. Salviati, son of Giacopo already mentioned, was made a cardinal by his
uncle Leo X.: he succeeded in some of the most difficult embassies of the Papal
Court; and brought to a favourable termination several long and intricate treaties.
He was an excellent scholar, as well as a patron of learned men, and by his unexcep-
tionable manners, kindness, and liberality, acquired a high reputation, both at home
and abroad. As he did not, however, always indulge Cellini in his humour and
caprices, we shall see, as he proceeds, in what terms he complains of this very
respectable prelate, who died in 1553.

the case of the bishop of Salamanca's piece of plate; but that narratives of this sort may not interfere with matters of much greater importance, I shall content myself with having barely touched upon this adventure.

CHAPTER V.

The Author quarrels with Rienzo da Ceri, and accepts a challenge from him.— He applies himself to seal-engraving, and improves in that art under Lautizio.— The plague breaks out at Rome, during which he amuses himself with taking views of the antiquities of that city.—Story of Signor Giacomo Carpi the surgeon, and of the vases designed by Benvenuto.—The pestilence having ceased, a society of artists is formed, who hold weekly meetings.—Grand entertainment at one of these meetings, and a frolic of the Author's, at which were present Michelagnolo of Siena, and Giulio Romano.

As I am sometimes obliged to quit the sphere of my profession, in writing the history of my life, I find it expedient, with regard to such articles as the last mentioned, not to give a circumstantial account of them, but a summary of the chief particulars.

I happened once, at our feast of Saint John, to dine with several of my countrymen of different callings—painters, sculptors, and goldsmiths; where, amongst other artists of distinguished reputation, were present one Rosso*, a painter, Giovanni Francesco, a pupil of Raffaello da Urbino, and many more. As I had invited them without any ceremony or constraint, they laughed and jested, as is usual with mixed companies, and made merry upon occasion of so great a festival. In the meantime a swaggering, bullying youth, a soldier of Signor Rienzo da Ceri†, happening to pass by, thought proper to ridicule the Florentines, and to cast many injurious

* Rosso, a Florentine painter, distinguished in his profession, and a great scholar, of a handsome person and prepossessing manners, was invited by Francis I. to take the place relinquished by Andrea del Sarto, at the French court. The liberality of that monarch enabled him to reside at Paris in comparative affluence and splendour. Imagining one of his countrymen had robbed him, he began a prosecution, but failing to make out the proofs, and fearful of being punished as a calumniator, he took poison, and died in 1541.

† *Renzo,* or Lorenzo da Ceri, was one of those stipendiary captains who were ready at the head of their company to take any side, or fight for any prince, according to their interest. Renzo gained high reputation by his defense of Crema, in the Venetian pay, 1514, and entering into the service of the Pope, afterwards conquered the dukedom of Urbino. When the king of France arrived in Italy, Renzo devoted his services to that monarch. He failed in an attack on the citadel of Arona, but his defence of Marseilles obtained for him the confidence of Francis I., who sent him to defend Rome from the threatened attack of the Imperialists. In this he altogether failed, as well for want of forces, as through his presumption and incapacity. The French call him Rentio Cerez.

reflections upon the whole body of the nation. As it was I who had invited all these men of genius and worth to this meeting, I considered myself as the person chiefly insulted; and therefore, unnoticed by any of the company, I went quietly up to the gentleman, who was in company with a woman of the town, and continued his gibing to divert her. I asked him whether he was the audacious man that abused the Florentines; and he immediately replied, "I am that man." Scarcely had he uttered these words, when I gave him a slap on the face, saying, "And I am *this* man:" we both instantly drew our swords in a violent rage. But we had hardly made three passes, when several of the by-standers interposed, most of them seeming to take my part, rather than that of my opponent; perceiving from what they had heard and seen, that I was in the right. The next day I received a written challenge from my adversary, which I accepted with great cheerfulness, declaring that I thought this an affair of much more urgent importance than the business of my art. I instantly went to consult an old man named Bevilacqua, who had the reputation of being the best swordsman in Italy, having fought above twenty duels, and always come off with honour*: this worthy man was my particular friend. He had become acquainted with me through my professional transactions, and had even interposed in some warm disputes between me and other persons: he therefore said to me, "My good friend, Benvenuto, if you were to cope with Mars himself, I have not the least doubt but you would acquire honour; for though I have been acquainted with you so many years, I never knew you in the wrong in any quarrel." He consented, therefore, to be my second, and, having repaired to the place appointed, in arms, I came off with much credit, by my opponent's yielding, though there was no blood shed. I pass by the particulars of this affair, which might indeed be entertaining in their way; rather choosing to dwell upon the events that befell me in the pursuits of my art, which was my chief motive for taking pen in hand, and in recounting which I shall find sufficient employment.

Though I was excited by an honest emulation to produce a piece of work which might equal, or even surpass, those of that able artist, Lucagnolo, I did not, however, upon that account, quit my agreeable art of jewelling; and, by uniting the two, I acquired much more reputation and profit, than I could have done by either singly; for, in both branches, I often accomplished things unknown to other artists.

* Paolo Giovio (Paulus Jovius), in the history of his times, relates that in the battle of Rapallo, in which the Aragonese were routed by the Genoese, in 1494, there were 400 Prætorians, all complete gladiators, famous for duels gallantly concluded, who fought in sight of the Doge, and amongst these he mentions Bevilacqua, a Milanese. This may probably be the same here mentioned by Cellini.

There was, at this time, in Rome, a native of Perugia, of great abilities, named Lautizio; the only man that worked in his branch of the business, which was that of a seal-engraver. Every Cardinal, at Rome, has a seal on which his title is engraved; it is made as large as the hand of a child ten years old, and the title is embellished with a variety of figures. One of these seals, well executed, costs a hundred crowns and upwards. I could not help desiring to rival so eminent an artist, though this business widely differs from that of the jeweller and goldsmith; but Lautizio, who was master of the art of seal-making, seemed to be confined to that alone, and knew nothing of any other art. I therefore set about learning this business, and though I found it extremely difficult, was never wearied by any labour it cost me, but steadily pursued the objects of gain and improvement. There was likewise, in Rome, another eminent artist, a native of Milan, who went by the name of Caradosso*. This man worked only in medals, engraved with a chisel, upon thin plates of metal, and many other materials: he made some Scripture pieces in mezzo rilievo†, and figures of Christ, a palm long, of thin plates of gold, and of such admirable workmanship, that I looked upon him to be one of the greatest masters in this art that I had ever known; and I envied him more than any of the rest. There were likewise other masters there, who worked in medals engraved on steel; these are the true guides and models of those who desire to acquire perfection in coining money. I set about learning all these different branches with the greatest assiduity. Next to these came the most elegant art of enamelling, in which I never heard of more than one that excelled, and this was a Florentine, named

* More commonly known by the name of Ambrogio Foppa, a jeweller and goldsmith, excellent in every branch of his art, (comprehending at that time various ingenious arts and inventions). The extreme exactness of his works often delayed their appearance, and he was in one instance so dilatory and slow, that a Spanish gentleman, having lost all patience, addressed him with the epithet of Cara d'Osso, or bear's face, in allusion to its deformity. Foppa, who was a quiet and simple kind of person, not aware of its application, only laughed, and applied to his companions for an explanation, which they gave him much to their amusement; nor has he been able to get rid of this nickname (Messer Caradosso) ever since. When Lazzari built the grand Octagon in Milan, near the Sacristy of S. Satiro, Foppa finished the interior decorations, and modelled a magnificent frieze with gigantic heads and Cupids in terra-cotta bronzed, which is considered as a masterpiece of its kind. During the Pontificate of Julius II. Foppa went to Rome, and being employed in the mint, produced both for Julius and Leo X. such noble medals and coins, as to be pronounced, by Vasari, incomparable. Few of his medals remain; among which are heads of Bramante, Trivulzio, Galeazzo Sforza, Galeazzo Maria and Lodovico il Moro.

† Scripture-pieces, in the Italian, "Paci," are those small tablets hung up in Catholic Churches, representing sacred emblems, to be kissed with the utmost devotion. One of these, from the hand of Caradosso, is preserved in S. Satiro, in Milan.

Amerigo, with whom I was not acquainted. His performances were indeed admirable, and such as were never equalled in any part of the globe; nor could I, or any other man, ever boast of having seen a piece of workmanship of the kind, that made even a faint approach to their excellence. The art of enamelling is extremely difficult on account of the fire, which is the last thing used in works of that nature, and often spoils and totally destroys them. Nevertheless, I attached myself likewise to it with the greatest ardour; and, though I found it very hard to be acquired, such was the pleasure I took in learning it, that its greatest difficulties appeared delightful to me. This was through the peculiar indulgence of the Author of nature, who had gifted me with a genius so happy, that I could with the utmost ease learn any thing I gave my mind to. These several branches are very different from each other; insomuch, that the man who excels in one, seldom or never attains to an equal degree of perfection in any of the rest; whereas I, having exerted myself with the utmost assiduity to be eminent in all these different arts, at last compassed my end, as I shall show in a proper place.

About this time, whilst I was still a young man, of three-and-twenty, so dreadful an epidemic disease prevailed in Rome*, that several thousands died every day. Somewhat terrified at this calamity, I began to indulge myself in certain recreations, as the fancy took me, and for a reason which I shall state. So on holidays I amused myself with visiting the antiquities of that city, and sometimes took their figures in wax, at other times I made drawings of them. As these antiquities are all ruinous edifices, where a number of pigeons build their nests, I had a mind to divert myself among them with my fowling-piece; but being greatly afraid of the plague, I avoided all commerce with the inhabitants, and made Paulino carry my gun. Thus we repaired together to the ruins, from whence I often returned home laden with pigeons of the largest size. But I never chose to put more than a single ball into my piece; and, in this manner, being a good marksman, I procured a considerable quantity of game. The fowling-piece, which I held in my hand, was both on the inside and outside as bright as a looking-glass. I likewise made the powder as fine as the minutest dust; and, in the use of it, I discovered some of the most admirable secrets that ever were known till this time. Of this I will, to avoid prolixity, give only one proof, which will surprise even those who are adepts in this matter. When I had charged my piece with a quantity of powder, equal in weight

* As Cellini arrived at Rome after the election of Clement VII., which took place November 1523, he could not have been witness to its ravages in 1522, by which Rome lost more than eighteen thousand inhabitants. It continued, at different periods, for two or three years and 50,000 of the Milanese died in four months.

to the fifth-part of the ball, it carried two hundred paces point blank. In a word, so great was the delight I took in shooting, that it often diverted me from the business of my shop. Though it had this ill consequence, it in other respects procured me considerable advantages; for, by this exercise of shooting, I greatly improved my constitution: the air was of vast service to me. Whilst I was enjoying these pleasures, my spirits suddenly revived; I no longer had my usual gloom, and I worked to more purpose than when my attention was totally engrossed by business: upon the whole, my gun turned rather to my advantage than the contrary.

By means of this recreation also, I contracted an acquaintance with certain persons, who were accustomed to watch for the peasants of Lombardy, who, at a particular season of the year, came to work in the vineyards about Rome. These peasants, in digging the ground, frequently discovered ancient medals, agates, cornelians, emeralds, and cameos. They likewise found precious stones, such as sapphires, diamonds, and rubies. Those who went in quest of the peasants often bought such things of them for a trifle; and I, dealing with the former, have frequently given them gold crowns for curiosities, which had cost them only so many pence. This traffic, besides the great profit I derived from it, which was ten-fold at least, procured me the friendship of most of the Roman cardinals. I shall mention only a few of the most remarkable of these rarities that happened to fall into my hands. One was a dolphin's head, about the size of a large bean. Though art was eminently conspicuous in this head, it was still surpassed by nature: for this emerald was of so fine a colour, that the person who purchased it of me for ten crowns, caused it to be curiously set in a gold ring, and sold it for a hundred. I had likewise one of the finest topazes that ever was beheld: art and nature seemed to rival each other in embellishing this stone, of the size of a large nut; and upon it was carved a remarkably fine head, intended to represent a Minerva. Also another stone, of a different sort from the latter: this was a cameo, upon which was engraved a Hercules, binding a triple-headed Cerberus. This was a piece of such extraordinary beauty, and such admirable workmanship, that our great Michel-Angelo declared he had never beheld any thing that surpassed it. Amongst a number of bronze medals, one fell into my hands, upon which was represented a head of Jupiter. This medal was the largest I ever beheld: the head was one of the most complete masterpieces of art. On the reverse were several other figures in a similar style. I might launch out into a long dissertation upon this subject, but I wish to avoid prolixity.

As I before said, the plague had prevailed for some time in

Rome (for though I must go back a little way, I shall still pursue my subject), when there arrived in that city an eminent surgeon, named Signor Giacomo da Carpi*. This extraordinary man, among other cures for which he was famous, undertook the most desperate cases in a certain disease. And as this was extremely prevalent at Rome among the priests, especially the more wealthy ecclesiastics, on being informed of the fact, he maintained that by means of certain perfumes he could effectually eradicate this pest. But he wished to bargain for his fees before he made his cures, and that not by tens, but by hundreds. He also understood the art of design extremely well. Happening one day to pass by my shop, he cast his eye upon some drawings, amongst which were several sketches of little fanciful vases, which I had drawn by way of amusement. These vases being, in form, very different from any that had ever been seen before, Signor Giacomo desired me to make him some of silver, according to the same model: this I readily agreed to do, because they were of my own invention. Though he paid me generously for my trouble, the reputation which I acquired by them was of a hundred times more value to me than the profit; for all the goldsmiths declared they had never seen any thing more complete, or better executed.

I had no sooner finished these pieces, than my new employer showed them to the pope, and the day following quitted Rome. He was a man of great learning, and talked admirably upon medical subjects. The pope was desirous of having him in his service, but he declared he did not care to confine himself to any service whatever, and that whoever had occasion for his assistance, should send for him. He was a person of great sagacity, and did very wisely to leave Rome; for, not many months after, all his patients relapsed, so that he would have been murdered, if he had stayed. He showed my little vases to the Duke of Ferrara† and to several other princes;

* Giacomo Berengaria da Carpi was no shrewd Charlatan, as Cellini would have us believe, but an able surgeon and physician. He is considered as the reviver of anatomical knowledge, and made many important discoveries, falsely attributed to more modern names. The qualities of his heart, however, were not of an amiable kind. Such was his cruelty in the exercise of his profession, that he is accused of having cut up two poor Spaniards alive to make experiments on the living subject. He was Professor in Bologna, and died at Ferrara, 1530, leaving the Duke in possession of the property acquired in his profession.

† Alfonso I. da Este, one of the first commanders of his age, and adored as the father of his subjects. Living in turbulent times, among the petty princes of Italy, he was a powerful and zealous defender of his states; and though no scholar, his encouragement of learned men was such, that he made use of his own plate and purse to relieve the wants, or pay the salaries, of those he had invited to his court, and whom he always treated like friends and equals. Among these, Ariosto pays high tribute to his merits. He had considerable knowledge of the mechanical arts, such as moulding, turnery, and founding artillery, and was an excellent engineer. He died in 1534, after a reign of 29 years.

and told them that they were presents from a great nobleman at Rome, of whom he had demanded them, upon undertaking to cure him of a disorder; that the nobleman had told him they were antiques, and begged he would rather ask any thing else, which he would freely part with, and leave him those; but he refused to cure him on any other terms, and thus got them into his possession.*

This I was told by Signor Alberto Bendidio, at Ferrara, who, with great ceremony, showed me certain figures, at which I laughed, without making any remark. Signor Alberto, who was a proud haughty man, said to me in a passion, "You may laugh as much as you please, but I must tell you that there has not been a man these thousand years able to make such figures." I, that I might not seem to detract from their reputation, stood apparently admiring them in silent astonishment. I was afterwards told in Rome, by many noblemen, some of whom were my friends, that these works appeared to them very extraordinary, and of genuine antiquity. Encouraged by this declaration, I confessed that they were my performances. They not giving credit to what I said, I formed a resolution to make new designs, in order to prove my veracity, because the above-mentioned Signor Giacomo had carried off the others. By this work I made considerable gain. The epidemic disease continuing to rage for many months, I took to a freer course of life, because many of my acquaintance had died of it, while I had remained in perfect health. It happened one evening, that a companion of mine brought to his house a courtezan, a Bolognese lady of extreme beauty. Her name was Faustina. She was about thirty years of age, and had with her a young servant-girl, some thirteen or fourteen years old. As I knew she was engaged by my friend, no temptation in the world would have induced me to act dishonourably. Still it was evident that she was not ill affected towards me; but finding me resolute in consulting my honour, she soon withdrew with her first lover, leaving, however, her pretty young attendant, as if to console me; a far more agreeable arrangement than if I had been favoured with the attentions of the mistress herself. Woe to us, however, had she divined the truth!

The ensuing day, about dinner time, I was seized with a severe headache, with extreme pain in my left arm, while a tremendous carbuncle broke out on the palm of my left hand. Terrified at the sight, my friend, the great lady, and the little lady, all disappeared together. Left alone, except with one of my work-boys, who would

* This solemn imposture of Berengario's on the noble Duke confirms us in our belief of what Bembo says of him, in one of his letters, that he thought there was nothing wrong in telling lies, where they could be made useful to the inventor.

never leave me, I felt as if I should be suffocated, and believed myself to be a dead man. The father of this boy happening to pass by the house, and being a medical man, physician to the Cardinal Jacoacci, the youth ran and stopped him: "Come, father, and see Benvenuto, who has been taken rather poorly, and is in bed." Knowing nothing respecting the nature of the attack, the doctor came close to me, and having felt my pulse, saw more than he would have desired. Turning suddenly upon the boy, he exclaimed, "O, thou treacherous child, thou hast ruined me for ever! How can I now go before the cardinal?" To this the son hardily replied, "Why, father, my master, Benvenuto, is worth more than all the cardinals in Rome." Regardless of such consolation, the doctor, again turning towards me, said, "Since I am here, I will endeavour to save you. But in most cases such an attack is mortal; it is well yours is not one of the worst kind, and that relief was near at hand."

When he had left, my friend Giovanni Rigogli made his appearance, and taking compassion on my sufferings and loneliness, exclaimed, "Be of good heart, Benvenuto, I will stay with you till you recover." I, on my side, told him not to come near me; that I had no hope; but begged him to take some crowns out of a little box close to my bed, and, after my death, to give them to my poor father. But he was unwilling to obey me, declaring that he knew what was due to friendship; and, come what would, he would attend upon me. His care, with the help of God, and the medicine I took, had a wonderful effect; and I survived, to my own great surprise, that terrific attack. While my wound was still open, with the lint in it, covered with a plaster, I used to ride out on a little wild pony I had, with a long rough coat, about the size of a great bear, and resembling one in every respect.

In this state I went to visit Rosso, the painter, who lived beyond the walls, on the road to Civita Vecchia, at a spot belonging to Count Anguillara, called Cerveterra, who seemed rejoiced to see me. "I am come," I said, "to do as you did to me, many, many months ago." He began to laugh, and giving me a hearty welcome, besought me, from regard to the count, not to flurry myself. The latter, too, treated me with the utmost friendship, setting the greatest dainties before me and invited me to remain, and enjoy the country air. This I did above a month, taking pleasure-rides along the shores on my little steed; and there I made quite a collection of rare stones, shells, and other aquatic curiosities. On the last day I went, I was suddenly assaulted by a band of Moors, in disguise, who had disembarked from some pirate boat, and who cut off the only way by which I could effect my escape. Leaping upon my little rough-coat, and

resolved to dispute the passage, though roasted or boiled alive, as there was nothing else for it, I spurred up to them in good style. As if aware of my purpose, my little Bayard, firing up when he reached the pass, took a running leap, which threw the rascals into confusion in a manner almost impossible to describe. Once on safe ground, I returned thanks to God, and went there no more. On mentioning the feat to the count, he ran for his arms; but, on looking out, we saw the boats already upon the waters. Rejoiced at my good fortune, the next day I rode back merrily to Rome.

The plague had by this time almost spent its fury, insomuch that those who had survived it congratulated each other, and expressed great joy at having escaped that fatal scourge. Upon this occasion there was established in Rome a society of painters, statuaries, and goldsmiths, the best that had ever been known in that capital. The founder of this society was a statuary, named Michelagnolo*, a native of Siena, and possessed of such extraordinary abilities, that he might justly vie with any artist belonging to the profession; but still more eminently distinguished for being the most complaisant and obliging man in the universe. He was the oldest member of this society, but might be considered as the youngest, on account of his vigorous constitution. We were frequently together, at least twice in the week. I must not omit that to this society also belonged Giulio Romano,† a painter, and Giovanni Francesco, both excellent pupils of the great Raffaello da Urbino.

After we had been several times in company together, our worthy president thought proper to invite us to sup at his house one Sunday, directing that every man should bring his *chère amie* (whom he called *cornacchia‡*) with him, and he who brought no lady should be obliged to treat the company with a supper. Such members of the society as had no acquaintance amongst the courtezans, were obliged to procure ladies with great trouble and expense, for fear of exposing themselves at this agreeable enter-

* This sculptor spent great part of his early life in Sclavonia. Coming to Rome, in conjunction with the painter Baldassar Peruzzi, and with the assistance of Tribolo, he built the splendid mausoleum of Adrian VI., in the church of the Germans, of which the design remains in the Ciaconio, and in the Adrian VI., of Gasp. Burmanno. He died about 1540.

† Giulio Pippi, the Roman, was the best pupil Raffaello had, and one who approached the nearest in design, invention, and colouring to his great master. He was also an excellent architect. Full of fire and imagination, he struck off his works at a few strokes in bold and vivid lines, of which he sometimes diminished the force and beauty by over-colouring. He produced many pieces for Clement VII., and the Marchese Gonzaga, as we shall hereafter see. On the death of Antonio da S. Gallo, he was to have been employed as architect for St. Peter's, which was prevented by his death in 1546.

‡ A crow.

tainment. I had thought myself vastly well provided in a fine girl of the name of Pantasilea, who had a fondness for me; but I was obliged to resign her to one of my most intimate friends, named Bachiacca,* who had been, and still continued, deeply in love with her. The girl, upon this occasion, was somewhat piqued, perceiving that I gave her up to Bachiacca, at the first word; a circumstance which induced her to imagine that I slighted her, and made a bad return for the affection she bore me. Her resentment afterwards involved me in a perplexing affair, of which I shall speak more at large in its proper place.

As the time drew near that we were to repair to the assembly above mentioned, and I happened to be without a female companion, I thought myself guilty of a great oversight in not having provided one; but not choosing to be disgraced by bringing any low, despicable creature amongst so many brilliant beauties, I thought of a frolic to increase the mirth of the company. Having formed my plan, I sent for a boy, of about sixteen, named Diego, who lived next door to me, and was son to a Spanish coppersmith. This lad was learning Latin at the grammar-school, to which he applied with great diligence: he had a very genteel person, with a fine complexion: the contours of his face surpassed those of the ancient statue of Antinous,† and I had often drawn his likeness, by which I acquired great reputation in my performances. The boy had no acquaintance in town, nor was he known to any of the society: he neglected his dress very much, his attention being entirely engrossed by study. Having sent for him to my house, I begged that he would dress himself in female attire, which I had provided. He was easily prevailed on to comply, and I, by means of a variety of ornaments, added a considerable lustre to the beauty of his countenance. I put two rings in his ears, in which were two beautiful pearls; the rings being divided in the middle fastened upon his ears, which appeared to be bored: I then dressed his neck with gold necklaces and costly jewels. In the same manner I adorned his fingers with rings, and taking him gently by the ear, placed him before a looking-glass. The

* Bachiacca or Bachicca, was the surname of Francesco and Antonio, twin brothers, both very distinguished Florentine artists. Francesco was a fine painter of miniature figures, as well as of birds and animals of every kind beautifully executed in oil. Antonio, on the testimony of Vasari, and particularly of Varchi, who compares him in a sonnet to Buonarroti, Bronzino, and Cellini, was one of the best chasers. To which of these he alludes as his intimate friend is not very clear.

† A youth of Bithynia, of extraordinary beauty, who is said to have devoted himself for the restoration of the emperor Adrian's health, by throwing himself into the Nile in the year 132, on the faith of a prophecy to that effect. He was honoured by Adrian with medals and statues to his memory, and among these is preserved the exquisite model of masculine grace and beauty above alluded to.

boy, seeing himself in the glass, exclaimed with an exulting tone, "Heavens! Is that Diego?"

"Yes," I replied, "that is Diego, of whom I never before asked any favour, but now, for the first time, I will ask him to oblige me in one harmless request; and that is, to go with me in his present dress to the agreeable society which I have mentioned so often."

The lad, who was virtuous and discreet, modestly cast his eyes upon the ground, and deliberated for a few moments, then suddenly looking up, made answer. "I will go with you, Benvenuto; let us set out directly."

I put on his head a large handkerchief, which is called at Rome a summer-cloth. When we came to the place, the whole company were already met, and all rose to salute me: Michelagnolo was between Giulio Romano and Giovanni Francesco. As soon as I had taken the handkerchief from the head of my beautiful companion, Michelagnolo, who, as I have already observed, was one of the most facetious and diverting men in the world, with one hand taking hold of Giulio, and with the other of Giovanni Francesco, with his utmost might drew them towards Diego, and obliged them to kneel down; at the same time falling upon his knees himself, and calling to the company he exclaimed aloud, "See in what form angels descend from the clouds! Though celestial beings are represented as males, behold there are female spirits in heaven likewise! O beautiful angel! O angel worthy of all praise, vouchsafe to save— vouchsafe to direct me!" At these words the facetious creature lifted up his right hand, and gave him a papal benediction. Michelagnolo rising, said, that it was customary to kiss the Pope's feet, but that angels were to be kissed on the cheeks; he then gave him a salute, at which the youth coloured deeply, which greatly added to his beauty.

This scene being over, every man produced a sonnet, upon some subject or other; and we gave them to Michelagnolo for his perusal. The latter read them aloud, in a manner which infinitely increased the effect of their excellence. The company fell into discourse, and many fine things were said, which I shall not here particularize, except one expression which I recollect to have heard from that famous painter Giulio. This great man having looked upon all present with affection, but more attentively upon the ladies, turned about to Michelagnolo, and spoke to him thus: "My dear Michelagnolo, the name of *crow,* which you have given to our ladies, suits them pretty well, though they even seem a little inferior in beauty to crows, when compared to one of the finest peacocks that ever was beheld."

Dinner was now ready to serve up, when Giulio begged to be the person that should place us in proper order. His request being granted, he took the ladies by the hand, and made them sit at the upper end of the table, with mine in the midst of them; the men he placed next, and me in the middle, telling me that I was deserving of all manner of honour and distinction. Behind us there were rows of flower-pots, with beautiful jessamines, which seemed to heighten the charms of the young ladies, and especially of my Diego, beyond expression. Thus we all began to regale ourselves, with great cheerfulness, at that elegant supper. After our repast was over, we were entertained with a concert of music, both vocal and instrumental; and as the performers sang and played with books before them, my angelical companion desired that he might be allowed to sing his part. He acquitted himself better than any of the rest, and Giulio and Michelagnolo, instead of expressing themselves in the same facetious terms they had done before, seemed to be struck with astonishment, and grew wild and extravagant in their praises. The music being over, one Aurelio Ascolano, a most wonderful *improvisatore**, sang some admirable verses in praise of the ladies. Whilst this person was singing, the two girls who had my beauty between them, never ceased prating and chattering; one of them explained in what manner she had fallen into that sort of life; another asked my companion how it came to be her fate, who were her friends, and how long she had been at Rome, with several other questions of the same kind. Were I to dwell upon trifles of such a nature, I might relate many odd things that were said and done there, occasioned by Pantasilea, who was passionately fond of me; but as that would be foreign to my design, I shall be content with briefly touching upon them.

The discourse of the two courtezans began at last to displease my counterfeit lady, who had taken the name of Pomona. As she was desirous to disengage herself from them, and get rid of their loose conversation, she sometimes turned to one side, sometimes to the other: the lady that Giulio brought with him, asked whether she was not ill; the counterfeit Pomona answered in the affirmative, whispering that she believed herself to be some months advanced in pregnancy, and felt at that very moment far from well. Upon which the two ladies who had her between them, taking compassion of Pomona, begged her to retire; which in spite of Diego's reluc-

* Tiraboschi gives us no farther account of this improvisatore, than this of Cellini. But I am led to think, he is the same as Eurialo d Ascoli, of whom there is a letter, written in the true style of a poet, in the Facetious Epistles, collected by Turchi.

tance, led to an *éclaircissement*. The exasperated females loaded him with abusive language. An outcry being instantly set up, accompanied with great laughter and expressions of surprise, the grave Michelagnolo desired permission of all present to inflict upon me a penance at his own discretion. The company giving their assent to this with loud acclamations, he put me out of pain by thrice repeating "Long live Signor Benvenuto!" This, he said, was the punishment I deserved for so humorous a frolic. Thus ended this pleasant entertainment, together with the day: and the company separating, retired to their respective habitations.

CHAPTER VI.

The Author learns to make curious Damaskeenings of steel and silver on Turkish daggers, &c.—Derivation of the word grotesque in works of design.—His ingenuity in medals and rings.—His great humanity to Luigi Pulci is repaid with the utmost ingratitude.—Tragical end of Pulci in consequence of his amour with Pantasilea.—Gallant behaviour of the Author on this occasion, in defeating a band of armed adversaries.—His escape and reconciliation with Benvenuto of Perugia.

WERE I to give a complete account of all the works I had at this time for persons of different stations in life, my narrative would become altogether tedious; suffice it at present to observe, that I exerted myself with the utmost diligence and care to acquire perfection in the variety of arts above enumerated; and therefore with unceasing perseverance worked at them all. But as an opportunity has not hitherto occurred of giving an account of any of my remarkable performances, I shall presently do so. Michelagnolo of Siena, the statuary, was at this time employed in erecting a monument to the late Pope Adrian. Giulio Romano the painter was gone into the service of the Marquis of Mantua*: the other members had retired to different quarters, as their business happened to lead them, so that our ingenious society was almost entirely dispersed.

Soon afterwards I met with some little Turkish daggers, the handles of which were of iron as well as the blade, and even the scabbard was of that metal. On these were engraved several fine

* The Marchese Federico Gonzaga, a valiant commander, and a liberal patron of the fine arts. He received a dukedom, in 1530, from Charles V. Giulio was introduced into his service by C. Baldassar Castiglione, in 1524. He was here very fortunate, and at the same time contrived to elude the just vengeance of the Pope, for designing a series of immoral prints, engraved by Marc Antonio, and accompanied with the sonnets of Aretino.

foliages in the Turkish taste, most beautifully filled up with gold. I found I had a strong inclination to cultivate this branch likewise, which was so different from the rest; and finding that I had great success in it, I produced several pieces in this way. My performances, indeed, were much finer and more durable than the Turkish, for several reasons: one was, that I made a much deeper incision in the steel than is generally practised in Turkish works; the other, that their foliages are nothing else but chiccory leaves, with some few flowers of Echites: these have, perhaps, some grace, but they do not continue to please like our foliages. In Italy there is a variety of tastes, and we cut foliages in many different forms. The Lombards make the most beautiful wreaths, representing ivy and vine leaves, and others of the same sort, with agreeable twinings highly pleasing to the eye. The Romans and Tuscans have a much better notion in this respect, for they represent Acanthus leaves, with all their festoons and flowers, winding in a variety of forms; and amongst these leaves they insert birds and animals of several sorts with great ingenuity and elegance in the arrangement. They likewise have recourse occasionally to wild flowers, such as those called lions' mouths, from their peculiar shape, accompanied by other fine inventions of the imagination, which are termed grotesques by the ignorant. These foliages have received that name from the moderns, because they are found in certain caverns in Rome, which in ancient days were chambers, baths, studies, halls, and other places of the like nature. The curious happened to discover them in these subterraneous caverns, whose low situation is owing to the raising of the surface of the ground in a series of ages and as these caverns in Rome are commonly called grottos, they from thence acquired the name of grotesque. But this is not their proper name; for, as the ancients delighted in the composition of chimerical creatures, and gave to the supposed promiscuous breed of animals the appellation of monsters, in like manner artists produced by their foliages monsters of this sort: and that is the proper name for them—not grotesques. In such a taste I made foliages filled up in the manner above mentioned, which were far more elegant and pleasing to the eye than the Turkish works.

It happened about this time that certain vases were discovered, which appeared to be antique urns filled with ashes. Amongst these were iron rings inlaid with gold, in each of which was set a diminutive shell. Learned antiquarians, upon investigating the nature of these rings, declared their opinion that they were worn as charms by those who desired to behave with steadiness and resolution either in prosperous or adverse fortune.

I likewise took things of this nature in hand at the request of some gentlemen who were my particular friends, and wrought some of these little rings; but I made them of steel well-tempered, and then cut and inlaid with gold, so that they were very beautiful to behold: sometimes for a single ring of this sort I was paid above forty crowns. At that time a sort of small medals were in fashion, upon which it was customary for noblemen and gentlemen to cause to be engraved certain devices and fancies of their own, and they wore them commonly upon their caps. I made several things of this sort, but found such works very difficult: the celebrated artist named Caradosso would not take less than a hundred crowns for one of them, because they contained a variety of figures. I was therefore employed, not so much on account of the greatness of his price, as his slowness in working, by some gentlemen, for whom I made one medal, amongst others, in emulation of this renowned artist, on which were four figures that I took uncommon pains with. It happened upon this occasion that the gentlemen, comparing my work to that of the famous Caradosso, declared mine to be by much the more elegant and masterly, and bid me ask whatever I thought proper for my trouble, for I had given them such satisfaction, that they were willing to pay me my own price. To this I answered, that the best recompense I could receive for my labour, and that which I desired most, was the happiness of making an approach to the excellence of so great a master; and if I appeared to gentlemen of their taste to have attained that honour, I thought myself sufficiently rewarded. Upon my leaving them at these words, they immediately sent me a generous present, with which I was perfectly satisfied; and my ardour to gain the approbation of my employers increased to such a degree, that it gave rise to the adventures which I am going to relate: for in the course of this history I must sometimes lose sight of my profession, to record some unlucky accidents by which this toilsome life of mine has been occasionally embittered.

I have already given an account of the ingenious society of artists, and of the adventure of Pantasilea the courtezan, who had so deceitful and dangerous a passion for me, and had been so greatly irritated on account of the frolic of introducing Diego, the Spanish boy, at supper: I shall now conclude that whimsical adventure. As she thought herself injured in the most outrageous manner imaginable, and had vowed revenge, an opportunity soon offered to carry her wicked purpose into execution; and I shall here explain in what manner my life was brought by her malice into the most imminent danger. About this time there arrived at Rome a young gentleman named Luigi Pulci, son to one of the Pulci family who had been

beheaded for having violated his own daughter. This young gentleman had an uncommon genius for poetry, was well versed in the Latin language, and wrote with great elegance; he was likewise extremely handsome and genteel. He had just quitted the service of some bishop, whose name I do not remember, and was in a very bad state of health. When he was at Florence, there were meetings in the open streets during summer, where he sang extempore, and distinguished himself amongst those who had the greatest talent that way. This singing was so well worth hearing, that the divine Michel Angelo Buonarroti, that renowned statuary and painter, whenever he heard that Pulci was to perform, went to listen to him with the utmost eagerness, and upon these occasions was generally accompanied by one Piloto*, a goldsmith, and myself. This was the first rise of my intimacy with Luigi Pulci. After some years had elapsed, he discovered to me the distressed condition he was in at Rome, and begged I would procure him some relief. I was moved to pity on account of his excellent qualities, and farther excited by the love of my country, as well as a compassionate disposition. I therefore took him into my house and had him treated with such care, that with the assistance of youth and a vigorous constitution, his health was quickly restored. While the young man was in this manner endeavouring to recover, he constantly amused himself with reading, and I procured him as many books as I could. Sensible of the obligations I laid him under, he often thanked me with tears in his eyes, assuring me if God ever prospered him, or any way put it in his power, he would endeavour to give me convincing marks of his gratitude. I told him that I had not served him as well as I could have wished, but had done my best, and it was the duty of human beings to assist each other; only admonishing him to show the same kindness to others, who might happen to stand in need of his assistance, as he had done of mine, and desiring that he would look upon me as his friend, and always love me.

The young man began to frequent the court of Rome, in which he was soon taken notice of, and entered into the service of a prelate, a man of fourscore, who was bishop of Urgenis. This prelate had a nephew, named Giovanni, a Venetian gentleman. Signor Giovanni seemed to be greatly struck with the shining qualities of Luigi Pulci, and had contracted such a familiar intimacy with him, that their mutual confidence seemed unbounded. Luigi having talked to him

* Piloto, of whom more hereafter, was an excellent Florentine goldsmith, and a friend of Michel-Angelo, Bandinelli, Giacone, Pierino del Vaga, and all the distinguished artists. He was of a facetious disposition, and fond of ridiculing his companions, and at length was assassinated by a young man, whom he had irritated by his raillery.

of me, and of the favours I had done him, Signor Giovanni conceived a desire to know me.

It happened about this time that I had made a little entertainment one evening for my mistress Pantasilea, to which I invited several men of genius of my acquaintance. At the very moment that we were sitting down to table, Signor Giovanni and Luigi Pulci entered the room, and after some little ceremony, were prevailed upon to stay to supper. The amorous courtezan no sooner set her eye on the handsome youth, than she formed a design upon him. I perceived the snare, so that the instant supper was over, I called Luigi aside, and requested him, by the obligations which he had acknowledged himself under to me, not to listen, upon any account, to the insinuations of that artful woman. In answer to this, he exclaimed, "What, my friend Benvenuto, do you take me for a madman?" I told him I did not take him for a madman, but for an inexperienced youth; at the same time assuring him that I gave myself not the least trouble about her, but that my concern was for him, and I should be sorry to see him ruined by so abandoned a strumpet. To this he answered, that he wished he might break his neck if he ever would so much as open his lips to her. He must have sworn this oath with great earnestness, for it was his fate afterwards to break his neck, as will appear in the sequel.

He began to appear every day new clothed, either in velvet or silk, and appeared to be addicted to all manner of debauchery: in short, he had thrown aside all his virtuous qualities, and pretended neither to see nor know me when we met; because I had reproved him, telling him that he had abandoned himself to all kinds of vices, and that they would be his destruction. Signor Giovanni, with whom he was a favorite, had bought him a fine black horse, which cost a hundred and fifty crowns; it was an admirable pacer, and Luigi rode it every day to pay his court to the courtezan Pantasilea. Though I beheld this scene, it gave me no manner of concern: I said only that all things act according to their nature, and I attached myself to my business.

It happened one Sunday evening in the summer that we were invited by the famous statuary Michelagnolo of Siena to sup with him. At this supper Bacchiaca, of whom mention has already been made, was a guest, and he had brought with him Pantasilea, with whom he had been formerly intimate. Whilst we were at supper she rose from table, telling us that a sudden indisposition obliged her to retire, but that she would quickly return. As we were engaged in cheerful conversation, she stayed away longer than we expected: I stood listening, and heard some people talking in a low voice in

the street, whilst I held a knife in my hand, which I made use of at table to cut my victuals. The window was so near the table, that, having risen up a little, I saw Luigi Pulci and Pantasilea in close conference, and overheard the former say, "If that cursed Benvenuto should happen to discover us we should be undone." She made answer, "Luigi, be under no apprehensions; observe what a noise they are making; they are far from thinking of us." At these words I perceived who they were, when immediately leaping from the window, I seized Luigi by the cloak, and should certainly have killed him with the knife in my hand, had he not instantly clapped spurs to a little white horse which he rode, and leaving his cloak behind to save his life, fled with Pantasilea to a neighbouring church. Those who were at table having suddenly risen, came all up to me, and begged I would not give myself or them any trouble for the sake of a harlot. I answered, that I should never have stirred upon her account, but that I could not help showing my resentment to that villain, who behaved to me in so perfidious a manner.

I would not therefore give ear to the persuasions and entreaties of my worthy friends, but snatching up my sword, went unaccompanied to Prati, for the house where we were at supper was near the gate Del Castello, which led to Prati. It was not long before the sun set, and I returned slowly to Rome, when it was already dark, but the gates of the city were not locked. I repaired to Pantasilea's habitation, firmly resolved, in case Luigi Pulci should be there, to treat them both as they deserved. Perceiving that there was nobody in the house but a servant girl, named Corida, I laid aside my cloak and the scabbard of my sword, and came up to the house, which stood behind the place called Banchi, upon the river Tiber. Opposite to this house was a garden belonging to an innkeeper, whose name was Romolo: this garden was enclosed with a quick-set hedge, in which I concealed myself in order to wait the coming of the lady and her gallant.—I had remained there some time when my friend Bacchiaca happened to pass by, who, whether he really thought I should go there, or had been told so, called to me in a low voice by the name of *gossip,* for so we used to style each other in jest. He besought me for God's sake to desist, uttering these words almost with tears in his eyes: "Gossip, I beg you would not hurt this poor unfortunate woman, for nothing can justly be laid to her charge." "If you do not directly quit the place," cried I, "I will cut you across the head with my sword." My poor gossip, frightened by this language, felt much disordered, and had not gone far, when he found himself under a necessity of obeying a natural impulse.

It was a bright starry night, and the sky shone with a refulgent lustre; when suddenly I heard the noise of several horses galloping on both sides. This was occasioned by Luigi and Pantasilea, who were accompanied by one Signor Benvegnato of Perugia, chamberlain to Pope Clement: they had four valiant captains from Perugia attending them, with other brave young officers, in all twelve persons that wore swords. When I perceived my situation, not knowing which way to get off, I resolved to continue under the hedge; but the briars pricked and hurt me very much, so that I could no longer bear it, but like a goaded bull, resolved to take a leap and seek my safety by flight. At this time Luigi had his arms about Pantasilea's neck, and told her that he must have a kiss in spite of that traitor Benvenuto. These words, which added a new sting to the pricking of the briars, provoked me to such a degree, that I leaped out of the hedge, and lifting up my sword, cried out, "I will instantly be the death of you all." My sword fell upon Luigi's shoulders, but as the young fellow was protected by a coat of mail, for they had wrapped him up in iron, the weapon was turned aside, and after cutting him over the nose, wounded the face of Pantasilea. Both having fallen to the ground, Bacchiaca with his hose half down his legs, ran away screaming. I then turned about boldly to the rest with my drawn sword, when my valiant adversaries hearing a loud uproar in the inn, imagined they had to deal with a party of a hundred men; they had however drawn their swords, but some of their horses taking fright, this occasioned so much confusion amongst them, that two of the cleverest were thrown, and the rest betook themselves to flight.

I seeing the affair turn out happily, made off with the utmost speed, pleased to get handsomely rid of this troublesome affair, and not caring to tempt fortune farther than honour required. In this terrible confusion and hurly-burly, some of the gentlemen and officers had wounded themselves with their own swords. Signor Benvegnato, the Pope's chamberlain, was thrown down and trampled upon by his own mule; his servant attempting to draw his sword, fell with him at the same time, and gave his master a deep wound in the hand. This accident, more than all the rest, made Signor Benvegnato swear in his Perugian jargon, that by G— *Benvegnato* should teach *Benvenuto* manners. He desired one of the officers, who perhaps had more courage than the rest, but was young and had very little to say for himself, to deliver me a challenge. This gentleman called upon me at the house of a Neapolitan nobleman, who had heard of my abilities, and seen some of my performances; and being likewise convinced that I was both in mind and body fit

for the military profession, to which he was attached above all others, grew exceedingly fond of me. Seeing myself thus protected and caressed, and being in proper spirits, I gave such an answer to the officer, as I believe made him heartily repent his coming on such an errand.

A few days after, Luigi, Pantasilea, and the rest, being pretty well recovered of their wounds, the nobleman, my patron, was solicited by Signor Benvegnato, whose passion had by this time subsided, to prevail upon me to be reconciled to Luigi, adding, that the gallant officers who were with him, and who had never had any difference with me on their own account, would be glad to cultivate my acquaintance. The nobleman made answer, that he would persuade me to agree to all that was proposed, and should willingly undertake to accommodate matters, upon condition that there was to be no upbraiding on either side for what had passed, as that would reflect dishonour on themselves; that we should only shake hands and drink together in token of reconcilement, and so he would engage to make all things agreeable. This design was carried into execution. One Thursday evening the nobleman carried me to the house of Signor Benvegnato, where all the military gentlemen, who had been in the late skirmish. were at table. My patron was accompanied by above thirty gallant men well armed, a circumstance which Signor Benvegnato did not expect.—Having entered the hall, my friend going before, and I following him, he addressed them thus: "Save you, gentlemen; I am come with Benvenuto, whom I love as my own brother; and we gladly present ourselves with an intention to do whatever you think proper to enjoin us." Benvegnato seeing the hall crowded with such a number, made answer, "All we desire of you is peace: we want nothing more." He then promised that the governor of Rome should give me no trouble. Thus we were reconciled, and I returned to my shop; but I was scarce able to pass an hour without the company of the Neapolitan nobleman, who either visited me, or sent for me to his own house.

In the meantime Luigi Pulci being cured, every day took an airing upon his black horse, which he managed with great skill. One day, after there had fallen a drizzling rain, having made his horse prance and curvet before Pantasilea's door, he happened to slip, and the horse fell upon him. By this accident he broke his right leg, and a few days after died in the house of Pantasilea; the curse which he had solemnly invoked against himself in the presence of God being thus accomplished. Hence it appears that the Deity watches over the conduct both of the good and bad, and rewards all according to their deserts.

CHAPTER VII.

The Duke of Bourbon besieges Rome, which is taken and plundered.—The Author kills the Duke of Bourbon as he is scaling the walls.—He retires to the castle of St. Angelo, where he acts as bombardier, and signalizes himself in an extraordinary manner.—The Prince of Orange is wounded by a ball from a cannon directed by the Author.—The Pope's acknowledgments to Benvenuto.—The castle of St. Angelo surrendered by capitulation.

ALL ITALY was now up in arms*, when Pope Clement sent to Signor Giovannino de' Medici for some troops, which accordingly marched to his assistance. These auxiliaries did so much mischief in Rome, that tradesmen were not in safety in their shops, which made me retire to a small house, behind the place called Banchi,

* It will here be necessary to give the reader a brief view of the political state of Italy at that period, in order to throw light on the ensuing account. Europe was involved in the wars between Charles V. and Francis I., in which the potentates of Italy took an active share. Jealous of the French interests, Leo X., and the other princes, after the battle of Marignano, when the dominions of Francesco Sforza had been twice occupied by the French, resolved to join the emperor. He had already in his service some of the best Italian generals, seconded by the voice of the people; and in the first campaign of 1521, succeeded in possessing himself of the whole of the Milanese. In 1522, he took Genoa, and driving back the numerous forces sent against him from France, followed them into Provence, and finally laid siege, though unsuccessfully, to Marseilles. The Pope and the Italians, having thus attained their object, tried to negotiate a peace, soon after concluded under Adrian II., and Clement VII. In a short time, however, they began to feel, that they had only made an exchange of masters, and even found the yoke of the emperor, who aspired after undisputed dominion, and sacrificed the interests of his allies to his immediate objects, more intolerable than that of the French. When, therefore, Francis I., at the head of a fresh army, again descended the Alps, Clement VII. withdrew from the league, declaring his wish to become arbitrator of their differences, and to preserve the balance of political power in Europe. But when Francis was made prisoner at Pavia, and the power of France humbled, Clement renewed his offers of alliance to the emperor, which the latter refused, at the same time that he accepted of the money advanced by the Pope to his viceroy of Naples, leaving the pontiff exposed to the insults and extortions of the Imperialists in Italy. On the liberation of Francis, and the renewal of the war in 1526, Clement, in league with the Venetians, and the other states of Italy, declared in favour of France. He proved, however, a very inefficient ally to Francis, withdrawing the troops from all active service, and even paying salaries to many of the Imperial generals, so as still to attempt to preserve the character of a mediator.

To this undecided conduct, added to the impolitic measure of disbanding the soldiers, and garrison of Rome, he owed the calamities he soon afterwards experienced, and fell a victim to the cupidity of the Spanish and German army—a memorable example of the fate of those princes, who from weakness or incapacity, adopt only half-measures, and endanger their existence for want of bold and determined policy.

60

where I worked for my particular friends. The business I was employed in at that time was not of any great importance: I therefore shall not at present enlarge upon it. I then took great delight in music, and other amusements of a like nature. Pope Clement having, by the advice of Signor Giacopo Salviati, dismissed the five companies which had been sent him by Signor Giovannino, lately deceased in Lombardy, the Constable Bourbon*, finding that there were no troops in Rome, eagerly advanced with his army towards that capital. Upon the news of his approach all the inhabitants took up arms. I happened to be intimately acquainted with Alessandro, the son of Pietro del Bene, who, at the time that the Colonnas came to Rome, had requested me to guard his house: upon this more important occasion, he begged I would raise a company of fifty men to guard the same house, and undertake to be their commander, as I had done at the time of the Colonnas†. I accordingly engaged fifty brave young men, and we took up our quarters in his house, where we were well paid and kindly treated.

The army of the Duke of Bourbon‡ having already appeared before the walls of Rome, Alessandro del Bene requested I would go with him to oppose the enemy: I accordingly complied, and taking one of the stoutest youths with us, we were afterwards joined on our way by a young man of the name of Cecchino della Casa. We came up to the walls of Campo Santo, and there descried that great army, which was employing every effort to enter the town at that part of the wall to which we had approached. Many young men

* Charles of Bourbon, who won the famous battle of Marignano, was cousin to king Francis, and constable of France. Highly gifted, and every way meritorious, he was bitterly persecuted by the queen-mother for having declined the honour of her hand, as well as by the king, to such a degree, that having rebelled in September 1523, he transferred his services to the Emperor Charles V. He then laid siege to Marseilles, fought at Biagrasso, and Pavia; and, in 1527, having formed a junction with the Germans, under Giorgio Fronspergli, and taken into his service banditti and felons from all countries, he carried terror and desolation into the heart of Italy. Under pretence of being unable to restrain the licentiousness of his troops, he disregarded the treaties and authority of the imperial ministers. He died in his 38th year, in the manner hereinafter related.

† The Colonna family, one of the most ancient and distinguished in Rome, abounding in wealth and territories, which not unfrequently made even the pontiffs tremble for their power. In defiance of the subtle policy of Alexander VI., they maintained their splendour and authority, and were much courted by Julius II., and Leo X. During this war, always devoted to the Ghibelline party, their interference assumed an independent character; and finding Clement VII. in favour of the French, they ventured, instigated, doubtless, by the emperor, to march their forces into Rome, on the 19th of September, 1526, and, exciting the people to rebellion, they sacked the palace and St. Peter's, and shutting up the pope in the castle, obliged him to make a treaty in favour of the emperor.

‡ Bourbon, without any artillery, arrived quite unexpectedly at Rome, on the night of the 5th of May, with 40,000 men: the ensuing morning, the assault, of which Cellini gives this account, took place.

were slain without the walls, where they fought with the utmost fury: there was a remarkably thick mist. I turned to Alessandro, and spoke to him thus:—"Let us return home with the utmost speed, since it is impossible for us here to make any stand; behold the enemy scales the walls, and our countrymen fly before them, overpowered by numbers." Alessandro, much alarmed, answered,—"Would to God we had never come hither:" and, so saying, he turned with the utmost precipitation, in order to depart. I thereupon reproved him, saying,—"Since you have brought me hither, I am determined to perform some manly action;" and, levelling my arquebuse where I saw the thickest crowd of the enemy, I discharged it with a deliberate aim at a person who seemed to be lifted above the rest, but the mist prevented me from distinguishing whether he was on horseback or on foot. Then, turning suddenly about to Alessandro and Cecchino, I bid them fire off their pieces, and showed them how to escape every shot of the besiegers. Having accordingly fired twice for the enemy's once, I cautiously approached the walls, and perceived that there was an extraordinary confusion among the assailants, occasioned by our having shot the Duke of Bourbon*: he was, as I understood afterwards, that chief personage whom I saw raised above the rest.

Quitting our post we now passed through Campo Santo, and entered by the quarter of St. Peter; from thence we passed behind the church of St. Angelo, and reached the gate of the Castle of St. Angelo with the greatest difficulty imaginable; for Signor Rienzo da Ceri, and Signor Orazio Baglioni†, were wounding and killing every body that deserted the walls. When we arrived at the gate above mentioned, part of the enemy had already entered Rome, and were at our heels. The castellan had thought proper to let down the portcullis; but there was just room enough made for us four to enter. No sooner had we entered, than the captain Pallone de'

* All historians agree, that Bourbon fell by a musket shot early in the assault, while, distinguished by his white mantle, with a scaling-ladder in his hand, he was leading on his troops to the walls.

† The Baglioni di Perugia, who, at the beginning of the sixteenth century, nearly rendered themselves masters of their country. They were all soldiers: Orazio, here mentioned, was the son of the great Gio. Paolo. He entered into the service of the Venetians, and afterwards, in 1522, fought for Florence. Clement VII., seizing upon his person, shut him up in the Castle of St. Angelo, under pretence of his having disturbed the peace of Perugia; but on the attack of Bourbon, he was liberated by his Holiness, for the purpose of defending Rome and (his prison) the castle. His military skill does not seem to have been very conspicuous on this occasion, any more than on others, although he obtained the command of the Black Bands, after the famous Giovanni. To obtain sole possession of Perugia, he caused several of his cousins to be assassinated. He fell in a battle fought near Naples, 1528.

Medici pressed me into the service, because I belonged to the Pope's household; and forced me to leave Alessandro, very much against my will. At this very juncture, as I mounted the ramparts, Pope Clement had entered the Castle of St. Angelo, by the long gallery from St. Peter's; for he did not choose to quit the Vatican sooner, never once dreaming that the enemy would storm the city. As soon as I found myself within the castle walls, I went up to some pieces of artillery, which a bombardier, named Giuliano, a Florentine, had under his direction. This Giuliano, standing upon one of the battlements, saw his house pillaged, and his wife and children cruelly used; fearing to shoot any of his friends, he did not venture to fire the guns, but throwing the match upon the ground, made a piteous lamentation, tearing his hair, and uttering the most doleful cries. His example was followed by several other gunners, which vexed me to such a degree, that I took one of the matches, and getting some people to assist me, who had not the same passions to disturb them, I directed the fire of the artillery and falcons, where I saw occasion, and killed a considerable number of the enemy.

If I had not taken this step, the party, which entered Rome that morning, would have proceeded directly to the castle; and it might, possibly, have been a very easy matter for them to have stormed it, as they would have met with no obstruction from the artillery. I continued to fire away, which made some cardinals and gentlemen bless me, and extol my activity to the skies. Emboldened by this, I used my utmost exertions: let it suffice that it was I that preserved the castle that morning, and by whose means the other bombardiers began to resume their duty; and so I continued to act the whole day.

Pope Clement having appointed a Roman nobleman, whose name was Antonio Santa Croce, to be chief engineer, this nobleman came to me in the evening, whilst the enemy's army was entering Rome, by the quarter of Trastevere, and behaving to me with the greatest demonstrations of kindness, posted me with five great guns in the highest parts of the castle, called "dall' Angiolo," which goes quite round the fortress, and looks both towards the meadows and towards Rome. He appointed several persons to serve under me, and assist me in managing the artillery; then causing me to be paid beforehand, he gave me a portion of bread and wine, and begged I would continue to behave as I had begun. I, who was at times more inclined to arms than to my own profession, obeyed my orders with such alacrity, that I had better success than if I had been following my own business.

Night being come, and the enemy having entered Rome, we, who were in the castle, and I, more than any of the rest, who always took

delight in beholding new and extraordinary sights, stood contemplating this strange novelty and the fire which those who were in any other part of the city could neither see nor conceive. I shall not, however, deviate from the history of my life, for the sake of such descriptions.

As I continued my operations in the artillery, there happened to me, during a month that we were besieged in the castle*, many extraordinary accidents, and all very well worth relating; but in order to be concise, and keep as much within the sphere of my profession as possible, I shall pass over most of these events in silence, relating only such as I cannot suppress:—I mean the most remarkable.

The first then is, that Signor Antonio Santa Croce, having made me come down from the place called Angiolo, with a view to fire at certain houses in the neighbourhood of the castle, into which some of the enemy had entered, whilst I was firing, a cannon-shot fell near me, which hit part of a battlement, and, fortunately for me, carried off a great part of it; for the remainder, falling upon my breast, stopped my breath, and I lay prostrate upon the ground, but could hear a great deal of what was said by the by-standers; amongst others, Signor Antonio Croce lamented me as dead, and exclaimed aloud—"Alas! we have lost our best support!" At this noise, an intimate acquaintance of mine, who was called Giovanni Francesco, the musician, (though this person had a greater turn to physic than music) wept bitterly, and ran directly for a flask of the best Greek wine; then making a slate red hot, put a handful of wormwood upon it, and sprinkling it with the wine, applied it to that part of my breast where I appeared to have received the injury. Such was the efficacy of the wormwood, that it immediately restored my vigour. I made an attempt to speak, but found myself unable to articulate, because some foolish soldiers had filled my mouth with earth, thinking that they had thereby given me the sacrament; though it had nearly proved an *excommunication* to me, for I could scarcely recover myself, as the earth did me a great deal more harm than the contusion. However, I escaped with life, and returned to those who were about the artillery, seconding their operations with my best abilities and endeavours.

* The castle of St. Angelo was besieged from the 6th of May to the 5th of June, during which time slaughter and desolation, accompanied with every excess of impiety, rapine, and lust, on the side of the Imperialists, devastated the city of Rome. For this picture of horrors, I need only refer the reader to the sackage of Rome by Guicciardini, by Jacopo Bonaparte, and by Valdes. Clement VII., being distressed for provisions, surrendered the castle, with all its treasures, and remained a prisoner until the 9th of September, when, disguised as a merchant, he fled almost alone to Orvieto, having learnt, though late, to distrust all conventions.

Pope Clement had sent to ask assistance of the Duke of Urbino, who was with the Venetian army, and directed his ambassador to tell his excellency, that so long as the castle should continue every night to make three fires on its top, at the same time firing three guns thrice over, these should be considered as signals that the fort had not surrendered. I was employed to make these signals, and to fire the guns; and as the besiegers continued to annoy us greatly, I pointed the artillery in such a manner as might be likely to injure them most, and retard their operations. The Pope upon this account conceived a great liking to me, seeing that I acquitted myself with all the prudence and sagacity requisite on such occasions. The Duke of Urbino never sent the succours stipulated; therefore as my intention is not to give a particular account of this siege, I shall dwell upon no more of the circumstances of it.

Whilst I continued to be employed in my destructive business of an engineer, several cardinals* came frequently to see me, but above all the cardinals of Ravenna† and Gaddi‡, whom I often warned not to come near me, as their scarlet hats could be seen at a distance, which exposed both them and myself to great danger from the neighbouring palaces, such as the Torre de Beni; but persuasions having no effect, I at last got them confined, by which I incurred their enmity and ill-will. Signor Orazio Baglioni, my very good friend, likewise frequently came where I was. Happening to be one day in conversation with me, he observed some appearances at a certain inn, which stood without the Castle-gate, at a place called Baccanello: the sign of this inn was the Sun, painted between two red windows, which were shut. Orazio, apprehending that opposite to this sign between the two windows was a table surrounded by soldiers carousing, said to me: "Benvenuto, if you were to fire your middle cannon near yonder Sun, I believe you would do execution; for I hear a great noise, and fancy there must be persons of consequence in that quarter." "Sir," said I, "what I myself see is sufficient to induce me

* Guicciardini and Valdes say, there were thirteen cardinals shut up in the castle of St. Angelo.

† Benedetto Accolti of Arezzo was secretary to Pope Clement VII., together with his friend Sadoleto. In 1524, he was made Archbishop of Ravenna, and afterwards a cardinal in 1527, just three days before the assault. He is extolled as a very elegant scholar by Bembo Molza and Ariosto. When he was governor of the March of Ancona in 1535, Paul III. ordered him to be imprisoned in the castle of St. Angelo; but he was afterwards set at liberty at the intercession of Charles V.

‡ Nicholo Gaddi, a Florentine, created cardinal on the same day as Accolti. He was delivered as hostage to the imperialists, and sent to Naples, October, 1527. After the death of Alessandro de' Medici, cardinal Gaddi attempted to re-establish the Florentine republic; but failed through the superior policy and power of Cosmo I. He was learned, liberal, and skilful in affairs of state. He died in 1532. Cellini gives a farther account of him.

to make a discharge at yon Sun, but I am afraid of that barrel full of stones, which stands hard by the mouth of the gun; for the force of the discharge, and the very wind of the cannon, will certainly throw it down." Orazio replied, "For God's sake, Benvenuto, lose no time: in the first place, it is impossible, considering how the barrel stands, that the wind of the cannon should throw it down; but even if it should fall, and the Pope himself be under it, the harm would not be so great as you imagine; so fire, fire." I, without thinking more of the matter, made a discharge at the Sun as I had promised; the barrel, which was filled with stones, fell to the ground, as I thought it would, exactly between Cardinal Farnese* and Signor Jacopo Salviati, both of whom it was near destroying. What saved them was Cardinal Farnese's reproaching Signor Jacopo† with being the cause of the sack of Rome; and as they both abused and railed at each other, their movements on the occasion alone prevented the barrel of stones from dashing them to pieces. Orazio having heard the noise, went down as fast as possible; and I going towards the place where the barrel had fallen, heard some people say, "Those gunners should be killed." This induced me to turn two falconets towards the steps leading to the battery, with a firm resolution to fire one of them at the first that should presume to ascend. The servants of Cardinal Farnese being sent by their master to attack me, I advanced in order to fire. As I knew some of them, I said—"Villains, if you do not instantly quit the place, or if any of you attempt to mount these stairs, I have two falconets ready charged, with which I will blow you into dust. Go, tell the cardinal from me, that I have done nothing but by the command of my superiors: I have been acting in defence of the clergy, and not to hurt them."

The servants having retired, Orazio came running up stairs; but I ordered him to stand back, declaring that if he did not, I would kill him upon the spot. He stopped a little, not without fear, and cried out, "Benvenuto, I am your friend." I answered, "Sir, only come by yourself, and you may come as often as you think proper." He then made a pause, for he was exceedingly proud, and said peevishly, "I have a mind to come up no more, but to act quite the reverse of what I intended towards you." I told him, that as I had received my post to defend others, I was likewise able to defend myself. He declared he was alone; and when he came up, appeared to be so much altered in countenance, that I kept my hand upon my sword and looked

* Alessandro Farnese, dean of the sacred college, a learned and distinguished personage, and successor of Clement VII., by the name of Paul III. in 1534. Cellini will have occasion to speak of him again.

† For having persuaded the Pope to dismiss the troops from Rome.

sternly at him as an enemy. Upon this he began to laugh, and his colour returning, he said to me with all the good humour imaginable, "My dear Benvenuto, no man can be more your friend than I am, and when an opportunity offers, I will endeavour to prove it; would to God you had killed those two scoundrels! one of whom has already done so much mischief, and the other is likely to do more." He then desired me, in case I was asked, not to discover that he had been present when I fired the guns, and to make myself quite easy about the consequences. This affair made a great noise, which lasted a long time; but I shall not dwell upon it any longer.

I now gave my whole attention to firing my guns, by which means I did signal execution, so that I had in a high degree acquired the favour and good graces of his Holiness. There passed not a day that I did not kill some of the army without the Castle.

One day amongst others the Pope happened to walk upon the round rampart, when he saw in the public walks a Spanish colonel, whom he knew by certain tokens; and understanding that he had formerly been in his service, he said something concerning him, all the while observing him attentively. I who was above at the battery, and knew nothing of the matter, but saw a man who was employed in getting the trenches repaired, and who stood with a spear in his hand, dressed in rose-colour, began to deliberate how I should lay him flat. I took my swivel, which was almost equal to a demi-culverin, turned it round, and charging it with a good quantity of fine and coarse powder mixed, aimed it at him exactly, though he was at so great a distance that it could not be expected any effort of art should make such pieces carry so far. I fired off the gun, and hit the man exactly in the middle. He had arrogantly placed his sword before him in a sort of Spanish bravado; but the ball of my piece struck against his sword, and the man was seen severed into two pieces. The Pope, who did not dream of any such thing, was highly delighted and surprised at what he saw, as well because he thought it impossible that such a piece could carry so far, as that he could not conceive how the man could be cut into two pieces. Upon this he sent for me, and made an inquiry into the whole affair. I told him the art I had used to fire in that manner; but as for the man's being split into two pieces, neither he nor I was able to account for it. So, falling upon my knees, I intreated his Holiness to absolve me from the guilt of homicide, as likewise from other crimes which I had committed in that Castle in the service of the Church. The Pope, lifting up his hands, and making the sign of the cross over me, said that he blessed me, and gave me his absolution for all the homicides that

I had ever committed, or ever should commit, in the service of the Apostolic Church.

Upon quitting him I again went up to the battery, and continuing to keep a constant fire, I scarcely once missed all the time. My drawing, my elegant studies, and my taste for music, all vanished before this butchering business; and if I were to give a particular account of all the exploits I performed in this infernal employment, I should astonish the world; but I pass them by for the sake of brevity. I shall only touch upon some of the most remarkable, which should not to be omitted upon any account. As I was incessantly meditating how to employ myself in defence of the Church, I took it into consideration that the enemy every night changed their guard, and passed through the great gate of S. Spirito, which was indeed a reasonable length for the artillery to carry; but because I shot crossways I did not do so much execution as I wished. And yet there was every day a considerable number slain, so that the enemy, seeing the pass become dangerous, one night heaped above a hundred barrels upon the top of a house, which obstructed my prospect. Having now reflected more maturely upon the matter than I had done at first, I levelled my whole five pieces of artillery against those barrels, and waited for the relieving of the guard till the dusk of the evening. As they imagined themselves in perfect security, they came on slower and in greater numbers than usual. I then fired off my pieces, and not only threw the barrels to the ground, but with the same shot killed above thirty men. Upon my repeating this feat two or three times more, the soldiers were put into such disorder, that amongst those who had loaded themselves with plunder at the sacking of Rome, some of them, desirous of enjoying the fruits of their military toil, were disposed to mutiny against their officers and march off; but being appeased by a valiant captain, whose name was Gian d'Urbino*, they were with great difficulty prevailed on to turn through another pass in order to relieve the guard. This obliged them to fetch a compass of about three miles; whereas they at first had but half a mile to march. This affair being over, all the nobility in the Castle conferred extraordinary favours on me. I chose to re-

* Juan d'Urbino, Urbina, or, according to others, Durbino, was a commander of distinguished reputation during this war. By birth a Spaniard, he fought his way from the ranks to the very highest station in the army, by which he was much beloved. He was also in high esteem with Prospero Colonna, the Marchese Davalo, and the Prince of Orange, to whom he was lieutenant-general. He acquired great reputation in the reduction of Genoa, and at the two battles of Lodi, in 1522 and 1526. He had an engagement with Fillippino Doria, in the Mediterranean: and, in a sortie from Naples, routed and killed Orazio Baglioni. Varchi informs us he was of an extremely haughty and cruel disposition.

late this exploit on account of its importance, though it is foreign to
the profession which first induced me to take pen in hand. But if I
wished to embellish the history of my life with such events, my nar-
rative would become too voluminous. I shall, therefore, relate but
one more of this sort, which I have reserved for its proper place.

I must here anticipate a little in point of time, and inform the
reader how Pope Clement, in order to preserve his regalia, together
with all the jewels of the apostolical chamber, sent for me, and shut
himself up with the master of the horse and me in an apartment.
This master of the horse had formerly been equerry to Filippo
Strozzi*, and was a Frenchman. Pope Clement had enriched him
considerably, being one of his favourite domestics. He was a person
of mean birth, yet the Pope put as much confidence in him as if he
had been his own brother. Thus, while we were shut up together in
the above-mentioned chamber, they placed before me the regalia, with
all the vast quantity of jewels belonging to the apostolical chamber,
and his Holiness ordered me to take off the gold in which they were
set. I did as I was directed, and wrapping up each of them in a little
piece of paper, we sewed them in the skirts of the Pope's clothes and
those of the master of the horse. They then gave me all the gold,
which amounted to about a hundred pounds weight, and ordered me
to melt it with the utmost secrecy. I repaired to the Angelo battery,
where was my apartment, which I could shut to avoid being seen or
interrupted in my operation; and having there made a little furnace
with bricks, and fastened to the bottom of the furnace a little pot
about the size of a dish, I threw the gold upon the coals, and it fell
by degrees into the pot.†

Whilst this furnace was going, I constantly watched my oppor-
tunity to annoy the enemy, and soon did them a great deal of damage
in their trenches with certain antique missiles‡, which I found in the

* This wealthy Florentine married the daughter of Pietro de' Medici. He was
a person of very distinguished merit and consideration in Florence, and was sent
as chief minister from the Medici to the Courts of France and Rome. When Duke
Alessandro, in 1535, usurped the government of Florence, he joined the exiled
citizens; but falling into the hands of Duke Cosmo, after many fruitless attempts,
he was thrown into a dungeon, where, after languishing a year, he put a period to
his life, like another Cato, in 1539.

† Giacopo Buonaparte relates, that the Pope melted down all his plate, and gold
and silver vases, to pay the soldiers. Though amounting to more than three hundred
thousand crowns, it proved too little for the imperial generals only, without the
soldiers. Our author farther explains the result of this proceeding, in the XIth
Chapter of his Art of Jewellery.

‡ In the original, *passatojacci,* the signification of which is not ascertained.
Dr. Nugent translates it "javelins."

armoury belonging to the castle. Having taken a swivel and a falconet, both somewhat broken at the mouth, I filled them with those weapons, and then fired off the pieces, which flew down like wild-fire, doing a great deal of damage to the trenches. Thus keeping my pieces constantly in order whilst I was melting the gold, I saw towards the evening a person mounted upon a little mule, who came upon the border of the trench; the mule went at a great rate, and the person spoke to the men in the trenches. I thought it most advisable to fire off my artillery before he came quite opposite to me; so having taken aim exactly, I fired and wounded him in the face with one of the missiles; the others hit the mule, which instantly fell dead. Hearing a loud noise in the trenches, I discharged the other piece, which did great execution. The person above mentioned was the Prince of Orange*, who was carried through the trenches to a neighbouring inn, whither all the nobility of the army quickly repaired.

Pope Clement having heard of what I had done, immediately sent for me, and desired me to give him an account of what had happened. I related to him the whole transaction, and farther told him that this must be some person of the first rank, because all the chief officers of the army, as they appeared to me, had immediately repaired to the inn to which he had been conveyed. The Pope, being a person of great sagacity, sent for Signor Antonio Croce, who was the chief engineer, as I have already observed, and directed him to command all the gunners to point their whole artillery, which was very considerable, against the inn, and all to discharge their pieces at the firing of a musket; that by killing those chief officers, the army, which would be in a great measure deprived of its leaders, might be totally dispersed; and God would at last hear their fervent and constant prayers, and thus deliver them from those impious invaders.

We thereupon put our artillery in order according to the directions of Santa Croce, and waited for the signal to fire. Cardinal

* Filiberto di Chalons, Prince of Orange, disliking his command under Francis the First, made an offer of his services to the emperor, forfeiting at once his fortune and his principality. He was a sworn and implacable enemy to France. When taken prisoner by Andrea Doria, and thrown into the castle of Lusignano, he indulged his hatred by writing lampoons against France upon the walls. He no sooner obtained his freedom, by the peace of Madrid, than he returned to the army of the emperor. He was in imminent danger from his wound, which historians agree in attributing to a musket-shot. He fell in the siege of Florence, 1530, only thirty years of age. He died, like the constable Bourbon, leaving his troops victorious.

Orsini* being informed of this resolution, came to high words with the Pope, and declared in the most peremptory manner, that no such step should be taken upon any account, as an accommodation was then upon the carpet, and if those officers were killed, the army being without a leader, would storm the castle, and put them all to the sword, therefore he would by no means agree to our project. The poor Pope, quite in despair to see himself thus attacked both within and without, told the cardinal and his party, that he left the whole affair to their discretion. The order being thus revoked, I, who could not stand idle and inactive, when I perceived that they were come to command me not to fire, discharged the middle cannon, and the ball hit a pillar of that house, about which a considerable crowd was gathered. This shot made such havoc amongst the enemy, that they were upon the point of quitting the inn. Cardinal Orsini was so incensed at this, that he was absolutely for having me hanged or put to death in some way or other; but the Pope took my part with great spirit and resolution. As I do not consider myself in the light of a professed historian, I shall not here insert the altercation that passed between them upon the occasion, but shall give my whole attention to my own business.

As soon as I had melted the gold, I carried it to the Pope, who returned me thanks, and ordered the master of the horse to give me five-and-twenty crowns, at the same time making an apology because he had it not in his power to recompense me more amply.

* Franciotto Orsini, of Rome, was educated in the house of Lorenzo de' Medici, his relation, and there became acquainted with Politian, who devoted himself to his service. Having been first a soldier, after marrying and becoming a widower, he determined to enter the church, and was elected cardinal in 1517. In the treaty here mentioned, concluded on the 5th of June, some hostages were surrendered by the Pope, who having broken prison, by inebriating their German guards, because they were threatened with death, for the purpose of extorting more money, the Pope was obliged to send Orsini, with four other cardinals, in their place. He died in 1553.

CHAPTER VIII.

The Author returns to Florence, and, with the assistance of Pier Maria di Lotto, compromises matters with the magistrates of that city.—He is pressed to go into the army by Orazio Baglioni; but, at his father's request, removes to Mantua.— There he sees his friend Giulio Romano, who recommends him to the Duke of Mantua as an artist.—An indiscreet speech obliges him to quit Mantua.—He goes back to Florence, where he finds that his father, and most of his relations, had been carried off by the plague.—Intimacy between him and Michel Angelo Buonarroti, through whose recommendation he is greatly encouraged in his business.— Story of Federigo Ginori.—Rupture between Pope Clement and the city of Florence.—The Author, at the Pope's solicitation, returns to Rome.

A FEW days after, an agreement was concluded with the imperialists, when I set out with Signor Orazio Baglioni, and three hundred soldiers, towards Perugia. This gentleman wished me to accept of the command of those men; but I declined his offer, telling him I chose to see my father first, and settle the affair of my banishment from Florence. He then acquainted me that I had already been made a captain by the Florentines. Signor Pier Maria di Lotto* was also there, on a mission from Florence, to whom Signor Baglioni highly recommended me as a follower of his own. So I repaired to Florence, in company with several comrades.

The plague had made terrible havoc in that city; but I found my worthy father alive, who thought that I must either have been killed at the sack of Rome, or that I should return to him quite naked and destitute. It proved however quite the reverse: I was alive, with my pockets well lined, and had a servant and a horse. So overjoyed was my aged father at the sight of his son, that I thought, whilst he was kissing and embracing me, he would die of the transport. I soon related to him the horrors of the sack of Rome, and presented him with a considerable number of crowns, which I had gained by the war. Our first caresses and demonstrations of joy being over, we repaired to the magistrates to compromise the affair of my banishment. One of those who had been concerned in pronouncing the sentence against me, happened to be then in the rotation of his office; he was the same

* Pier Maria di Lotto di S. Miniato was notary this year to the republic, which, having collected the remnants of the black bands, gave the command to Signor Orazio. Joined by Renzo da Ceri, he made a gallant sally out of the castle of St. Angelo, just before the treaty, and brought his company safe off to Perugia, whilst Renzo was surprised and taken prisoner by the imperialists.

that had said to my father, in a passion, that he would send me with a guard of spearmen to prison. My father, therefore, to avenge my severe treatment, threw out some sharp expressions against him, emboldened by the favours which I had received from Signor Orazio Baglioni. Matters standing thus, I told my father that Signor Orazio had appointed me captain in the Florentines' service, and it was proper I should begin to think of raising my company. My poor father, quite stunned at these words, begged and entreated me not to think of any such thing, though he was very sensible that I was equal to that, and even to any undertaking of the greatest importance; adding, that he had already one son in the army, my younger brother, who was so gallant a youth; and that I ought to attach myself totally to that admirable art, which I had followed so many years with unwearied application.

Though I promised to obey him, he judged, like a man of sense, that in case Signor Orazio should come to Florence, I should not fail, either through a regard to my promise, or some other motives, to embrace the military profession. He therefore devised a very good expedient to prevent it, which was to persuade me to remove from Florence; and said, "My dear son, a most dreadful pestilence rages in this city, and you are come home just at the time of its greatest fury: I remember when I was very young I went to Mantua, where I met with a kind reception, and made a stay of several years. I request you, and even command you, for my sake to repair thither, and to do it directly, and not so much as defer it till to-morrow." As I was always glad of an opportunity of seeing the world, and had never been at Mantua, I readily complied with his request. The greatest part of the money I had brought with me I left with the old man, promising to assist him in whatever part of the world I should happen to live: at the same time I earnestly recommended it to my eldest sister to take care of my father. The name of this sister was Cosa; and as she never chose to marry, she was admitted as a nun of St. Ursula; so she stayed to attend and take care of my old father, and likewise to direct my younger sister, who was married to a statuary of the name of Bartolomeo. Thus, my father giving me his blessing, I mounted my good horse, and set out for Mantua.

My narrative would swell to a tedious prolixity, were I to give the reader a circumstantial account of this little journey. As all Italy was at that time ravaged by war and pestilence, I, with great difficulty, travelled as far as Mantua, where, when I arrived, I endeavoured to get into business, and was immediately employed by one Signor Niccolo, a Milanese, who was goldsmith to the duke. As soon as I had obtained employment, I went to pay a visit to Giulio Ro-

mano, a most excellent painter, and my particular friend: he gave me the kindest reception imaginable, and seemed to take it very ill that I had not, on my arrival, come directly to alight at his door. This painter lived like a nobleman, and was employed in a work for the duke, without the gate of Mantua, at a place called the Te.* This work was grand and magnificent, as it appears to this day.—Giulio immediately recommended me in the most honourable terms to the duke, who gave me an order to make a little shrine for the relic of the blood of Christ, which the Mantuans boast themselves to be possessed of, and affirm to have been brought thither by Longinus: he then turned to Signor Giulio, and desired him to draw a model of the shrine. Giulio made answer,—"Please your excellency, Benvenuto is a man that has no occasion for the design of another artist; and this you will readily acknowledge when you see his performance." Having undertaken this task, I sketched out a design for the shrine, in which the phial of blood could easily be contained. I also made a little model of wax representing a Christ sitting, who, in his left hand, which was raised aloft, held his cross, in a reclining attitude, and, with his right hand, seemed to be going to tear open the wound in his side. When I had finished this model, the duke was so highly pleased with it that he grew lavish of his favours to me, giving me to understand that I should continue in his service, and he would amply provide for me.

Having at this juncture paid my respects to the cardinal his brother†, the latter requested the duke to give me permission to make his pontifical seal, which I immediately took in hand. Whilst I was employed about this work, a quartan fever attacked me, and I grew delirious; I then began to curse Mantua, and its sovereign, and all that chose it for their place of residence. These words were reported to the duke by his Milanese goldsmith, who saw plainly that his excellency had a desire to retain me in his service. The duke having heard these ravings, was incensed against me to the highest degree, and I being as much dissatisfied with Mantua, our disgust was reciprocal. After finishing my seal in about four months, with several other little works which I executed for the duke in the name of the

* Sign. Gio. Bottani has published a fine historical description of this villa, on which Giulio Romano exhausted his extraordinary talents both in painting and architecture.

† Ercole Gonzaga, bishop of Mantua, made a cardinal in 1527, was one of the brightest ornaments of the church in the sixteenth century. Of an elevated genius, and excellent disposition, he cultivated literature and the arts, gave them every encouragement in his power; and took singular pleasure in the company of artists and of scholars. After the death of duke Frederic, he was sixteen years regent of Mantua, during the minority of his nephews.

cardinal, I was well paid by the latter, who entreated me to return to Rome, to that excellent country where we had become acquainted.

I left Mantua with a good purse of crowns, and arrived at Governo, the place where the brave Signor Giovanni de' Medici was slain. I was attacked in this place by a slight fever, which did not in the least interrupt my journey; there it left me, never to trouble me afterwards. Upon my arrival at Florence, thinking to find my dear father alive, I knocked at the door; when a hump-backed old woman, in a violent rage, looked out of the window, and bidding me, with the most abusive language, be gone, told me I had infected her. I made answer to the hag, "Old beldame, is there no other face to be seen in this house but you, with your unlucky ill-boding voice?" "No! begone, and bad luck to you!" she retorted. I rebuked her sharply; and it was more than two hours before our dispute brought a woman in the neighbourhood to her window, who told me that my father, and all belonging to my family, were dead of the plague*; and as I partly guessed this to be the case, my grief was the less violent. The good woman, at the same time, acquainted me that the only one of my relations left alive was my younger sister, whose name was Liperata; and that a religious lady, called Mona Andrea de Bellacci, had taken care of her. I then set out for my inn, and accidentally meeting a friend of mine, whose name was Giovanni Rigogli, I alighted at his house, and we went together to the grand square, where I received information that my brother was still living, of whom I went in quest to the house of a friend of his, named Bertino Aldobrandi.

Upon finding my brother, we embraced each other with the utmost ardour of affection, and what rendered our demonstrations of joy the more rapturous was, that we had each received news of the other's death. My brother afterwards bursting into a loud fit of laughter, and at the same time expressing the utmost surprise, took me by the hand, and said: "Come, brother, I will conduct you to a place which you would never think of. The case is this: I have procured our sister Liperata, who has no doubt of your death, a second husband." Whilst we were going to her house, we related to each other the many extraordinary events which had befallen us; and when we reached the place, our sister was so astonished at the unexpected sight, that she fell into my arms in a swoon. If my brother had not been present, this sudden accident, which deprived her of all utterance, would have prevented the husband from knowing that I

* From the month of May to November, in 1527, no less than 40,000 persons died of the plague in Florence.

was her relation. My brother Cecchino assisting our sister, who had fainted away, she soon came to herself. Having for a while lamented her father, her sister, her husband, and a little son that she had been deprived of, she began to prepare supper*; and during the rest of the evening, there was not a word more spoken of the dead; but much about weddings: thus we supped together with the greatest cheerfulness and satisfaction imaginable.

My brother and sister prevailed upon me to stay at Florence, though my own inclination led me to return to Rome. Besides that, my dear friend, by whom, as I have already mentioned, I had been assisted in my distress, I mean Piero, the son of Giovanni Landi, joined with them in persuading me to reside some time in Florence. For the Medici family being driven out of that city, viz. Signor Ippolito and Signor Alessandro (one of whom was afterwards cardinal, and the other duke of Florence), Piero was for having me stay by all means, and await the event.† I therefore began to work in the New Market, and set a great number of jewels, by which I was a considerable gainer.

About this time arrived at Florence a native of Siena, a man of lively genius, whose name was Girolamo Mazetti, and who had resided a long time in Turkey: he came to my shop, and employed me to make him a golden medal, to be worn upon a hat. He desired me to represent upon the medal the figure of Hercules‡ tearing asunder the jaws of the lion. I instantly set about the work, and, whilst I was employed upon it, Michel Angelo Buonarroti came to see it. I had taken immense pains with this piece: the attitude and strength of the animal were better represented than in any previous performance of the kind. My manner of working was likewise entirely new to the divine Michel Angelo, so that he praised me to such a degree, that I conceived the strongest inclination imaginable

* She who lamented over these persons was Liperata, younger sister of Cosa, and first married to Bartolomeo, a sculptor, as stated before.

† As soon as the Florentines saw the Pope besieged, they persuaded Cardinal Passerini, his vice-governor of Florence, to restore the ancient government, by obliging the Medici to resume a private station. The Cardinal, yielding to circumstances, soon after retired with the young princes to Lucca. In the revolution which followed, on the 17th of May, the papal authority was abolished, and Niccolo Capponi elected gonfaloniere, by the grand council. All the military and civil powers were strenuously exerted to support the change; and the magistrates, having no reliance upon *earthly* princes, had recourse to the enthusiasm, and the tenets of Savonarola, and Jesus Christ was solemnly declared sole lord and king of Florence; but when peace was made between the Pope and the emperor Charles V. the republic was soon overthrown, and Florence ever afterwards remained an absolute hereditary principality.

‡ In his treatise on the "Goldsmith's Art," our author speaks more at length respecting this medal. It is there said to have been made for Girolamo Marretta.

to perform something extraordinary. But as I had no other employ than setting jewels, though I could not earn more money in any other branch, I was not yet satisfied, but wished to be concerned in business of more consequence.

It happened about this time that one Federigo Ginori, a young man of sublime genius (who had resided several years at Naples, and having a very advantageous person, had an intrigue with a princess in that city) conceived a fancy to make a medal representing Atlas, with a world upon his shoulders : he therefore requested the divine Michel Angelo to draw him a design. The latter said to him, "Go to a young jeweller, whose name is Benvenuto : he will serve you as well as you could wish : but that you may not think I shun so slight a trouble, I will, with all the pleasure imaginable, sketch you out a design ; but at the same time speak to Benvenuto to draw you another, and take the best of the two for your model."

Federigo Ginori came to me accordingly, and told me what he wanted, letting me know withal how highly the divine Michel Angelo had commended me and that it was at his recommendation he had recourse to my assistance, that that great man had promised him a design, and that I was also to make a little waxen model. I accordingly set about it with the utmost ardour of application. When I had finished it, a painter, who was an intimate friend of Michel Angelo, and whose name was Giuliani Bugiardini* brought me his design of the Atlas. At the same time I showed this Giuliani my little model of wax, which was very different from the drawing made by Michel Angelo ; but Federigo and Bugiardini determined that I should follow my own model. I then began my work, and the divine Michel Angelo bestowed the highest praises imaginable, both on me and my performance. This work was a figure engraved on a thin plate, supporting on its shoulders the heavens, represented by a ball of crystal, on which was cut the zodiac, with a field of lapis lazuli. The effect was excessively fine. Under it was this motto, *Summam tulisse juvat*†. Federigo, being satisfied with my perform-

* Bugiardini, a disciple of Bertoldo was a very diligent artist, and exact copyist of the pictures of others. Such also was his simplicity of taste and manners, that Michel Angelo, who was fond of being in his company, used to call him the *happy man*, because, when he had bestowed the utmost pains upon his labours, he appeared perfectly satisfied with the result ; whilst he (Michel Angelo) was never known to be contented with any thing he did. Notwithstanding this *happy* taste, Bugiardini, with the assistance of his friends, left many elegant works behind him, both in Bologna and Florence. He died in 1556, in his 75th year.

† There is mention of this medal again, in the Vth chapter of "The Goldsmith's Art," where the motto is, *Summa tulisse,* and not *Summam,* &c. Cellini's pencil-design of the zodiac is found catalogued by Bartsch, in the prince of Ligne's collection, and was most probably intended for this same work.

ance, paid me generously. Signor Luigi Alamanni*, an intimate friend of Federigo, happening to be at this time in Florence, the latter brought him several times to my house, and by his means we became intimately acquainted.

Pope Clement having declared war against Florence†, that city prepared to make a defence; orders were therefore given that the militia should muster in every quarter, and I was commanded to take arms myself. I got ready in the best manner I could, and exercised with the first nobility in Florence, who seemed all very well disposed to exert their utmost efforts in defence of their country: the prayers customary on such occasions were made in every quarter of the city. The young men were oftener assembled than usual, and nothing else was talked of, but how to repel the enemy. It happened one day, about noon, that a number of gallant youths, of the first quality in the city, were assembled in my shop, when a letter was brought me from a certain person at Rome, who was called Jacopino della Barca: his true name was Jacopo della Sciorina, but in Rome he had the appellation of "della Barca," because he was master of a ferry over the river Tiber, between the Ponte Sisto, and the Ponte St. Angelo. This Jacopo was a very ingenious person, highly entertaining and agreeable in company: he had formerly been a manufacturer of cloth in Florence, and was now in favour with Pope Clement, who took great delight in his conversation. As they happened, at a particular time, to be conversing on various topics, the sack of Rome was mentioned, with the affair of the castle. In the course of this conversation, the Pope, recollecting my services, spoke of my conduct on that occasion in the most favourable terms imaginable; adding, that if he knew where I was, he should be glad to have me again in his service. Master Jacopo thereupon telling him that I resided at Florence, the Pope desired him to invite me to return. The purport of this invitation was, that I should enter into the service of Pope Clement, which would turn out considerably to my advantage. The young gentlemen present were very earnest to know the

* Alamanni, whose genius seemed peculiarly fitted to succeed in eclogue, pastoral, and romance, was unfortunately involved in the political bitterness and distractions of the times. Engaged in the conspiracy of 1525, against the Cardinal Giulio de' Medici, he was first imprisoned, and afterwards, on his release, wandered in desertion and poverty through many parts of France and Italy. Returning to his native place about 1527, he again devoted himself to his favorite object of restoring the ancient government; but all his attempts proving abortive, he was compelled, after being declared a rebel, to return into exile. He went to France, where his poetical talents acquired him the favour and protection of Francis I., and of Catherine de' Medicis.

† The peace between the Pope and the Emperor was concluded in June, 1529, and the Prince of Orange marched towards Florence the ensuing September.

contents of the letter, which I endeavoured to conceal from them as well as I could; and I wrote to Signor Jacopo, requesting him to send me no more letters, upon any account.

Jacopo, however, growing more officious and obstinate, wrote me a second epistle, couched in such terms, that if it had been discovered, I might have been involved in great difficulty. The substance of it was, that I should repair directly to Rome, where the Pope wanted to employ me in affairs of the greatest importance; and that the best course for me to take was to drop all other projects, and not join with a pack of senseless rebels, in acting against his Holiness. When I had perused this letter, I was so much alarmed that I immediately went in quest of my dear friend Pier Landi, who, upon seeing me, asked what had happened, that I appeared to be in such disorder. I answered my friend, that I could by no means disclose what occasioned my uneasiness; I only begged the favour of him to take my keys, which I put into his hands, and deliver the jewels, with the gold he should find, to the persons whose names were set down in my memorandum-book; and then pack up the furniture of my house, and keep an account of it, with his usual fidelity and friendship; adding that I should, in a few days, let him know what should become of me. Pier Landi, guessing pretty nearly how the matter stood, made answer: "Brother, go your ways without loss of time, and write to me afterwards. Make yourself quite easy about your affairs, and do not give yourself the least concern on that account." I took his advice. This was the most faithful, the most prudent, virtuous, and loving friend that I ever had in my whole life.

CHAPTER IX.

The Author returns to Rome, and is introduced to the Pope.—Conversation between him and his Holiness—the Pope employs him as a jeweller in a piece of exquisite workmanship.—He is made engraver of the Mint, notwithstanding the obloquy and detraction of several courtiers, and particularly of Pompeo of Milan, and Trajano, the Pontiff's favourites.—Fine medal of his designing.—Dispute between him and Bandinelli, the sculptor.

AFTER I had retired from Florence, I repaired to Rome, and immediately upon my arrival wrote to my friend Landi. I met with many of my former acquaintance in that city, by whom I was well received, and greatly caressed: however, I lost no time, but set

about several works, which proved very lucrative, but were not of sufficient importance to require a particular description. There was an old goldsmith in Rome, named Raffaello del Moro, who had great reputation in his profession, and was moreover an honest man. He requested me to go to work at his shop, because he had some business of consequence upon his hands, which would not fail to turn out to good account: I readily accepted the offer. Ten days had already elapsed before I had seen Jacopo della Barca, who meeting me by chance, accosted me in the most affectionate manner imaginable. Upon his asking me how long I had been there, I answered about a fortnight: at this he was highly offended, telling me that I showed very little respect to a Pope who had written for me thrice, in terms the most pressing. I was not at all pleased with his freedom, yet made no reply, suppressing my indignation as well as I could. This person, who was exceedingly loquacious, began to run on at a strange rate; and when I at last perceived that he was tired, I merely said to him, that he might conduct me to his Holiness whenever he thought proper. He told me that any time suited him; and I replied that I for my part was always ready.

We bent our course towards the palace (this was on Holy Thursday), and as soon as we arrived at the Pope's apartments, he being known, and I expected, were both admitted into his Holiness's presence. The Pope* being somewhat indisposed, was in bed, attended by Signor Jacopo Salviati and the Archbishop of Capua.†

As soon as his Holiness saw me, he was quite overjoyed: I approached him in the most humble manner, kissed his feet, and endeavoured to show by my gestures that I had something of the last importance to communicate. The Pope thereupon made a sign with his hand, and Signor Jacopo Salviati and the archbishop retired to a considerable distance from us. I thereupon addressed his Holiness in these terms: "Holy father, ever since this city was sacked, I have not been able to confess or receive the sacrament, because nobody will give me absolution. The case is this: when I melted down the gold in the tower, after labouring so hard to take off the jewels, your Holiness charged the master of the horse to

* This was in 1530. The Pope never enjoyed good health after his illness in 1529. V. Marini, *Archiatri,* vol. i. p. 326.

† F. Nicchola Schomberg, a learned Dominican and disciple of Frà Savonarola, was made archbishop of Capua in 1520. He was one of Pope Clement VII.'s most intimate and faithful counsellors; and succeeding in several delicate negotiations, he acquired so much credit that, though a Swede by birth, and wanting a cardinal's hat, he had very nearly succeeded in being appointed by the Pope as his successor. He received the purple from Paul III. in 1535, and died in 1537, aged 65 years. Many of his works are published.

give me some little recompence for my trouble; but I received nothing from him: on the contrary, he loaded me with abusive language. Thus provoked, I went up to the place where I had melted the gold, and removing the ashes, took out about a pound and a half of that metal, in a number of grains, small like millet; and not having sufficient money to bear my charges in my journey home, I thought to apply them to my private use, and afterwards make restitution when I should have an opportunity. I am now here at the feet of your Holiness, who are possessed of the full power of absolving, and request you would be so good as to give me permission to confess and communicate, that I may with your favour be restored to the divine grace." The Pope, with a faint sigh, perhaps occasioned by the remembrance of his past sorrows, uttered these words:—"Benvenuto, I have not the least doubt of the truth of what you say: I have it in my power, and am even willing, to absolve you from any guilt you may have incurred. Therefore freely and with confidence confess the whole; for if you had taken the value of one of those triple crowns, I am ready and willing to pardon you." I then said—"Holy father, I took nothing but what I have mentioned, and it did not amount to above the value of one hundred and fifty ducats; for that was the sum I received for the gold at the mint of Perugia, and I went with it to assist my aged father." The Pope replied:—"Your farther was as virtuous, as good, and worthy a man as ever was born, and you do not in the least degenerate from him. I am very much concerned that you got so little money, but I make you a present of it, whatever it was, and absolve you of any crime you may have committed. Declare this to the confessor, if that be all you require; when you have confessed and communicated, let me see you again; it will be for your interest."

As soon as the Pope had dismissed me, Master Jacopo and the Archbishop of Capua came forward. The Pope spoke as favourably of me as possible, declaring that he had heard my confession, and given me absolution: he moreover desired the archbishop to send for me to his house, and ask me if there was any other case that troubled my conscience, directing him to give me a thorough absolution; and at the same time to treat me with all possible marks of kindness. This interview being over, little Signor Jacopino had a curiosity to know what long conversation I had had with the Pope. After he had asked me this question several times, I made answer that I did not choose to tell him, for it was no concern of his, and he might, therefore, save himself the trouble of interrogating me any farther. I then went to execute all that I had agreed for with the Pope; and the two festivals being over, I paid him another visit. His Holiness

received me in a still more gracious manner than before, and told me that if I had come a little sooner to Rome I should have been employed in setting the jewels again, which I had taken out of the two crowns at the castle. As that was not, however, a work in which I could gain great reputation, he was resolved, he said, to employ me in an undertaking of the last importance, in which I should have an opportunity of displaying my abilities. "The work," added he, "I mean, is the button for the pontifical cope, which is made round, and in the form of a large trencher, and sometimes like a small one, half or one third of a cubit wide. In this I would have God the Father represented in half rilievo, and in the midst of it I would have the fine edge of the large diamond set, with many other jewels of the greatest value. Caradosso began one some time ago, but never finished it: this I would have completed with all speed, for I should be glad to have the pleasure of wearing it a little while myself: go then, and draw a fine design of it." Thereupon he caused all his jewels to be shown me, and I left him, highly pleased with my success.

During the siege of Florence, Federigo Ginori, for whom I made the medal of Atlas, died of a consumption, and it fell into the hands of Signor Luigi Alamanni, who soon after made a present of it to King Francis I; together with some of his admirable writings. His majesty being highly pleased with the medal, the worthy Luigi Alamanni spoke of me in such favourable terms to that monarch, that he testified a desire to know me. Being now employed on this little model, I proceeded with the utmost expedition, making it much of the same size as that intended for the work itself. Meanwhile several persons of my profession, who thought themselves equal to such a task, began to stir upon the occasion, and among the rest one Micheletto*, who had not been long in Rome, a person noted for his skill in cutting cornelians, and an excellent jeweller. This man was advanced in years, and having acquired a high degree of reputation, was employed in adjusting the Pope's triple diadem. Finding that I was engaged in designing this model, he expressed great surprise that I had not informed him of the affair, as he was an intelligent man, and in great favour with the Pope. At last, perceiving that I did not go near him, he came to my house, and asked me what I was about. I answered that I was busy with a work, which was put into my hands by the Pope himself. He replied, that he had received orders to examine the several works then in hand for his Holiness.

* Micheletto, or as Vasari writes it, Michelino, was a very fine and accurate artist, as well on a grand scale, as on smaller works. He was equal to the very first engravers of an age rich in every species of excellence depending on the arts.

I told him I would first inquire of the Pope, and then I should know what answer to return him. Upon which he said that he would make me repent.

After leaving me in a passion, he had an interview with all the most eminent men in the business; and when they had consulted about the affair, they made choice of Micheletto for their agent. The latter being a man of genius, got certain able designers to draw about thirty models, all different from each other: at the same time knowing the Pope to be very ready to listen to his insinuations, he entered into a confederacy against me with another artist, named Pompeo, a Milanese, who was very much in favour with his Holiness, and related to Signor Trajano, first gentleman of the bedchamber, and highly in the Pope's good graces. They began to intimate to the Pontiff that they had seen my design, and did not think me capable of so great an undertaking. He answered that he would examine into the affair himself, and in case I should not prove equal to the task, he would find a more proper person. They both said that they had got several admirable designs for the purpose; the Pope replied, "That he was satisfied with what they had done, but did not choose to inspect their designs till I had finished mine, and then he would examine them all together."

In a few days I had completed my model, and carried it one morning to the Pope; Signor Trajano made me wait a long while, and in the mean time sent for Micheletto and Pompeo in all haste, desiring them to bring their models with them. As soon as they came, we were all admitted; Micheletto and Pompeo began to show their plans, and the Pope to examine them; and because designers unacquainted with the jewelling business do not understand the placing of precious stones, unless those who are practised in the art have taught them the secret, (for when a figure is to be set off with jewels, the jeweller must know how to design, otherwise he can produce nothing good,) it happened that all those who had drawn those designs had laid the fine, large, and beautiful diamond in the middle of the breast of God the Father. The Pope, who was a person of uncommon genius, having taken notice of this blunder, was highly delighted with his own discovery. After he had inspected about ten, he threw the rest upon the ground, and said, "Let us now see what Benvenuto has got;" desiring me to give him my model, that he might ascertain whether I had committed the same mistake. Thereupon I came forward, and opened a little round box, when instantly there seemed to flash from it a lustre which dazzled the Pope himself, and he cried out with a loud voice, "Benvenuto, had you been my very self, you could not have designed this otherwise than you have.

Your rivals have done every thing they could to disgrace themselves." Several nobles approaching, the Pope showed them the difference between the models: and when he had bestowed sufficient praises upon it, and my enemies appeared ready to burst with pride and vexation, he turned about to me and said, "I discover here an inconvenience which is of the utmost consequence; my friend Benvenuto, it is easy to work in wax, the grand difficulty is to execute it in gold." To which I answered boldly, "Most holy father, I will make it my bargain with you, that if I do not execute the work itself in a manner ten times superior to this model, I am to have nothing for my trouble." Upon my uttering these words there was a general outcry, the noblemen affirming that I promised too much. But one of them, who was a great philosopher, said in my favour, "From the admirable symmetry of shape, and happy physiognomy of this young man, I venture to engage that he will perform all he promises, and more." The Pope replied, "I am of the same opinion;" then calling to Trajano, his gentleman of the bedchamber, he ordered him to fetch five hundred ducats.

Whilst they were bringing the money, he examined more minutely the ingenious artifice by which I had placed that fine diamond, and God the Father, in a proper position. I had laid the diamond exactly in the middle of the work, and over it I had represented God the Father sitting in a sort of a free, easy attitude, which suited admirably well with the rest of the piece, and did not in the least crowd the diamond; his right hand was lifted up, giving his blessing. Under the diamond I had drawn three little boys, who supported it with their arms raised aloft. One of these boys, which stood in the middle, was in full, the other two in half, rilievo. Round it were several figures of boys placed amongst other glittering jewels. The remainder of God the Father was covered with a mantle, which waved in the wind, from whence issued several figures of boys, with other striking ornaments, most beautiful to behold. This work was made of a white stucco upon a black stone. When the officer brought the money, the Pope gave it to me with his own hand, and in the most obliging manner requested me to endeavour to please him by my execution, promising me that I should find my account in it.

Having taken leave of his Holiness, I went home with the money and the model, and was in the utmost impatience to begin the work. I set about it with the greatest assiduity, and in a week's time the Pope sent one of his gentlemen of the bedchamber, a native of Bologna, and of great distinction, to desire I would repair to him directly, and carry my work along with me. By the way, the gentleman of the bedchamber, who was one of the politest persons at court,

told me that the Pope not only wanted to see how far I had advanced in that undertaking, but likewise intended to employ me in another business of great importance, which was the stamping of the coins in the Roman mint, desiring me at the same time to be in readiness to answer his Holiness, for he had given me previous notice, that I might not be unprepared. I waited upon his Holiness, and showed him the golden plate, upon which was engraved God the Father alone; which figure, even in this sketch, discovered a degree of perfection greatly superior to the model of wax. The Pope exclaimed with astonishment, "From this time I will believe whatever you say." After several other declarations in my favour, he added, "I propose employing you in another work, which you will be as much pleased with as this, or rather more, if you have but the spirit to undertake it;" then telling me that he would be glad to have his coins struck, he desired to know whether I had ever done any thing in that way, and had the courage to engage in such a work. I answered, that I was very ready to accept of it, and that I had seen how it was done, though I had never been employed in that business.

There was present at this conversation, Signor Tommasso da Prato, datary to his Holiness; this man, being greatly attached to my enemies, said, upon the occasion, "Holy father, the favours which you lavish upon this young man, and his own presumption, would make him promise you a new creation; but as you have put a work of vast importance into his hands, and now are giving him another of still greater, the consequence must be that one will interfere with the other." The Pope turned about to him in an indignant mood, and bade him mind his own business. He then ordered me to make him a model of a broad piece of gold, upon which he wished to have engraved a naked Christ with his hands tied behind him, and the words *Ecce Homo,* as a legend; with a reverse, on which should be represented a pope and an emperor together, fixing up a cross, which should appear to be falling, with these words inscribed, *Unus spiritus et una fides erat in eis.** The Pope having

* Cellini speaks more at length of this coin with the "Ecce Homo" in his Goldsmith's Art, chapter vii; where he says, he had given on the reverse the head of the Pope, and transferred his fine design of the Pope and Emperor, sustaining the cross, to another equally well executed in gold, with a reverse representing St. Peter and St. Paul. In fact, the coin of "Ecce Homo," with the head of the Pope, was published by Floravantes, and was to be seen in the Museum of Mons. Leoni Strozzi, and at the Marche Raggi's in Rome. The other of the Pope and the Emperor, with the heads of the Saints on the reverse, is described by Saverio Scilla, who supposes it to have been published by the Chevalier Marescotti. Indeed both are extremely rare, as we gather from Cellini's own words. These coins, made to the great disadvantage of the Pope, were in a short time melted down by the avaricious bankers.

employed me to stamp this fine medal, Bandinello, the sculptor, who was not yet made a knight, came forward, and with his usual presumption and ignorance, said, before all present, "These goldsmiths must have some person to draw the designs of these fine pieces for them." I immediately turned about and told him, that I did not want his assistance in my business; but that I hoped by my skill and designs in a short time to give him some uneasiness with respect to his own professional reputation. The Pope seemed to be highly pleased with what I said, and addressing himself to me, said, "Go, my dear Benvenuto, exert your utmost efforts to serve me, and never mind these blockheads." So having taken my leave, I, with great expedition, made two irons; and having stamped a piece of gold, I carried both the money and irons to the Pope one Sunday after dinner. He then said, his surprise was equal to his satisfaction; and though the execution pleased him highly, he was still more amazed at my expedition.

In order to increase his satisfaction and surprise, I had brought with me all the old coins which had formerly been struck by those able artists, who had been in the service of Pope Julius and Pope Leo; and seeing that mine gained much higher approbation, I took a petition out of my bosom, requesting to be made stamp-master to the mint, the salary annexed to which place was six gold crowns a month; besides that the dies were afterwards paid for by the superintendent of the mint, who for three gave a ducat. The Pope having approved of my request, charged the datary to make out my commission; the latter, who had views of his own, and wanted to be a gainer by the affair, said, "Holy father, do not so precipitate matters; things of this nature require mature deliberation." The Pontiff replied, "I know what you would be at; give me that petition directly." Having taken it, he instantly signed it, and putting it into the hand of the datary, said, "Now you have no farther objections to make, draw up the commission directly, for such is my pleasure; the very shoes of Benvenuto are more precious than the eyes of all those blunderers." So having thanked his Holiness with the warmest sentiments of gratitude, I returned overjoyed to my work.

CHAPTER X.

The daughter of Raffaello del Moro having an ailing hand, the Author gets her cured, but is disappointed in his design of marrying her.—He strikes a fine coin of Pope Clement VII.—Melancholy catastrophe of his brother, who is killed at Rome in a fray.—His grief for the loss of his brother, to whom he erects a monument, with an epitaph.—He revenges his brother's death.—His shop is robbed.—Extraordinary instance of the fidelity of his dog upon that occasion.—The Pope puts great confidence in him, and gives him all possible encouragement.

I CONTINUED still to work in the shop of Raffaello del Moro. This worthy man had a handsome young daughter, respecting whom he formed a design on me; and I having partly discovered his views, felt well disposed to second them: I did not, however, make the least discovery of the affair; but was so discreet and circumspect that her father was highly pleased with my behaviour. This girl was attacked by a disorder in her right hand, which corroded the two bones belonging to the little finger and the one next to it. Through the inadvertency of her father, she had fallen into the hands of an ignorant quack, who declared it as his opinion that she would lose her right arm, if no worse were to befall her. I seeing her father terribly frightened, desired him not to mind what was said by that ignorant pretender; he told me that he had no acquaintance either with physicians or surgeons, and requested me to recommend him a skilful person, if I knew any such: I then sent for one Signor Jacopo of Perugia*, an eminent surgeon. As soon as he had seen the poor frightened girl, and been informed of what the ignorant quack had said, he affirmed that she was in no danger, but that she would have the full use of her right hand, though her two last fingers might remain somewhat weak; therefore her father need not be under the least apprehension. As he had undertaken the cure, and was preparing to cut off part of the diseased flesh about the two little bones, her father called me, and desired that I would myself be a spectator of the operation.

Having observed that Signor Jacopo was making use of some clumsy instruments, with which he hurt the girl very much, and

* Jacopo Rastelli di Rimini, more commonly called di Perugia, having been born and passed his infancy there, was considered one of the most distinguished professors of his time, and was surgeon to Clement VII. and the succeeding Popes, until the year 1566. He died at Rome, in his 75th year.

did her no manner of good, I bade him wait for about a quarter of an hour, and proceed no farther. I then ran to my shop, and made a little instrument of the finest steel, which I delivered to the surgeon, who continued his operation with so gentle a hand, that the patient did not feel the least pain, and the affair was soon over. Upon this and many other accounts the worthy man conceived so warm a friendship for me, that he seemed to love me better than his two sons, who were grown young men, and applied his whole attention to the recovery of his fair daughter.

He was very intimate with Signor Giovanni Gaddi*, who was a clerk of the chamber, and had a great attachment to the polite arts, though no artist himself. He was also connected with Signor Giovanni Greco, a person of the most profound erudition; with Signor Luigi da Fano, who was likewise a man of letters; with Signor Antonio Allegretti†, and with Signor Annibal Caro‡, a young man, from a distant part of Italy. I became a member of this society, in conjunction with Signor Bastiano§, a Venetian, and excellent painter; and we almost every day saw each other once at least at the house of Signor Giovanni. This intimacy having given the worthy

* Gio. Gaddi, a Florentine, an extremely able and intelligent man, passionately devoted to literature and learned men, but probably of unamiable and repulsive manners, since Annibal Caro, for many years patronised and supported by him, could never become sincerely attached to his benefactor. Gaddi was on intimate terms with Aretino, and other distinguished characters, and his death was lamented in a sonnet of Caro's, beginning "Lasso quando fioria," &c. He died in 1542, in his 49th year.

† Some poems of Allegretti's are preserved in a collection by Atanigi, and by Gobbi. He was an intimate friend of Alamanni.

‡ Caro was born in Civitanova, in Ancona, in 1507. Driven by the narrowness of his circumstances to instruct the children of Luigi Gaddi, in Florence, he there became acquainted with Monsignor Giovanni, who engaged him as his private secretary, and conferred upon him many ecclesiastical distinctions. Caro frequently tried to withdraw himself from this kind but disagreeable patron; and once actually engaged himself in the service of Sig. Guidiccioni; but Gaddi recovered his secretary, and retained him in his service till his death. Caro then went into the service of Pier Luigi Farnese, who not only availed himself of his talents as a secretary, but employed him in many important negotiations. After the assassination of Pier Luigi, by his courtiers, he was engaged by the Cardinals Rannucio and Alessandro Farnese, in whose service he died in 1566. His high literary and political character is too well known to require comment.

§ Sebastiano was born at Venica, 1485. Invited to Rome by Agostino Chigi, he gave his whole study to Michel Angelo, but by his advice attempted the manner of Raffaello, and soon acquired a distinguished reputation. As a disciple of Giorgione, he became extremely successful in colouring, and his portraits were much admired. Diffident, however, of his talents, he painted with so much timidity and caution, that he left many noble works unfinished; and as soon as Clement VII. gave him the office of Sealer in the Chancery he resolved to abandon the art altogether. Finding himself in easy circumstances, he gave himself up to a love of ease and pleasure, living in the society of his friends, and devoting much of his time to the charms of poetry and music, in which he excelled. He died in 1547.

Signor Raffaello an opportunity, he said to the other, "My good friend, Signor Giovanni, you know me very well; as it is my intention to give my daughter in marriage to Benvenuto, I am not acquainted with a fitter person to apply to upon this occasion than yourself; I therefore request you to assist me in settling on her what portion out of my property she wishes to have." The shallow fellow scarcely let the worthy man make an end of speaking, when he cried out, without the least hesitation, "Say no more, Signor Raffaello, what you propose is a thing utterly impracticable." The poor man, much mortified, sought to marry his daughter without loss of time, as the mother and all the relations were highly offended. I was entirely ignorant of the cause, and thinking they made me a very bad return for all my politeness, endeavored to open a shop hard by them. Signor Giovanni said nothing to me of what had passed, till the girl was married, which happened a few months after.

I attached myself with the most unremitting application to my work, which I was in the utmost haste to finish, and likewise attended to my business at the Mint, when the Pope set me to make a piece equal in value to two carlins, upon which was his Holiness's head, on the reverse, Christ walking upon the sea, and stretching out his hands to St. Peter, with this inscription round it, *Quare dubitasti?*† This piece gave such high satisfaction that a certain secretary to the Pope, a man of great worth, whose name was Sanga*, said on the occasion, "Your Holiness may boast of having a coin superior to that of the Roman emperors, amidst all their pomp and magnificence." The Pope made answer, "Benvenuto may also boast of serving a prince like me, who knows his merit." I continued my grand work in gold, frequently showing it to the Pope, who was very earnest to see it, and every day expressed new admiration at the performance.

A brother of mine was at this time in Rome, in the service of Duke Alessandro, for whom the Pope had procured the duchy of Penna; in the same service were also a considerable number of gallant men, trained in the school of that great prince Giovannino de' Medici; and my brother was esteemed by the duke, as one of the bravest of

* Battista Sanga, of Rome, secretary to Giammatteo Ghiberti, and afterwards to Clement VII., was celebrated for his Latin poems. He was carried off by poison at any early age.

† There is also mention made of this silver coin in the same treatise, *Dell' Orificeria*. Floravantes has published as the work of our author, another of nearly similar design. It is distinguished, however, from that of Cellini, by having the date of the year XI. round the head of the Pope, and by representing our Saviour in the act of supporting St. Peter with his left hand, and blessing him with the right; whilst in the former Christ is seen stretching out his right hand only to the Apostle, without any date to it whatever.

the whole corps. Happening one day, after dinner, to be in the part of the town called Banchi, at the shop of Baccino della Croce, to which all those brave fellows resorted, he had laid himself down upon a bench, and was overcome with sleep. At this time there passed by a company of city-guards, having in their custody one Captain Cisti, a Lombard, who had been bred likewise in the school of the same great Signor Giovannino, but was not then in the service of the duke. Captain Cattivanza degli Strozzi, happening to be in the shop of Baccino della Croce, Captain Cisti saw him, and immediately cried out, "I was bringing you that large sum of money which I owed you: if you want it, come for it, before they carry me to gaol." This Cattivanza was very ready to put the courage of others to the proof, but did not care to run any risk himself; and as some gallant youths were present, who were willing to undertake this hazardous enterprise, though scarce strong enough for it, he desired them to advance towards Captain Cisti, in order to get the money from him, and, in case the guards made any resistance, to overpower them if necessary. These young men were only four in number, all of them beardless: the first was Bertino Aldobrandi, the second Anguillotto da Lucca, I cannot recollect the names of the rest. Bertino had been pupil to my brother, who was beyond measure attached to him. These four bold young men came up to the city-guards, who were above fifty in number, pikemen, musqueteers, and two-handed swordmen. After a few words they drew their swords, and the four youths pressed the guards so hard, that if Captain Cattivanza had only just shown himself a little, even without drawing his sword, they would inevitably have put their adversaries to flight; but as the latter made a stand for a while, Bertino received some dangerous wounds, which brought him to the ground. Anguillotto too, at the same time, was wounded in his right arm, and being so far disabled that he could not hold his sword, he retreated in the best way he could; whereupon the others followed his example. Bertino was taken up in a dangerous condition.

During this transaction we were all at table, having dined about an hour later than usual; upon hearing of the disturbance, the eldest of the young men rose from table, to go and see the scuffle: his name was Giovanni. I said to him, "For God's sake do not stir from hence, for in such affairs as this the loss is always certain, and there is nothing to be gained." His father spoke to him to the same effect, begging he would not leave the room. The youth without minding a word that was said to him, instantly ran down stairs. Being come to the place, where the grand confusion was, and seeing Bertino raised from the ground, he began to turn back, when he met with my

brother Cecchino, who asked him the cause of this quarrel. Giovanni, though warned by some persons not to tell the affair to Cecchino, cried out foolishly and indiscreetly, that Bertino Aldobrandi had been murdered by the city-guards. At this my brother set up a loud howl, which might be heard ten miles off, and said to Giovanni, "Alas! unhappy wretch that I am: can you tell me which of them it was that killed him?" Giovanni made answer that it was one who wore a large two-handed sword, with a blue feather in his hat. My poor brother having followed the guards, and knowing the person by the mark he had been told of, fell upon the murderer with great agility and bravery, and in spite of all resistance ran his sword through his body, pushing him with the hilt of it to the ground. He then assailed the rest with such intrepidity, that he alone and unassisted would have put all the guards to flight; but unluckily turning about to attack a musqueteer, the latter finding himself obliged to fire in his own defence, hit the valiant but unfortunate youth, just above the right knee, which brought him to the ground; whereupon the guards made haste to retreat, lest some other formidable champion should fly to his assistance.

Finding the tumult continue, I likewise rose from table, and putting on my sword, as swords were then worn by every body, I repaired to the bridge of St. Angelo, where I saw a great concourse of people. I advanced up to the crowd, and as I was known to some of them, room was made for me, when they showed me what I by no means was pleased to see, though I had discovered a great curiosity to inquire into the matter. At my first coming up, I did not know my brother, for he was dressed in different clothes from those I had seen him in a short time before: but he knew me first, and said, "Dear brother, do not be afflicted at my misfortune: it is what I, from my condition of life, foresaw and expected: get me quickly removed from this place, for I have but few hours to live." After he had related to me the accident that had befallen him, with all the brevity that such cases require, I answered him, "Brother, this is the greatest misfortune that could happen to me in this world; but have a good heart, for before you die you shall see me revenge your much-lamented fate." The city-guard was about fifty paces distant from us: Maffio their captain having caused part of them to return, in order to carry off the corporal, whom my brother had slain, I walked up to them with the utmost speed, wrapped and muffled up in my cloak; and as I had forced my way through the crowd, and was come up to Maffio, I should certainly have put him to death; but when I had drawn my sword half out of the scabbard, there came behind me Berlinghieri, a gallant youth, and my particular friend; and with

him four brave young men, who said to Maffio, "Fly instantly, for this man will kill you!" Maffio having asked them who I was, they answered, "He is the brother of him you see lying there." Not choosing to hear anything farther, he retired with the utmost precipitation to the tower of Nona: the others then said to me, "Benvenuto, the hinderance we have been to you, however disagreeable, was intended for a good end. Let us now go to the assistance of the dying man." So we turned back, and went to my brother, whom I ordered to be removed to a neighbouring house.

A consultation of surgeons being immediately called in, they dressed his wound, but he would not hear of having his leg cut off, though it would have been the likeliest way to save his life. As soon as they had done, Duke Alessandro made his appearance, and spoke to my brother with great tenderness: the latter being still in his right mind, said to his excellency, "My dear lord, there is nothing I am grieved at, but that you are going to lose a servant, who may be surpassed by others in courage and abilities, but will never be equalled for his fidelity and attachment to your person." The duke desired he would endeavour to live, declaring that he knew him to be in all respects a valiant and worthy man: he then turned about to his people, and bid them supply the youth with whatever he wanted. No sooner was the duke departed, but the overflowing of blood, which could not be stanched, affected my brother's brain, insomuch that he became the next night delirious. The only sign of understanding he discovered was, that when they brought the sacrament to him, he said, "You would have done well to make me begin with confessing my sins: it does not become me to receive that divine sacrament with this crazy and disordered frame. Let it be sufficient that my eyes behold it with a profound adoration; it will be received by my immortal soul, and that alone supplicates the Deity for mercy and pardon." When he made an end of these words, and the sacrament was carried away, his delirium returned again. His ravings consisted of the greatest abominations, the strangest frenzies, and the most horrid words that could possibly come from the mouth of man; and thus he continued during the whole night, and till next day. No sooner had the sun appeared on the horizon, than he turned to me and said, "Brother, I do not choose to stay here any longer, for these people might make me commit some extravagant action, which would cause them to repent having any way molested me;" then disengaging both his legs, which we had put into a box, he made an effort as if he was going to mount on horseback, and turning his face about to me, he said three times, "Adieu, adieu, adieu!" At the last word, his generous soul departed.—The hour for the funeral being come, which

was about ten o'clock at night, I got him honourably interred in the church of the Florentines; and afterwards caused a fine marble monument to be erected over him, on which were represented certain trophies and standards. I must not omit that one of his friends having asked him, who it was that shot him, and whether he should know him again, he answered in the affirmative, and told him all the marks by which he might be distinguished; and though he took the utmost care to conceal this declaration from me, I overheard all that passed, and intend in a proper place to give the sequel of that adventure.

To return to the tomb-stone above mentioned: certain literati of the first rank who were well acquainted with my brother*, and greatly admired his prowess, gave me an epitaph for him, telling me that so brave a youth well deserved it.—It was as follows:

"Francisco Cellino Florentino, qui quod in teneris annis ad Johannem Medicem ducem plures victorias retulit, et signifer fuit, facile documentum dedit quantæ fortitudinis et consilii vir futurus erat, ni crudelis fati archibuso transfossus quinto ætatis lustro jacerit. Benvenutus frater posuit. Obiit die 27 Maii, MDXXIX."

"To Francesco Cellini, a Florentine, who having in his youth gained many victories for Duke Giovanni of Medici, whose standard-bearer he was, plainly showed how brave and wise a man he would have proved, if he had not been shot by the arquebuss of cruel fate in his fifth lustre. Benvenuto his brother erected this monument. He died on the 27th May, MDXXIX."

He was twenty-five years of age; and though in the army he was called Cecchino the musician's son, I chose to give him our family name, with the arms of Cellini. This name I ordered to be carved in the finest antique characters, all of which were represented broken except the first and last. Being asked the reason of this by the literati who had written the epitaph for me, I told them that the letters were represented broken, because his corporeal frame was destroyed; and those two letters, namely, the first and last, were preserved entire—the first in allusion to that glorious present, which God has made us, of a soul enlightened by his divine rays, subject to no injury; the last on account of the great renown of his brave actions. This device met with general approbation, and the method was afterwards adopted by others. I caused the arms of Cellini to

* Varchi eulogises the bravery and worth of Francesco Cellini, in the XIth chapter of his History, where he also speaks at length respecting Bertino Aldobrandi, the before-mentioned pupil of the same, who fell, in a duel, near Florence, March, 1530.—See Ammirato.

be wrought upon the same tomb-stone, in which I made some little alteration; for there are in Ravenna, a very ancient city, some of the Cellini family, who are respectable gentlemen, and have for their arms a lion rampant of the colour of gold, in an azure field, with a red lily upon the right paw, and three gold lilies upon the basis. This is the true coat of arms of our family*; my father showed me one which contained only the paw with the remaining particulars already described; but that of the Cellini of Ravenna pleases me most. To return to the devices which I ordered to be made for the monument, and to the arms in particular: the paw of the lion was represented upon it, and in the room of the lily I caused an axe to be placed in the paw, with a field of the said arms divided in four quarters, with no other view but to remind me of revenging his injured manes.

Meanwhile I exerted my utmost efforts to finish the work in gold which I was employed in by Pope Clement: his Holiness was very earnest to have it completed, and sent for me two or three times a week to observe my progress. He was more and more pleased with it every time, but frequently found fault with the deep sorrow which I expressed for the loss of my brother. Seeing me one day more dejected than usual, he said to me, "Benvenuto, I did not think that you were so weak a man; did you never know that death is unavoidable? You seem to want to follow your brother." I took my leave of his Holiness, and went on with the work which he had put into my hands, as well as the business of the Mint; still thinking, day and night, of the musqueteer that shot my brother.

He had formerly been in the light cavalry, and afterwards entered as a musqueteer amongst the city-guards. What increased my vexation and resentment was, that he made his boasts in these terms: "If I had not despatched that bold youth, he alone would quickly have made us fly, which would have been an eternal disgrace." Perceiving that my solicitude and anxious desire of revenge deprived me both of sleep and appetite, which threw me into a lingering disorder, and not regarding the baseness of the undertaking, one evening I prepared to put and end to my inquietude. This musqueteer lived hard by a place called Torre Sanguigna, next door to a house occupied by a courtesan, whose name was Signora Antea, one of the richest and most admired, and who made the greatest figure of any

* Such was Cellini's predilection for this coat of arms, that he has left us a drawing of them in black chalk, and in ink upon card, under which is affixed the following notice:—"The original arms of the Cellini family, as worn by the gentlemen of the ancient city of Ravenna, remaining in our house from the time of Cristofano Cellini, my great grandfather, father of Andrea, my grandfather." It is also thus stated in the Preface to the Goldsmith's Art, edition of 1731.

of her profession in Rome. Just after sunset, about eight o'clock, as this musqueteer stood at his door with his sword in his hand, when he had done supper, I, with great address, came close to him with a long dagger, and gave him a violent back-handed stroke, which I had aimed at his neck. He instantly turned round, and the blow falling directly upon his left shoulder, broke the whole bone of it, upon which, he dropped his sword, quite overcome by the pain, and took to his heels. I pursued, and in four steps came up with him, when, raising the dagger over his head, which he lowered down, I hit him exactly upon the nape of the neck. The weapon penetrated so deep, that though I made a great effort to recover it again, I found it impossible; for at this same instant there issued out of Antea's house four soldiers with their swords drawn, so that I was obliged to draw mine also in my own defence.

Having left the dagger, I retired, and for fear of a discovery repaired to the palace of Duke Alessandro, which was between the Piazza Navona and the Rotonda. I immediately acquainted his excellency with what had happened, who told me that if I had been alone upon the occasion, I might make myself quite easy, and be under no apprehensions. He bid me at the same time proceed in the business I had undertaken for his Holiness, who was impatient to see it finished, and gave me leave to work there eight days. He was the more ready to protect me, as the soldiers who had interrupted me related the whole affair as it happened, mentioning the great difficulty with which they had drawn the dagger out of the neck of the wounded person, who was entirely unknown to them. But Giovanni Bandini* happening to pass that way, told them that the dagger belonged to him, and he had lent it to Benvenuto, who wanted to revenge the death of his brother. The soldiers expressed great concern at their having interposed, though I had taken my revenge to the full.

More than eight days passed without the Pope's once sending for me according to his usual custom; at last he ordered the Bolognese gentleman of his bedchamber to call upon me, who, with great modesty, said that the Pope knew all that had happened, that his Holiness was very much my friend, and desired me to go on with my business, without giving myself any uneasiness. When I came into the presence of the Pontiff, he frowned upon me very much, and with angry looks seemed to reprimand me; but, upon viewing

* A name famous in Florentine history. He was long in the service of Duke Alessandro, but being sent by Duke Cosmo to the Emperor, in 1543, he seized the opportunity of indulging his fierce and treacherous disposition by joining Filippo Strozzi. Detected in the conspiracy, he with difficulty got a sentence of death changed into perpetual imprisonment, in which he languished for fifteen years, in the keep of an old tower.

my performance, his countenance grew serene, and he praised me highly, telling me that I had done a great deal in a short time; then looking attentively at me, he said, "Now that you have recovered your health, Benvenuto, take care of yourself." I understood his meaning, and told him that I should not neglect his advice. I opened a fine shop in the place called Banchi, opposite to Raffaello, and there I finished the work which I had in hand. The Pope soon after having sent me all the jewels except the diamond which he had pawned to certain Genoese bankers, in order to supply some particular necessities, I took possession of all the rest, but had only the model of the diamond.

I kept five able journeymen, and besides the Pope's business did several other jobs, insomuch that the shop contained different wares in jewels, gold, and silver, to a very considerable amount. I had in the house a fine large shock-dog, which Duke Alessandro had made me a present of: it was an admirable good pointer, for it would bring me all sorts of birds, and other animals, that I shot with my gun; and it was an excellent house-dog besides. It happened about this period (as my time of life permitted, being then only in my twenty-ninth year), that having taken into my service a young woman equally genteel and beautiful, I made use of her as a model in my art of drawing; and it was not long before our intimacy assumed an amorous character. My chamber was situated at a considerable distance from that of my work-people, and also from my shop; and although, in general, no man's sleep is lighter than mine, it, upon some occasions, is very profound and heavy.

It happened one night, that a thief, who had been at my house, pretending to be a goldsmith, and had laid a plan to rob me of the above-mentioned jewels, watched his opportunity and broke into my shop, where he found several small wares in gold and silver; but as he was breaking open the caskets, in order to come at the jewels, the dog flew at him, and the thief found it a difficult matter to defend himself with a sword. The faithful animal ran several times about the house, entering the journeymen's rooms, which were open, it being then summer-time; but as they did not seem to hear him barking, he drew away the bed-clothes, and pulling the men alternately by the arms, forcibly awakened them; then barking very loud, he showed the way to the thieves, and went on before; but they would not follow him. The scoundrels being quite provoked with the noise of the dog, began to throw stones and sticks at him (which they found an easy matter, as I had given them orders to keep a light in their room the whole night), and at last locked their door. The dog, having lost all hopes of the assistance of these rascals, undertook the

task alone, and ran down stairs. He could not find the villain in the shop, but came up with him in the street, and tearing off his cloak, would certainly have treated him according to his deserts, if the fellow had not called to some tailors in the neighbourhood, and begged, for the love of God, they would assist him against a mad dog. The tailors, giving credit to what he said, came to his assistance, and with great difficulty drove away the poor animal. Next morning, when my young men went down into the shop, they saw it broken open, and all the caskets rifled; upon which they began to make a loud outcry, and I coming to them quite terrified, they said, "Alas, we are undone; the shop has been plundered and robbed by a villain, who has carried off every thing valuable, and broken all the caskets. Such an effect had these words upon my mind, that I had not the heart to go to the chest, to see whether the Pope's jewels were safe; but being quite shocked at the report, and scarce able to trust my own eyes, I bid them open it, and see whether his Holiness's jewels were missing. When the young men, who were both in their shirts, found all the Pope's jewels, as likewise the work in gold, they were overjoyed, and said "There is no harm done, since both the work and the jewels are untouched. The thief, however, has stripped us to our shirts; for, as the heat was excessive last night, we undressed in the shop, and there left our clothes." Hearing this, I perfectly recovered my spirits, and desired them to provide themselves with clothes, as I would pay for whatever damage had been done.

When I heard the whole affair at my leisure, what gave me most concern, and had thrown me into great confusion at opening the chest, was my apprehension lest I should be thought to have invented this story of the thief, merely with a design to rob the Pope of his jewels. Besides, it had been said to Pope Clement, by one of his greatest confidants, and others, namely, Francesco del Nero, Zanni di Biliotti, his accomptant, the Bishop of Vaison*, &c., that they were surprised how his Holiness could trust such a quantity of jewels with a wild young man, who was more a soldier than an artist, and not yet quite thirty. The Pope asked them whether they had ever known me guilty of any thing that could justly give room for suspicion. "Most holy father," answered Francesco del Nero†, "I have not, for he never had any such opportunity before." To this

* Girolamo Schio, or Schedo, of the Vicentine, a very expert minister in affairs of state, and confessor to Clement VII.—Besides being employed in many important and delicate missions, he was appointed to the bishoprick of Vaison, in the state of Avignon. He died in Rome, in 1533, aged 52 years. The Datario, Tomasso Cortez da Prato, before mentioned, succeeded him in the bishoprick.

† This same Francesco, so very chary and considerate of other people's honour, was, according to Varchi, possessed of no very immaculate virtue himself.

the Pope replied, "I take him to be an honest man in every respect, and if I thought him otherwise, I should not trust him." This suddenly recurring to my memory, gave me all the uneasiness I have described above.

As soon as I had ordered by journeymen to go and get themselves new clothes, I took both the work and the jewels, and putting them in their places as well as I could, went directly to the Pope, who had been told something of the adventure of my shop by Francesco del Nero. The Pope thereupon conceiving a sudden suspicion, and giving me a most stern look, said with a harsh tone of voice— "What are you come hither about? What's the matter?" To this I answered—"Holy father, here are all your jewels and the gold: there is nothing missing." His Holiness, with a serene brow, said, in allusion to my name—"Then are you indeed *welcome*." I showed him my work, and whilst he was examining it, told him the whole affair of the thief, the dilemma I had been in, and what had been the chief cause of my uneasiness. At these words he frequently looked me full in the face, in the presence of Francesco del Nero, seeming to me half sorry that he had not opposed that man's insinuations. At last the Pope turning all he had heard into merriment, said—"Go and continue to show yourself an honest man: I know you deserve that character."

CHAPTER XI.

The Author's enemies avail themselves of the fabrication of counterfeit coin to calumniate him to the Pope, but he vindicates his character to the satisfaction of his Holiness.—He discovers the villain who had robbed his shop by the sagacity of his dog.—Inundation at Rome.—He is employed to draw a design of a magnificent chalice for a papal procession.—Misunderstanding between him and the Pope. —Cardinal Salviati is made legate of Rome in the Pope's absence, and greatly discountenances and persecutes the Author.—He is attacked by a weakness in his eyes, which prevents him from finishing the chalice.—The Pope at his return is angry with the Author.—Extraordinary scene between him and his Holiness.

WHILST I continued to go on with the work, and at the same time did business for the Mint, certain false coins impressed with my dies appeared in Rome, which my enemies immediately carried to the Pope, endeavouring to fill him with new suspicions to my prejudice. The Pope ordered Giacopo Balducci, master of the Mint, to use his utmost endeavours to discover the offender, that my innocence might be manifest to the whole world. This treacherous man

being my sworn enemy, said—"God send, most holy father, that it may turn out as you say, and that we may have the good fortune to detect the criminal." The Pope thereupon turned about to the governor of Rome, and ordered him to exert all his diligence to discover the delinquent. At the same time his Holiness sent for me, and with great art and address entering upon the affair of the false coins, said—"Benvenuto, do you think you could find in your heart to make counterfeit money?" I answered, that "I thought myself much better able to counterfeit coins, than the low fellows that were generally guilty of that crime: for," added I, "the men who commit such offences are not persons of any great genius, that can gain much by their business. Now, if I with my slender abilities make such profits that I have always money to spare, (for when I made the irons for the Mint, I every day before dinner gained at least three crowns, so much being always paid me for those instruments; but the stupid master of the Mint hated me, because he fain would have reduced them to a lower price,) what I gain with the favour of God and man is enough for me, without resorting to the infamous and less profitable trade of false coining." The Pope gave a particular attention to what I said, and though he had previously ordered that care should be taken to prevent my quitting Rome, he now commanded his attendants to make a diligent inquiry after the delinquent, but to take no farther notice of me, lest I should be offended, and he might perhaps lose me. Certain ecclesiastics having made a proper inquiry, soon discovered the criminal. He was a stamper of the Mint, named Cesare Maccheroni, a Roman citizen, and with him was taken another officer belonging to the Mint.

Happening just about this time to pass by the square of Navona with my fine shock-dog, as soon as I came to the door of the city marshal, the dog barked very loudly and flew at a young man, who had been arrested by one Donnino, a goldsmith of Parma, formerly a disciple of Caradosso, upon suspicion of having committed a robbery. My dog made such efforts to tear this young fellow to pieces, that he roused the city-guards. The prisoner asserted his innocence boldly, and Donnino did not say so much as he ought to have done, especially as I was present. There happened likewise to be by one of the chief officers of the city-guards, who was a Genoese, and well acquainted with the prisoner's father; insomuch that on account of the violence offered by the dog, and for other reasons, they were for dismissing the youth, as if he had been innocent. As soon as I came up, the dog, which dreaded neither swords nor sticks, again flew at the young man. The guards told me that if I did not keep off my dog, they would kill him. I called off the dog with some

difficulty, and as the young man was retiring, certain little paper bundles fell from under the cape of his cloak, which Donnino immediately discovered to belong to him. Amongst them I perceived a little ring which I knew to be my property: whereupon I said, "This is the villain that broke open my shop, and my dog knows him again." I therefore let the dog loose, and he once more seized the thief, who then implored my mercy, and told me he would restore me whatever he had of mine. On this I again called off my dog, and the fellow returned me all the gold, silver, and rings that he had robbed me of, and gave me five-and-twenty crowns over, imploring my forgiveness. I bade him pray for the Divine mercy, as I, for my part, did not intend to do him either harm or good. I then returned to my business, and in a few days after, Cesare Maccheroni the forger was hanged in the quarter called Banchi, opposite to the gate of the Mint: his accomplice was sent to the galleys. The Genoese thief was hanged in the Campo di Fiore, and I remained possessed of a greater reputation for probity than ever.

When I had at last finished my work, there happened a great inundation, which overflowed the whole city.* As I was waiting the issue, the day being far spent, the waters began to increase. The fore part of my house and shop was in the quarter of Banchi, and the back part jutted out several cubits towards Monte Giordano. Making the preservation of my life my first care, and my honour the next, I put all my jewels in my pockets, left my work in gold under the care of my journeymen, and taking off my shoes and stockings, went out at a back window, and waded though the water as well as I could, till I reached Monte Cavallo. There I found Signor Giovanni Gaddi, a clerk of the chamber, and Bastiano, the Venetian painter. Accosting Signor Giovanni, I gave him all my jewels to take care of, knowing he had as great a regard for me as if I had been his brother. A few days after, the waters having subsided, I returned to my shop, and finished my work with the help of God and by my own industry so happily, that it was looked upon as the most exquisite performance of the kind that had ever been seen in Rome.† Upon

* On the authority of Lodovico Comesio, this was the twenty-third inundation of the Tiber, on the 8th and 9th of October, 1530. It was so sudden and violent, that many persons were unable to escape, and bridges with the strongest buildings were in a few hours overwhelmed and washed away. The most extraordinary fact attending it was the perfect mildness of the weather, no rains having fallen for some time previous. See the same author, " De Prodigiosis Tyberis inundat. Rome, 1531."

† This pontifical button, so much praised by Vasari, has been religiously preserved in the Castle of St. Angelo, and is brought out with the diadem in legal form, in commemoration of the Passover, Christmas-day, and St. Peter's, when the Pope himself chants mass. There is a more particular account of it in his "Oreficeria," chap. v.

carrying it to the Pope, I thought he would never have been tired of praising it. "If I were a great and opulent emperor," said he, "I would give my friend Benvenuto as much land as his eye could take in; but as I am only a poor little potentate, I will endeavour to make such a provision for him, as will satisfy his moderate desires." After the Pope had made an end of his rodomontade, I asked him for a mace-bearer's place which was just then become vacant: he made answer that it was his intention to give me a much more considerable employ. I again desired his Holiness to grant me that other trifling post by way of earnest. He replied with a laugh, that he was willing to gratify me, but did not choose I should serve with the common mace-bearers. He advised me therefore to make it my agreement with them to be exempt from attendance; and to get me excused, he would grant them a favour, for which they had applied to him, viz. to be allowed to demand their salaries by authority: which was accordingly done. This place of mace-bearer brought me to the amount of above two hundred crowns a year.*

Whilst I continued in the service of the Pope, sometimes employed by him in one way, sometimes in another, he ordered me to draw a fine chalice for him; and I accordingly sketched out a design and model of such a cup.† This model was of wood and wax; instead of the boss of the chalice, I had made three little figures of a pretty considerable size, representing Faith, Hope, and Charity: upon the foot of it, I represented the stories relative to those figures on three bosses in basso rilievo: on one was the nativity of Christ, on another the resurrection, on a third St. Peter crucified with his head downwards—for in that attitude I was ordered to draw him.

During the progress of this work, the Pope several times desired to see it; but finding that his Holiness had quite forgotten to give me any preferment, the place of one of the fraternity del Piombo (the seal-office) being vacant, I one evening asked him for it. The good Pope, no longer recollecting the florid harangue he had made upon my finishing the other work, answered me thus: "The place you ask has annexed to it a salary of above eight hundred crowns a-year, so that if you were to have it you would think of nothing afterwards

* The very learned Marini informs us that Cellini was preferred to the College of Mazzieri, or Mace-bearers, on the 14th of April, 1531, and that he gave up the office in favour of Pietro Cornaro, of Venice, in 1535. The Mazzieri were a sort of state sergeants, who preceded the Pope with the Apostolical arms, bearing rods like the ancient lictors.—See Archiatri Pontifici.

† The celebrated Mariette, in his copy of this Life, which formerly belonged to the distinguished painter Signor Bossi, secretary to the Academy of Fine Arts, in Milan, wrote here on this passage: "I have this beautiful design now in my possession."

but indulging yourself, and pampering your body; thus you would entirely forget that admirable art, of which you are at present so great a master, and I should be condemned as the cause of it." I instantly replied, "that good cats mouse better to fatten themselves, than merely through hunger; and that men of genius exert their abilities always to most purpose when they are in affluent circumstances; insomuch that those princes, who are most munificent to such men, may be considered as encouraging, and, as it were, watering the plants of genius: left to themselves they wither and die away—it is encouragement alone that makes them spring up and flourish. I must however inform your Holiness," added I, "that I did not petition for this preferment, expecting to have it granted me; I looked upon myself as happy, getting the poor place of macebearer: it was only a transient thought that just came into my head. You will do well to bestow it upon some man of genius that deserves it, and not upon an ignorant person, who will make no other use of it but to pamper his body, as your Holiness expresses it. Take example of Pope Julius, of worthy memory, who gave such a place to Bramante*, an ingenious architect." Having spoken thus I made him a low bow, and took my leave.

Bastiano, the Venetian painter, then coming forward, said to him, "Most holy father, please to give this place to some person that exerts himself in the ingenious arts; and as your Holiness knows me to have dedicated my time to those studies, I humbly request you would think me worthy of that honour." The Pope made answer, "This devil Benvenuto cannot bear a word of rebuke: I did intend to bestow the place upon him; but it is not right to behave so proudly to a Pope: I therefore do not know how I shall dispose of it." The bishop of Vaison suddenly coming forward, took Bastiano's part, and said, "Most holy father, Benvenuto is a young man, the sword becomes him much better than the monk's habit: please your Holiness to bestow it upon this ingenious man, Bastiano, and you may

* Donato Lazzari, surnamed Bramante, was born near Urbino, in the year 1444. After making a surprising progress in painting and architecture, he went to Milan, in 1476, to study the building of the Duomo, which then employed some of the most distinguished artists. He met with the patronage of Gio. Galeazzo, and of Lodovico and Ascanio Sforza, and engaged in several noble works, remaining at Milan until 1499. He thence went to Rome, enriching his genius, and improving his style upon the models of antiquity. In Julius II. he found a patron who knew how to appreciate noble works; engaged him in numerous designs, both as an artist and an architect; and availed himself of his knowledge as a military engineer. Being chosen architect for one of the grandest churches in the world, he made the design, and proceeded with the work. But the architects who succeeded him almost entirely changed the plan, leaving few traces of Lazzari's own design. Of the most engaging manners, he was everywhere loved and respected. He was also a good poet and musician. He died at Rome, 1514.

give Benvenuto some other lucrative place which will suit him better." The Pope then turning about to Signor Bartolomeo Valori, said to him, "How much too hard you are for Benvenuto! Tell him that he himself was the cause of the place he applied for being given to Bastiano, the painter; and that he may depend upon it, he shall have the first lucrative post that becomes vacant: in the mean time desire him to exert himself, and finish my business."

The evening following, at two hours after sunset, I happened to meet Signor Bartolomeo Valori* hard by the Mint, as he was driving on precipitately with two torches before him, being sent for by the Pope: upon my bowing to him, he called out to me, and in the most friendly manner told me all that his Holiness had said. I answered, that I would finish the work I had in hand with greater diligence than I had shown on any other occasion, but without hopes of being recompensed by his Holiness. Signor Bartolomeo thereupon reprimanded me, adding, that I should not receive the offers of a Pope in that manner. I replied, that if I were to depend upon such promises before they took effect, I should be a fool, and so I went about my business. Signor Bartolomeo doubtless informed the Pope of my bold answer, and in all probability added something to it; for it was two months before his Holiness sent for me, and during all that time I would not go to court upon any account.

At length the Pope, becoming quite impatient for my finishing the chalice, gave orders to Signor Ruberto Pucci to inquire what progress I had made. This worthy man every day paid me a visit, and constantly said something kind and obliging to me, which I returned with the like courtesy. His Holiness being upon the point of leaving Rome to go to Bologna, when he found that I never thought of going near him, sent of his own accord Signor Ruberto to desire me to bring my work, for he wanted to see how far I had proceeded. I took it with me, and showed his Holiness that the most important part of the work was finished, but requested him to advance me five hundred crowns, partly on account, and partly to buy some more gold, which was wanting to complete the chalice. The Pope said, "Make haste and finish it." I answered in going away, "That I would obey him, if he would leave me money," and so took my leave.

* Baccio, or Bartolomeo Valori, a Florentine, and a devoted friend to the house of Medici, was the commissary of Clement VII. to the Prince of Orange, at the siege of Florence. After succeeding in this design, Baccio, naturally of a restless and dissipated turn, in want of money, and thinking his services unduly appreciated (disappointed of a cardinal's hat), by degrees forsook his party, and at length entered into the conspiracy of Filippo Strozzi. Shortly afterwards he was apprehended, and beheaded in Florence, together with his son and a nephew, in 1537, without being lamented by any party.

The Pope set out for Bologna*, leaving cardinal Salviati his legate in Rome, and ordered him to hurry me on with the work, expressing himself in these words, "Benvenuto is a man that sets but little value upon his abilities, and less upon me; so be sure you hurry him on, that the chalice may be finished at my return." This stupid cardinal sent to me in about eight days, ordering me to bring my work with me; but I went to him without it. As soon as I came into his presence, he said to me, "Where is this fantastical work of yours? Have you finished it?" I answered, "Most reverend sir, I have not finished my fantastical work, as you are pleased to call it, nor can I finish it, unless you give me wherewithal to enable me." Scarce had I uttered these words, when the cardinal, whose physiognomy was more like that of an ass than a human creature, began to look more hideous than before, and immediately proceeding to abusive language, said, "I'll confine you on board of a galley, and then you will be glad to finish the work." As I had a brute to deal with, I used the language proper on the occasion, which was as follows: "My lord, when I shall be guilty of crimes deserving the galleys, then you may send me thither; but for such an offence as mine, I am not afraid. Nay, I will tell you more; on account of this ill treatment, I will not finish the work at all; so send no more for me, for I will not come, unless I am dragged hither by the city-guards." The foolish cardinal then tried by fair means to persuade me to go on with the work in hand, and to bring what I had done, that he might examine it. In answer to all his persuasions, I said, "Tell his Holiness to send me the materials, if he would have me finish this fantastical work;" nor would I give him any other answer, insomuch that despairing of success, he at last ceased to trouble me with his importunities.

The Pope returned from Bologna, and immediately inquired after me, for the cardinal had already given him by letter the most unfavourable account of me he possibly could. His Holiness being incensed against me to the highest degree, ordered me to come to him with my work, and I obeyed. During the time he was at Bologna, I had so severe a defluxion upon my eyes, that life became almost insupportable to me, which was the first cause of my not proceeding with the chalice. So much did I suffer by this disorder, that I really thought I should lose my eyesight; and I had computed how much

* On the 18th November, 1532, Pope Clement set out for Bologna, to have an interview with the Emperor Charles V. He had before performed the journey in 1529, for the purpose of crowning him; but judging from a comparison of dates and previous circumstances, of which the exact period is made clear, the journey here mentioned must be that of 1532.

would be sufficient for my support when I should be blind. On my
way to the palace I meditated within myself an excuse for discon-
tinuing the work, and thought that whilst the Pope was considering
and examining my performance, I might acquaint him with my case;
but I was mistaken, for as soon as I appeared in his presence he said
to me, with many unbecoming words, "Let me see that work of
yours: is it finished?" Upon my producing it he flew into a more
violent passion than before, and said, "As there is truth in God,
I assure you, since you value no living soul, that if a regard to
decency did not prevent me, I would order both you and your work
to be thrown this moment out of the window." Seeing the Pope
thus transformed to a savage beast, I was for quitting his presence
directly; and, as he continued his bravadoes, I put the chalice under
my cloak, muttering these words to myself,—"The whole world
would prove unable to make a blind man proceed in such an under-
taking as this." The Pope, then, with a louder voice than before,
said,—"Come hither: what is that you say?" For a while I hesitated,
whether I should not run down stairs. At last I plucked up my
courage, and, falling on my knees, exclaimed as loud as I could (be-
cause he continued to bawl), "Is it reasonable that when I am become
blind with a disorder, you should oblige me to continue to work?"
He answered, "You could see well enough to come hither, and I
don't believe one word of what you say." Observing that he spoke
with a milder tone of voice, I replied, "If your Holiness will ask your
physician, you will find that I declare the truth."—"I shall inquire
into the affair at my leisure," said he. I now perceived that I had an
opportunity to plead my cause, and therefore delivered myself thus:
"I am persuaded, most holy father, that the author of all this mis-
chief is no other than Cardinal Salviati; because he sent for me im-
mediately upon your Holiness's departure, and, when I came to
him, called my work a fantastical trifle, and told me he would make
me finish it in a galley. These opprobrious words made such an im-
pression on me, that through the great perturbation of mind I was
in, I felt my face all on a sudden inflamed, and my eyes were at-
tacked by so violent a heat, that I could hardly find my way home.
A few days after there fell upon them two cataracts, which blinded
me to such a degree, that I could hardly see the light, and since your
Holiness's departure I have not been able to do a stroke of work."
Having spoken thus, I rose up and withdrew. I was told that the
Pope said after I was gone, "When places of trust are given, dis-
cretion is not always conveyed with them. I did not bid the cardinal
treat people quite so roughly: if it be true that he has a disorder

in his eyes, as I shall know by asking my physician, I should be inclined to look upon him with an eye of compassion."

There happened to be present a person of distinction, who was a great favourite of the Pope, and equally conspicuous for his virtues and extraordinary endowments. Having inquired of the pontiff who I was, he added, "Holy father, I ask you this, because you appeared to me, in the same breath, to fall into a most violent passion, and to be equally affected and softened into pity, so I desire to know who he is: if he be a person deserving of assistance, I will tell him a secret to cure his disorder." The Pope made answer,—"The person you speak of is one of the greatest geniuses, in his way, that the world ever produced. When I see you again I will show you some of his admirable performances, as likewise the man himself; and it will be a great satisfaction to me, if you are able to do him any service."

In a few days the Pope sent for me after dinner, and the above-mentioned person of distinction was present. No sooner was I come, than his Holiness sent for the button of his pontifical cope, which has been already described. In the mean time I produced my chalice; upon seeing which, the gentleman declared he had never beheld so extraordinary a piece of work in his life. The button being brought, his surprise was greatly increased: he looked at me attentively and said, "He is but a young man, and therefore the better able to make a fortune." He then asked me my name. I told him it was Benvenuto. He replied, alluding to my name, "Upon this occasion I am *welcome* to you: take lily of the valley its stalk, flower, and beard altogether, distill them with a gentle fire, bathe your eyes with the water several times a-day, and you will certainly get rid of your complaint; but before you begin the bathing, take physic." The Pope spoke kindly to me, and I left him, tolerably well pleased with my reception.

My disorder, which was of a serious kind, contracted at the time of the robbery, had remained latent for above four months, and then broke out at once. The only external symptom by which it showed itself was, by covering me all over with little red blisters, about the size of a farthing. The physicians would never call this malady by its right name, though I told them the causes to which I ascribed it. They continued to treat me in their own way, but I received no benefit from their prescriptions. At last I resolved, contrary to the advice of the most eminent physicians of Rome, to have recourse to lignum vitæ. This I took with all the precautions and abstinence imaginable, and recovering surprisingly, in the space of fifty days was perfectly cured, and as sound as a roach. Then, by way of recreation after what I had gone through, winter approach-

ing, I took the diversion of fowling: this made me wade through brooks, face storms, and pass my time in marshy grounds; so that in a few days I was attacked by a disorder a hundred times more severe than the former. I put myself a second time into the hands of physicians, and found I grew worse every day by their medicines. My disorder being attended with a fever, I proposed to take lignum vitæ, but the physicians opposed it, assuring me that if I meddled with it whilst the fever was upon me, I should die in a week. I resolved, however, to take it, even against their opinion, observing the same regimen as before. After I had for four days drunk the decoction of lignum vitæ, the fever totally left me, and I began to recover surprisingly.

Whilst I was taking this wood, I went on with the model of the work above mentioned, and abstinence sharpening my invention, I performed the finest things and of the most admirable invention that I ever did in my life. In fifty days I was perfectly recovered, and afterwards gave my chief attention to the preservation of my health. This long course of medicine being at last over, I found myself as thoroughly cured of my disorder as if I had been new born; and though I took pleasure in securing my much wished-for health, I continued to labour both on the work above mentioned, and for the Mint; and did as much as could reasonably be expected from the most diligent artificer.

CHAPTER XII.

Tobbia, the goldsmith of Milan, who had been condemned to death at Parma for counterfeiting the current coin, is reprieved by cardinal Salviati, legate of that city.—The cardinal sends him to Rome as an ingenious artist, capable of rivaling our Author.—Tobbia is employed by the Pope, which gives Cellini great uneasiness.—In consequence of the calumnies of Pompeo of Milan, Cellini is deprived of his place of engraver to the Mint.—He is arrested for refusing to deliver up the chalice, and carried before the governor of Rome.—Curious conversation between him and that magistrate.—The latter by an artifice persuades him to deliver up the chalice to the Pope, who returns it to the Author, and orders him to proceed with the work.

CARDINAL SALVIATI, with whom I had the difference above related, and who was so much my enemy, happened about this time to be made legate of Parma, when a certain Milanese goldsmith, named Tobbia, was taken up in that city for counterfeiting the current coin. Upon his being condemned to the flames, a great man spoke in his

favour to the legate. The cardinal caused the execution to be respited, and wrote to Pope Clement, giving him to understand that there had fallen into his hands one of the ablest artists living in the goldsmith and jeweller's business, and that he had been condemned to be burnt for coining, but that he was a mere simpleton: this appeared by his saying he had asked the opinion of his confessor, who told him he gave him permission, and that he might do it with a safe conscience. He added, "If your Holiness should send for this great artist to Rome, you will have the means of humbling the pride of your favourite Benvenuto, and I make no doubt but the workmanship of Tobbia will please you much more than that of Benvenuto."

The Pope was accordingly induced by the legate's persuasion to send for this person to Rome, and upon his arrival ordered us both into his presence. He then commanded each of us to draw a design for setting an unicorn's horn*, the most beautiful that ever was seen, and which had cost 17,000 ducats: and as the Pope proposed making a present of it to King Francis, he chose to have it first richly adorned with gold: so he employed us both to draw the designs.†

When we had finished them, we carried them to the Pope. Tobbia's design was in the form of a candlestick; the horn was to enter it like a candle, and at the bottom of the candlestick he represented four little unicorns' heads—a most simple invention. As soon as I saw it I could not contain myself so as to avoid smiling at the oddity of the conceit. The Pope perceiving this, said, "Let me see that design of yours." It was a single head of an unicorn, fitted to receive the horn. I had made the most beautiful sort of head conceivable, for I drew it partly in the form of a horse's head, and partly in that of a hart's, adorned with the finest sort of wreaths and other devices; insomuch that no sooner was my design seen but the whole court gave it the preference. However, as some Milanese gentlemen of great authority were witnesses of this contest, they said "Most holy father, if you propose sending this noble present to France, you should take it into consideration that the French are an undiscerning, tasteless people, and will not be sensible of the excellence of this

* An animal hitherto supposed by naturalists to be fabulous. It has a single horn, but the numerous horns we often see attributed to it (as fabulous as the animal itself) are either horns of other well-known animals, or fishes' teeth, or the work of ingenious artists.—*Carpani.*

From all we hear of the fine specimen of the Unicorn's head—an unique we suppose, now in London—the Italian Commentator will soon be obliged to change his tone, and to believe in more things than he has "dreamed of in his philosophy." —Ed.

† In October, 1533, Clement VII. went to Marseilles to hold a conference with Francis I., and Jovius relates that, on that occasion, the two sovereigns vied with each other in the splendour and magnificence of their respective courts.

masterly piece of Benvenuto's. But they will be pleased with these grotesque figures of Tobbia's, which will be sooner executed; and Benvenuto will in the mean time finish your chalice: thus will two works be completed at once, and this poor man will be employed, without having reason to complain that he has been brought hither for nothing." The Pope, who was in haste to have his chalice finished, readily acquiesced in the opinion of these Milanese; so the day following he gave the unicorn's horn to Tobbia, and sent me word by his wardrobe-keeper that I was to finish his chalice.

I made answer, that there was nothing I more ardently desired than to complete the fine piece of work I was about; adding, that if it were to be made of any other materials than gold I could easily finish it myself, and that without assistance; but that his Holiness must now supply me with more gold. Scarce had I uttered these words, when this man, a low retainer to the court, bid me take care how I asked money of the Pope: if I did, I should put him into such a passion, that I should afterwards repent it. To this I replied, "Then, good sir, please to inform me how bread can be made without flour; just in the same manner can this work be finished without gold." The wardrobe-keeper, who felt the keenness of the ridicule, told me he would inform his Holiness of all I had said, and was as good as his word. The Pope, flying into a most furious passion, said, he would see whether I was mad enough to neglect finishing it. He waited, however, two months, during which, though I had declared I would not work a single stroke, I had done quite the reverse, and wrought constantly with the utmost diligence; the Pope, however, finding I did not bring the chalice, began to be greatly out of temper, and declared that he was resolved to punish me.

There was present, when he uttered these words, a Milanese, his Holiness's jeweller: his name was Pompeo, and he was a near relation of one Signor Trajano, who of all Pope Clement's servants was most in his master's favour. These two in concert said to the Pope, "If your Holiness were to deprive him of his place in the Mint, perhaps he would think of finishing the chalice." The Pope replied, "That would rather be productive of two misfortunes— one that I should be ill served at the Mint, which is of the greatest consequence to me, the other that I should certainly never see the chalice." The two Milanese, however, seeing the Pope very angry with me, used such persuasions, that at last he deprived me of my place in the Mint, and gave it to a young Perugian, who had the surname of Fagiolo.* Pompeo came to tell me from the Pope that

* Vasari frequently speaks of a certain Girolamo Fagiuoli, goldsmith and sculptor, much distinguished about this period, but styles him of Bologna, not of Perugia.

his Holiness had removed me from my place in the Mint, and would deprive me of something else, if I did not make haste to finish my work. "Tell his Holiness," answered I, "that he deprives himself and not me of the place in the Mint; that the case would be the same with respect to other matters; and that if his Holiness should be ever so desirous to restore my place to me, I would upon no account accept of it."

This vile wretch thought it an age till he could see the Pope again, in order to repeat to him every word I said, to which he took care to add something of his own. About a week after, the Pope sent me word by the same messenger, that he no longer desired I should finish the chalice, but wanted to have it exactly in the state to which I had brought it. I answered, "Pompeo, this is not like the place in the Mint, which it was in his power to deprive me of: five hundred crowns, which I received, are indeed his Holiness property, and those I will restore to him; as for the work, it is mine, and that I will dispose of as I think proper." Pompeo hastened to repeat this to the Pope, with some severe and sarcastical expressions, which I threw out against himself, and which he well deserved.

Three days after, upon a Thursday, there came to me two of the Pope's favourite gentlemen of the bedchamber, one of whom is now living, and a bishop. This was Signor Pier Giovanni, wardrobe-keeper to his Holiness; the other was of a still more noble family, but I cannot recollect his name. As soon as they entered my house, they addressed me thus; "The Pope sends us, Benvenuto, because you have trifled with him, and would not be prevailed on by fair means: we have orders, in case you do not give us the chalice, to conduct you directly to prison." I looked them in the face boldly, and said, "Gentlemen, were I to give his Holiness my work, I should give him my property, and not his, and I do not intend to part with any thing that is mine; for, as I have brought this piece to a high degree of perfection with the sweat of my brow, I do not choose that it should be put into the hands of some ignorant fellow, who will probably spoil it."

The goldsmith, Tobbia, was present, who was so rash as to require of me the models of my work: the words with which I answered him, and which such a wretch well deserved, it would not be proper here to insert. As the gentlemen of the bedchamber pressed me to determine what I intended to do, I told them that I had already determined; and having taken my cloak, before I went out of the shop, I turned to an image of Christ, and said with the utmost reverence and devotion, holding my cap in my hand, "Merciful and immortal, just and holy Lord, all that thou dost is according to thy

justice which is not to be equalled; thou knowest that I am arrived at maturity of years, and that I was never before threatened with imprisonment for any action whatever; since it is now thy pleasure that I should go to gaol, I submit, and thank thee with a heart resigned." Then turning about to the two gentlemen, I said to them with a smile, which did not entirely conceal some perturbation of mind, "Surely, gentlemen, a man of my consequence well deserved such a guard as you; therefore put me between you, and conduct me wheresoever you think proper."

These two well-bred gentlemen, laughing very heartily, placed me between them, and chatting all the way, carried me before the governor of Rome, whose name was Magalotti*: there was with him the procurator of the Exchequer, and both waited my coming. The gentlemen laughing all the while, said to the governor, "We consign this prisoner to you: be sure to take proper care of him. We are very glad that we have saved your officers some trouble, for Benvenuto told us, that as this was the first time of his being arrested, meaner guards would have been unworthy of him." They repaired to the Pope, and having given him a circumstantial account of all that passed, he at first seemed to be ready to fly into a passion, but upon recollecting himself forced a smile, because there were present some noblemen and cardinals my friends, who were very much inclined to favour me. In the mean time the governor and the procurator partly rated, partly expostulated with me, and partly gave me their advice, telling me, "That it was but just and reasonable that he who employs another in any work whatever, should take it back when and in what manner he thinks proper." I made answer, "That this was not agreeable to justice, and that a Pope had no right to act in that manner; because his Holiness was not like those petty tyrants who oppress their subjects to the utmost, paying no regard either to law or justice; but he was Christ's vicar, and therefore was not allowed to pursue the same measures." The governor, in a tone and manner which might become a bailiff, cried out, "Benvenuto, Benvenuto, you will at last oblige me to use you according to your deserts." "If so," replied I, "you will behave honourably and politely to me; since I deserve no less." He then said, "Send for the work

* Gregorio Magalotti was a great favourite of Pope Clement, who gave him the bishopric of Lipari in 1532, and soon after that of Chiusi. He exercised the severest discipline in his office of governor, so as to be in frequent danger of assassination. He had the government of Romagna under Paul III. as well as the embassy at Bologna, where he died in 1537. He published "A Treatise upon the nature of Passports and Safe Conducts."—C.

A very important consideration for Heretics and Ambassadors about that period. —Ed.

directly, and don't make me speak to you a second time." I thereupon rejoined: "Gentlemen, do me the favour to permit me to say but four words more in my defence." The procurator of the Exchequer*, who was a more humane magistrate than the governor, turned about to the latter, and said to him: "My lord, indulge him in a hundred words; provided he returns the work, that is sufficient." I then delivered myself in these terms: "If a man were to build a house or a palace, he might justly say to the mason employed in that business, give me my house; I don't choose you should work any longer at my palace or my habitation; and, upon paying the mason for his trouble, he would have a just right to dismiss him. If it were even a nobleman, who gave directions for setting a jewel worth a thousand crowns, and if he perceived that the jeweller did not do it to his mind, he might say, give me my jewel, for I don't approve of your workmanship. But the present case is quite different; for neither a house nor a jewel is here in question; nothing more can be required of me but that I should return five hundred crowns, which I have received. So, my lord, do what you will, you shall have nothing more than the five hundred crowns, and this you may tell the Pope. Your menaces do not in the least intimidate me, for I am an honest man, and fear God only."

The governor and procurator of the Exchequer having risen from their seats, said, they were going to his Holiness, and that when they had received his orders, they would return to my sorrow. Thus I remained under a guard. I walked about in a little hall, and it was near three hours before they returned. Upon this occasion I was visited by all the chief men of our country in the mercantile way, who earnestly entreated me not to contend with a Pope, as my ruin might very likely be the consequence. I made answer, that I had maturely considered the measures I was pursuing.

As soon as the governor returned with the procurator of the Exchequer, he called to me and said, "Benvenuto, I am sorry to come back from his Holiness with so severe an order; either quickly produce the chalice, or beware of the consequences." I made answer, that as I could never persuade myself that a vicar of Christ was capable of doing injustice, I would not believe it till I saw it; so that he might do whatever he thought proper. The governor replied. "I have two words more to say to you from his Holiness, after which I shall proceed to execute my orders. It is the Pope's pleasure you

* Benvenuto Valenti was at this time procurator of the Exchequer and a friend of Magalotti, whose works he printed. He was a celebrated collector of ancient statues, of which he made a grand display in his native place of Trevi.—See Ughelli and Tiraboschi.

shall bring your work hither, that I may get it put into a box, and then I am to carry it to his Holiness, who promises upon his word to keep it sealed up as he receives it, and will quickly return it to you without ever meddling with it; but he requires that this should be complied with, as his honour is concerned in the affair." To these words I answered smiling, that I would very readily put my work into his hands in the manner he required, because I was desirous to know what dependence there could be upon the faith of a Pope.

Accordingly, having sent for my work, I put it into his hands, sealed up in the manner required. The governor having returned to the Pope with the box sealed up as above, his Holiness, after turning it several times, as I was afterwards informed by the governor, asked the latter if he had seen my work? He answered that he had, and it had been sealed up in his presence; adding, that it appeared to him a very extraordinary performance. Upon which the Pope said, "You may tell Benvenuto, that Roman Pontiffs have authority to loose and bind things of much greater importance than this;" and whilst he uttered these words, he with an angry look opened the box, taking off the cord and the seal. He then examined it attentively, and, by what I could learn, showed it to Tobbia, the goldsmith, who praised it highly. The Pope asked him whether he would undertake to make a piece of work in the same taste, and according to the same model. The other answered he would. The Pope desired him to follow that model exactly; and, turning to the governor, spoke to him thus: "See whether Benvenuto is disposed to let us have it in its present condition: in case he is ready to comply, he shall be paid for it, whatever price it may be valued at by any intelligent person. If he is willing to finish it, let him take his own time, and give him whatever assistance he can reasonably require." Hereupon the governor answered, "Most holy father, I am acquainted with the audacious character of this young man: grant me authority to deal sharply with him in my own way." The Pope replied, that he gave him full liberty as to words, though he was sure he would only make the breach wider; adding, that when he found all ineffectual, he should order me to carry the five hundred crowns to his jeweller Pompeo.

The governor being returned sent for me to his apartment, and addressed me thus with the bluff air of a grenadier: "Popes have authority to loose and bind the whole world; and what they do in this manner upon earth, immediately receives the sanction of heaven: here is your box, which has been opened and examined by his Holiness." I then loudly exclaimed, "I return thanks to heaven that I am now qualified to set a proper value on the word of God's vice-

gerent." The governor thereupon offered me many gross insults, both in word and deed; but perceiving that all his brutality had no effect, he quite despaired of success in what he had undertaken, namely, to browbeat me into compliance: he, therefore, assumed a milder tone, and said to me, "Benvenuto, I am sorry you are blind to your own interest; since that is the case, carry the five hundred crowns to Pompeo when you think proper."

Having taken back the box, I went directly to Pompeo with the five hundred crowns. The Pope thought that, either through inability or some other accident, I should not carry the money quite so soon; but as he had still a great desire to get me again into his service, when he saw Pompeo come smiling with the money, he began to rate him soundly, and expressed great concern that the affair had taken such a turn. He then said to him, "Go to Benvenuto's shop, behave with as much complaisance to him as your stupidity and ignorance will permit, and tell him, that if he will finish that piece of work, to serve as a shrine for carrying the holy sacrament in, when I walk in procession with it, I will grant him whatever favour he desires of me." Pompeo came and called me out of the shop, and behaving to me with a great deal of awkward ceremony and grimace, repeated all the Pope had said to him. I immediately made answer, "that the highest pleasure I could wish for in this world, was to recover the favour of so great a Pontiff, which I had lost not by any fault of my own, but by sickness and misfortune; as also by the ill offices of those envious persons who take pleasure in injuring their neighbours. But, as his Holiness has a great number of servants," I continued, "let him no more send you to me, if he values your life; and be sure you mind your own business. I shall never cease by day or night to think and do all I can to serve the Pope; but remember that you have spoken ill of me to his Holiness, and never interpose any more in what concerns me: if you do, I will make you sensible of your error, by treating you according to your deserts." The fellow having left me, repeated every word I had said to the Pope, but misrepresented it in such a manner as to make me appear in a much worse light than I otherwise should have done. Here the affair rested for a time, and I again attended to my shop and business.

During this interval, Tobbia, the goldsmith, was employed in finishing the case and ornament for the unicorn's horn: the Pope had given him orders when he had finished that piece, to begin the chalice upon my model, which he had seen. Tobbia having shown his Holiness some specimens of his work, the latter was so little satisfied with them, that he began to repent his having ever differed

with me, and expressed great dislike for the man's workmanship, highly censuring the person who had recommended him: in consequence of which, Baccino della Croce often came to me from the Pope, desiring me to make the shrine in question. I told him that I entreated his Holiness to let me take my repose a little after the severe disorder with which I had been afflicted, and from which I was not yet thoroughly recovered, and that as soon as ever I was in a condition to work, I would devote all my hours to his Holiness's service. I had now begun to draw his likeness, and was employed in secret to engrave a medal for him.* The tools of steel for stamping the medal, I made at home; in my shop I had a partner, who had been my journeyman, and whose name was Felice.†

CHAPTER XIII.

The Author falls in love with a Sicilian courtezan, named Angelica, who is suddenly obliged by her mother to withdraw to Naples.—His despair upon the loss of his mistress.—He gets acquainted with a Sicilian priest, who professes necromancy.—Account of the magical spells used by the necromancer.—The Author attends the priest's incantations, in hopes of recovering his mistress.—Surprising effects of the conjuration.—He receives a promise of seeing Angelica in a month. —Quarrel between him and signor Benedetto, whom he dangerously wounds with a stone.—Pompeo of Milan representing to the Pope, that the Author had killed Tobbia of Milan, his Holiness orders the governor of Rome to get him apprehended, and executed upon the spot.—He makes his escape, sets out for Naples, and meets his friend Solosmeo, the sculptor, on the road.

ABOUT this time I fell in love, as young men are apt to do. The object of my passion was a Sicilian girl, of extraordinary beauty, who seemed to repay my attachment with an equal ardour. Although we concealed our mutual regard from her mother, the old lady perceived it, and was apprehensive of the consequences. I had indeed formed a design to run away with the girl to Florence, and stay there a year with her, unknown to her mother. The latter being apprised of my intention, quitted Rome one night with her daughter, and having taken the road to Naples, gave out that she was going to Civita Vecchia, but went to Ostia. I followed them to Civita Vecchia, and committed innumerable extravagancies in search of my mistress. It would be tedious to give a circumstantial account of all these

* This is the medal of Peace, of which there is farther mention.
† Felice Guadagni, one of Cellini's most intimate friends, as will hereafter appear.

follies; let it suffice to say, that I was upon the point of losing my senses or dying of grief.

Two months after, the girl wrote me word that she was in Sicily, extremely unhappy. I was then indulging myself in pleasures of all sorts, and had engaged in another amour to cancel the memory of my Sicilian mistress. It happened, through a variety of odd accidents, that I made acquaintance with a Sicilian priest, who was a man of genius, and well versed in the Latin and Greek authors. Happening one day to have some conversation with him upon the art of necromancy, I, who had a great desire to know something of the matter, told him, that I had all my life felt a curiosity to be acquainted with the mysteries of this art. The priest made answer, "that the man must be of a resolute and steady temper who enters upon that study." I replied, "that I had fortitude and resolution enough, if I could but find an opportunity." The priest subjoined, "If you think you have the heart to venture, I will give you all the satisfaction you can desire." Thus we agreed to undertake this matter.

The priest one evening prepared to satisfy me, and desired me to look out for a companion or two. I invited one Vincenzio Romoli, who was my intimate acquaintance: he brought with him a native of Pistoia, who cultivated the black art himself. We repaired to the Colosseo, and the priest, according to the custom of necromancers, began to draw circles upon the ground with the most impressive ceremonies imaginable: he likewise brought thither assafœtida, several precious perfumes, and fire, with some compositions which diffused noisome odours. As soon as he was in readiness, he made an opening in the circle, and having taken us by the hand one by one, he placed us within it. Then having arranged the other parts and assumed his wand, he ordered the other necromancer, his partner, to throw the perfumes into the fire at a proper time, entrusting the care of the fire and the perfumes to the rest, and began his incantations. This ceremony lasted above an hour and a half, when there appeared several legions of devils, insomuch that the amphitheatre was quite filled with them.

I was busy about the perfumes, when the priest, perceiving there was a considerable number of infernal spirits, turned to me, and said, "Benvenuto, ask them something." I answered, "Let them bring me into the company of my Sicilian mistress, Angelica." That night we obtained no answer of any sort; but I had received great satisfaction in having my curiosity so far indulged. The necromancer told me it was requisite we should go a second time, assuring

me, that I should be satisfied in whatever I asked, but that I must bring with me a pure and immaculate boy.

I took with me a youth who was in my service, of about twelve years of age, together with the same Vincenzio Romoli, who had been my companion the first time, and one Agnolino Gaddi, an intimate acquaintance, whom I likewise prevailed on to assist at the ceremony. When we came to the place appointed, the priest having made his preparations as before, with the same and even more striking ceremonies, placed us within the circle, which he had likewise drawn with a more wonderful art, and in a more solemn manner than at our former meeting. Thus having committed the care of the perfumes and the fire to my friend Vincenzio, who was assisted by Agnolino Gaddi, he put into my hand a pintaculo or magical chart*, and bid me turn it towards the places that he should direct me; and under the pintaculo I held my boy. The necromancer having begun to make his tremendous invocations, called by their names a multitude of demons, who were the leaders of the several legions, and invoked them by the virtue and power of the eternal uncreated God, who lives for ever, in the Hebrew language, as likewise in Latin and Greek; insomuch, that the amphitheatre was almost in an instant filled with demons a hundred times more numerous than at the former conjuration. Vincenzio Romoli was busied in making a fire with the assistance of Agnolino, and burning a great quantity of precious perfumes. I, by the direction of the necromancer, again desired to be in the company of my Angelica. The former thereupon turning to me said, "Know, they have declared that in the space of a month you shall be in her company."

He then requested me to stand resolutely by him, because the legions were now above a thousand more in number than he had designed, and besides, these were the most dangerous, so that after they had answered my question it behooved him to be civil to them, and dismiss them quietly. At the same time, the boy under the pintaculo was in a terrible fright, saying, that there were in that place a million of fierce men, who threatened to destroy us; and that moreover four armed giants of an enormous stature were endeavouring to break into our circle. During this time, whilst the necromancer, trembling with fear, endeavoured by mild and gentle methods to dismiss them in the best way he could, Vincenzio Romoli, who quivered like an aspen leaf, took care of the perfumes. Though I was as much terrified as any of them, I did my utmost to conceal

* The most exact writers call it pentacolo, a sort of magical preparation of card, stone, and metal, on which are inscribed words and figures considered very efficacious against the power of demons.—See Ariosto Orl. F. c. 3. st. 21.

the terror I felt, so that I greatly contributed to inspire the rest with resolution; but the truth is, I gave myself over for a dead man, seeing the horrid fright the necromancer was in. The boy placed his head between his knees, and said, "In this posture will I die; for we shall all surely perish." I told him that all those demons were under us, and what he saw was smoke and shadow*; so bid him hold up his head and take courage. No sooner did he look up, but he cried out, "The whole amphitheatre is burning, and the fire is just falling upon us;" so covering his eyes with his hands, he again exclaimed, that destruction was inevitable, and he desired to see no more. The necromancer entreated me to have a good heart, and take care to burn proper perfumes; upon which I turned to Romoli, and bid him burn all the most precious perfumes he had. At the same time I cast my eye upon Agnolino Gaddi, who was terrified to such a degree, that he could scarce distinguish objects, and seemed to be half dead. Seeing him in this condition, I said, "Agnolo, upon these occasions a man should not yield to fear, but should stir about and give his assistance; so come directly and put on some more of these perfumes." Poor Agnolo, upon attempting to move, was so violently terrified, that the effects of his fear overpowered all the perfumes we were burning. The boy hearing a crepitation, ventured once more to raise his head, when seeing me laugh, he began to take courage, and said, that the devils were flying away with a vengeance.

In this condition we stayed till the bell rang for morning prayer. The boy again told us that there remained but few devils, and these were at a great distance. When the magician had performed the rest of his ceremonies, he stripped off his gown, and took up a wallet full of books which he had brought with him. We all went out of the circle together, keeping as close to each other as we possibly could, especially the boy, who had placed himself in the middle, holding the necromancer by the coat and me by the cloak. As we were going to our houses, in the quarter of Banchi, the boy told us that two of the demons whom we had seen at the amphitheatre, went on before us leaping and skipping, sometimes running upon the roofs of the houses, and sometimes upon the ground.

The priest declared, that though he had often entered magic circles, nothing so extraordinary had ever happened to him. As we went along he would fain have persuaded me to assist with him at consecrating a book, from which he said we should derive immense

* This confirms us in the belief that the whole of these appearances, like a phantasmagoria, were merely the effects of a magic-lanthorn, produced on volumes of smoke from various kinds of burning wood.—Ed.

riches: we should then ask the demons to discover to us the various
treasures with which the earth abounds, which would raise us to
opulence and power; but that those love affairs were mere follies,
from whence no good could be expected. I answered, "That I would
have readily accepted his proposal, if I had understood Latin." He
redoubled his persuasions, assuring me that the knowledge of the
Latin language was by no means material. He added, that he could
have found Latin scholars enough, if he had thought it worth while
to look out for them, but that he could never have met with a partner
of resolution and intrepidity equal to mine, and that I should by all
means follow his advice. Whilst we were engaged in this conversa-
tion, we arrived at our respective homes, and all that night dreamt
of nothing but devils.

As I every day saw the priest, he did not fail to renew his solici-
tations to engage me to come into his proposal. I asked him what
time it would take to carry his plan into execution, and where this
scene was to be acted. He answered, "That in less than a month we
might complete it, and that the place best calculated for our purpose
was the mountains of Norcia: though a master of his had performed
the ceremony of consecration hard by the mountains of the Abbey
of Farfa*, but that he had met with some difficulties which would
not occur in those of Norcia." He added, "that the neighbouring
peasants were men who might be confided in, and had some knowl-
edge of necromancy, insomuch, that they were likely to give us great
assistance upon occasion." Such an effect had the persuasions of this
holy conjurer, that I readily agreed to all he desired, but told him,
that I should be glad to finish the medals I was making for the Pope
first: this secret I communicated to him, but to nobody else, and
begged he would not divulge it. I constantly asked him whether he
thought I should, at the time mentioned by the devil, have an inter-
view with my mistress Angelica; and finding it approach, I was
surprised to hear no tidings of her. The priest always assured me
that I should without fail enjoy her company, as the demons never
break their promise, when they make it in the solemn manner they
had done to me. He bid me, therefore, wait patiently, and avoid
giving room to any scandal upon that occasion, but make an effort
to bear something against my nature, as he was aware of the great
danger I was to encounter; adding, that it would be happy for me if
I would go with him to consecrate the book, as it would be the way
to obviate the danger, and could not fail to make both him and
me happy.

* Farfa is a village in the Labina, thirteen miles from Rome.

I, who began to be as eager to undertake the enterprise as he to propose it, told him that there was just come to Rome one Giovanni da Castello*, a native of Bologna, and an excellent artist; that he was particularly skilful in making such medals of steel as I was employed about; and I desired nothing more than to emulate this great man, in order to display my genius to the world, hoping by that means, and not by the sword, to subdue my numerous enemies. The priest continued his persuasions notwithstanding, and said to me, "My dear Benvenuto, come along with me, and keep out of the way of a very great danger, which I see impending over your head." I had resolved, however, to finish my medal first, and the end of the month was now approaching, but my mind was so taken up with my medal, that I thought no more either of Angelica, or any thing else, except my present task.

I happened one day, about the hour of vespers, to have occasion to go from home at an unusual hour to my shop (fronting Banchi, while my house was situated at the back), where I left all the business to the care of my partner, whose name was Felice. Having stayed there a short time, and recollecting that I had something to say to Alessandro del Bene, I instantly set out, and being arrived in the quarter of Banchi, accidentally met with a friend of mine, whose name was Benedetto; he was a notary public, a native of Florence, and the son of a blind man of Siena, who lived by alms. This Benedetto had resided several years at Naples, from whence he went to Rome, where he transacted business for certain merchants of Siena, of the name of Figi. My partner had several times requested him to pay for some rings, which Benedetto had given him to mend. Meeting him that day in the quarter of Banchi, he asked him again for the money with some asperity (which was customary with him), when Benedetto was with his employers. These people, observing what passed, rebuked the latter severely, telling him they would employ another person, to prevent their being any longer disturbed with such uproars. Benedetto made the best defence he could, assuring them that he had paid that goldsmith, and could not prevent madmen from raving. The merchants, not satisfied with this excuse, dismissed him from their service. Immediately after this affair, he dressed himself and came to my shop, in a

* Gio. Bernardi, a celebrated engraver of cameos, and in steel and crystal. After working some time for the Duke of Ferrara, he was invited to Rome by Jovius, where under the patronage of the Cardinals Salviati and de' Medici, he produced some exquisite specimens of his art. He gave the portrait of Clement VII. on that fine medal, with a reverse of Joseph discovering himself to his brothers. He was very assiduous and rapid in his works. He was also a pontifical mace-bearer, and died at sixty years of age in 1555.

great rage, perhaps in order to abuse Felice. It happened that we met exactly in the middle of the Banchi quarter. As I knew nothing of what had passed, I saluted him with my usual complaisance, but he returned my politeness with a torrent of opprobrious language. I thereupon recollected what the necromancer had told me of an impending danger, and keeping upon my guard in the best manner I could, I said to him, "My dear friend, Benedetto, don't be angry with me, for I have done you no injury, and know nothing of the misfortunes that may have befallen you. If you have any thing to do with Felice, go and settle it with himself: he is very able to give you an answer. As I am entirely ignorant of the affair in question, you are in the wrong to give me such language, especially as you know that I am not a man to put up with an affront." He made answer,—"That I was thoroughly acquainted with the whole transaction; that it should not end so, and that Felice and I were both very great scoundrels."

By this time a crowd had gathered about us to hear the dispute. Provoked by his abusive language, I stooped down, and taking up a lump of dirt (for it had just been raining), I aimed it at him, intending to throw it full in his face, but he bowed himself down a little, and it hit exactly in the middle of his head. In this dirt was a sharp flint, which cut him most severely, so that he fell upon the ground insensible, and like a dead person. From this circumstance, and from the great quantity of blood which flowed from his wound, it was the opinion of all the bystanders that he was killed upon the spot.

Whilst he lay stretched out upon the ground, and some porters who were amongst the crowd expected to be employed to carry off the corpse, Pompeo, the jeweller, whom the Pope had sent for about some job in his way, happening to pass by, and seeing the man in so dismal a plight, asked who had used him in that manner. He was told that Benvenuto was the man, but that it had been all the fool's own seeking. Pompeo ran in all haste to the Pope, and said to him, "Most holy father, Benvenuto has just murdered Tobbia; I saw it with my own eyes." The Pope hearing this, flew into a most violent passion, and ordered the governor, who happened to be present, to seize and hang me directly upon the very spot where the murder was committed. He enjoined him to use the utmost diligence in taking me, and upon no account to appear before him till he had seen justice done.

As soon as I beheld the unfortunate man in the situation I have described, I began to think of taking measures for my safety, seriously reflecting on the power of my enemies, and the danger in

which this affair might involve me. I therefore quitted the place, and retired to the house of Signor Gaddi, clerk of the chamber, proposing to get myself in readiness with all possible expedition, and go where Providence should direct me; though Signor Gaddi advised me not to be in such a hurry, as the danger might possibly be much less than I imagined. Having thereupon sent for Signor Annibale Caro, who lived in the same house with him, he desired him to inquire into the affair. Whilst we were talking of this matter, and the above orders were giving, there came to us a Roman gentleman, who lived with the Cardinal de' Medici*, and had been sent to us by that prince. This gentleman, taking Signor Gaddi and me aside, told us that the cardinal had repeated to him the words above-mentioned, which he had heard uttered by the Pope; he added, that it was impossible to save me, advising me to fly that first ebullition of anger, and not venture upon any account to stay in Rome. As soon as the gentleman was gone, Signor Gaddi, looking at me attentively, seemed to shed tears, and said, "Alas! how unfortunate am I, that I have it not in my power to assist you." I answered, "With the help of God I shall extricate myself out of all difficulties; all I ask of you is, that you will be so good as to lend me a horse." Instantly a brown Turkish horse, one of the handsomest and best in Rome, was got ready for me; I mounted it, and placed a wheel musquet at the pummel of the saddle, to defend myself.

When I arrived at Sixtus's bridge, I found the whole body of city-guards, horse and foot, drawn up there; so, making a virtue of necessity, I boldly clapped spurs to my horse, and, by God's mercy, passed free and unobserved. Thus I repaired with the utmost speed to Palombara, the place of residence of Signor Giambattista Savelli; and from thence I sent back the horse to Signor Giovanni Gaddi, but chose to make a secret of the place where I was, even to

* Ippolito, the same mentioned previously, a natural son of Julian, brother of Leo X., was made a cardinal at eighteen years of age in 1529. He possessed all the qualities fitted for a prince, but by no means for an ecclesiastic. With a fine person, and accomplished in every manly and elegant art, he soon became weary of the churchman's gown, and delighted to wear the knightly sword and mantle. Surrounded by military men, artists, and scholars, he boasted of assembling at his table persons of all nations and professions, speaking more than twenty different languages. In 1532 he was sent Apostolic Legate, at the head of ten thousand Italians against the Turks in Hungary, but so far awakened the suspicions of the Emperor by his martial character and ambition, that he was in a few days put under arrest. Unsatisfied with his immense wealth, and jealous of the power of the Duke Alessandro in Florence, he entered into a conspiracy against him, which failed of success. Stung with insult and disappointment, he offered his services to Charles V. in the expedition to Tunis; but finding himself equally neglected by the Imperialists, this added disgrace threw him into a violent fever, of which he died in 1555. He left a natural son of the name of Asdrubal, who gave his countrymen an elegant translation of the Second book of the Æneid.

that gentleman. Signor Giambattista, after giving me the kindest reception imaginable, and treating me in the most generous manner during two whole days, advised me to quit the place, and bend my course towards Naples, till the first gust of the Pope's fury should be over. Having procured me company, he put me in the road to Naples.

I met by the way a statuary, a friend of mine, named Solosmeo, who was going to S. Germano, to finish the tomb of Piero de' Medici at Monte Casini. This person informed me, that the very evening of my departure, Pope Clement had sent one of the gentlemen of his bedchamber to inquire after Tobbia; and that the gentleman upon finding him at work, and that nothing at all had happened to him, nay, that he was quite ignorant of the whole affair, had made a report to his Holiness of the real state of the case. The Pope thereupon turned to Pompeo, and said, "You are a most abandoned wretch; but one thing I can assure you of, you have stirred a snake which will sting you, and that's what you well deserve." He next addressed himself to the Cardinal de' Medici, and desired him to inquire after me, telling him he would not lose me upon any account whatever.

In the mean time, Solosmeo and I jogged on together towards Naples, by way of Monte Casini, singing all the way.

CHAPTER XIV.

The Author arrives safe at Naples.—There he finds his mistress Angelica and her mother, which gives rise to an extraordinary interview.—He meets with a favourable reception from the Viceroy of Naples who endeavours to fix him in his service.—Finding himself greatly imposed upon by Angelica's mother, he accepts of Cardinal de' Medici's invitation to return to Rome, the Pope having discovered his error concerning the supposed death of Tobbia, the goldsmith.—Curious adventure upon the road.—He arrives safe at Rome, where he hears that Benedetto was recovered of his wound.—Benvenuto strikes a fine medal of Pope Clement, and waits upon his Holiness.—What passed at this interview.—The Pope forgives and takes him again into his service.

SOLOSMEO* having reviewed his work at Monte Casini, we travelled together towards Naples. When we came within half a mile of

* Antonio Solosmeo da Settignano, with the exception of the large figures, completed the whole of this magnificent tomb, which was begun in 1532, and which long engaged the talents of the most eminent artists:—Antonio da St. Gallo, in the architecture, Giuliano da St. Gallo, for the statues, and Matteo de' Quaranta, a Neapolitan. Solosmeo was pupil to Sansovino, and being of an animated and daring character, very satirical, and a declared enemy of Bandinelli's, he stood high in favour with Cellini. See Gattula and Vasari.

that capital, we were accosted by an innkeeper, who invited us to put up at his house, and told us that he had lived several years in Florence with Cardinal Ginori*, adding that if we would take up our quarters with him, we should meet with the civilest and kindest treatment. We told the man several times that we did not choose to stop at his house. The fellow, notwithstanding, continued to ride on with us; and frequently turning back, repeated the same thing, telling us he should be very glad of our company at his inn. Tired at last of his importunity, I asked him whether he could direct me to a Sicilian lady, named Beatrice, who had a daughter called Angelica, and who were both courtezans. The innkeeper thinking I was in jest, made answer, "Curse on all such, and all that take pleasure in their company;" then clapping spurs to his horse, he galloped off, as if determined to quit us entirely.

I began to applaud the address with which I had got rid of this impertinent devil; though I still was never the nearer, for when I recollected my passion for Angelica, I fetched a deep sigh, and began to talk of her to Solosmeo. As we were thus engaged in chat, the innkeeper came riding up to us again full speed, and as soon as he joined us, said, "Two or three days ago, there came a lady and her daughter to lodge next door to me, of the very name you mention, but whether they are Sicilians or not I cannot justly say." I replied, "The name of Angelica has such charms for me, that I am resolved by all means to take up my quarters at your inn." Thus we rode into Naples in company with the innkeeper, and dismounted at his house. I thought it an age till I had put every thing belonging to me into proper order; and then went to the house adjoining to the inn, where I found my dear Angelica, who received me with the greatest demonstrations of affection and kindness. I continued with her from eight o'clock that evening until the following morning. Whilst I enjoyed the exquisite pleasure of her company, I recollected that this very day the month was expired, which had been fixed in the necromancer's circle by the demons: so let every one who has recourse to such oracles, seriously reflect upon the dangers which I had to encounter.

I happened to have in my purse a diamond, which was particularly noticed by the goldsmiths; and though but a young man, I was generally known in Naples for a person of some consequence, and greatly caressed by the citizens. Amongst others a very worthy man, a jeweller, named Signor Dominico Fontana, was lavish of his civili-

* Carlo Ginori was Gonfalonier of the Florentine Republic in 1527.

ties to me, so as to discontinue the business of his shop during three days that I passed at Naples; he showed me the most interesting remains of art both in and beyond the city; and moreover introduced me to the viceroy, who had intimated a desire to see me. As soon as I came into the presence of his excellency, he showed me a thousand civilities, during which my diamond dazzled his eye. When at his particular desire I had shown it him, he told me, that if I were disposed to part with it, he hoped I would not forget him. Upon his returning me the diamond, I again put it into his excellency's hand, telling him, that both the jewel and its owner were very much at his service. He declared that he set a high value upon the diamond, but should be better pleased if I would reside at his court; adding that he would take care I should be satisfied with my treatment. Many civilities thereupon passed between us; but the conversation afterwards turning on the value of the diamond, his excellency commanded me to set a price upon it. I told him that it was worth exactly two hundred crowns. To this his excellency made answer, that I appeared to him not to be unreasonable; but that he ascribed the extraordinary beauty of the stone to its being set by me, who was one of the first men living in the jewelling business; and if it were set by another hand, it would not seem to be of half the value. I told him it was not I that had set the diamond, for the work was but indifferent, and that he who did it had considered only its intrinsic value; but, if I were to set it myself, it would appear to much greater advantage, and shine with redoubled lustre. Thereupon I put my thumb-nail to the ligatures of the diamond, and drew it out of the ring: then rubbing it a little, I handed it to the viceroy. His excellency's surprise was equal to his satisfaction, and he wrote me an order that the two hundred crowns which I demanded should be paid at sight.

At my return to my lodgings I found a letter from the Cardinal de' Medici, by which I was desired to return to Rome without loss of time; and, immediately upon my arrival, to dismount at his palace. When I had read the letter to Angelica, she with a flood of tears entreated me either to stay at Naples, or to carry her with me to Rome. I answered, that if she chose to accompany me to Rome, I would give her the two hundred ducats, which I had received from the viceroy, to keep for me. Her mother, seeing us close in conversation, came up to us, and accosted me thus, "Benvenuto, if you propose carrying my Angelica to Rome with you, leave me fifteen ducats to pay for my lying-in, and afterwards I will follow you myself." I told the old beldame, that I would leave her thirty with

pleasure, if she would let her daughter accompany me. This being agreed on, Angelica requested me to buy her a gown of black velvet, as that manufacturer was cheap at Naples. I consented to every thing, and having sent for the velvet, bargained for it myself. The old woman thereupon thinking me soft and easy to be made a dupe of, asked me for fine clothes for herself and her sons, and a larger supply of money than I had promised her. I complained of this in gentle terms, and said, "My dear Beatrice, is not what I have offered you enough?" She answered in the negative. I then told her, that what was not enough for her, would suffice for me; and taking my leave of Angelica, who shed tears at parting, whilst I only laughed, I set out in order to return to Rome.

I left Naples with my pocket full of money by night, for fear of being way-laid and assassinated, which is a common thing in that country. When I arrived at Selciata, I with great valour and address defended myself against several men on horseback, who attacked and would have murdered me. Having left Solosmeo busy with his monument at Monte Casini, I one day stopped at the inn of Adananni to dine. Near this place, I shot at some birds and killed them, but at the same time tore my right hand with the lock of my gun; and though the hurt was not of much consequence, it had an ugly appearance, the blood flowing in copious streams from my hand. When I had got to the inn, and put my horse into the stable, I was shown into a room, where I found several Neapolitan gentlemen just going to sit down to table, and with them a young lady, one of the most lovely creatures my eyes ever beheld. On entering the chamber, I was attended by my servant, a clever stout young fellow, armed with a long partizan: the sight of us, together with the arms and the blood, threw the poor gentlemen into such a panic (there being a nest of assassins in the place), that, rising from their seats, they in the utmost terror and consternation prayed to God to assist them. I told them with a smile that God had already heard their prayers, and that I was ready to be their defender against whoever should dare to attack them. I then asked them to help me to some sort of bandage for my hand, when the beautiful lady took a hand-kerchief embroidered with gold, in order to make a bandage. I declined this offer, but the lady tore it in two, and wrapt up my hand in it herself with a grace inexpressible. Our fears seemed to be now removed, and we dined together cheerfully. Dinner being over we mounted on horseback, and travelled on in company. Yet as there still remained some distrust on the side of the gentlemen, they caused the lady to engage me in conversation, leaving us at

some little distance, and she and I rode on together. I made a sign to my servant to lag behind, so that we had an opportunity of conversing on subjects which are not to be disclosed to all the world. Thus was my journey to Rome the most agreeable I ever had in my life.

Upon my arrival at that city I went to alight at the palace of the Cardinal de' Medici. I soon was introduced to that prince, and paid my respects to him, with thanks for his favours: I at the same time requested him to secure me from all danger of imprisonment, or even from a fine if it were possible. The cardinal appeared overjoyed to see me, and desired me to fear nothing: he then turned to one of his gentlemen, whose name was Pierantonio Pecci of Siena*, and bid him, in his name, command the city-guards not to meddle with me. He asked him next in what condition the person was, whom I had wounded in the head with a stone? Pierantonio answered that he was very ill, but would soon be worse; for having heard that I was at Rome, he declared he should willingly die to do me mischief. The cardinal answered laughing, "The man could not have taken a surer way to convince us that he was born in Siena." Addressing himself next to me he said, "For my sake and your's avoid being seen in the quarter of Banchi for four or five days; after that you may go where you please, and let fools die when they will."

I went to my own house, and set about finishing the medal I had begun, which was a head of Pope Clement: on the reverse was a figure representing Peace. This was a little female, dressed in a thin garment, with a torch in her hand; a heap of arms tied together like a trophy, near to which was part of a temple, with a figure of Discord bound by many chains, and round it these words as a motto: *Clauduntur belli portæ.*† Whilst I was employed about this medal, the man whom I had wounded was cured. The Pope was incessantly asking me why I did not go near the Cardinal de' Medici, though every time I visited his Holiness he put some job of importance into my hands, which was sufficient to prevent me. When I had finished

* He afterwards passed into the service of Catherine de' Medici, and having attempted to surprise and deliver up Siena to the French, he was declared a rebel by the Spaniards.—See Pecci, Mem. di Siena.

† This medal was struck in reference to the peace, which continued throughout Christendom from the year 1530 to 1536. It was published by Molinet and Bomanni, who were equally unacquainted with the artist, and the description he gives of it, both in this place and in the *8th Chap. of the Oreficeria.* Thus in explaining the figure of Fury, they call her Discord or Mars, or a personification of War. That beautiful design of Peace of Guercino's, engraved by Rosaspina, seems to have been taken from the reverse.

the medal, it came to pass that Signor Piero Carnesecchi*, the Pope's chief favourite, became my patron. He took care to acquaint me that his master was extremely desirous to retain me in his service. I told this gentleman, that I should soon make it appear that I had been always animated by an equal zeal for his Holiness.

Having a few days after finished my medal, I stamped it upon gold, silver, and copper, and showed it to Signor Piero, who immediately introduced me to the Pope. I was admitted into the presence of his Holiness one day just after dinner: it was in the month of April, and the weather very fine, when he was at Belvidere. Upon entering the apartment I delivered him the medals, with the steel instruments which I used in stamping them. He took them into his hand, and observing the great ingenuity with which they were made, looked at Signor Piero, and said, "Were the ancients ever as successful in striking medals as we?" Whilst they both were examining, now the instruments, now the medals themselves, I addressed the Pope in the most modest terms I could think of. "If the influence of my adverse stars had not been counteracted by a power still greater than theirs, your Holiness would have lost a faithful and zealous servant, without its being either your fault or mine. For it must be allowed to be right and well-judged in cases of the utmost emergency, to do according to the proverbial expression of the vulgar, namely, to look before you leap†; since the wicked, lying tongue of one of my malicious adversaries had so irritated your Holiness against me, that you were incensed to the highest degree, and commanded the governor to seize and hang me directly. I make no doubt, however, that your Holiness, upon reflecting on your loss, and the prejudice you had done to your own interest, in depriving yourself of such a servant as you acknowledge me to be, would have felt some remorse, and been sorry for what you had done. Neither parents, nor masters, possessed of prudence or good-nature, will ever proceed to sudden severities against their children or their servants, since to repent afterwards of what they have done in a passion can avail them nothing. But as the Divine Providence has defeated this

* A Florentine, distinguished for his learning and agreeable qualities, and a great favourite with Clement VII. His society was much sought by most of the literary geniuses of the time, as appears from the letters of Mureto, Boufadio, Casa, Flaminio, and others; but having formed an intimacy with Giovanni Valdes, in Naples, and with Melancthon in France, he imbibed the doctrines of those reformers. Accused of heresy at Rome, in 1546, he was in the first instance absolved; but, on a fresh accusation, he was condemned by the Inquisition for contumacy. At the instance of Pius V. he was sent by Duke Cosmo to Rome, where he was beheaded and burnt, as an obstinate heretic, in August, 1567.

† An Italian proverb:—"Si deve segnar sette e tagliar uno." To mark seven and cut off one.—Ed.

malignant influence of the stars, and preserved me for your Holiness's service, I must entreat that for the future you would not so easily suffer yourself to be incensed against me."

The Pope having made an end of looking at the medals, was listening to me with the greatest attention. As there were present several noblemen of the first rank, he coloured a little, and appeared to be in come confusion; but not knowing how to palliate what he had done, he declared that he did not remember to have ever given any such order. Perceiving this, I turned the conversation to other topics, in order to amuse him, and dissipate his confusion. His Holiness again entering upon the subject of the medals, asked me by what means I had contrived to stamp them so well, being so very large, for he had never oberved any antique medals of the same size. We talked of this for a while, and his Holiness being apprehensive that I might say something still more severe than I had done already, told me that the medals were very fine, that he was highly pleased with them, and should be glad to have another reverse made to them, agreeable to his fancy, if medals of that sort could be stamped with two reverses. I declared they could. Upon this he ordered me to represent that part of the history of Moses, where he strikes the rock, and water issues from it, with a Latin inscription to this effect, *Ut bibat populus.** He then added, "Set about it, Benvenuto, and when you have done, I will begin to think of providing for you." As soon as I was gone he boasted that he would find me constant employ, so that I should have no occasion to work for any body else. Thus encouraged, I exerted myself to the utmost, and lost no time till I had finished the reverse, with the figure of Moses upon it.

* This reverse is also to be seen in Bonanni, with the allusion explained as follows: When the Pope was at Orvieto, in 1528, having noticed the scarcity of water to which the city was liable, being built upon a rock, at a distance from any spring, he ordered Antonio da S. Gallo to open a large well, which was in fact a wonderful effort of art. It was cut through the solid rock to the depth of 265 feet, and 25 ells wide. It has two flights of hanging steps, one above the other, to ascend and descend, executed in such a manner, that even beasts of burden may enter; and by 248 convenient steps they arrive at a bridge placed over a spring, where the water is laden. And thus, without returning back, they arrive at the other stairs, which rise above the first, and by these return from the well by a passage different to the one they entered. This work was nearly finished at the death of Clement VII., and it was therefore natural that he should record this singular fact by a medal.

CHAPTER XV.

Pope Clement is attacked by a disorder of which he dies.—The Author kills Pompeo of Milan.—He is protected by Cardinal Cornaro.—Paul III. of the House of Farnese is made Pope.—He reinstates the Author in his place of engraver of the Mint.—Pier Luigi, the Pope's bastard son, becomes Cellini's enemy.—He employs a Corsican soldier to assassinate the Author, who has intelligence of the design, and escapes to Florence.

In the meantime, the Pope was taken ill, and his physicians being of opinion that he was in great danger, my adversary, who was still afraid of me, hired certain Neapolitan bravoes to treat me in the manner he was apprehensive I should treat him: so that I found it a very difficult matter to defend my life from his attacks. However I went on with my work, and having finished it, waited on the Pope, whom I found very ill in bed; he gave me nevertheless the kindest reception, and expressing a desire to see both the medals and the instruments with which I had stamped them, ordered his spectacles and a light to be brought, but could discern nothing of the workmanship. He therefore began to examine them by the touch, and having done so for a time, he fetched a deep sigh, and told some of his courtiers, that he was sorry for me, but if it pleased God to restore his health, he would settle matters to my satisfaction. Three days after, he died, and I had my labour for my pains. I took heart notwithstanding, and comforted myself with the reflection of having acquired by means of those medals so much reputation, that I might depend upon being employed by any future Pope, and perhaps with better success.

By such considerations did I prevent myself from being dejected; and totally forgetting the injuries I had received from Pompeo, I put on my sword and repaired to St. Peter's, where I kissed the feet of the deceased pontiff, and could not refrain from tears. I then returned to Banchi, to reflect undisturbed on the confusion that happens on such occasions. Whilst I was sitting here in the company of several of my friends, Pompeo happened to pass by in the midst of ten armed men, and when he came opposite to the place where I sat, stopped awhile as if he had an intention to begin a quarrel. The brave young men, my friends, were for having me draw directly, but I instantly reflected, that by complying with their desire, I could not avoid hurting innocent persons; therefore thought it most advis-

able to expose none but myself to danger. Pompeo having stopped before my door, whilst you might say a couple of *Ave Marias,* began to laugh in my face; and when he went off, his comrades fell a-laughing likewise, shook their heads, and made many gestures in derision and defiance of me. My companions were for interposing in the quarrel, but I told them in an angry mood, that I was man enough to manage all my feuds by myself; so that every one might mind his own business. Mortified at this answer, my friends went away muttering to themselves: amongst these was the dearest friend I had in the world, whose name was Albertaccio del Bene, brother to Alessandro, and Albizzo, who now resides in Lyons, and is exceeding wealthy. This Albertaccio del Bene* was one of the most surprising young men I ever knew, as intrepid as Cæsar, and one who loved me as he loved himself. He was well aware that my forbearance was not an effect of pusillanimity, but of the most daring bravery, which he knew to be one of my qualities. In answer therefore to what I said, he begged of me as a favour, that I would indulge him so far as to take him for my companion in whatever enterprise I might meditate. To this I replied, "My dearest friend, Albertaccio, a time will soon come when I shall need your assistance; but on the present occasion, if you love me, do not give yourself any concern about me; only mind your own affairs, and quit the place directly, as the rest have done, for we must not trifle away time."

These words were uttered in great haste: in the meantime my enemies of the Banchi quarter had walked on slowly towards a place called Chiavica, and reached a crossway where several streets meet; but that in which stood the house of my adversary, Pompeo, led directly to the Campo di Fiore. Pompeo entered an apothecary's shop at the corner of the Chiavica, about some business, and stayed there some time: I was told that he had boasted of having bullied me; but it turned out a fatal adventure to him. Just as I arrived at that quarter, he was coming out of the shop, and his bravoes having made an opening formed a circle round him. I thereupon clapped my hand to a sharp dagger, and having forced my way through the file of ruffians, laid hold of him by the throat so quickly, and with such presence of mind, that there was not one of his friends could defend him. I pulled him towards me, to give him a blow in front, but he turned his face about through excess of terror, so that I

* Cellini has already mentioned his intimacy with the family del Bene. Alberto, of whom he again speaks as a person of singular merit, is praised in a letter written by Bembo, directed to him at Padua, in 1542, for his elegant compositions, and for his critical taste in subjects relating to the fine arts.

wounded him exactly under the ear; and upon repeating my blow, he fell down dead. It had never been my intention to kill him, but blows are not always under command.

Having withdrawn the dagger with my left hand, and drawn my sword with the right, in order to defend myself, when I found that all the heroes of his faction ran up to the dead body, and that none of them advanced towards me, or seemed at all disposed to encounter me, I retreated down the street Julia, revolving within myself whither I could make my escape. When I had walked about three hundred paces, Piloto, the goldsmith, my intimate friend, came up to me, and said, "Brother, since the mischief is done, we must think of preserving you from danger." I answered him, "Let us go to Albertaccio del Bene, whom I told awhile ago that I should shortly have occasion for his assistance." As soon as we reached Albertaccio's dwelling house, infinite caresses were lavished on me, and all the young persons of condition, of the different nations in the quarter of Banchi, except those of Milan, made their appearance, offering to risk their lives in order to preserve mine. Signor Luigi Rucellai also sent to make me a tender of all the service in his power, as did likewise several of the nobility besides him, for they were glad that I had despatched Pompeo, from an opinion that he had insulted me past all enduring, and they expressed great surprise that I had so long been patient under accumulated injuries.

In the mean time, the affair coming to the knowledge of Cardinal Cornaro, he sent thirty soldiers, and as many spear-men, pike-men, and musketeers, who were charged to conduct me to his house. I accepted the offer and went with them, accompanied by more than an equal number of the brave young fellows above-mentioned. Signor Trajano*, Pompeo's relation, and first gentleman of the bedchamber, being likewise informed of the affair, sent a person of quality, of Milan, to Cardinal de' Medici, to acquaint him with the heinous crime I had committed, and excite him to bring me to condign punishment. The Cardinal immediately made answer, "Benvenuto would have done very wrong not to prefer the lesser to the greater evil: I thank Signor Trajano, for having informed me of what I was ignorant of." Then, in the presence of the person of quality above-mentioned, he turned to the Bishop of Furli, his

* There is a letter of Bembo's, dated 1530, directed to Messer Trajano Alicorno, master of the bedchamber to the Pope; from which it is conjectured, he must have had great influence with the Pope. I presume he was a Roman, since I find in the inscriptions of Rome, collected by Galetti, others of the same name. In other respects, he seems not to have enjoyed any great reputation; for Pao. Jovio, in a letter dated 1535, mentions that Trajano would obtain payment of his pensions which were granted to him rather through good fortune than merit.

intimate acquaintance, and said to him, "Make diligent inquiry after my friend Benvenuto, and conduct him hither, because I intend to befriend and assist him, and shall look upon his enemies as mine." Hearing this the Milanese gentlemen coloured, and left the place; but the Bishop of Furli came in search of me to Cardinal Cornaro's palace. Upon seeing his reverence, he told him that the Cardinal de' Medici had sent for Benvenuto, and proposed taking him under his protection. Cornaro, who was one of the most whimsical men breathing, flew into a violent passion, and told the Bishop that he was as proper a person to take care of me as the Cardinal de' Medici. The Bishop replied, that he begged it as a favour that he might be allowed to speak a word to me about some other business of the Cardinal's. Cornaro made answer, that he should not see me that day. The Cardinal de' Medici was highly incensed at this; however I went the night following without Cornaro's knowledge, well guarded, to pay him a visit. I then begged it of him as a favour that he would permit me to stay with Cornaro, telling him of the great politeness with which the latter had treated me; and that if his reverence would suffer me to stay at that Cardinal's palace, I should always be sure of an additional friend in my utmost need, otherwise his reverence might dispose of me as he judged proper. He made answer that I might act as I thought fit.

I then returned to Cornaro. A few days after, Cardinal Farnese* was elected Pope. As soon as this new pontiff had settled other affairs of greater importance, he inquired after me, and declared that he would employ nobody else to stamp his coins. When he spoke thus, a gentleman, whose name was Signor Latino Giovenale†, said that I was obliged to abscond, for having killed one Pompeo, a Milanese, in a fray: he then gave an account of the whole affair, putting it in the most favourable light for me that was possible. The Pope made answer: "I never heard of the death of Pompeo, but I have often heard of Benvenuto's provocation; so let a safe-conduct be instantly made out, and that will secure him from all manner of danger." There happened to be present an intimate friend of Pompeo's, who was likewise a favourite of the pontiff: this was Signor Ambrogio, a native of Milan. This person told his Holiness,

* He was elected to the papal chair, on the 13th October, 1534.

† Latino Giovenale de' Manetti, extolled by Bembo, Sadoleto, Castiglione, and others, as an excellent poet and scholar. He was equally distinguished for his knowledge of antiquities and the fine arts. On Charles the Fifth's arrival in Rome, he was fixed upon to accompany that sovereign in a survey of the ancient monuments. He conducted many important negotiations both at Rome and elsewhere, and would have arrived at still higher honours, had he consented to devote his days to celibacy. (See Marini.)

that it might be of dangerous consequence to grant such favours, immediately upon being raised to his new dignity. The Pope instantly said, "You do not understand these matters : I must inform you that men who are masters in their profession, like Benvenuto, should not be subject to the laws : but he less than any other, for I am sensible that he was in the right in the whole affair." So the safe-conduct being immediately made out, I entered into his service, and met with great encouragement.

About this time, Signor Latino Giovenale came to me, and gave me an order to work for the Mint directly. Thereupon all my enemies rose up against me, and used their utmost endeavours to prevent me from being employed in that department. I began to make the dies for crown-pieces, upon which I represented the bust of St. Paul with this legend, *Vas Electionis.** This piece proved far more agreeable to his Holiness than those of the other artists, who worked in competition with me; insomuch, that he declared that I alone should have the stamping of his coins. I therefore exerted all my diligence in my art, and Latino Giovenale introduced me occasionally to the Pope, who had made choice of him for that purpose. I applied again for the place of engraver to the Mint; but the Pope having asked advice upon this point, told me that I must first receive pardon for the manslaughter, which I should have by the festival of the Virgin Mary in August, by order of the Caporioni; for every year at that solemn festival, twelve persons under sentence of banishment are pardoned upon the account of those magistrates. He directed at the same time that, during this interval, another safe-conduct should be taken out in my behalf, that I might remain till then secure and unmolested.

My enemies finding that they could by no means whatever exclude me from the Mint, had recourse to another expedient to wreak their malice. Pompeo, whom I sent to the other world, having left a portion of three thousand ducats to a bastard daughter of his, they contrived to prevail upon a favourite of Signor Pier Luigi†,

* This piece of coin is mentioned in the catalogue of Saverio Scilla. Molinet, who produced a medal of Paul III., with the very same motto of *Vas Electionis,* is of opinion that he thus meant to allude to the very unanimous consent of the Cardinals in electing this Pontiff, which, according to Jovius, was carried by acclamation with the general voice.

† Pier Luigi Farnese, a natural son of Paul III. whose violent and savage temper so long disturbed the repose and glory of this Pontiff, who always evinced for him the utmost paternal tenderness. The titles of gonfalonier of the church, Duke of Castro, Marquess of Novara, and lastly, in 1545, Duke of Parma and Placenza, were in a short period conferred upon him; but he wholly disappointed the high expectations formed of him. Ungoverned, rash, and dissipated, his contempt of his father's counsels and his usage of his own courtiers were the cause of his being assassinated by the latter in the year 1547.

bastard son to the Pope, to marry her; which was brought about by means of that lord. This favourite was a country fellow, in narrow circumstances: it was said that he received but very little of the money, for Pier Luigi laid hands on it, and was for converting it to his own use. But as this favourite had several times, through complaisance to his wife, requested Pier Luigi to get me taken into custody, the latter promised to bring it about, as soon as the high favour in which I was with the Pope had somewhat subsided. Things continuing in this state about two months, as that servant endeavoured to get the portion paid to him, Pier Luigi avoided giving a direct answer, but told his wife that he would revenge the death of her father.

Though I knew something of what was in agitation, whenever I happened to appear in the presence of Pier Luigi, he was lavish of demonstrations of kindness to me: he had, notwithstanding, at the same time, secretly given orders to the captain of the city-guard, either to cause me to be seized, or to get somebody to assassinate me. As he thought it most advisable to determine upon one of these two methods, he employed a cut-throat of a Corsican soldier to do the work; and my other enemies, especially Signor Trajano, promised to make the assassin a present of a hundred crowns: the latter declared thereupon, that he would make no more of it than swallowing a new-laid egg. Having heard the whole affair, I kept a constant look-out, and went always well accompanied and armed with a coat of mail, for I had received permission from the government. This bravo was so covetous, that in order to engross the whole money to himself, he thought he might undertake the murder unassisted. One day, just after dinner, they sent for me in the name of Signor Pier Luigi. I went directly, as that lord had often talked to me about several pieces of plate of new invention, which he proposed to have executed. I left my house in a hurry with my usual arms, and went down the street Julia, not thinking to meet any body at that time of day.

When I was at the top of the street, and preparing to turn towards the Farnese palace, it being customary with me to take the round-about way, I saw this Corsican quit the place where he was sitting, and advance to the middle of the street. Without being in the least disconcerted, I kept on my guard, and having slackened my pace a little, approached the wall as close as I could, to make way for the ruffian, and the better to defend myself. He drew towards the wall, and we were near to each other, when I plainly perceived by his gestures, that he had a design upon me, and seeing me alone in that manner, imagined it would succeed. I broke silence first:

"Valiant soldier," said I, "if it were night-time you might possibly have mistaken me for another, but as it is broad daylight you must be sensible who I am, and that I never had any connexion with you, nor ever gave you offence, but should rather be disposed to serve you, were it in my power." Upon my uttering these words, he, with a resolute air, and without ever quitting his ground, told me that he did not know what I meant. I replied, "But I know very well what you mean; yet your enterprise is more dangerous than you are aware of, and the success may be very different from what you imagine. I must tell you, that you have a man to deal with who will sell his life very dear; neither does your design become such a brave soldier as you appear to be." All this while I stood upon my guard with a stern and watchful eye, and we both changed colour. By this time a crowd was gathered about us, and the people perceived what we were talking of, so that, not having the spirit to attack me under those circumstances, he only said, "We shall see one another again." I answered, "I am always glad to see gallant men, and those who behave themselves as such."

Having left him, I went to Signor Pier Luigi, but found that he had not sent for me. From thence I returned to my shop, when the bravo gave me notice, by means of a particular friend of his and mine, that I had no longer any danger to apprehend from him, since he would for the future consider me as a brother; but that I must beware of others, for many persons of distinction had sworn they would have my life. I returned him thanks by the messenger, and kept upon my guard in the best way I could.

A few days after I was told by an intimate friend, that Signor Pier Luigi had given express orders for taking me that evening: this I heard at eight o'clock. I thereupon spoke to some of my friends, who advised me to make my escape without loss of time; and as the order was to be carried into execution at one in the morning, I took post at eleven for Florence. The truth is, when the soldier had miscarried in his enterprise for want of courage, Signor Pier Luigi had, by his own authority, given orders that I should be arrested, to make Pompeo's daughter easy, who was restless to know where her portion was deposited. Unsuccessful in his two first attempts to revenge the death of that woman's father, he had recourse to a third, of which I shall give the reader an account in its proper place.

CHAPTER XVI.

Duke Alessandro receives the Author with great kindness.—The latter sets out from Florence with Tribolo and Sansovino, two sculptors, upon a tour to Venice.—They pass through Ferrara, and meet with several adventures upon the road.—After a short stay at Venice, they return to Florence.—The Author's extraordinary behaviour to an innkeeper.—At his return to Florence he is appointed master of the Mint by Duke Alessandro de' Medici, who makes him a present of a very curious gun.—Ill offices done the Author by Ottaviano de' Medici.—He receives a promise of pardon from Pope Paul III., with an invitation to return to Rome and enter again into his service.—He accepts the invitation, and goes back to Rome.—Generous behaviour of Duke Alessandro.

UPON my arrival at Florence I paid a visit to Duke Alessandro, who gave me the most gracious reception, and even pressed me to stay with him. There happened to be in Florence at that time a statuary, named Tribolo*, to one of whose children I had stood godfather. In some conversations between us, he acquainted me that Giacopo del Sansovino†, his first master, had sent for him to Venice; and as he had never seen that city, and expected to gain considerably there, he was glad of an opportunity of making the trip. He asked me whether I had ever seen Venice? I answered in the negative, whereupon he pressed me to bear him company. I immediately accepted his proposal, and told Duke Alessandro that I intended to undertake a journey to Venice, and, upon my return, should be at his service. This he made me promise, desiring, at the same time, that I would

* Niccolo de' Pericoli, a Florentine, whose extraordinary humour and vivacity, from his earliest years, acquired for him the name of *Tribolo*. He was an eminent sculptor, and produced some specimens of such very extraordinary merit, that they were believed to be from the hand of Michel Angelo. He was also equally excellent in other branches of his art; and among other ingenious works, produced a topographical rilievo of the city and environs of Florence, one of the earliest efforts in that branch of art which has been since carried to such a degree of perfection by Exchaquet, and by Gen. Pfiffer, of Lucerne. His success in hydraulics, to which he also applied himself, was not equally great.

† Giacopo was born in Florence, and assumed the name of Sansovino, from the master under whom he studied, Andrea Contucci da Monte a Sansovino, one of the most eminent sculptors of his time. His family name was Tatti. His works acquired him a high reputation at Rome and Florence. In the year 1527 he visited Venice, and being made architect to the procurature, he renounced the study of sculpture, to devote himself entirely to his new profession, by which he obtained equal reputation and emolument. He was thus enabled to leave his son Francesco a noble fortune, which is, perhaps, the reason he has written so many indifferent books. Giacopo died in 1570, aged 93 years.

137

call upon him before my departure. I got myself in readiness the next day, and went to take my leave of the duke, whom I found at the palace of Pazzi, where the wife and daughter of Signor Lorenzo Cibo* were also lodged. Having given his excellency to understand that I was just setting out for Venice, an answer was brought me by Signor Cosmo de' Medici, the present Duke of Florence, that I should go to Niccolo di Monte Acuto, to receive fifty crowns, of which his excellency made me a present, and that after I had taken my pleasure at Venice, he expected I would return to his service.

Having received the money from Niccolo, I repaired to my friend Tribolo, who was ready for his journey, and asked me whether I had bound up my sword. I told him that a man who was just mounted for a journey had no occasion for any such precaution. He replied that it was the custom in Florence, for that there was in that city a certain Signor Maurizio, who for the least offence used to plague and persecute every body, so that travellers were obliged to keep their swords bound up till they had passed the gate. I laughed at this; so we set out with the procaccio or postman of Venice, named Lamentone, and travelled in his company.

Having passed the other towns without stopping at any of them, we at last arrived at Ferrara, and took up our quarters at the inn in the great square. The procaccio went in quest of some of the Florentine exiles, in order to deliver them letters and messages from their wives; for such was the pleasure of the duke, that this fellow should speak with them; but no Florentine traveller was to take the same liberty, upon pain of being involved in their punishment. In the mean time, as it was not above six in the afternoon, Tribolo and I went to see the Duke of Ferrara come back from Belfiore, whither he was gone, to be present at a tournament. At his return we met with several of the exiles, who looked at us attentively, as if to force us to speak to them. Tribolo, who was one of the most timorous men breathing, said to me every moment, "Neither look at nor speak to them, if you intend ever to return to Florence." So we stayed to see the duke's entrance; then going back to the inn, we found Lamentone. It was almost eleven o'clock at night, when Niccolo Benintendi made his appearance, with Piero his brother,

* Lorenzo Cibo, brother of the cardinal already mentioned, was Marquess of Massa, where he resided. It appears on the authority of Varchi, that his marchioness was a little too often honoured with the visits of the duke, who had very nearly paid a high price for his attentions. The Cardinal de' Medici, and Giambaptista Cibo, Archbishop of Marseilles, and a relation of the lady, had taken measures in 1535 to rid the marquess of the invader of his honour, by means of a small barrel of gunpowder, placed under his chair near the bed, but from some accident it failed to explode.

and an old man, whom I take to have been Giacopo Nardi*, together with several young gentlemen. The procaccio went to talk with the Florentine exiles: Tribolo and I stood at some distance, to avoid their conversation. After they had chatted a considerable time with Lamentone, Niccolo Benintendi said, "I know those two men there very well. What's the reason they make such a difficulty about speaking to us?" Tribolo begged I would remain silent. Lamentone told them that we had not the same permission as he had. Benintendi swore it was all mere nonsense, and wished the devil might take us, with other imprecations. I looked up, and said in the gentlest terms I could, "Dear gentlemen, do but seriously consider that you may hurt us; but it is not in our power to be of any manner of service to you; and though you have given us language by no means becoming gentlemen, yet we are willing to overlook that affront." Thereupon old Nardi declared that I spoke like a worthy young man. Niccolo Benintendi said, "I know how to deal both with them and the duke." I answered that he had behaved very ill to us, and that we had nothing to do with him or his affairs.

Old Nardi took our part, and told Benintendi that he was in the wrong. The latter still continued to insult us with abusive language: I assured him that I would presently take such a course with him as he would not like, so he had best attend to his own business, and let us alone. He replied that he held both the duke and us in abhorrence, and that we were no better than so many jackasses. I thereupon gave him the lie, and drew my sword; the old man, who wanted to be the first to get down stairs, had not descended many steps, when he tumbled down, and all the rest fell over him. I rushed towards them, and brandishing my sword, cried out in a furious manner, "I will kill every man of you;" but I took particular care not to hurt any one, as I might easily have done. The innkeeper, hearing the noise, set up a loud outcry; Lamentone begged for quarter; one cried out, "Oh, my head!" another, "Let me get out of this cursed place." In short, there was a most horrid uproar, you would have thought a whole herd of swine had got together. At last the innkeeper came with a light, when I drew back, and put up my sword. Lamentone told Niccolo Benintendi that he had behaved very ill: the landlord assured him that it was as much as his life was worth to wear arms

* Giacopo, born of a noble family in Florence, 1476, highly distinguished himself both as a soldier and a statesman, and rendered great services to the republic. He was afterwards declared an enemy to the Medici, his fortunes confiscated, and he himself imprisoned. His pleasing qualities and powerful talents acquired for him the praises and esteem of his contemporaries. He chiefly resided at Venice, where he wrote the history of his country, a translation of Titus Livy, and other excellent works. He lived beyond his 80th year.

in such a place. "If the duke," said he, "were to be acquainted with your insolence, he would order you to be hanged. I will not treat you as you deserve; but begone from my house, and let me see you no more, at your peril." After this speech the host came up to me, and, as I was going to make an apology for what had passed, he would not suffer me to say a word, but telling me he knew I was entirely in the right, advised me to beware of them upon the road.

As soon as we had supped, the master of a bark came to carry us to Venice. I asked him whether he would let us have the bark to ourselves, to which he agreed. In the morning we took horse betimes, to ride to the port, which is but a few miles distant from Ferrara. When we got thither, we met with the brother of Niccolo Benintendi, and three of his companions, who waited my coming; they had with them two pikes, and I had purchased a fine spear at Ferrara. Being thus well armed, I was not in the least terrified, as Tribolo was, who exclaimed, "God help us! these men have way-laid us, and will murder us." Lamentone, addressing himself to me, said, "The best course you can take is to return directly to Ferrara, for I see there is great danger: my dear Benvenuto, avoid the fury of these savage beasts." "Let us go on boldly," said I; "God assists those who are in the right, and you shall see how I assist myself. Is not this bark hired for us?" "It is," answered Lamentone. I then rejoined, "We will make our passage without them, or I will die for it." I spurred my horse forward, and when I was within ten paces of them, dismounted, and boldly advanced, with my spear in my hand. Tribolo staid behind, and had so contracted himself upon his horse, that he seemed to be quite frozen. Lamentone, the procaccio, who always puffed and blew in such a manner that he might have passed for Boreas, now puffed more than ever, being impatient to see how this fray was to conclude.

When I reached the bark, the master told me "that there was a considerable number of gentlemen from Florence, who wanted to sail in the vessel, if it were agreeable to me." "The boat," said I, "is hired for us, and for nobody else; and I am very sorry that I cannot have the pleasure of their company." To this a stout young fellow, named Magalotti, answered, "Benvenuto, we will contrive matters so as to put it in your power." I replied, "If God and the justice of my cause, together with my own arm, have any efficacy or influence, you will never be able to fulfil your promise." Having uttered these words, I leapt into the bark, and turning the point of my weapon towards them, said, "By this I will prove to you that I cannot comply with your request." In order to show that he was in earnest, Magalotti clapped his hand to his sword, and made

towards me; when instantly I jumped upon the side of the bark, and gave him so violent a thrust, that, if he had not instantly fallen flat, I should have run him through the body. His companions, instead of assisting him, retreated; and I, seeing that it was in my power to kill him, would not repeat my blow, but said, "Arise, brother, take your arms, and go about your business: I have sufficiently shown you that I can do nothing contrary to my own will; and that which I am able to do, I have not wished to do." I then called to Tribolo, the master of the bark, and Lamentone, and we set out for Venice together.

After we had sailed ten miles upon the Po, the young fellows above-mentioned, having embarked in a skiff, came up with us, and when they were opposite to our boat, that fool Piero Benintendi said to me, "Benvenuto, this is not the time to decide our difference; but you are to be seen again at Venice."—"Take care of yourself," said I, "for I am going thither, and shall frequent all places of public resort."

In this manner we arrived at Venice; where I applied to a brother of Cardinal Cornaro's, for permission to wear a sword. He told me that I was at liberty to do so, and the worst that could befall me was, that I might lose my sword. Thus having received permission to carry arms, we went to visit Giacopo del Sansovino the statuary, who had sent for Tribolo: he caressed me greatly, and invited us both to dinner. In his conversation with Tribolo, he told him he had no business for him then, but that he might call another time. Hearing him speak thus, I burst out a-laughing, and said jestingly to Sansovino, "His house is at too great a distance from yours for him to call again." Poor Tribolo, quite shocked at the man's behaviour, said, "I have your letter in my pocket, inviting me to come and see you at Venice." Sansovino replied, "That such men as himself, of abilities and unexceptionable character, might do that and greater things." Tribolo shrugged up his shoulders, muttering *patience* several times. Upon this occasion, without considering the splendid manner in which Sansovino had treated me, I took my friend Tribolo's part, who was certainly in the right; and as the former had never once ceased to boast at table of his own performances, whilst he made very free with *Michel Angelo* and all other artists, *however eminent,* I was so disgusted at this behaviour that I did not eat one morsel with appetite. I only took the liberty to express my sentiments thus: "O Signor Giacopo, men of worth act as such; and men of genius, who distinguish themselves by their works, are much better known by the commendations of others, than by vainly sound-

ing their own praises." Upon my uttering these words, we all rose from table murmuring our discontent.

Happening the very same day to be near the Rialto, I met with Piero Benintendi, who was in company with several others, and, perceiving that they intended to attack me, I retired to an apothecary's shop till the storm blew over. I was afterwards informed that young Magalotti, to whom I had behaved so generously, had expressed a great dislike to their proceedings, and thus the affair ended.

A few days after we set out on our return to Florence. Happening to lie at a place on this side of Chioggia, on the left hand as you go to Ferrara, the landlord demanded his reckoning before we went to bed. Upon my telling him that in other places it was customary to pay in the morning, he answered, "I insist upon being paid overnight, and as I think proper." I replied, "That when people insist upon having things their own way, they should make a world of their own; but the practice of this globe of ours was very different." The landlord said, "That it did not signify disputing the matter, for he was determined it should be so." Tribolo trembled with fear, and by signs entreated me to be quiet, lest the man should do something worse: so we paid him in the manner he required, and went to bed. We had very fine new beds, with every thing else new, and in the utmost elegance. Notwithstanding all this I never closed my eyes the whole night, being entirely engaged in meditating revenge for the insolent treatment of our landlord. Now it came into my head to set the house on fire, and now to kill four good horses which the fellow had in his stable. I thought it was no difficult matter to put either design in execution, but did not see how I could easily secure my own escape and that of my fellow-traveller afterwards.

At last I resolved to put our baggage into the ferry, and requesting my companions to go on board, I fastened the horses to the rope that drew the vessel, desiring my friends not to move it till my return, because I had left a pair of slippers in the room where I lay. This being settled, I went back to the inn, and inquired for the landlord, who told me that he had nothing to say to us, and that we might all go to the devil. There happened to be a little stable-boy in the inn, who appeared quite drowsy. He told me that his master would not stir a foot for the Pope himself, and asked me to give him something to drink my health; so I gave him some small Venetian coin, and desired him to stay awhile with the ferryman, till I had searched for my slippers. I went up stairs, carrying with me a little knife, which had an exceedingly sharp edge, and with it I cut four beds, till I had done damage to the value of upwards of fifty crowns.

I then returned to the ferry, with some scraps of bedclothes in my pocket, and ordered the person who held the cable to which the ferry was tied, to set off with all speed. When we were got to some little distance from the inn, my friend Tribolo said, "That he had left behind him some little leather straps, with which he used to tie his cloak-bag, and that he wanted to go back in search of them." I desired him not to trouble his head about two little straps of leather, and assured him that I would make him as many large ones as he should have occasion for. He told me that I was very merry, but that he was resolved to return for his leather straps; but as he called out to the ferryman to stop, I bade him go on, and in the mean time told Tribolo all the damage I had done at the inn, in proof of which I produced some of the scraps of the bed-clothes. He thereupon was seized with a panic so violent, that he never ceased crying out to the ferryman to make haste, and did not think himself secure from danger till we arrived at the gates of Florence. When we had thus reached our journey's end, Tribolo said to me, "Let us bind up our swords, for God's sake, and do nothing to bring us into any more scrapes, for I have been continually scared out of my wits for some days past."—"My good friend, Tribolo," answered I, "you need not bind up your sword, for it was fast enough during the whole journey." This I said, because he had not shown the least sign of courage upon the road. He looked at his sword, and said, "By the Lord, you say true; it is still tied up in the very same manner it was before I went from home." My fellow-traveller thought I had been a bad companion to him, because I had shown some resentment, and defended myself against those who would have used us ill; while I looked upon him in a worse light, for neglecting to assist me upon those occasions: let the impartial reader determine who was in the right.

Upon my arrival at Florence, I went directly to Duke Alessandro, and returned him a great many thanks for the fifty crowns, telling his excellency that I was ready to undertake any thing to serve him. He answered, that he wanted me to be engraver to his mint. I accepted the offer; and the first coin I stamped was a piece of forty pence, with the duke's head on one side, and on the other, a San Coscino, and a San Damiano. He declared that these silver coins were the finest in Christendom; and all Florence said the same. I then desired to be put into possession of the offices, with a provision, to which the duke replied that it should be done,—that I must devote myself to his service, that I should receive more than I required, and that he had given orders to Carlo Acceainolo, the master of the mint, to supply me with every thing I should want. After that I

made a stamp for the half giulios, upon which I represented a head of St. John, in profile, with a book in his hand, and the ducal arms upon the reverse. This was the first piece of the kind that had been ever made of so thin a plate of silver. The difficulty of such a piece of work is known only to those who are masters of the business. I then made stamps for the gold crowns, on which a cross was represented on one side, with certain figures of little cherubim, and on the other were the duke's arms. When I had finished this job, that is, when I had stamped these four sorts of pieces, I again requested his excellency that he would provide apartments* for me according to his promise, if he was satisfied with my services. He answered in the most obliging terms, "that he was perfectly satisfied, and would give the proper orders." When I spoke to him on this occasion, he happened to be in his armoury, in which was a fusil of admirable workmanship, that had been sent him from Germany. Seeing me look attentively at this fine piece, he delivered it into my hands, telling me that he knew very well how fond I was of fowling, and, as an earnest of what he proposed doing for me, he desired I would choose any other gun, except that, out of his armoury; assuring me that I should meet with some that were full as handsome and as good. I accepted of his kind offer, and returned him thanks; whereupon he gave directions to the keeper of his armoury, one Pietrino da Lucca, to let me have any piece I should make choice of: he then said many obliging things to me, and withdrew, to give me an opportunity of pleasing my fancy. I stayed some time behind, picked out the finest and best gun I ever saw in my life, and carried it home with me.

Two days after, I waited upon him with some little sketches which I had received orders from his excellency to draw, for some works in gold; these he had given me directions to begin directly, proposing to send them as presents to his consort, who was then at Naples. I again pressed him to provide for me in the manner he had promised. He thereupon told me, that I should make the mould for a fine portrait of him, as I had done for Pope Clement. I began this portrait in wax, and his excellency gave orders, that at whatever hour I came to take his likeness, I should be admitted. Perceiving that the affair hung a long time upon my hands, I sent for one Pietro Paolo of Monte-ritondo, the son of him at Rome, whom I had known from a child: and finding that he was then in the service of one Bernardaccio, a goldsmith, who did not use him well, I took him from his master, and taught him the art of coining. In the mean time I drew the duke's likeness, and often found him

* In fact, he never before mentioned these apartments.

taking a nap after dinner, with his kinsman Lorenzo de' Medici, who afterwards murdered him, but with nobody else. I was very much surprised that so great a prince should have so little regard to the security of his person. It came to pass that Ottaviano de' Medici, who seemed to have the general direction of affairs, showed a desire contrary to the Duke's inclination, to favour the old master of the mint, named Bastiano Cennini. This man, who adhered to the ancient taste, and knew but little of the business, had caused his ill-contrived tools to be used promiscuously with mine in stamping the crowns. This I complained of to the Duke, who finding that I spoke the truth, grew very angry, and said to me, "Go tell Ottaviano of this, and let him see the pieces." I went directly, and showed him the injury that was done to my fine coins: he told me bluntly, that it was his pleasure to have matters conducted in that manner. I answered, that it was a very improper manner, and extremely disagreeable to me. He replied, "But suppose it should be agreeable to the Duke?" "Even so I should disapprove of it," answered I, "for the thing is neither just nor reasonable." He then bade me begone, telling me I must swallow the pill were I even to burst. Upon my return to the Duke, I related to him the whole contest between Ottaviano de' Medici and myself, requesting his Excellency not to suffer the fine pieces which I had stamped for him to be brought into disgrace; and at the same time I desired my discharge. He then said, "Ottaviano presumes too much: you shall have what you require of me, for the insult upon this occasion is offered to myself."

That very day, which was Thursday, I received from Rome an ample safe-conduct of the Pope's, directing me to repair forthwith to that city, at the celebration of the feast of the Virgin Mary in August, that I might clear myself from the charge of murder. When I waited on the Duke I found him in bed; being indisposed, from some intemperance, as he told me himself. I finished in a little more than two hours what remained for me to do of his waxen medal, and he was highly pleased with it. I then showed his excellency the safe-conduct, which I had received by the Pope's order, telling him at the same time, that his Holiness was for employing me in some works, which would give me an opportunity of seeing once more the beautiful city of Rome, and in the mean time I would finish his excellency's medal. The duke answered, half angrily, "Benvenuto, do as I desire of you: I will provide for you and assign you apartments in the mint, with much greater advantages than you could expect from me, since what you ask is but just and reasonable. Who else do you think is able to stamp my coins like you, if you should leave me?" I replied, "My lord, I have taken care to obviate all

inconveniences: I have a pupil of mine here, a young Roman, whom I have trained to my business, and who will serve your Excellency to your satisfaction, till I finish the medal, and at my return I will devote myself for ever to your service. As I have a shop open in Rome, with workmen and some business, as soon as I have received my pardon at the capitol, I intend to leave all my affairs at Rome under the care of a pupil of mine, who resides in that city, and then, with your excellency's permission, I will come back to serve you." Upon this occasion there was present Lorenzo de' Medici, to whom the duke made several signs for him to join in persuading me to stay; but Lorenzo never said more than, "Benvenuto, your best way would be to remain where you are." I made answer, that I was resolved by all means to see Rome again. Lorenzo did not add another word; but continued to eye the duke with the most malicious glances. Having finished the medal, and shut it up in a little box, I said to his excellency: "My lord, you shall have reason to be satisfied, for I will make you a much finer medal than that of Pope Clement. It is natural that I should succeed better in this than in the other, as it was my first essay; and Signor Lorenzo, being a person of learning and genius, will furnish me with a device for a fine reverse." Lorenzo instantly replied, "That is the very thing I was just thinking of, to give you the hint of a reverse worthy of his excellency." The duke smiled, and looking upon Lorenzo, said, "You shall give him the subject of the reverse, and he will stay with us." Lorenzo thereupon answered without hesitation, "I will think of it as soon as I possibly can: my intention is to produce something to surprise the world." The duke, who sometimes was inclined to think him a little foolish, and sometimes to look upon him as a coward, turned about in bed, and laughed at his boasts.

I then took my leave without any ceremony, and left them together. The duke, who never thought I would leave him, said nothing farther. When he was afterwards informed that I had set out for Rome, he sent one of his servants after me, who overtook me at Siena, and gave me fifty gold ducats as a present from his master, desiring me to return as soon as I possibly could, and adding from Signor Lorenzo, that he was preparing an admirable reverse for the medal which I had in hand. I had left full directions to Pietro Paolo, the Roman above-mentioned, in what manner to stamp the coins; but as it was a very nice and difficult affair, he never acquitted himself in it as well as I could have wished. There remained at this time above twenty crowns due to me from the mint for making the irons.

CHAPTER XVII.

The Author, soon after his return, is attacked in his house by night by a numerous posse of sbirri, or constables, sent by the Magistrate to apprehend him for killing Pompeo of Milan.—He makes a noble defence, and shows them the Pope's safe-conduct.—He waits upon the Pope, and his pardon is registered at the Capitol.—He is taken dangerously ill.—Account of what passed during his illness.—Surprising fidelity of his partner Felice.

On my journey to Rome, I carried with me the fine gun which had been given me by Duke Alessandro, and with great pleasure made use of it several times by the way. I had a little house in the street Julia at Rome; but as it was not in order upon my arrival in that capital, I went to dismount at the house of Signor Giovanni Gaddi, a clerk of the chamber, to whose care I had at my departure committed a quantity of choice arms, and many other things upon which I set a high value. I did not, therefore, choose to alight at my own shop; but sent for my partner Felice, and desired him to set my little house in order. The day following I went to lie there, and provided myself with clothes and all other necessaries, intending the next morning to pay my respects to the Pope, and thank him for all favours. I had two servant boys, and a laundress, who cooked for me incomparably.

Having in the evening entertained several of my friends at supper, and passed the time very agreeably, I went quietly to bed; but scarce had the morning dawned, when I heard a violent knocking at the door. I thereupon called to the eldest of my boys, named Cencio (the very same whom I carried with me into the necroman-cer's circle), and bade him go and see what fool knocked at such a strange rate at that unseasonable hour. Whilst Cencio was gone, I lighted another candle (for I always kept one burning by night), and immediately put over my shirt an excellent coat of mail, and over that again some clothes, that accidentally came to hand. Cencio returning, said, "Alas! master, it is the captain of the city-guards, with all his followers; and he declares that if you make him wait, he will pull the door off the hinges; they have lighted torches, and a thousand implements with them." "Go tell them," I answered, "that as soon as I have huddled on my clothes, I will come down." Thinking that it might be an attempt to assassinate me, like that already made

by Signor Pier Luigi, I took an excellent hanger in my right hand, and in my left the Pope's safe-conduct, and ran directly to the back window, which looked into certain gardens, where I saw above thirty of the city-guards, which convinced me that it would be impossible to make my escape on that side. Having placed my two boys before me, I directed them to be ready to open the door when I should bid them; then holding the hanger in my right hand, and my safe-conduct in my left, quite in a posture of defence, I ordered the boys to open the door, and fear nothing.

That instant, Vittorio, the captain of the city-guards, rushed in with two of his myrmidons, thinking they should find it an easy matter to seize me; but when they saw me prepared for them, they fell back, and said one to another, "This affair is no jest." I threw them the safe-conduct, and said, "Read that: you have no authority to arrest me, and I am resolved you shall not so much as touch my person." The captain of the guard ordered some of his followers to seize me, adding, "That he would examine the safe-conduct at his leisure." Upon this I was animated with new courage, and brandishing my sword, I exclaimed, "You shall not take me alive!" The place we were in was very narrow: they seemed determined to have recourse to violence, and I was resolved to defend myself. The captain perceived that there was actually no probability of getting me alive into their power. The clerk being called, whilst he was reading the safe-conduct, the captain made signs two or three times to his men to lay hands on me, but they were intimidated at seeing me continue in the same posture of defence. At last giving up the enterprise, they threw the safe-conduct upon the ground, and went away without me.

I went to bed again, but found myself extremely fatigued, and could not sleep a wink afterwards. Though I formed a resolution to get myself blooded as soon as it should be day, I asked the advice of Signor Giovanni Gaddi, who consulted his physician: the latter desired to know whether I had been frightened? Here was a pretty physician to ask such a question, after I had related an event so replete with terror. He was one of those vain triflers who are always laughing, the least thing being sufficient to put him into a merry mood; so in his usual jocular strain he bid me drink a glass of good Greek wine, be cheerful, keep up my spirits, and fear nothing. Signor Giovanni then said, "A statue of bronze or marble would have been afraid upon such an occasion, much more a man." This precious physician replied, "My lord, we are not all formed in the same manner: this is neither a man of bronze nor of marble, but of iron itself." So having felt my pulse, he burst out a-laughing, as was

customary with him, and said to Signor Giovanni, "Do but feel this
pulse, it is neither that of a man nor of a timorous person, but of a
lion or a dragon." But I, finding my pulse immoderately high, knew
what that meant, and perceived that my doctor was an ignorant
quack, who had neither studied Galen nor Hippocrates; but for fear
of increasing the terror and agitation I was in, I assumed an appear-
ance of intrepidity and resolution. In the mean time, Signor Gio-
vanni ordered dinner to be served up, and we all dined together.
The company, exclusive of Signor Giovanni, consisted of Signor
Luigi da Fano, Signor Giovanni Greco, Signor Antonio Allegretti,
all men of profound learning, and Signor Annibale Caro, who was
very young. The conversation, during the whole time that we were
at table, turned upon no other topic but the gallant action which has
been related above. They likewise caused the whole story to be re-
lated by my boy Cencio, who was very ready-witted, had a becoming
confidence, and fine person. The lad, as he related my bold exploit,
assumed the attitudes which I had thrown myself into, and repeated
exactly the expressions I made use of, constantly making me recol-
lect some new circumstance; and as they asked him several times
whether he had been afraid, he answered that they should propose
the question to me, for he had been affected upon the occasion just
in the same manner that I was. This trifling became at last disagree-
able to me, and finding myself very much disordered, I rose from
table, telling the company that I intended to change my clothes, and
to dress myself, together with my boy, in blue and silk; for I pro-
posed in four days' time, upon the festival of the Virgin Mary, to
walk in procession, and that Cencio should carry before me a white
torch lighted. Having left them, I went and cut out the blue clothes
and a fine waistcoat of blue silk, with a little cloak of the same; and
I had a cloak and a waistcoat of blue taffety made for the lad.

As soon as I had cut out the clothes, I repaired to the Pope, who
desired me to confer with Signor Ambrogio, as he had given orders
for a work of great importance, which I was immediately to take in
hand. I went directly to Signor Ambrogio, who had received a cir-
cumstantial account of the whole proceedings of the captain of the
city-guard, was in the plot with my enemies to drive me from Rome,
and had reprimanded the captain for not taking me; but the latter
alleged in his vindication that he could not do it in defiance of a safe-
conduct. This Signor Ambrogio began to talk to me of the work
which the Pope had proposed to him; and next desired me to com-
mence the designs, declaring that he would afterwards provide what-
ever was necessary. In the mean time the festival of the Virgin
Mary drew near; and as it was customary for those who had received

such a pardon as mine to surrender themselves prisoners, I went again to the Pope, and told his Holiness that I did not choose to be confined, but begged it as a favour of him that he would dispense with my going to prison. The Pope answered that it was an established custom, and that I must conform to it. I fell upon my knees again, and returned thanks for the safe-conduct which his Holiness had granted me; adding, that I should return with it to serve my patron the Duke of Florence, who waited for me with so much eagerness and ardour of affection. Upon this, his Holiness turned about to one of his confidants, and said, "Let the pardon be granted to Benvenuto without his complying with the condition of imprisonment; and let his patent be properly made out." So the patent being settled, the Pope returned it, and caused it to be registered in the Capitol. Upon the day appointed for that purpose I walked very honourably in procession between two gentlemen, and received a full pardon.

About four days after I was attacked by a violent fever, which began with a most terrible shivering. I confined myself to my bed, and immediately concluded the disease to be mortal. I sent, however, for the most eminent physicians of Rome, amongst whom was Signor Francesco da Norcia, an old physician, and one of the greatest reputation in his business in that city. I told the physicians what I apprehended to be the cause of my disorder, and that I had desired to be let blood, but was dissuaded from it; but if it was not too late, I begged they would order me to be blooded. Signor Francesco made answer, that bleeding could then be of no service, though it might have been so at first; for if I had opened a vein in time I should have had no illness, but now it would be necessary to have recourse to a different method of cure. Thus they began to treat me to the best of their knowledge, and with the utmost care. My disorder, however, gained ground daily, so that in about a week it rose to such a pitch that the physicians gave me over, and directed that whatever I desired should be given me. Signor Francesco said, "As long as there is breath in his body send for me at all hours, for it is impossible to conceive how great the power of nature is in such a young man: but even if it should quite fail him, apply these five medicines one after another, and send for me. I will come at any hour of the night, and should be better pleased to save his life than that of any cardinal in Rome.

Signor Giovanni Gaddi came to see me two or three times a-day, and was continually handling my fine fowling-pieces, my coat of mail, and my swords, saying, "This is very fine; this again is much finer." The same of my little models, and other knick-knacks, inso-

much that he quite tired my patience. With him there came one Mattio Franzesi, who seemed quite impatient till I was dead; not because he was to inherit any thing of mine, but he wished for what Signor Giovanni appeared to have so much at heart. I had with me my partner Felice, of whom mention has so often been made, and who gave me the greatest assistance that ever one man afforded another. Nature was in me debilitated to such a degree, and brought so low, that I was scarcely able to fetch my breath; but my understanding was as unimpaired as when I enjoyed perfect health. Nevertheless I imagined that an old man, of an hideous figure, came to my bedside, to haul me violently into a large bark: I thereupon called to my friend Felice, and desired him to approach, and drive away the old villain. Felice, who had a great friendship for me, ran towards the bedside in tears, and cried out, "Get thee gone, old traitor, who attemptest to bereave me of all that is dear to me in life." Signor Gaddi, who was then present, said, "The poor man raves, and has but a few hours to live." Mattio observed, that I had read Dante, and in the violence of my disorder was raving from passages in that author; so he continued to say laughing, "Get hence, old villain, and do not disturb the repose of our friend Benvenuto." Perceiving myself derided, I turned to Signor Gaddi, and said to him, "My dear sir, do not think I rave: what I tell you of the old man who persecutes me so cruelly is strictly true. You would do well to turn out that cursed Mattio, who laughs at my sufferings; and since you do me the honour to visit me, you should come in the company of Signor Antonio Allegretti, and Signor Annibale Caro, with the other men of genius of your acquaintance, who are very different in sentiment and understanding from that blockhead." Thereupon Signor Gaddi, in a jesting way, bade Mattio quit his presence for ever. However, though the fellow laughed, the jest became earnest, for Gaddi would never see him more, but sent for Signor Antonio Allegretti, Signor Lodovico, and Signor Caro.

No sooner had those worthy persons appeared, than I began to take comfort, and conversed with them awhile in my right senses. As I, notwithstanding, from time to time urged Felice to drive away the old man, Signor Lodovico asked me, what I thought I saw, and what appearance the old man had. Whilst I was giving him a description of this figure, the old man pulled me by the arm, and dragged me by main force towards his horrid bark. When I had uttered the last word, I was seized with a terrible fit, and thought that the old man threw me into the vessel. I was told that whilst I was in this fainting fit, I struggled and tossed about in bed, and gave Signor Gaddi abusive language, telling him that he came to rob me,

and not for any good purpose; with many other ugly expressions, which occasioned great confusion to Gaddi; after which, as I was told, I left off speaking, and remained like a dead creature for above an hour.

Those that were present, imagining that the agonies of death were coming upon me, gave me over and went to their respective homes. Mattio heard the news, and immediately wrote to Florence, to Benedetto Varchi, my most intimate friend, that I had expired at such an hour of the night. That great genius, upon this false intelligence, which gained universal credit, wrote an admirable sonnet, which shall be inserted in its proper place. It was three hours before I came to myself, and all the remedies prescribed by Signor Francesco having been administered without effect, my good friend Felice flew to the doctor's house, and knocked till he made him awake and get out of bed: he then with tears in his eyes entreated him to come and see me, as he was afraid I had just expired. Signor Francesco, who was one of the most passionate men living, answered, "To what purpose should I go? If he is dead, I am more sorry for him than yourself. Do you think, even if I should go, that I am possessed of any nostrum to restore him to life?" Perceiving however that the poor young man was going away in tears, he called him back and gave him a sort of oil to anoint the several pulses of my body, directing my little fingers and toes to be pressed hard, and that they might send for him again in case I was to come to myself. Felice, at his return, did all that he was ordered by Signor Francesco; and having in vain continued to do so until day-light, they all believed the case to be hopeless, and were just going to lay me out. In a moment, however, I came to myself, and called to Felice to drive away the old man that tormented me. Felice was for sending for Signor Francesco, but I told him that he need not send for any body, that he had nothing more to do but to come close to me himself, for the old man was afraid of him, and would immediately quit me upon his approach. Upon Felice's coming up to the bedside, I touched him, and then my imagination was impressed, as if the old man had left me in a passion: I therefore entreated my friend to stay constantly by my bedside.

Signor Francesco then making his appearance, declared that at any rate he would save me, and that he had never in his life known a young man of so vigorous a constitution. Then sitting down to write a recipe, he prescribed perfumes, poultices, washings, unctions, and many things more, too tedious to enumerate. In the mean time I found myself in a sad perplexity, a prodigious crowd being come to see my resuscitation. There were present men of great importance, and in vast numbers, before whom I declared, that what little gold

and money I had, (the whole might amount to the value of about eight hundred crowns in gold, silver, jewels, and money,) I desired to be made over to my poor sister, who lived at Florence, and whose name was Mona Lipperata. The remainder of my effects, whether furniture, or other things, I left to my poor Felice, and fifty gold crowns besides, to purchase clothes. At these words, Felice threw his arms about my neck, and protested he desired nothing but that I should recover and live. I then said, "If you wish me to live, touch me in this manner, and scold this old fellow who is so much afraid of you." When I spoke thus, some present were quite frightened, seeing that I did not rave, but spoke coherently, and to the purpose. In this manner my disorder continued, and I recovered but slowly. The kind Signor Francesco visited me four or five times a-day, but I saw no more of Signor Gaddi, whom I had put into such confusion. My brother-in-law came from Florence for the legacy, but being a very worthy man, was highly rejoiced to find me alive. It was a great consolation to me to see him, and he behaved to me with the utmost kindness, declaring that his visit was with no other view but to take care of me himself; so he did for several days, and then I dismissed him, having scarce any doubt of my recovery. At his departure he left the sonnet of Signor Benedetto Varchi, which is as follows:

SONNET UPON THE FALSE REPORT OF THE DEATH OF BENVENUTO CELLINI

Who shall, Mattio, ease our present grief?
 Can streaming tears and sorrow soften death?
Can sad complaints bestow the wish'd relief?
 Since our loved friend resigns his latest breath.

His soul, with all the shining graces fraught,
 In early youth felt friendship's sacred flame
To tread the rugged path of virtue taught,
 To mount the skies, and leave a matchless name.

O gentle shade, if in the realms of day,
 Thou'rt sway'd by love or tender friendship's powers;
Hear me bewail my loss in mournful lay,
 Not weep a friend transferr'd to heavenly bowers.

To blissful seats, in glories bright array'd,
 Too soon, alas! thou'st wing'd thy rapid flight;
The great Creator, to full view display'd,
 There without dazzling meets thy ravish'd sight.

 Thus thou beholdest, in yon radiant sphere,
 Him, whom thy art so well depicted here.

My disorder was so exceedingly violent, that there appeared no possibility of a cure, and the good Signor Francesco da Norcia had more trouble than ever, bringing me new remedies every day, and endeavouring to strengthen and repair my poor crazy frame; but notwithstanding all the pains he took, it did not appear possible for him to succeed. All my physicians were disheartened, and quite at a loss what course to follow. I was troubled with a violent thirst, but for several days observed the rules they prescribed me; while Felice, who thought his achievement great in saving my life, never quitted my bedside: at the same time the old man began to be less troublesome, though he sometimes visited me in my dreams. One day Felice happened to be out, and there were left to take care of me an apprentice and a girl named Beatrice. I asked the apprentice what had become of my boy, Cencio, and why I had never seen him there to attend me? The lad told me, that Cencio had been afflicted with a more severe disorder than myself, and was then at the point of death; adding, that Felice had strictly enjoined them to conceal it from me. When he told me this, I was very much concerned. Shortly after, the servant Beatrice, who was a native of Pistoia, was in an adjoining room; I called and begged of her to bring me a large crystal wine-cooler, which stood hard by, full of cold water. The girl ran directly and brought it. I desired her to hold it up to my mouth, telling her, that if she would let me drink a good draught, I would make her a present of a new gown. Beatrice, who had stolen some things of value from me, and was apprehensive that the theft might be discovered, wished very much for my death; she therefore let me, at two draughts, swill myself with as much water as I could swallow, so that I may say, without exaggeration, that I drank above a quart. I then covered myself up with the bed clothes, began to sweat, and fell asleep. Felice returning after I had slept about an hour, asked the boy how I was? He answered, "I cannot tell, Beatrice has taken the wine-cooler full of water, and he has drunk it nearly all: I do not know now whether he is dead or alive." They say that the poor young man was so affected at this intelligence, that he was almost ready to drop; but seizing a stick he soundly cudgelled the girl, exclaiming, "Ah! traitress, that you should be the cause of his death." Whilst Felice was beating, and the girl screaming, I dreamt that the old man had cords in his hands, and that upon his making an attempt to bind me, Felice came upon him with an axe, which he used to such effect, that the old fellow ran away, crying out, "Let me be gone; I shall be in no hurry to return." In the mean time Beatrice ran into my chamber, bawling so loud that I awoke and said, "Let the girl alone, with a design, perhaps, to hurt me, she has done me more good than you,

with all your kind attentions: now lend me a helping hand, for I have just had a sweat." Felice, recovering his spirits, rubbed me well, and said all he could to hearten me; and I finding myself much better, began to have hopes of my recovery. Signor Francesco soon made his appearance, and seeing me so much better, the girl crying, the apprentice running backwards and forwards, and Felice laughing, concluded from this hurry, that something extraordinary had happened, which was the cause of so great a change. Immediately after came in Bernardino, who had been against bleeding me in the beginning. Signor Francesco, who was a man of sagacity, could not help exclaiming, "O wonderful power of Nature! She knows her own wants; physicians know nothing!" The fool Bernardino thereupon said, "Had I drunk another flask, I had been immediately cured." Signor Francesco da Norcia, from his great experience, treated this opinion with the contempt it deserved; saying, "The devil give you good of such a notion!" and turning about to me, asked me, whether I could have drunk any more? I answered that I could not, as I had completely quenched my thirst. Then addressing himself to Bernardino, "Do not you see," said he, "that nature took just what she had need of, and neither more nor less: in like manner she required what was necessary for her relief, when the poor young man begged of you to bleed him. If you knew that drinking two flasks of water would save his life, why did you not say so before? you would then have had something to boast of." At these words the little doctor took himself off crest-fallen, and never made his appearance again. Signor Francesco directed, that I should be removed out of that apartment, to a lodging upon one of the hills of Rome.

Cardinal Cornaro, having heard of my recovery, ordered me to be carried to a house which he had at Monte Cavallo. That very evening I was carefully conveyed in a sedan, well covered and wrapt up. No sooner was I arrived, than I began vomiting, during which there came from my stomach a hairy worm, about a quarter of a cubit long: the hairs were very long, and the worm was most disgusting, having spots of different colours, green, black, and red—it was kept to be shown to the doctor. Signor Francesco, declaring he had never seen any thing like it, addressed himself thus to Felice: "Take care of your friend Benvenuto, who is now cured: do not let him be any way intemperate, for though he has escaped this time, another excess may occasion his death. You see his disorder was so violent, that when the holy oil was brought him, it was too late. I now perceive that, with a little patience and time, he will be again in a condition to produce more masterpieces of art." He then turned about to me and said, "Dear Benvenuto, be careful, and do not

indulge in any excess, and as you are now recovering, I intend you shall make me an image of our Lady, whom I shall always worship for your sake." I promised to follow his advice, and asked him whether it would be safe to have myself removed to Florence. He answered that I should stay till I was a little better, and we saw how nature stood affected.

CHAPTER XVIII.

The Author upon his recovery sets out for Florence, with Felice, for the benefit of his native air.—He finds Duke Alessandro greatly prepossessed against him by the malicious insinuations of his enemies.—He returns again to Rome, and attaches himself with assiduity to his business.—Strange phenomenon seen by him in coming home from shooting in the neighbourhood of Rome.—His opinion concerning it.— News of the murder of Duke Alessandro, who is succeeded by Cosmo de' Medici.— The Pope having received intelligence that the Emperor Charles V. was setting out for Rome after his successful expedition against Tunis, sends for our Author, to employ him in a curious piece of workmanship, intended as a present for his Imperial Majesty.

HAVING waited a week, I found in myself so little alteration for the better, that my patience was almost tired out, for my illness had now continued above fifty days; I resolved to delay no longer, and having accommodated myself with an open carriage, my dear friend Felice and I set out directly for Florence. As I had not written to any person, I went to my sister's, who welcomed me with tears and smiles at the same moment. The same day many of my friends came to see me, and among them Pier Landi, one of the best and dearest I ever had.

A day or two after, there came one Niccolo da Monte Acuto, who was likewise my particular acquaintance. He had heard the duke say, "It would have been better for Benvenuto if he had died, for in coming hither he has fallen into a snare, and I will never forgive him." Poor Niccolo said to me, with the tone of a man in despair, "Alas! my dear Benvenuto, what brought you hither? Did you not know that you had given offence to the duke? I have heard him swear that you had fallen into a snare." I answered, "Signor Niccolo, I beg you will put his excellency in mind that Pope Clement was going to treat me in the same manner, and with as little reason. Let him but suffer me to recover my health thoroughly, and I shall convince him that I am the most faithful servant he ever had in his life, and that some of my enemies have prejudiced him against me."

The person that had thus brought me into disgrace with his ex-
cellency, was Giorgetto Vasellai of Arezzo, the painter, in return
for the many favours I had conferred on him. I had maintained
him at Rome, and borne his charges, though he had turned my house
topsy-turvy; for he was troubled with a sort of dry leprosy, which
made him contract a habit of scratching himself continually: hence,
as he lay with a journeymen of mine, named Manno, whilst he
thought he was scratching himself, he tore the skin off one of
Manno's legs, with his great claws, for he never pared his nails:
Manno thereupon left me, and would have put him to death; but I
found means to reconcile them. I afterwards got Giorgio into the
service of the Cardinal de' Medici, and was always a friend to the
man. In return for all these favours and acts of friendship, he told
Duke Alessandro, that I had spoken ill of his excellency, and had
made it my boast that I should be one of the first to scale the walls
of Florence, and assist his enemies against him. These words, as I
understood afterwards, he dropped at the instigation of Ottaviano
de' Medici, whose aim was to be revenged for the trouble given him
by the duke upon occasion of my coins, and my departure from
Florence. But as I knew myself entirely innocent of the charge, I
was not under any sort of apprehensions: what contributed still more
to make me easy was, that the worthy Signor Francesco da Monte
Varchi attended me with the utmost care, and had brought thither
my dear friend Luca Martini, who passed the greatest part of the
day with me.

In the mean time I despatched my trusty partner Felice to Rome,
to look into the state of my affairs in that city. As soon as I could
raise my head from the pillow, which was at the end of a fortnight,
being still unable to walk, I desired to be carried into the palace of
the Medici, to the little terrace, and there to be left seated till the
duke should pass by. Several of my friends at court expressed great
surprise that I should suffer the inconvenience of being carried in
that manner, being still so very infirm; telling me, that I should
have waited till my health was thoroughly restored, and then have
visited the duke. A great number had now gathered about me, and
they all seemed to consider my being there as a sort of miracle, not
so much from their having heard that I was dead, as that I should
make my appearance there in such a state. I said to the gentlemen
present, that some malicious villain had told the duke, that I had
boasted I should be one of the first to scale his excellency's walls,
and that I had spoken disrespectfully of him; therefore I could
neither live nor die contented, till I had cleared myself from the
infamous aspersions cast upon me, and discovered the villain who

gave rise to so black a calumny. When I spoke thus, there was gathered about me a crowd of courtiers, all of whom seemed deeply to compassionate my case, and expressed their sentiments variously concerning it: as for me, I declared my resolution never to quit the place till I had discovered my accuser. When I had uttered these words, Signor Agostino, the duke's tailor, mixing with the gentlemen belonging to the court, came up to me, and said, "If that is all you are so solicitous to know, you shall soon be satisfied." Just at that instant, Giorgetto the painter, of whom mention has been made, passed that way. Agostino said, "There goes your accuser; whether what he says be true or false, you know best." Though I could neither stir nor move, I boldly asked Giorgetto, whether it was true that he had accused me in that manner? Giorgetto answered, that it was false, and that he had never said any such thing. Agostino then replied, "Abandoned wretch, don't you know that I speak upon a certainty?" Giorgetto instantly quitted the place, declaring it was false. A short time after the duke himself appeared: I caused myself to be supported in his excellency's presence, and he stopped. I then said, that I was come there for no other motive but to justify my conduct. The duke looked at me attentively, and expressing great surprise that I was still alive, bade me endeavour to show myself an honest man, and take care of my health. As soon as I had got home, Niccolo da Monte Acuto came to me, and told me that I was in the most dreadful jeopardy conceivable, such as he never should have believed; that I was a marked man; that it was most advisable therefore for me to endeavour to recover my health with all convenient speed, for danger impended over my head from a man who was to be feared. He then added, "Consider with yourself, how have you offended that good-for-nothing Ottaviano de' Medici?" I answered that I had never offended him, but that he had wronged me; so I related to him the whole affair of the mint. His reply to me was, "Go your ways, in God's name, with all the expedition possible, and make yourself quite easy, for you will have the pleasure of being revenged sooner than you desire." I made a short stay to recover my health, gave Pietro Paolo my directions with regard to stamping the coins, and then set out upon my return to Rome, without saying a word to the duke, or to any body else.

Upon my arrival in that capital, after I had sufficiently enjoyed myself in the company of my friends, I began the duke's medal, and had in a few days engraved the head upon steel: it was the finest piece of work of the sort that ever came out of my hands. At this time I was visited at least once every day by a foolish sort of a person, named Francesco Soderini, who seeing what I was about,

frequently said to me, "Cruel man, will you then immortalize so fierce a tyrant? As you never made any thing so fine before, it is evident that you are our inveterate foe, and so much a friend to that party, that both the Pope and he were mistaken when they would have hanged you: one was the Father, the other the Son, now beware of the Holy Ghost." It was believed for a certainty that Duke Alessandro was the son of Pope Clement. Signor Francesco farther added, and even swore, that if he had had an opportunity, he would have stolen the irons with which I made that medal. I replied that he had done well to tell me his mind, for I would take particular care he should never see them again.

I then sent to Florence to let Lorenzo know, that it was time for him to send me the reverse of the medal. Niccolo da Monte Acuto, to whom I wrote on this occasion, returned for answer, "that he had applied to that melancholy simpleton Lorenzo, who assured him that he thought of nothing else day and night, and that he would finish it as soon as he possibly could. He at the same time advised me not to depend upon that reverse, but devise one of my own imagination, and as soon as it was finished, carry it to Duke Alessandro. Having made a design of what appeared to me a proper reverse, I began to work upon it with all expedition. But as I had not yet thoroughly got the better of my late dreadful disorder, I frequently took the recreation of fowling. On these occasions I was accompanied by my dear friend Felice, who understood nothing of my business, but, from our being inseparable companions, it was generally thought that he must have great talents that way; so, as he was a very facetious person, we several times diverted ourselves with the reputation which he had acquired. His name being Felice Guadagni, he would sometimes play upon the word, saying, "I should have little right to be called Felice Guadagni (gains), if you had not procured me so great a reputation, that I may justly be named from gain." My answer to him was, that there are two methods of gain, the first that of gaining for ourselves, the second that of gaining for others; and that I gave him much more credit for the second method than the first, as he had gained me my life.

Such conversations as these frequently passed between us, but particularly once at the Epiphany, when we were both near the Magliana. The day was then almost spent, and I had shot a considerable number of ducks and geese; so having, as it were, formed a resolution to shoot no more that day, we made all the haste we could to Rome, and I called my dog, to whom I had given the name of Baruccio. Not seeing him before me, I turned about, and saw the well-taught animal watching some geese that had taken up their

quarters in a ditch. I thereupon dismounted, and having charged my piece, shot at them from a considerable distance, and brought down two with a single ball; for I never used a greater charge, and with this I seldom missed at the distance of two hundred cubits, which is more than can be accomplished by other modes of loading. Of these one was almost dead, and the other, though wounded, made an impotent attempt to fly: my dog pursued the last, and brought it to me. Seeing that the other was sinking in the ditch, I came up to it, trusting to my boots, which were tolerably high: however, upon pressing the ground with my foot, it sunk under me; and though I took the goose, the boot on my right leg was filled with water. I held my foot up in the air to let the water run out: and, having mounted, we returned to Rome with the utmost expedition: but as the weather was extremely cold, I felt my leg frozen to such a degree, that I said to Felice—"Something must be done for the relief of this leg, for the pain it gives me is insupportable." The good-natured Felice, without a moment's delay, alighted from his horse, and having collected some thistles and small sticks, was going to make a fire: in the mean time having put my hands upon the feathers of the breast of the goose, I felt them very warm; upon which I told Felice that he need not trouble himself to make a fire: and, filling my boot with the feathers, I felt a genial warmth which invigorated me with new life.

Having again mounted our horses, we rode full speed to Rome. It was just night-fall when we arrived at a small eminence; and happening to look towards Florence, we both exclaimed in the utmost astonishment—"Great God! what wonderful phenomenon is that which appears yonder over Florence!" In figure it resembled a beam of fire, which shone with an extraordinary lustre. I said to Felice, "We shall certainly hear that some great event has occurred at Florence." By the time we arrived at Rome it was exceedingly dark; and when we were come near the Bianchi quarter, not far from our own house, I going at a brisk canter, there chanced to be a heap of rubbish and broken tiles in the middle of the street, which neither my horse nor I perceived. He ascended it with precipitation; and then descending, stumbled and fell with his head between his legs; but by God's providence I escaped unhurt. The neighbours came out of their houses with lights upon hearing the noise. I had then got up, and ran to my house quite overjoyed at having received no harm, when I had been so near breaking my neck. I found some of my friends at home, to whom during supper I gave an account of my achievements in fowling, and of the strange phenomenon we had seen. They inquired what, in God's name, could be the meaning

of such an appearance. "Doubtless," answered I, "some revolution must have happened at Florence." Thus we supped together cheerfully, and late the day following news was received at Rome of the death of Duke Alessandro. Thereupon several of my acquaintance came to me and said, "Your conjecture was very right, that something extraordinary happened at Florence."

In the mean time Signor Francesco Soderini came trotting upon a little mule, and laughing ready to split his sides. "This," cried he, "is the reverse of the medal of that vile tyrant, which you were promised by your friend Lorenzo de' Medici: you were for immortalizing dukes, but we are for no more of them:" and went on jeering me, as if I had been a leader of one of those factions by which men are raised to ducal authority. Just at this time came up one Baccio Bettini, who had a head as big as a bushel: even he must rally me upon the same subject, and say—"We have unduked them at last, and we will have no more dukes, though you were for immortalizing them;" with a deal more such senseless prating, which I, being in no humour to relish, replied, "O you fools! I am a poor goldsmith, and work for whoever pays me, yet you turn me into ridicule, as if I were the leader of a party. I will not, however, in return reproach you with the avarice, folly, and worthlessness of your ancestors; but I must tell you, in answer to all your insipid raillery, that before two, or at farthest three days are over, you will have another duke, and perhaps a much worse than your last."

A day or two after Bettini came again to my shop, and said, "You have no occasion to spend your money to pay messengers, since you are acquainted with events before they come to pass: What familiar spirit are you indebted to for your intelligence?" He then gave me to understand that "Cosmo de' Medici, son to Signor Giovanni, was made duke, but that he was invested with the dignity on certain conditions, which would control him in the indulgence of his caprice." I now had an opportunity of laughing at them in my turn, so I said, "The citizens of Florence have put a young man upon a mettlesome horse; they have fitted him with spurs, left the bridle to his guidance, and set him at liberty upon a fine plain, in which are flowers, fruits, and all things that can delight the senses: after this they direct him not to go beyond certain limits assigned. Now pray tell me, who has the power to prevent him, when he has an inclination to pass them? Laws cannot be prescribed to him who is master of the law." From that time forward they ceased to molest me.

Beginning now to attend the business of my shop, I set about some jobs which were not of great importance; for I made the re-

covery of my health my chief care, and did not think myself yet entirely secure from a relapse. About this time the Emperor returned victorious from his enterprise against Tunis, when the Pope sent for me and asked my advice what sort of present he should make that prince. I answered, that the most proper present to make his Imperial Majesty was a golden crucifix, for which I had devised a sort of ornament which would be extremely suitable, and do both his Holiness and myself great honour; having already made three small figures in gold, round, and about a span high. These were the same figures that I had begun for the chalice of Pope Clement; and which were intended to represent Faith, Hope, and Charity. Having therefore added, in wax, what was wanting at the foot of the cross, I carried it to the Pope with the figure of Christ in wax, and several other elegant ornaments, with which he was highly pleased, and before I left him we agreed upon every thing that was to be done, and calculated the expense of the work.

This was a little after sunset, and the Pope had given orders to Signor Latino Giovenale to supply me with money the next morning. Latino, who had a great dash of the fool in his composition, wanted to furnish the Pope with a new invention, which should come entirely from himself, so that he counteracted all that his Holiness and I had settled. In the morning, when I went for the money, he said to me, in that coarse tone of presumption so peculiar to him: "It is our part to invent, yours to execute: before I left the Pope last evening, we designed something much better." When he had uttered these words, I did not suffer him to proceed, but said, "Neither you nor the Pope can ever think of a better device than this, in which Christ is represented with his cross, so now you may continue your courtier-like impertinence as long as you please." Without making any answer, he quitted me with great indignation, and endeavoured to get the work put into the hands of another goldsmith; but the Pope was against it.

His Holiness sent for me directly, and told me, "That I had given very good advice, but that they intended to make use of an office of the Virgin Mary, with admirable illuminations, which had cost the Cardinal de' Medici above two thousand crowns, and that this would be a very proper present for the empress; that the emperor should afterwards receive what I had proposed, which would be indeed a present worthy of his majesty; but now there was no time to lose, that prince being expected in about six weeks. For this book, the Pope desired to have a cover made of massy gold, richly chased, and adorned with a considerable number of jewels, worth about six thousand crowns: so when he had furnished me with the

jewels and the gold, I immediately set about the work, and, as I used all possible expedition, it appeared in a few days to be of such admirable beauty, that the Pontiff was surprised at it, and conferred extraordinary favours upon me, at the same time forbidding that fool, Giovenale, to disturb me in my business.

CHAPTER XIX.

The Emperor Charles V. makes a triumphant entry into Rome.—Fine diamond presented by that Prince to the Pope.—Signor Durante and the Author nominated by his Holiness to carry his presents to the Emperor.—The presents sent by the Pope.—The Author makes a speech to the Emperor, who admits him to a private conference.—He is employed to set the fine diamond, which the Emperor had presented to the Pope.—Signor Latino Giovenale invents some stories to prejudice his Holiness against the Author, who thinking himself neglected, forms a resolution to go to France.—Anecdote of his boy Ascanio.

WHEN I had almost finished the work above mentioned, the emperor arrived at Rome,* and a great number of grand triumphal arches were erected for his reception. He entered that capital with extraordinary pomp, which it is the province of others to describe, as I shall not treat of subjects that do not concern me. Immediately on his arrival he made the Pope a present of a diamond, which had cost him twelve thousand crowns. The latter sent for me, and putting the diamond into my hands, desired me to set it in a ring for his finger; but first to bring him the book unfinished as it was. When I carried it to his Holiness, he was highly pleased with it, and consulted me respecting the excuse to be made to the emperor for the non-completion of the work. I said, "That the most plausible apology was my being indisposed, which his Imperial Majesty would be very ready to believe, upon seeing me so pale and emaciated." The Pope answered, "That he highly approved of the excuse; but desired me to add in his name, that in presenting his majesty with the book, I at the same time made him a present of myself." He suggested the words I was to pronounce, and the manner in which I was to behave: these words I repeated in his presence, asking him whether he approved of my delivery? He made answer, "That if I had but the confidence to speak in the emperor's presence in the same manner, I should acquit myself to admiration." I replied, "That without being in the least confusion, I could deliver, not only those words, but many more, because the emperor wore a lay habit like myself, and

* He entered Rome on the 6th of April, 1536.

I should feel that I was speaking to one formed like myself: but it was different when I addressed myself to his Holiness, in whom I discovered a much more awful representation of the divine power, as well because of his ecclesiastical ornaments which were heightened with a sort of glory, as on account of his venerable and majestic age: all which circumstances made me stand much more in awe in his presence, than in that of the emperor." The Pope then said, "Go, my good friend Benvenuto, acquit yourself like a man of worth, and you will find your account in it."

His Holiness at the same time ordered out two Turkish horses, which had formerly belonged to Pope Clement, and were the finest that had ever been brought into Christendom. These he committed to the care of Signor Durante, his chamberlain, to conduct them to the porch of the palace, and there present them to the emperor, at the same time directing him what to say on the occasion. We both went together, and when we were admitted into the presence of that great prince, the two horses entered the palace with so much grandeur and spirit, that the emperor and all the bystanders were astonished. Thereupon Signor Durante advanced in the most awkward and ungracious manner, and delivered himself in a sort of Brescian jargon, with such hesitation, and so disagreeably, that the emperor could not help smiling. In the mean time I had already uncovered my work, and perceiving that his Majesty looked at me very graciously, I stepped forward and expressed myself thus: "Sire, our holy father, Pope Paul, sends this office of our Lady, as a present to your Majesty: it was written, and the figures of it were drawn by the ablest man that the world ever produced. He presents you likewise with this rich cover of gold and jewels, which as yet remain unfinished in consequence of my indisposition: upon this account his Holiness, together with the book, presents me also, desiring that I should come to finish the work near your sacred person, and also serve your Majesty in whatever you may require of me, so long as I live." To this the emperor made answer: "The book is highly agreeable to me, and you are so likewise; but I wish you to finish the work for me at Rome, and when it is completed, and you are thoroughly recovered, I shall be glad to see you at my court." In the course of his conversation with me, he called me by my name, which I was greatly surprised at, as in what passed between us it had not been mentioned. He told me that he had seen the button of Pope Clement's pontifical habit, upon which I had designed such admirable figures. In this manner we protracted our discourse for the space of half an hour, talking upon many other curious and entertaining subjects. I acquitted myself upon the whole better than I expected;

and when the conversation came to a pause, I bowed and retired. The emperor was then heard to say: "Let five hundred gold crowns be given to Benvenuto without delay." The person who brought them, inquired which was he that had delivered the message from the Pope to the emperor. Durante thereupon came forward, and robbed me of the money. I complained of this to his Holiness, who desired me to be under no apprehensions, saying he was sensible how well I had behaved, and that I should certainly have my share of his majesty's bounty.

Upon my returning to my shop, I exerted myself with the utmost assiduity to finish the ring for the diamond, upon which account four of the most eminent jewellers in Rome were ordered to consult with me. The Pope had been given to understand, that the diamond had been set at Venice by the first artist in the world, whose name was Miliano Targhetta; and as the stone was somewhat sharp, it was thought too difficult an attempt to set it, without the advice and assistance of others. I made the four jewellers highly welcome; amongst whom was a native of Milan, named Gajo. This was one of the most arrogant blockheads breathing, who pretended to great skill in what he was altogether ignorant of: the rest were men of singular modesty and merit. Gajo took the lead of the rest, and said, "Endeavour to preserve the tint of Miliano: to that, Benvenuto, you must show due respect; for as the tinting of diamonds is the nicest and most difficult article in the jeweller's business, so Miliano is the greatest jeweller the world ever produced, and this is the hardest diamond that ever was worked upon." I answered, that it would be so much the more glorious for me to vie with so renowned an artist: then addressing myself to the other jewellers, I added, "You shall see now that I will preserve the tint of Miliano, and try whether I can in so doing improve it: in case I should fail of success, I will restore its former tint." The fool Gajo answered, "That if I could contrive to be as good as my word, he would bow to my superior genius." When he had finished, I began to make my tints. In the composition of these, I exerted myself with the utmost diligence, and shall in a proper place inform the reader how they are made.

I must acknowledge that this diamond gave me the most trouble of any that ever before or since fell into my hands, and Miliano's tint appeared to be a masterpiece of art; however I was not discouraged. My genius being upon this occasion in a particular manner sharpened and elevated, I not only equalled, but even surpassed it. Perceiving that I had conquered Miliano, I endeavoured to excel even myself, and by new methods made a tint much superior to my former. I then sent for the jewellers, and having given to the

diamond Miliano's tint, I afterwards tinted it again with my own. I showed it to the artists, and one of the cleverest amongst them, whose name was Raffaello del Moro, took the stone in his hand, and said to Giovanni, "Benvenuto has surpassed Miliano's tint." Gajo, who could not believe what he heard, upon taking the jewel into his hand cried out, "Benvenuto, this diamond is worth two thousand ducats more than it was with Miliano's tint." I replied, "Since I have surpassed Miliano, let me see whether I cannot outdo myself." Having requested them to have patience a few moments, I went into a little closet, and unseen by them gave a new tint to my diamond: upon showing it to the jewellers, Gajo instantly exclaimed, "This is the most extraordinary case I ever knew in my life; the diamond is now worth above 18,000 crowns, and we hardly valued it at 12,000." The other artists turning about to Gajo, said to him, "Benvenuto is an honour to our profession: it is but just that we should bow to the superiority of his genius and the excellence of his tints." Gajo made answer, "I will go and inform the Pope in what manner he has acquitted himself; and contrive so that he shall receive a thousand crowns for setting this diamond." Accordingly he waited on his Holiness and told him all he had seen: the Pontiff thereupon sent three times that day to inquire whether the ring was finished.

Towards evening I carried it to him: and as I had free access, and was not obliged to observe any ceremony, I softly lifted up a curtain, and saw his Holiness with the Marquess of Guasto, who would fain persuade him to something he did not approve of. I heard the Pope say to the marquess, "I tell you no, for it is proper that I should be neuter in the affair." As I immediately drew back, the Pope himself called to me: upon which I advanced, and put the fine diamond into his hand: his Holiness then took me aside, and the marquess retired to some distance. The Pope, whilst he was examining the diamond, said to me, "Benvenuto, pretend to talk to me of some subject of importance, and never once leave off whilst the marquess stays in this apartment." So choosing the subject that was most interesting to myself, I began to discourse of the method which I had observed in tinting the diamond. The marquess stood leaning on one side against a tapestry-hanging; sometimes he turned round on one foot, sometimes on the other. The subject of this conversation of ours was of such consequence, that we could have talked upon it three hours. The Pope took such delight in it, that it counterbalanced the disagreeable impression, which the conference with the marquess had made upon his mind. As I mixed with our conversation that part of natural philosophy which is connected with the jeweller's art, our chat was protracted almost the space of an

hour, and the marquess's patience was so worn out, that he went away half angry. The Pope then showed me great demonstrations of kindness, and concluded with these words, "My dear Benvenuto, be diligent in your business, and I will reward your merit with something more considerable than the thousand crowns which Gajo told me you deserved for your trouble."

I took my leave, and his Holiness praised me afterwards in the presence of his domestic officers, amongst whom was Latino Giovenale, who, being now become my enemy, endeavoured to do me all the ill offices in his power. Perceiving that the Pope spoke of me so advantageously, he said, "Benvenuto indeed is acknowledged to be a person of extraordinary talents; but though it is natural for every man to be partial to his own countrymen, and give them the preference, still the manner of speaking to so great a personage as a Pope deserves a proper degree of attention. He has had the boldness to declare, that Pope Clement was the handsomest prince that ever existed, and that his virtues and abilities were worthy of his majestic person, though he had adverse fortune to struggle with. This man, at the same time affirms, that your Holiness is quite the reverse, that your triple crown does not sit well on your head, and that you appear to be nothing more than a figure of straw dressed up, though you have always had prosperous fortune." These words were pronounced in so emphatical a manner by the person that spoke them, who knew very well how to give them a proper emphasis, that the Pope believed him. I had, notwithstanding, neither uttered such words, nor had it ever come into my head to make any such comparison. If the Pope had had it in his power to do it without hurting his character, he would certainly have done me some great injury, but being a man of understanding, he pretended to turn the thing into a jest: yet he bore me an inconceivable grudge in his heart, and I soon began to perceive it; for I had no longer the same easy access to him as formerly, but found it exceedingly difficult to be admitted into his presence. As I had long frequented his court, I immediately concluded that somebody had been doing me ill offices with him, and upon my artfully tracing the affair to its source, I was told all, but could not discover the person who had thus traduced me. I for my part was incapable of guessing who it was: had I come to the knowledge of the villain, I should have wreaked an ample revenge.

In the mean time I worked at my little book with the utmost assiduity, and when I had finished it, carried it to the Pope, who upon seeing it could not contain himself, but extolled it to the skies. I thereupon reminded him of his promise of sending me with it to the emperor. He made answer, that he would do what was proper,

and that I had done my part. He then gave orders that I should be well paid for my trouble. However, for the different works upon which I had been employed two months, I was paid five hundred crowns, and no more. All the great promises that had been made me were totally forgotten. I received for the diamond, a hundred and fifty crowns only; the remainder I had for the little book, for which I deserved above a thousand crowns, as the work was rich in figures, foliages, enamel, and jewels. I took what I could get, and formed a resolution to quit Rome directly. His Holiness sent the book to the emperor, by a nephew of his, named Signor Sforza*: that great prince was so pleased with the present as to bestow excessive praises on it, and immediately inquired after me. Signor Sforza, having received proper instructions, made answer, that an indisposition had prevented my waiting upon his Imperial Majesty; for I was afterwards informed of all that had passed upon the occasion.

Having in the mean time got myself in readiness for a journey to France, I proposed visiting that kingdom unaccompanied; but could not do as I intended on account of a youth who lived with me, and whose name was Ascanio. This young person was the best servant in the world: when I took him into my house he had just left a master, named Francesco, who was a Spanish goldsmith. I was unwilling to receive the lad for fear of having some dispute with the Spaniard, and therefore told him that I could not receive him, lest his master should be offended. At last the young man contrived to get his master to write me a letter, intimating that he had no objections to his entering into my service. He passed several months with me as meagre and lean as a skeleton. We called him the old man, and I thought that he was in fact old, as well because he was so good a servant, and so knowing, as because it did not appear probable that at the age of thirteen (for he said he was no more) he should be possessed of such maturity of understanding. To return to my subject: the young man in a few months began to improve in his person, and, getting into a good plight, was become the handsomest young fellow in Rome. As I found him so good a servant, and so apt and ready in learning my business, I conceived as great an affection for him as if he had been my son, and kept him as well dressed as if I had really been his father. Seeing himself so much altered for the better, he thought himself very happy in falling into my hands, and went several times to return thanks to his old master,

* Sforza Sforza, son of Bosio, Count of Santa Fiore, and of Costanza Farnese, a natural daughter of Paul III. He was then only a youth of sixteen years of age, but had at that time volunteered into the veteran army of Charles V., and proved one of the first commanders of the age.—See Ratti's *History of the Sforza Family.*

who had been the cause of his good fortune. The Spaniard had a handsome young wife, who frequently said to Ascanio, "My lad, how have you contrived to grow so handsome?" (for it was customary with them to call him lad at the time that he lived with them.) Ascanio answered, "Donna Francesca, it is my new master I am obliged to for this improvement in my person, and in every thing else." The malicious woman was not well pleased that Ascanio should praise me: however, being loosely inclined, she stifled her resentment so as to caress the youth a little more perhaps than was consistent with the laws of strict virtue; and I quickly perceived that he went much oftener to see his mistress than had been usual.

It happened one day that he struck one of my apprentices, who, upon my return home, for I had been out at that time, complained to me that Ascanio had beaten him without his having given him any sort of provocation. I therefore said to Ascanio, "Never presume again to strike anybody that belongs to my family, either with or without provocation, for, if you do, I will make you feel the weight of my arm." To this he made a pert answer; so I immediately fell upon him, and laying on both with my hands and feet, gave him the severest correction he had ever received in his life. As soon as he could get out of my grasp, he ran from the house, without either cloak or hat, and for two days after I neither knew nor inquired what was become of him. At length a Spanish gentleman, named Don Diego, came and desired to speak to me. This was one of the most generous men I had ever known in my life. I had executed several orders for him, and had then some in hand: in a word, he was my very good friend. He gave me to understand that Ascanio had returned to his old master, and desired I would please to let him have his cloak and hat. I answered, "That Francesco had behaved very ill, and acted in a very unpolite and ungentlemanlike manner; adding, that if he had sent me word, immediately upon Ascanio's repairing to him, that he had taken refuge at his house, I should have been very ready to have discharged him; but that as he had kept him two days without ever letting me know any thing of the matter, I was determined the lad should not stay with him, but insisted that upon no account he should keep him any longer in his house.

Don Diego told what I had said to Don Francesco, who only turned it into a jest. The next morning I saw Ascanio employed upon some little trifling knick-knacks in his master's shop. As I passed by he made me a bow, and his master burst out a-laughing: he then sent to me Don Diego, the gentleman above-mentioned, to desire I would let Ascanio have the clothes which I had given him; but that if I chose to do otherwise, he did not care, for the lad should

never want for clothes. Hereupon I turned to Don Diego, and said, "Signor Don Diego, I never in my life knew a more generous or a more worthy man than yourself, nor a person of greater integrity, or more just in all his dealings; but this Francesco is the very reverse of you in every respect: he is one of the most worthless scoundrels breathing. Tell him from me, that if he does not, before the bell rings for vespers, bring back Ascanio to my shop himself, I am determined I will have his life; and tell Ascanio, that if he does not quit the place where he is, in the time which I have allotted his master, he must expect the same fate." Don Diego made no reply; but, instantly departing, repeated all I had said to Francesco, who, upon hearing this intelligence, was frightened out of his wits, and did not know what to resolve upon. In the mean time Ascanio went in quest of his father, who was just arrived at Rome from Tagliacozzo, the place of his nativity. Upon hearing the disturbance that had happened, he was the first to advise Francesco to bring back Ascanio to me. Francesco said to Ascanio, "Go yourself, and your father will go with you." Don Diego then interfered, saying, "Francesco, I see impending danger: you know better than I do what sort of a man Benvenuto is. Carry the boy back to him without any sort of apprehension, and I will accompany you."

I had now got myself in readiness, and was walking to and fro in my shop, intending to wait till the bell rang for vespers; and then to make this one of the most desperate affairs I had ever been concerned in, during the whole course of my life. Just then entered Don Diego, Francesco, Ascanio, and his father, whom I did not know. Upon Ascanio's entering, I looked angrily at them all, when Francesco, who was as pale as death through fear, said, "I have here brought you back your servant Ascanio, whom I entertained in my house without any intention to offend you." Ascanio then said, in a respectful manner, "Master, forgive me; I am come here to submit to whatever you shall please to enjoin." I asked him whether he was come to serve out the time he had agreed to? He answered that he was, and never to leave me more. I then turned about to the apprentice whom he had beaten, and bade him reach him that bundle of clothes, saying at the same time, "Here are all the clothes that I gave you; with these I likewise restore you to your liberty, so you may go wherever you think proper." Don Diego, who by no means expected this, was in the utmost astonishment. At the same time both Ascanio and his father entreated me to forgive and take him again into my service. Upon my asking him who the person was that pleaded his cause, he told me it was his father, to whom, after much entreaty, I said, "As you are his father, I am willing, upon your account, to take him again into my service."

CHAPTER XX.

The Author sets out with Ascanio for France, and passing through Florence, Bologna, and Venice, arrives at Padua, where he makes some stay with the celebrated Cardinal Bembo.—Generous behaviour of the latter to Cellini.—The Author soon after resumes his journey, and travels through Switzerland.—He is in great danger in crossing a lake.—He visits Geneva in his way to Lyons, and after having rested four days in the last-mentioned city, arrives safe at Paris.

I HAD formed a resolution to set out for France, as well because I perceived that the Pope's favour was withdrawn from me, by means of slanderers, who misrepresented my services, as for fear that those of my enemies, who had most influence, might still do me some greater injury: for these reasons I was desirous to remove to some other country, and see whether fortune would there prove more favourable to me. Having determined to set out the next morning, I bid my faithful Felice enjoy all I had as his own till my return; and in case I should never come back, my intention was that the whole should devolve to him. Happening at this time to have a Perugian journeyman, who assisted me in the last-mentioned work for the Pope, I paid him off and dismissed him my service. The poor man entreated me to let him go with me, offering to bear his own expenses: he observed to me, moreover, that if I should happen to be employed for any length of time by the king of France, it was proper I should have Italians in my service, especially such as I knew, and were most likely to be of use to me. In a word, he used such persuasions, that I agreed to carry him with me upon his own terms. Ascanio happening to be present at this conversation, said to me, with tears in his eyes, "When you took me again into your service I intended it should be for life, and now I am resolved it shall." I answered, that it should not be so upon any account. The poor lad was then preparing to follow me on foot. When I perceived that he had formed such a resolution, I hired a horse for him likewise, and having put my portmanteau behind him, took with me a great deal more baggage than I should otherwise have done.

Leaving Rome*, I bent my course to Florence, from whence I travelled on to Bologna, Venice, and Padua. Upon my arrival at

* He set out from Rome on the second day after Easter, 1537, as appears from a letter of Varchi to Bembo, dated the 5th April of the same year; as is also Cellini's first letter given at the end of his life.

the last city, my friend, Albertaccio del Bene, took me to his own house from the inn where I had put up. The day following I went to pay my respects to Signor Pietro Bembo*, who had not then been made a cardinal. He gave me the kindest reception I had ever met with; and said to Albertaccio, I am resolved that Benvenuto shall stay here with all his company, if there were a hundred in number; so make up your mind to stay here with him, for I will not restore him to you upon any account. I stayed accordingly to enjoy the conversation of that excellent person. He had caused an apartment to be prepared for me, which would have been too magnificent even for a cardinal, and insisted upon my sitting constantly next to him at table: he then intimated to me in the most modest terms he could think of, that it would be highly agreeable to him if I were to model his likeness. There was, luckily for me, nothing than I desired more†; so, having put some pieces of the whitest alabaster into a little box, I began the work, working the first day two hours without ceasing. I made so fine a sketch of the head, that my illustrious friend was astonished at it; for though he was a person of immense

* Pietro Bembo, born at Venice, received an excellent education in some of the most learned universities of the age. He had so highly distinguished himself before the time of Leo X., that, on that Pontiff's ascending the papal throne, he was invited to the place of secretary, with a salary of 3000 crowns in addition to considerable ecclesiastical rank and benefices. On the death of Pope Leo, Bembo having amassed some property, and giving way to a passionate admiration of a beautiful lady called Marosini, no less than to his love of letters, retired to Padua. He there collected a splendid library, and entered into habits of intimacy with the learned and scientific characters of that place. He formed a museum, and a botanic garden, and such was his liberality to poets and scholars, that he soon became a centre of union for the taste and literature of all Italy. Paul III. ambitious of adding such a name to his College of Cardinals, was frequently dissuaded from it, by the malicious accusations of atheism and dissipation, brought against him by his enemies. But, on the death of the lady to whom he was attached, having answered the charge of want of orthodoxy, he was elected in 1539, and invited to Rome. He soon discovered by his great qualities, how well entitled he had been to this dignity, by his devotion to the Pope and to the church. He had the merit of restoring the Latin language to the polished style and graces of Cicero; and of leading back his countrymen to a purer taste in Tuscan poetry, by imitating Petrarch. He has, however, been censured for following too closely in the footsteps of those two great masters of poetry and eloquence, as well as for too great study of refinement and elegance of style.

† A medal of Bembo, had already been struck by Valerio de' Belli, in 1532, and is now in the Museo Mazzucchelliano. It has the head without a beard; and on the reverse, a figure of a man seated beside a fountain. But as this did not altogether please, Benvenuto undertook to produce a better in 1535; but not having it in his power to go to Padua, he made up his mind to prepare the reverse for it at Rome. We are convinced of this, from a letter of Varchi to Bembo, dated 3d July, 1536, as well as from part of a letter of Cellini himself, addressed to Luca Martini, mentioned by Martelli in one of his to Bembo, where he says, "I have heard from M. Benedetto (Varchi) of the wish of Monsignor Bembo respecting the medal, and I will do what he desires me. Indeed, I shall have particular pleasure in obliging him: only I must beg, that I may have the reverse as I please, and with some motto in honour of so great a man."

literature, and had an uncommon genius for poetry, he had not the least knowledge of my business; for which reason he thought that I had finished the figure when I had hardly begun it; insomuch, that I could not make him sensible that it required a considerable time to bring it to perfection. At last I formed a resolution to take my own time about it, and finish it in the completest manner I could; but as he wore a short beard, according to the Venetian fashion, I found it a very difficult matter to make a head to please myself. I, however, finished it at last, and it appeared to me to be one of the most complete pieces I had ever produced. He seemed to be in the utmost astonishment; for he took it for granted, that as I had made it of wax in two hours, I could make it of steel in ten; but when he saw that it was not possible for me to do it in two hundred, and that I was upon the point of taking my leave of him, in order to set out for France, he was greatly concerned, and begged I would make him a reverse for his medal, and that the device should be the horse Pegasus, in the midst of a garland of myrtle. This I did in about three hours, and it was finished in an admirable taste: he was highly pleased with it, and said, "Such a horse as this appears to be a work ten times more considerable than that little head, upon which you bestowed so much pains: I cannot possibly account for this." He then desired me to make it for him in steel and said, "I hope you will oblige me: you can do it very soon if you will." I promised him that, though it did not suit me to make it there, I would do it for him without fail at the first place at which I should happen to fix my residence.*

After this conversation, I went to bargain for three horses, which I had occasion for on my journey to France. My illustrious host, who had great interest in Padua, secretly befriended me on this occasion; insomuch that when I was going to pay for the horses, for which I had agreed to give fifty ducats, the owner of them said to me, "In consideration of your merit, sir, I make you a present of the three horses." I answered, "It is not you who make me the present; and I do not choose to accept it of the real donor, because I have not earned it by my services." The good man told me, that if I did not take those horses, I could not get any others in Padua,

* Cinelli informs us, that he had seen "a very beautiful medal by Cellini, with the head of Cardinal Bembo, having on the reverse a Pegasus, both of them admirably executed," belonging to Antonio Magliabecchi. Among the four medals of Bembo in the Mazzucchelli Museum, the largest and the best has exactly the reverse here described, which would lead us to take it for *a Cellini,* if the learned Mazzucchelli himself did not convince us of the contrary, by observing that it bears the title of Cardinal, has a long beard to the portrait, and wants the crown of myrtle on the reverse, so as not at all to correspond with the model by Cellini.

but should be under a necessity of walking. I thereupon went to the munificent Signor Pietro, who affected to know nothing at all of the matter, but loaded me with caresses, and used his utmost persuasions to prevail upon me to stay at Padua. I, who would by no means hear of this, and was determined to perform the journey at any rate, found myself obliged to accept of the three horses, and with them instantly set out for France.

I took the road through the Grisons, for it was unsafe to travel any other way, on account of the war.* We passed the two great mountains of Alba and Merlina†, (it was then the eighth of May, and they were, nevertheless, covered with snow,) at the utmost hazard of our lives. When we had travelled over them, we stopped at a little town, which, as nearly as I can remember, is called Valdistà‡, and there took up our quarters. In the night a courier arrived from Florence, whose name was Burbacca. I had heard this courier spoken of as a man of character, and clever at his business, but did not know that he had then forfeited that reputation by his knavery. As soon as he saw me at the inn, he called me by my name, and said that he was going about some business of importance to Lyons, and begged I would be so good as to lend him a little money to defray the expense of his journey. I answered that I could not lend him money, but if he would travel in my company, I would bear his charges as far as Lyons. The rogue then began crying, and counterfeited great concern, telling me that when a poor courier, who was about business of importance to the nation, happened to be in want of cash, it was the part of a man like me to assist him. He told me at the same time, that he was charged with things of great value belonging to Signor Filippo§ Strozzi; and as he had a casket with a leather cover, he whispered me very softly, that there were jewels to the amount of many thousand ducats in it, together with letters of the utmost consequence from Signor Filippo Strozzi. I thereupon desired him to let me fasten the jewels somewhere about his body, which would be running less hazard than carrying them in the casket; at the same time he might leave the casket, worth, perhaps, ten crowns, to me, and I would assist him as far as five-and-twenty. The fellow made answer, that he would travel with me in

* In 1537, the Imperialists, after their famous retreat from Provence, gave battle to the French in Piedmont, and resisted until the truce concluded in November, and a peace was stipulated the year following for ten years.

† The principal mountains which Cellini had to pass, in his road through the Grisons, were the *Bernina*, near Puschiavo, and the *Albul*, in the Engadine. Merlina (in the text) is a corruption of Bernina.

‡ Wallenstadt, in the province of Sargans.

§ Filippo was, at this period, at the head of the Florentine exiles, and fell into the hands of Duke Cosmo on the 1st August, 1537.

that manner, since he had no other remedy, for it would do him no honour to leave the casket; and so we were both agreed.

Setting out betimes in the morning, we arrived at a place situated between Valdistate and Vessa, where there is a lake fifteen miles long, upon which we were to sail to Vessa. When I saw the barks, I was terribly frightened, because they are made of deal boards, neither well nailed together, nor even pitched; and if I had not seen four German gentlemen, with their horses, in one of them, I should never have ventured on board, but have turned back directly. I thought within myself, at seeing the stupid security of these gentlemen, that the waters of the German lakes did not drown the passengers like those of Italy. My two young fellow-travellers said to me, "Benvenuto, it is a dangerous thing to enter one of these barks with four horses." My answer to them was, "Don't you see, you poor cowards, that those four gentlemen have entered one before you, and that they sail away merrily? If it were a lake of wine, I should fancy that they were rejoiced at the thoughts of being plunged into it; but as it is a lake of water only, I take it for granted they have no more inclination to be drowned in it than ourselves." This lake was fifteen miles long, and about three broad: the country, on one side, was a lofty mountain, full of caverns, on the other it was level, and covered over with grass.

When we had advanced about four miles, it began to grow stormy, insomuch that the watermen called out to us for help, begging that we would assist them in rowing; and so we did for a time. I signified to them soon after that their best way was to make the opposite shore; but they affirmed it to be impossible, because there was not a sufficient depth of water, so that the bark would be soon beaten to pieces in the shallows, and we should all go to the bottom. They, however, still importuned us to lend them a hand, and were constantly calling out to each other for assistance. As I perceived them in such terror and jeopardy, having a sorrel horse on board, I put on its bridle, and held it in my left hand. The horse, by a kind of instinct, and intelligence, common to these animals, seemed to perceive my intention; for by turning his face towards the fresh grass, I wanted him to swim to the opposite shore, and carry me over upon his back. At the very same instant there poured in from that side a wave so large that it almost overwhelmed the vessel. Ascanio then crying out, "Mercy! help me, dear father!" was going to throw himself upon me; but I clapped my hand to my dagger, and bid the rest follow the example I had set them, since by means of their horses they might save their lives, as I hoped to save mine; adding, that I would kill the first who should offer to throw himself upon me.

In this manner we proceeded several miles in the most imminent danger of our lives. When we had advanced about half-way, we saw a piece of level ground under the foot of a mountain, where we might get ashore and refresh ourselves. Here the four German gentlemen landed. But upon our expressing a desire to go on shore, the watermen would not consent to it upon any account. I then said to my young men, "Now is the time, my boys, to show your spirit; clap your hands to your swords, and compel them to land us." We effected our purpose with great difficulty, as they made a long resistance; however, even after we had landed, we were obliged to climb a steep mountain for two miles, which was more difficult than going up a ladder of equal height. I was armed with a coat of mail, had heavy boots, with a fowlingpiece in my hand, and it rained as hard as it could pour.* Those devils of Germans ascended at a surprising rate with their horses, whilst ours were quite unequal to the task, and ready to sink with the fatigue of climbing the rugged steep.

When we had mounted a good way, Ascanio's horse, which was a fine Hungarian courser, had got a little before Burbacca, the courier, and the young man had given him his pike to carry. It happened through the ruggedness of the road that the horse slipped, and went staggering on in such a manner, being quite helpless, as to come in contact with the point of the courier's pike, which he could not keep out of the way, and which ran into the beast's throat and killed it. My other young man, in attempting to help his brown nag, slipped down towards the lake, but saved himself by catching at a very small vine-branch. Upon this horse there was a cloak-bag, in which I had put all my money, with whatever else I had most valuable, to avoid being under a necessity of carrying it about me. I bid the youth endeavor to save his life, and never mind what became of the horse: the fall was of above a mile, and he would have tumbled headlong down into the lake. Exactly under this place our watermen had stationed themselves, so that if the horse had fallen it would have come directly down upon their heads. I was before all the rest, and waited to see the horse tumble, which seemed without the least fear to go headlong to perdition. I said to my young men, "Be under no sort of concern: let us endeavour to preserve ourselves, and return thanks to God for all his mercies. I am most sorry for poor Burbacca, who has lost a casket of jewels to such an enormous amount. Mine is only a few paltry crowns. Burbacca told me he was not concerned for his own loss, but for mine. I asked him why he was

* Cellini says, Quanto Dio ne sapeva mandare.

sorry for my trifling loss, and not for his own, which was so considerable. He then answered in a passion, "In such a case as this, and considering the terms we are upon, it is proper to tell the whole truth. I knew that you had a good heap of ducats in the cloak-bag: as for my casket, which I affirmed to be full of jewels and precious stones, it is all false: there is nothing in it but a little cavier." When I heard this I could not help laughing; the young fellow laughed also; as for Burbacca, he lamented and expressed great concern for my loss. The horse made an effort to relieve and extricate itself, when we had let it go, so that it was happily saved. Thus laughing, and making ourselves merry, we again exerted our strength to ascend the steep mountain.

The four German gentlemen who had got to the summit of the craggy precipice before us, sent some peasants to our assistance. At last we arrived at the miserable inn, wet, tired, and hungry. We were received in the kindest manner by the people of the house, and met with most comfortable refreshment. The horse which had been so much hurt was cured by means of certain herbs of which the hedges are full: and we were told, that if we constantly applied those herbs to the wound, the beast would not only recover, but be of as much use to us as ever: accordingly we did as we were directed. Having thanked the gentlemen, and being well refreshed and recovered of our fatigue, we left the inn, and continued our journey, returning thanks to God for preserving us from so great and imminent a danger. We arrived at a village beyond Vessa, where we took up our quarters: here we heard the watch sing at all hours of the night very agreeably and as the houses in town were of wood, he was constantly bidding them take care of their fires. Burbacca, who had been greatly frightened in the daytime, was continually crying out in his dreams, "O God, I am drowning!" This was occasioned by his panic the day before, and by his having indulged in the bottle too freely, and drunk with all the Germans. Sometimes he roared out, "I am burning;" sometimes "I am drowning;" and sometimes he thought himself in hell suffering punishment for his sins. This night passed away so merrily, that all our anxiety and trouble were converted into laughter.

Having risen very early next morning, we proceeded on our journey, and went to dine at a very agreeable place called Lacca, where we met with the best of treatment. We then took guides to conduct us to a town called Zurich. The guide who attended me passed over a dyke which was overflowed, so that the stupid creature slipped, and both the horse and he tumbled into the water. I, who was behind, having that instant stopped my horse, stayed awhile to

see him rise, and behold, the fellow, as if nothing at all had happened, fell a-singing again, and made signs to me to go on. I thereupon turned to the right, and breaking through certain hedges, served as a guide to Burbacca and my young men. The guide began scolding, telling me in the German language that if the country-people saw me they would put me to death. We travelled on, and escaped this second danger.

Our next stage was Zurich, a fine city, which may be compared to a jewel for lustre, and there we stayed a day to rest ourselves. We left it early in the morning, and arrived at another handsome town called Solthurn. From thence we proceeded to Lausanne, Geneva, and Lyons. We stopped four days at this last city, having travelled thither very merrily, singing and laughing all the way. I enjoyed myself highly in the company of some of my friends; was reimbursed the expenses I had been at; and at the expiration of four days set out for Paris. This part of our journey was exceedingly agreeable, except that, when we came as far as Palesse, a gang of freebooters made an attempt to assassinate us, and with great difficulty we escaped them. From thence we continued our journey to Paris, without meeting any ill accident, and travelling on in uninterrupted mirth, arrived safely at that metropolis.

CHAPTER XXI.

Ungrateful behaviour of Rosso the painter.—The Author is introduced to the French king, Francis I. at Fontainebleau, and meets with a most gracious reception. —The king offers to take him into his service, but, from a sudden illness, he conceives a great dislike to France, and returns to Italy.—Great kindness of the Cardinal Ferrara to the Author.—Adventures on the road from Lyons to Ferrara.—Cellini is kindly received by the duke.—He arrives at Rome, where he finds Felice.— Curious letter from the Cardinal of Ferrara concerning the behaviour of Cardinal Gaddi.—The Author is falsely accused by his Perugian servant of being possessed of a great treasure, of which he had robbed the Castle of St. Angelo, when Rome was sacked by the Spaniards.—He is arrested and carried prisoner to the Castle of St. Angelo.

AFTER having rested myself a short time, I went in search of Rosso* the painter, who was then in the service of King Francis. I took it for granted that this man was one of the best friends I had in the world, because I had in Rome behaved to him in as obliging a

* The French (who seem very fond of disguising names) call him Maitre Roux.—Ed.

manner as it is possible for one person to behave to another; and as a concise account may be sufficient to convey an idea of my conduct to the reader, I will here lay the whole before him, that the sin of ingratitude may appear in its most odious and shocking colours.

When he was at Rome he endeavoured to depreciate the works of Raffaello da Urbino, at which his scholars were provoked to such a degree that they were bent on killing him: this danger I preserved him from, watching over him day and night with the greatest fatigue imaginable. Upon another occasion he had spoken ill of Signor Antonio da San Gallo, an excellent architect; in consequence of which the latter soon had him turned out of an employment, which he had procured for him from Signor Agnolo da Cesi, and from that time forward became so much his enemy, that he would have starved, if I had not often lent him ten crowns for his support. As he had never discharged this trifling debt, I went to pay him a visit, being informed that he was in the king's service, and thought he would not only return me my money, but do all that lay in his power in recommending me to the service of the great monarch. But the fellow no sooner saw me, than he appeared to be in a terrible confusion, and said, "My friend Benvenuto, you have put yourself to too great an expense to come so long a journey, especially at such a time as this, when the court is entirely taken up with the approaching war, and can give no attention to our trifling performances." I answered that I had brought with me money enough to bear my expenses back to Rome, in the same manner that I had travelled to Paris; adding, that he made me a very indifferent return for all I had suffered on his account, and that I began to believe what Signor Antonio da San Gallo had told me concerning him. Upon his turning what I said into a jest, I saw through his low malice, and showed him a bill of exchange for 500 crowns addressed to Ricardo del Bene. The wretch was greatly ashamed, and would have detained me in a manner by force, but I laughed at him, and went away in the company of a painter who happened to be then present. His name was Sguazella*, and he was a Florentine likewise. I went to lodge and board at his house, having with me three horses and three servants. I met with the best of treatment there, and paid liberally for it.

I afterwards solicited an interview with the king, to whom I was

* Andrea Sguazella went with his master, Andrea del Sarto, to France, and there produced many estimable works.

introduced by Signor Giuliano Buonaccorsi* his treasurer. I was in
no haste on the occasion, as I did not know that Rosso had exerted
himself to the utmost to prevent my speaking to his Majesty. But,
as soon as Signor Giuliano perceived this, he carried me with him to
Fontainebleau, and introduced me into the presence of the monarch,
of whom I had a most favourable audience a whole hour. The king
was preparing for a journey to Lyons, which made him desire
Signor Giuliano to take me with him, adding, that we should dis-
course by the way of some fine works which his Majesty intended
to have executed. So I travelled in the retinue of the court, and
cultivated the friendship of the Cardinal of Ferrara†, who had not
as yet received the scarlet hat. I had every evening a long conversa-
tion with this great personage, who told me that I should stay at
Lyons at an abbey of his, and there enjoy myself till the king re-
turned from the campaign; adding, that he himself was going to
Grenoble, and that I should find all proper accommodation at his
abbey at Lyons.

Upon our arrival at that city I was taken ill, and Ascanio found
himself attacked by a quartan ague; I now began to dislike the
French and their court, and to be in the utmost impatience to return
to Rome. The cardinal seeing me resolved to go back, gave me a sum
of money to make him a basin and a cup of silver. Things being
thus settled, my young men and I set out for Rome, extremely well
mounted.

As we crossed the mountains of the Simplon, I happened to fall
into the company of some Frenchmen, with whom we travelled part
of the way. Ascanio had his quartan ague, and I a slow fever, which
I thought would never leave me. My stomach was so much out of
order, that for four months, I hardly eat a roll a week, and was very
eager to get to Italy, choosing rather to die in my own country than
in France. When we had passed the mountains of the Simplon above
mentioned, we came to a river hard by a place called Isdevedro.‡
This river was very broad and deep, and had a long narrow bridge
over it without any rails. A shower had fallen in the morning, so
that when I came to the bridge, which was some time before the rest,
I perceived it to be very dangerous: I therefore ordered my young

* A Florentine exile mentioned by Varchi. I suspect, however, he was not the
same who attempted to kill Cosmo I., executed in Florence in 1543.

† Ippolito da Este, son of Alfonzo, Duke of Ferrara, was elected Archbishop of
Milan, at fifteen years of age. Residing at the French court, he obtained many
benefices, and was at length made a Cardinal in 1539. Faithful to the ruling bias of
his family, Ippolito persevered in patronizing artists and learned men, in whose
company he was accustomed to relax his mind from the vexations and tedious cares
of state.

‡ The Doveria, in the Valdivedro.

men to dismount, and lead their horses. Thus I safely got over, and rode on, talking to one of the Frenchmen, who was a person of condition. The other, who was a scrivener, stayed behind us, and laughed at the French gentleman and me, for being so fearful about nothing as to take the trouble of walking. I turned about, and seeing him at the middle of the bridge, begged of him to come on cautiously, as the place was exceedingly dangerous: the other, keeping up to the national character of his country, told me in French that I was a poor, timid creature, and that there was no danger at all. Whilst he uttered these words, he spurred his horse a little, which, instantly stumbling, fell close by the side of a great rock; but as God is very merciful to fools, the stupid rider and his horse both tumbled into a great hole.

As soon as I perceived this, I began to run as fast as I could, and with great difficulty got upon the rock; from this I reached down, and catching at the border of the scrivener's cloak, pulled him up by it, whilst the water still ran from his nostrils; for he had swallowed a great quantity of it, and narrowly escaped being drowned. Seeing him at last out of danger I congratulated him on his escape, and expressed my joy at having saved his life. He answered in French that I had done nothing at all, and the point of most importance was his having lost a bundle of papers, to the value of many a score of crowns; and this he seemed to say in anger, being still wet, and his clothes all dripping with water. I turned about to our guides, and desired them to help the fool, telling them I would pay them for their trouble. One of the men exerted himself to the utmost, and fished up his papers, so that the scrivener lost nothing. The other would put himself to no trouble to assist him or save his bundle, and therefore deserved no recompense.

When we were arrived at the place above mentioned, we had made up a purse amongst us, which was to be at my disposal. After dinner I gave several pieces out of the common purse to the guide who had helped the scrivener: the latter said that I might be liberal of my own, for he did not intend to give the man any thing more than was in our agreement for conducting us. This provoked me to give the sordid wretch much opprobrious language. The other guide, who had taken no trouble, came up, and insisted on sharing the reward; when I told him, that he who had borne the cross deserved the recompense, he answered, that he would soon show me a cross, at which I should bewail my folly. I told him that I would light a candle at that cross, by means of which I hoped that he should be the first who would have cause to weep.

As we were then upon the confines of the Italian and German

territories, the fellow ran to alarm the neighbourhood, and returned with a hunting-pole in his hand, followed by a crowd. I being still on horseback, cocked my piece, and turning about to my fellow-travellers, said, "I will begin with shooting that man, and do you endeavour to do your duty: these fellows are cut-throats and common assassins, who catch at this opportunity to rob and murder us." The innkeeper, at whose house we had dined, then called to one of the ringleaders of the band of ruffians, who was a man advanced in years, and begged he would endeavour to prevent the mischief likely to ensue, telling him, that they had a young man of great spirit to deal with; that even if they were to cut me to pieces, I should be sure to kill a number of them first; and that after all I might very probably escape out of their hands, and even kill the guide. Thereupon the old ruffian said to me, "Go your ways; you would have enough to do to cope with us, even if you had a hundred men to back you." I, who was aware that he spoke the truth, and finding resolution in despair, had determined to sell my life as dear as I could, shook my head and answered, I should have done my best, and endeavoured to show myself a man.

We continued our journey, and as soon as we put up in the evening, we settled accounts with regard to our common purse. I separated from the sordid scrivener with the utmost contempt, whilst I had a great esteem for the other Frenchman, who was in every respect a gentleman. Soon afterwards I arrived at Ferrara, accompanied only by my two fellow-travellers on horseback.

I had no sooner dismounted, than I went to pay my respects to the duke, that I might set out next morning for our Lady of Loretto. After I had waited till it was dark, the duke made his appearance: I kissed his hand, and he received me with all possible demonstrations of kindness, desiring me to stay to supper. I answered him in the politest manner, "Most excellent sir, for these four months past I have eaten so little that it is almost a wonder I should be alive: as I am, therefore, sensible that I can eat nothing that is served up to your table, I will pass away the time you are at supper in chat, which will prove more agreeable to us both, than if I were to sup with your excellency." Thus we entered into a conversation which lasted till late at night. I then took my leave, and, upon returning to my inn, found grand preparations made there, for the duke had sent me the remains of his supper, with plenty of excellent wine, so, as I had passed my usual time of supper by two hours, I sat down to table with a most voracious appetite; and this was the first time I had been able to eat heartily during the course of four months.

Having set out in the morning I repaired to our Lady of Loretto,

and after paying my devotions at that place, I continued my journey to Rome, where I found my faithful friend Felice, to whom I resigned my shop, with all my furniture and ornaments, and opened another next door to Sugarello, the perfumer, which was much more spacious and handsome than that which I had quitted. I took it for granted, that the great French monarch would forget me, and therefore I engaged in several works for noblemen. Amongst others I began the cup and basin that I had promised to make for the Cardinal of Ferrara. I had a number of hands at work, and several things to be done both in gold and silver. I had made an agreement with my Perugian journeyman, who had kept an exact account of all the money that had been laid out for him in clothes and other articles (which, with his travelling expenses, amounted to about seventy crowns), that three crowns a month should be set aside to clear them off, as he earned above eight crowns a month in my service. In about two months the rogue left my shop, whilst I had a great deal of business upon my hands, declaring that I should have no further satisfaction. I was advised to have recourse to the law for redress, for I had formed a resolution to cut off one of his arms; and should certainly have done it, if my friends had not remonstrated with me, advising me to take care how I attempted any such thing, as it might be the cause not only of my losing the money entirely, but even of my being banished a second time from Rome; since it was impossible to tell how far my violence might extend. They added, that it was in my power to get him arrested directly, by virtue of the bill in his own handwriting, which I had in my possession. This advice I determined to follow, but chose to behave as dispassionately in the affair as I could. I commenced a suit with him before the auditor of the chamber; and, having succeeded in it, I threw him into prison, in consequence of a decree of the court, after the cause had been several months depending. My shop was at this time full of works of great importance; and, amongst others, were the ornaments in gold and jewels of the wife of Signor Girolamo Orsino*, father to Signor Paolo, now son-in-law to our duke Cosmo. These pieces I had brought pretty near a conclusion, and others of still greater importance offered every day. I had eight hands in all, and worked day and night myself, excited by the desire of reputation and profit.

Whilst I was thus assiduous in going on with my business, I received a letter from the Cardinal of Ferrara, the purport of which was as follows :—

* Girolamo Orsini, Lord of Bracciano, married Francesca Sforza, daughter of Bosio, Count of Santa Fiora. His son, Paolo Giordano, created Duke of Bracciano in 1560, married, in 1553, Isabella de Medici, a daughter of Cosmo I.

"My dear friend Benvenuto, A few days ago his Most Christian Majesty mentioned your name, and said he would be glad to have you in his service. I told him that you had made me a promise, that whenever I should send for you upon his majesty's account, you would come directly. His majesty replied, 'I desire he may be supplied with money, to enable him to perform the journey in a manner becoming so eminent an artist.' Upon saying this he instantly spoke to his admiral to order me to be paid a thousand gold crowns out of the treasury. Cardinal Gaddi happened to be present at this conversation; who, thereupon <u>interp</u>osing, told his majesty that it was unnecessary for him to give such an order, as he had himself remitted to you a proper supply of money, and you were already upon the road. Now if this should not be the case, if you have neither received the money, nor are set out upon the journey, nor have heard any thing of the matter, but it should be a mere finesse of the cardinal, to show that he patronises men of genius favoured by the king, or to make an ostentatious parade of having befriended you, as I am inclined to think it is nothing more, immediately upon receiving this letter, which contains the real truth, send me your answer. In consequence thereof I will at my next interview with the great monarch, contrive, in the presence of the crafty cardinal, to make the conversation turn upon you, and I will tell him that you never received any of the money which Cardinal Gaddi pretends to have remitted to you, nor ever set out upon the journey, but are still at Rome: and I intend to make it evident that Cardinal Gaddi said this merely through vanity, and shall contrive matters so that his majesty shall again speak to his admiral to order the charges of your journey to be defrayed by the treasury; thus you may depend upon receiving the supply promised you by this munificent prince."

Let the whole world learn from hence, the great power and influence of malignant stars and adverse fortune over us poor mortals. I had never spoken twice in my days to this foolish little Cardinal Gaddi, and he did not play me this trick with any view to hurt or injure me, but merely through folly and senseless ostentation, that he might be thought to patronise men of genius, whom the king was desirous to have in his service, and to concern himself in their affairs in the same manner as the Cardinal of Ferrara. He was guilty of another folly in not apprising me of it afterwards; for rather than expose him to shame, I should, for the sake of my country, have thought of some excuse to palliate the absurdity of his conduct. I had no sooner received the letter from the Cardinal of Ferrara, but I wrote him back word that I had heard nothing at all from Cardinal Gaddi, and that even if he had made me any proposal I should never

have quitted Italy without the knowledge of my friend the Cardinal
of Ferrara; especially as I then had in Rome more business than I
ever had before; but that at the first intimation of his most Christian
Majesty's pleasure, signified to me by so great a personage as his
reverence, I should instantly lay aside all other business, and set out
for France.

When I had sent my letters, my treacherous Perugian journey-
man thought of playing me a trick, in which he was but too success-
ful, through the avarice of Pope Paul Farnese, and still more
through that of his bastard son, who then had the title of Duke of
Castro.* This journeyman gave one of the secretaries of Signor
Pier Luigi to understand, that having worked in my shop several
years, he had discovered that I was worth not less than eighty thou-
sand ducats; that the greatest part of this wealth consisted in jewels
which belonged to the church; that they were part of the booty I had
possessed myself of in the Castle of St. Angelo, at the time of the
sack of Rome: and that there was no time to lose, but that I ough†
without delay to be taken up and examined.

I had one morning worked above three hours at the jewels of the
above-mentioned married lady; and whilst my shop was opening, and
my servants were sweeping it, I put on my cloak in order to take a
turn or two. Bending my course through the Julian street, I entered
the quarter called Chiavica, where Crispino, captain of the city-guard,
met me with his whole band of followers, and told me roughly, I
was the Pope's prisoner. I answered him, "Crispino, you mistake
your man." "By no means," said Crispino: "you are the ingenious
artist Benvenuto. I know you very well, and have orders to conduct
you to the Castle of St. Angelo, where noblemen and men of genius
like yourself are confined." As four of his soldiers were going to fall
upon me, and deprive me forcibly of a dagger which I had by my
side, and of the rings on my fingers, Crispino ordered them not to
offer to touch me: it was sufficient, he said, for them to do their
office, and prevent me from making my escape. Then coming up to
me, he very politely demanded my arms. Whilst I was giving them
up, I recollected that it was in that very place I had formerly killed
Pompeo. From thence they conducted me to the Castle, and locked
me up in one of the upper apartments of the tower. This was the
first time I ever knew the inside of a prison, and I was then in my
thirty-seventh year.

* Pier Luigi was created Duke of Castro in 1537.

CHAPTER XXII.

Pier Luigi, the Pope's illegitimate son, persuades his father to proceed against Cellini with great severity.—Cellini undergoes an examination before the governor of Rome and other magistrates.—His speech in vindication of his innocence.—Pier Luigi does his utmost to ruin him, whilst the French King interposes in his behalf.— Kind behaviour of the governor of the Castle to him.—Anecdotes of the Friar Pallavicini.—The Author prepares to make his escape with the assistance of his boy Ascanio.—The Pope is offended at the French King's interposition, and resolves to keep the Author in perpetual confinement.

PIER LUIGI, the Pope's illegitimate son, considering the great sum of money which I was charged with having in my possession, immediately applied to his father to make that money over to him. The Pope readily granted his request; at the same time adding, that he would assist him in the recovery of it. After I had been detained prisoner a whole week, they appointed commissioners to examine me, in order to bring the affair to an issue. I was thereupon sent for into a large handsome hall in the castle, where the examiners were assembled. These were, first, the governor of Rome, Signor Benedetto Conversini*, a native of Pistoia, who was afterwards bishop of Jesi; the second, the procurator of the Exchequer, whose name I cannot now recollect†; the third, the judge of criminal causes, named Signor Benedetto da Gali.‡ They began first to examine me in an amicable way, but afterwards broke out into the roughest and most menacing terms imaginable, occasioned, as I apprehend, by this speech of mine: "Gentlemen, you have for above half an hour been questioning me about an idle story, and such nonsense, that it may be justly said of you that you are trifling, and there is neither sense nor meaning in what you say; so I beg it of you, as a favour, that you would tell me your meaning, and let me hear something like sense and reason from you, and not idle stories and fabulous inventions." At these words the governor could no longer disguise his brutal nature, but said to me, "You speak with too much confidence, or rather with too much insolence; however, I will humble your pride, and make you as tame as a spaniel, by what I am going to tell you,

*Conversini was made bishop of Forlimpopoli in October, 1537, and in 1540 he had the archbishopric of Jesi. He bore a high character, and was well skilled in the jurisprudence of his time.

† It was Benedetto Valenti, mentioned at p. 120.

‡ Perhaps we ought to read *Benedetto da Cagli,* of whom mention is made again.

which you will find to be neither an idle story nor nonsense, but such conclusive reasoning that you will be obliged to submit to it." So he began to deliver his sentiments as follows :—

"We know with certainty that you were in Rome at the time of the sacking of this unfortunate city, and in this very castle of St. Angelo, where you performed the office of gunner. As you are by trade a goldsmith and jeweller, Pope Clement, having a particular knowledge of you, and being unable to meet with others of the business, employed you secretly to take out all the precious stones from his crowns, mitres, and rings; and putting entire confidence in you, desired you to sew them up in your clothes. You availed yourself of that confidence to appropriate to your own use to the value of 80,000 crowns unknown to his Holiness. This information we had from a journeyman of yours, to whom you discovered the whole affair, and boasted of the fraud. We now therefore enjoin and command you to find these jewels, or the value of them, after which we will discharge and set you at liberty."

I could not hear these words without bursting out into a loud laugh. When I had sufficiently indulged my mirth, I expressed myself thus : "I return my hearty thanks to God, that this first time it has pleased his Divine Majesty that I should be made a prisoner, I have the happiness not to be confined for any criminal excess of passion, as generally happens to young men. If what you say were true, I am in no danger of suffering corporal punishment, as the laws at that time had lost all their force and authority : for I might excuse myself by affirming that, as a servant to his Holiness, I had kept that treasure as a deposit for the Apostolical See, with an intention to put it into the hands of some good pope, or of those that should claim it of me, as you do now, if the fact were as you represent it." The tyrannical governor would not suffer me to proceed any farther, but interrupting me at these words, cried out in a fury, "Give what gloss you please to the affair, Benvenuto, it is enough for us that we have discovered the person who possessed himself of the treasure. Be as expeditious therefore as possible; otherwise we shall take other methods with you, and not stop at words." As they were then preparing to depart, I said to them, "Gentlemen, you have not finished my examination : hear me out, and then do as you please." They seated themselves again, though they appeared to be much enraged, and unwilling to hear any thing I could say for myself; nay, they seemed to be in a manner satisfied with their inquiry, and to think that they had discovered all they wanted to know. I therefore addressed them in the following terms : "You are to know, gentlemen, that I have lived in Rome nearly twenty years, and I was never

before imprisoned either here or any where else." At these words the brute of a governor interrupted me and said, "Yet you have killed men enough in your time." I replied, "That is your bare assertion, unsupported by any acknowledgment of mine: but if a person were to endeavour to deprive you of life, no doubt but you would defend yourself in the best way you could; and if you were to kill him, you would be fully justified in the eye of the law: so let me conclude my defence, as you propose to lay it before his Holiness, and profess that you mean to pass a just judgment.

"I must repeat it to you, gentlemen, that I have been nearly twenty years an inhabitant of this great metropolis, and have been often employed in works of the greatest importance. I am sensible that this is the seat of Christ, and should, in case of any temporal prince had made a wicked attempt against me, immediately have had recourse to this holy tribunal, and to God's Viceregent, to prevail on him to espouse my cause. But alas! what power shall I have recourse to in my present distress? To what prince shall I fly, to defend me from so wicked an attempt? Should not you, before you ordered me to be arrested, inquire where I had deposited the 80,000 crowns in question? Should not you likewise have examined the list of those jewels, as they were carefully numbered in the Apostolical Chamber five hundred years ago? In case you had found any thing wanting, you should have taken my books and myself, and confronted them with the jewels. I must inform you, that the books, in which the pope's jewels and those of the triple crown have been registered, are all extant; and you will find that Pope Clement was possessed of nothing but what was committed to writing with the utmost care and exactness. All I have to add is, that when the unfortunate Pope Clement was for making an accommodation with the Imperial freebooters, who had plundered Rome and insulted the Church, there came a person to negotiate the accommodation, whose name was Cæsar Iscatinaro*, if my memory does not fail me, who having virtually concluded the treaty with that injured pontiff, the latter, in order to compliment the negotiator, let a ring drop from his finger, worth about four thousand crowns, and upon Iscatinaro's stooping to take it up, his Holiness desired him to wear it for his sake. I was present when all this happened, and if the diamond be missing, I have told you what became of it; but I am

*He means to speak of Gio. Bartolommeo di Gattinara, brother of the celebrated Mercurio di Gattinara, High Chancellor of Charles V. He was Regent of Naples, and being present at Rome with the Imperial army when Clement was besieged, he concluded the capitulation entered into on the 5th June, 1527, which is published at the end of Guicciardini's account of the sack of Rome, but which was not observed.

almost positive that you will find even this registered. You may therefore well be ashamed of having thus attacked a man of my character, who has been employed in so many affairs of importance for the Apostolical See. I must acquaint you, that had it not been for me, the morning that the Imperialists scaled the walls of Rome, they would have entered the castle without meeting with any opposition; I, though unrewarded for my services, exerted myself vigorously in managing the artillery, when all the soldiers had forsaken their posts. I likewise animated to the fight a companion of mine, named Raffaello da Montelupor*, a statuary, who had quitted his post like the rest, and hid himself in a corner quite frightened and dismayed; when I saw him entirely neglect the defence of the castle, I roused his courage, and he and I, unassisted, slaughtered such numbers of our foes, that the soldiers turned their force another way. I was the man who fired at Iscatinaro because I had seen him speak disrespectfully to Pope Clement, and behave insolently to his Holiness, like a Lutheran and an impious heretic as he was. Pope Clement, notwithstanding, caused the person who had performed that glorious action to be sought all over the Castle in order to have him hanged.† I was the man that shot the Prince of Orange in the head, under the ramparts of this Castle. I have, moreover, made for the use of the Holy Church a vast number of ornaments of silver, gold, and precious stones; as likewise many medals, and the finest and most valuable coins. Is this, then, the priest-like return which is made to a man that has served you with so much diligence and zeal? Go now and repeat to the Pope all I have said, assuring him that he has all his jewels, and that I got nothing else in the Church's service at the melancholy sack of this city but wounds and bruises; and reckoned upon nothing but an inconsiderable recompence which Pope Paul had promised me. Now I know what to think of his Holiness, and of you his ministers."

Whilst I uttered these words they stood astonished, and looking attentively at each other departed with gestures that testified wonder and surprise. They then went all three together to inform the Pope of what I had said: the latter in some confusion gave orders that a diligent and accurate inquiry should be made into the account of all

* He not only excelled Baccio, his father, who had been a sculptor, but under the direction of Michel Angelo, produced some statues of first-rate merit. He successively worked at Rome, at Loretto, at Orvieto, and at Florence, his native place.

† Valdes informs us, that whilst Gio. Bartolommeo di Gattinara was employed in going from one party to the other, endeavouring to conclude the armistice, a shot was fired at him from the castle, which broke his arm; and takes occasion to insinuate that Clement VII. had thus violated the common law of nations. It here appears to be entirely the fault of Cellini.

the jewels; and upon finding that none of them were missing, they left me in the castle, without taking any farther notice of me. Signor Pier Luigi, however, went so far as to endeavour to destroy me, in order to conceal his own misconduct in the affair.

During this time of agitation and trouble, King Francis had heard a circumstantial account of the Pope's keeping me in confinement so unjustly; and as a nobleman belonging to his court, named Monsieur de Monluc, had been sent ambassador to his Holiness, he wrote to him to apply for my enlargement to his Holiness, as a person that belonged to his Majesty. The Pope, though a man of sense and extraordinary abilities, behaved in this affair of mine like a person of as little virtue as understanding: the answer he returned the ambassador was, "That the king his master need not give himself any concern about me, as I was a very turbulent, troublesome fellow: therefore he advised his Majesty to leave me where I was, because he kept me in prison for committing murder and other atrocious crimes." The king of France made answer, "That justice was strictly observed in his dominions, and that as he rewarded and favoured good men, so he punished and discountenanced the bad;" adding, "That as his Holiness had suffered me to leave Italy, and had been no longer solicitous about my services, he, upon seeing me in his dominions, had gladly taken me under his patronage, and now claimed me as his subject." Though these were the greatest honours and favours that could possibly be conferred upon a man in my station of life, they were highly prejudicial and dangerous to my cause. The Pope was so tormented with jealous fear, lest I should go to France and discover his base treatment of me, that he was constantly watching for an opportunity to get me despatched, without hurting his own reputation.

The constable of the Castle of St. Angelo was a countryman of mine, a Florentine, named Signor Giorgio Ugolini. This worthy gentleman behaved to me with the greatest politeness, permitting me to walk freely about the castle on my parole of honour, and for no other reason, but because he saw the severity and injustice of my treatment. Upon my offering to give him security for this indulgence, he declined taking it, because he heard every body speak of me as a man of truth and integrity, though he knew the Pope to be greatly exasperated against me. Thus I gave him my word and honour, and he even put me into a way of working a little at my business. As I took it for granted that the Pope's anger would soon subside, on account not only of my innocence, but of the king of France's intercession, I caused my shop to be kept open, and my young man Ascanio came often to the castle, bringing me some

things to employ me; though I could do but very little, whilst so unjustly confined. However, I made a virtue of necessity, and bore my hard fortune as well as I could, having won the hearts of all the guards and soldiers belonging to the garrison. As the Pope sometimes came to sup at the castle, whenever this happened, it was not guarded; but the doors were left open like those of any other palace. On such occasions the prisoners were put under close confinement; but this general rule was not observed with respect to me, for I was always at liberty to walk about the courts. Under these circumstances I was frequently advised by the soldiers to make my escape, and they declared that they would assist me in the recovery of my liberty, being sensible how unjustly I was treated. The answer I made them was, "That I had given my word and honour to the constable of the castle, who was one of the most worthy men breathing, and had conferred great favours on me."

Amongst the soldiers who advised me to make my escape, there was one, a man of great wit and courage, who reasoned with me thus: "My good friend, Benvenuto, you should consider that a man who is a prisoner neither is nor can be bound to keep his word, nor to any thing else: take my advice, and fly from this villain of a Pope, and from his bastard son, who have sworn your destruction." But I, being determined rather to lose my life than break the promise I had made to the worthy constable, bore my hard lot as patiently as I could.

I had for the companion of my confinement a monk of the Pallavicini family, who was a celebrated preacher. He was confined for heresy, and had a great deal of wit and humour in conversation, but was one of the most profligate fellows in the world, contaminating himself with all sorts of vices: I admired his shining qualities, but his odious vices I freely censured and held in abhorrence. This monk was constantly preaching to me, that I was under no obligation to keep the word I had given to the constable of the castle, because I was a prisoner. I answered, "That he spoke like a monk, but not like a man; for he that is a man and not a monk thinks himself obliged to keep his word upon all occasions, and in whatever circumstances he happens to be situated. Therefore, as I was a man and not a monk, I was resolved never to violate my plighted faith." The monk, perceiving that he could not corrupt me by all the subtle and sophistical arguments which he urged with so much force, had recourse to other means to seduce my virtue. For several days after he read to me the sermons of the monk Jeronimo Savonarola, and made so admirable a comment upon them that I was more delighted with it than even with the discourses themselves, though they had

given me such high satisfaction: in fine, I had conceived so high an opinion of him, that I would have done any thing else at his recommendation, except breaking my word. The monk, seeing me astonished at his great talents, thought of another expedient: he asked me what method I should have had recourse to if they had made me a close prisoner, in order to effect my escape? Desirous of giving the ingenious monk some proof of my own acuteness, I told him that I could open any lock, even the most difficult, especially those of that prison, which I should make no more of forcing than of eating a bit of cheese. The monk, in order to make me discover my secret, began to disparage my ingenuity, observing that men who have acquired fame by their talents make many boasts, and that, if they were afterwards called upon to carry their boastings into execution, they would soon forfeit all the reputation they had acquired; adding, that what I said seemed so far to pass all the bounds of probability that he apprehended were I to be put to the trial I should come off with but little honour.

Finding myself pushed hard by this artful monk, I told him that I generally promised much less than I was able to perform, and that what I had said concerning the locks was a mere trifle; for I would soon convince him that I had said nothing but the truth: in a word, I inconsiderately discovered to him my whole secret. The monk, affecting to take little or no notice of what he saw, immediately learned the mystery. The worthy constable continued to allow me to walk up and down the castle, as I thought proper, and did not even order me to be locked up at night, like the rest of the prisoners; at the same time he suffered me to work as much as I pleased in gold, silver, and wax. I had been employed some weeks on a basin for the Cardinal of Ferrara, but being weary of my confinement, I grew tired also of large works, and only amused myself with now and then making little figures of wax. The monk stole a piece of this wax, and by means thereof put in practice all I had inconsiderately taught him with regard to counterfeiting the keys of the prison. He had taken for his associate and assistant a clerk named Luigi, who was a native of Padua: upon their attempting to counterfeit these keys, the smith discovered them. As the constable sometimes came to see me at my apartment, and saw me working in this wax, he immediately knew it, and said, "That poor unfortunate Benvenuto has indeed been very hardly used; he should not, however, have concerned himself in such tricks, since I have done so much to oblige him; for the future I must confine him close prisoner, and show him no indulgence." So he ordered me to be closely confined, and with some circumstances of severity, which I suffered from the

reproaches and opprobrious language of his servants, who had been my well-wishers, but now upbraided me with the obligations their master had laid me under, calling me an ungrateful and faithless man. As one of them was more bitter and abusive on the occasion than was consistent with decency, I, being conscious of my own innocence, answered boldly, that I had never acted the part of a traitor or a faithless man; that I would assert my innocence at the hazard of my life; and that if either he, or any other, ever again offered to give me any such abusive language, I should, without hesitation, give him the lie. Not being able to bear this affront, he ran to the constable's apartment, and brought me the wax, with the model of the key. As soon as I saw the wax I told him that both he and I were in the right; but begged to speak with the constable, that I might let him into the whole affair, which was of much greater importance than they imagined. The constable soon after sent for me, and I told him all that had passed: he thereupon put the monk into close confinement, and the latter informed against the clerk, who had nearly been hanged for it. The constable, however, hushed up the affair, which was already come to the ears of the Pope, saved the clerk from the gallows, and restored me the same liberty as I had enjoyed before.

But, finding I had been treated with so much rigour in this affair, I began to think seriously, and said within myself, "If this man should again happen to take such a whim, and not choose to trust me any longer, I should not wish to be obliged to him, but to make a trial of my own skill, which I doubt not would have a very different success from that of the monk." I got my servants to bring me new thick sheets, and did not send back the dirty ones: upon their asking me for them, I answered, that I had given them away to some of the poor soldiers; adding, that if it should come to be discovered, they would be in danger of being sent to the galleys: thus my journeymen and servants, Felice in particular, took the utmost care to keep the thing secret. I pulled all the straw out of the tick of my bed, and burned it, for I had a chimney in the room where I lay. I then cut those sheets into a number of slips, each about one-third of a cubit in length, and when I thought I had made a sufficient quantity to reach from the top to the bottom of the lofty tower of the Castle of St. Angelo, I told my servants that I had given away as much of my linen as I thought proper, and desired they would take care to bring me clean sheets, adding, that I would constantly return them the dirty ones. This affair my workmen and servants quickly forgot.

The cardinals Santiquattro and Cornaro caused my shop to be

shut up, telling me in plain terms that his Holiness would not hear of my enlargement, and that the great favour shown me by the king of France had rather been of prejudice than any benefit to me. They added, that the last words which Mons. de Monluc had spoken to the Pope, by the direction of the king, were, that his Holiness ought to get the cause tried by the ordinary judges of the court; and that if I had any way transgressed I should suffer the punishment ordained by the law; but in case I were innocent, it was but just they should discharge me. These words had provoked the Pope to such a degree, that he had almost formed a resolution to detain me prisoner the rest of my days. It must be acknowledged, that the constable of the castle, on this occasion, espoused my cause to the utmost of

CHAPTER XXIII.

Quarrel between the Author and Ascanio.—Strange disorder of the constable of the Castle, which causes an alteration in his behaviour to Cellini.—The latter is confined more closely than ever, and treated with great severity.—His wonderful escape out of the Castle.—He is received and concealed for a time at Cardinal Cornaro's palace.

MY enemies, when they saw that my shop was shut up, took every opportunity to insult and revile my servants and friends who visited me in my confinement. It happened that Ascanio, who came twice every day to see me, begged that I would get a little waistcoat made for him of a blue satin waistcoat of mine, which I had worn but once, when I walked in procession with it. I told him that it was no time nor place for such finery. The lad was so affronted at my refusing him a rag of a waistcoat, that he declared he would go home to his father's, at Tagliacozzo. I answered with indignation, that I should be glad if I were never to see his face more; and he swore, in a most furious passion, that he would never again appear in my presence. Whilst this altercation passed between us, we were walking round the battlements of the castle, and as the constable himself happened to be taking a turn at the same time, we met him just as Ascanio said to me, "I am going to leave you, farewell for ever." To this I answered, "For ever let it be, and to make it more certain, I shall speak to the guards not to let you pass for the future:" so turning to the constable, I earnestly entreated him to command the sentinels never to suffer Ascanio to pass, telling him at the same time, that the good-for-nothing fellow came only to increase my sufferings, and therefore I begged it, as a favour, that he might no longer have

any admittance. The constable was sorry for what had happened, as he knew the lad to be possessed of an uncommon genius, and as his beauty was so great, that those who had seen him but once could not help conceiving an affection for him. The young man left the place weeping, having about him a short sword, which he sometimes wore concealed under his clothes. As he was coming out of the castle, with his face bedewed with tears, he happened to meet two of my most inveterate enemies, Jeronimo the Perugian, and Michele, both goldsmiths. This Michele, who was a friend to that Perugian rogue, and an enemy to Ascanio, said to the latter, "What can this mean? Ascanio weeping! Is your father dead? I mean your father at the castle?" "He is living," answered Ascanio, "but you are a dead man." Thereupon raising his arm, he, with his sword, gave him two wounds, both on the head: with the first he brought him to the ground, and with the second he cut off the fingers of his right hand, besides wounding him on the head: so that he lay motionless, like one deprived of life.

The Pope, having received information of what had happened, said, with great indignation, "Since it is the king's pleasure that Benvenuto be brought to a trial, go, bid him prepare for his defence in three days' time." The proper officers came to me from His Holiness, and delivered themselves according to his directions. The worthy constable upon this repaired to the Pope, and made him sensible that I had nothing at all to do with the affair, and that I had turned off the youth who had committed that rash action: in short, he defended my cause so well, that he prevented me from falling a victim to the Pontiff's resentment. Ascanio fled to Tagliacozzo, to his father's house, and wrote to me from thence to beg my pardon a thousand times, and acknowledge his fault in having added to my sufferings by his misbehaviour. He concluded by assuring me that if God should ever be so merciful as to deliver me from my confinement, he would never again forsake me. In my answer I desired he would endeavour to improve, telling him that if the Almighty restored my liberty, I should certainly send for him.

The constable of the castle had annually a certain disorder, which totally deprived him of his senses, and when the fit came upon him, he was talkative to excess. Every year he had some different whim: one time he fancied himself metamorphosed into a pitcher of oil; another time he thought himself a frog, and began to leap as such; another time again he imagined he was dead, and it was found necessary to humour his conceit by making a show of burying him: thus had he every year some new frenzy. This year he fancied himself *a bat,* and when he went to take a walk, he sometimes made

just such a noise as bats do: he likewise used gestures with his hands and his body, as if he were going to fly. His physicians, and his old servants, who knew his disorder, procured him all the pleasures and amusements they could think of; and as they found he delighted greatly in my conversation, they frequently came to me, to conduct me to his apartment, where the poor man often detained me three or four hours chatting with him. He sometimes kept me at his table to dine or sup, and always made me sit opposite to him: on which occasion he never ceased to talk himself, or to encourage me to join in conversation. At these interviews I generally took care to eat heartily, but the poor constable neither ate nor slept, insomuch that I was tired and jaded by constant attendance. Upon examining his countenance, I could perceive that his eyes looked quite shockingly, and that he began to squint.

He asked me whether I had ever had a fancy to fly: I answered, "that I had always been very ready to attempt such things as men found most difficult; and that with regard to flying, as God had given me a body admirably well calculated for running, I had even resolution enough to attempt to fly." He then proposed to me to explain how I could contrive it. I replied, that "when I attentively considered the several creatures that fly, and thought of effecting by art what they do by the force of nature, I did not find one so fit to imitate as the bat." As soon as the poor man heard mention made of a bat, his frenzy for the year turning upon that animal, he cried out aloud, "It is very true, a bat is the thing." He then addressed himself to me and said, "Benvenuto, if you had the opportunity, would you have the heart to make an attempt to fly?" I answered, that if he would give me leave, I had courage enough to attempt to fly as far as Prati by means of a pair of wings waxed over. He said thereupon, "I should like to see you fly; but as the Pope has enjoined me to watch over you with the utmost care, and I know that you have the cunning of the devil, and would avail yourself of the opportunity to make your escape, I am resolved to keep you locked up with a hundred keys that you may not slip out of my hands." I then began to solicit him with new entreaties, putting him in mind that I had had it in my power to make my escape, but through regard to the promise I had made him, would never avail myself of the opportunity. I therefore besought him for the love of God, and as he had conferred so many obligations on me, that he would not make my condition worse than it was. Whilst I uttered these words, he gave instant orders that I should be secured and confined a closer prisoner than ever. When I saw that it was to no purpose to entreat him any farther, I said before all present, "Confine me as close as

you please, I will contrive to make my escape notwithstanding." So they carried me off, and locked me up with the utmost care.

I then began to deliberate upon the method I should pursue to make my escape: as soon as I saw myself locked in, I set about examining the place in which I was confined, and thinking I had discovered a sure way to get out, I revolved in my mind in what manner I could descend the height of the great tower. Having first of all formed a conjecture of the length of line sufficient for me to descend by, I took a new pair of sheets which I had cut into slips, and sewed fast together. The next thing I wanted was a pair of pincers, which I took from a Savoyard, who was upon guard at the castle. This man had care of the casks and cisterns belonging to the castle, and likewise worked as a carpenter; and as he had several pairs of pincers, and one amongst others which was thick and large, thinking it would suit my purpose, I took it, and hid it in the tick of my bed. The time being come that I intended to make use of it, I began, with the pincers, to pull at the nails which fastened the plates of iron fixed upon the door, and as the door was double, the clenching of those nails could not be perceived. I exerted my utmost efforts to draw out one of them, and at last with great difficulty succeeded. As soon as I had drawn the nail, I was again obliged to torture my invention, in order to devise some expedient to prevent its being perceived. I immediately thought of mixing a little of the filings of rusty iron with wax, and this mixture was exactly the colour of the heads of the nails which I had drawn; I with it counterfeited their resemblance on the iron plates, and as many as I drew I imitated in wax. I left each of the plates fastened both at top and bottom, and refixed them with some of the nails that I had drawn; but the nails were cut, and I drove them in slightly, so that they just served to hold the plates. I found it a very difficult matter to effect all this, because the constable dreamed every night that I had made my escape, and therefore used to send frequently to have the prison searched: the person employed on this occasion had the appearance and behaviour of one of the city-guards. The name of this fellow was Bozza, and he constantly brought with him another, named Giovanni Pedignone; the latter was a soldier, the former a servant. This Giovanni never came to the room where I was confined without giving me abusive language. The other was from Prato, where he had lived with an apothecary: he every evening carefully examined the plates of iron above mentioned, as well as the whole prison. I constantly said to him, "Examine me well, for I am positively determined to make my escape." These words occasioned a bitter enmity between him and me.

With the utmost care I deposited all my tools, that is to say, my pincers, and a dagger of a tolerable length, with other things belonging to me, in the tick of my bed, and as soon as it was daylight swept the room myself, for I naturally delighted in cleanliness, but on this occasion I took care to be particularly neat. As soon as I had swept the room, I made my bed with equal care, and adorned it with flowers, which were every morning brought me by a Savoyard. This man, as I have observed before, took care of the cisterns and the casks belonging to the castle, and sometimes amused himself with working in wood: it was from him I stole the pincers, with which I pulled out the nails that fastened the iron plates on the door. To return to my bed: whenever Bozza and Pedignone came, I generally bade them keep at a distance from it, that they might not dirty and spoil it: sometimes I would say to them (for they would now and then merely for diversion tumble my bed), "You dirty wretches, I will draw one of your swords, and give you such a chastisement as will astonish you. Do you think yourselves worthy to touch the bed of a man like me? Upon such an occasion I should not spare my own life, but am sure that I should be able to take away yours; so leave me to my own troubles and sorrows, and do not make my lot more bitter than it is. If you act otherwise, I will show you what a desperate man is capable of." The men repeated what I said to the constable, who expressly commanded them never to go near my bed, ordering them at the same time when they came to me, to have no swords, and to be particularly careful with respect to every other circumstance. Having thus secured my bed from their searches, I thought I had gained the main point, and was on that account highly rejoiced.

One holiday evening the constable being very much disordered, and his madness being at the highest pitch, he scarce said any thing else but that he was become a bat, and desired his people, that if Benvenuto happened to make his escape, they should take no notice of it, for he must soon catch me, as he should, doubtless, be much better able to fly by night than I; adding, "Benvenuto is only a counterfeit bat; but I am a bat in good earnest. Let me alone to manage him, I shall be able to catch him, I warrant you." His frenzy continuing thus in its utmost violence for several nights, he tired the patience of all his servants; and I by various means came to the knowledge of all that passed, though I was indebted for my chief information to the Savoyard, who was very much attached to me.

As I had formed a resolution to attempt my escape that night, let what would happen, I began with praying fervently to Almighty God, that it would please His Divine majesty to befriend and assist me

in that hazardous enterprise: I then went to work, and was employed the whole night in preparing whatever I had occasion for. Two hours before daybreak I took the iron plates from the door with great trouble and difficulty, for the bolt and the wood that received it made a great resistance, so that I could not open them, but was obliged to cut the wood. I however at last forced the door, and having taken with me the above-mentioned slips of linen, which I had rolled up in bundles with the utmost care, I went out and got upon the right side of the tower, and having observed, from within, two tiles of the roof, I leaped upon them with the utmost ease. I was in a white doublet, and had on a pair of white half hose, over which I wore a pair of little light boots, that reached half way up my legs, and in one of these I put my dagger. I then took the end of one of my bundles of long slips, which I had made out of the sheets of my bed, and fastened it to one of the tiles of the roof that happened to jut out four inches; and the long string of slips was fastened to the tiles in the manner of a stirrup. When I had fixed it firmly, I addressed myself to the Deity in these terms: "Almighty God, favour my cause, for thou knowest it is a just one, and I am not on my part wanting in my utmost efforts to make it succeed." Then letting myself down gently, and the whole weight of my body being sustained by my arm, I at last reached the ground.

It was not a moonlight night, but the stars shone with resplendent lustre. When I had touched the ground, I first contemplated the great height which I had descended with so much courage; and then walked away in high joy, thinking I had recovered my liberty. But I soon found myself mistaken; for the constable had caused two pretty high walls to be erected on that side, which made an inclosure for a stable and a poultry-yard: this place was fastened with great bolts on the outside. When I saw myself immured in this inclosure, I felt the greatest anxiety imaginable. Whilst I was walking backwards and forwards, I stumbled on a long pole covered with straw; this I with much difficulty fixed against the wall, and by the strength of my arms climbed to the top of it; but as the wall was sharp, I could not get a sufficient hold to enable me to descend by the pole to the other side. I therefore resolved to have recourse to my other string of slips, for I had left one tied to the great tower; so I took the string, and having fastened it properly, I descended down the steep wall. This put me to a great deal of pain and trouble, and likewise tore the skin off the palms of my hands, insomuch that they were all over bloody; for which reason I rested myself a little, and was reduced even to wash them in my own water. When I thought I had sufficiently recruited my strength, I came to the last wall, which

looked towards the meadows, and having prepared my string of long slips, which I wanted to get about one of the niched battlements, in order to descend this as I had done the other higher wall, a sentinel perceived what I was about. Finding my design obstructed, and myself in danger of my life, I resolved to cope with the soldier, who seeing me advance towards him resolutely with my drawn dagger in my hand, thought it most advisable to keep out of my way. After I had gone a little way from my string, I quickly returned to it; and though I was seen by another of the soldiers upon guard, the man did not care to take any notice of me. I then fastened my string to the niched battlement, and began to let myself down. Whether it was owing to my being near the ground, and preparing to give a leap, or whether my hands were quite tired, I do not know, but being unable to hold out any longer, I fell, and in falling struck my head and became quite insensible.

I continued in that state about an hour and a half, as nearly as I can guess. The day beginning to break, the cool breeze that precedes the rising of the sun brought me to myself; but I had not yet thoroughly recovered my senses, for I had conceived a strange notion that I had been beheaded, and was then in purgatory. I however, by degrees, recovered my strength and powers; and perceiving that I had got out of the castle, I soon recollected all that had befallen me. As I perceived that my senses had been affected, before I took notice that my leg was broken, I clapped my hands to my head, and found them all bloody. I afterwards searched my body all over, and thought I had received no hurt of any consequence; but upon attempting to rise from the ground, I found that my right leg was broken three inches above the heel, which threw me into a terrible consternation. I thereupon pulled my dagger with its scabbard out of my boot: this scabbard was cased with a large piece of metal at the bottom, which occasioned the hurt to my leg; as the bone could not bend any way, it broke in that place. I therefore threw away the scabbard, and cutting the part of my string of slips that I still had left, I bandaged my leg as well as I could. I then crept on my hands and knees towards the gate, with my dagger in my hand, and, upon coming up to it, found it shut; but observing a stone under the gate, and thinking that it did not stick very fast, I prepared to push it away; clapping my hands to it, I found that I could move it with ease, so I soon pulled it out, and effected my egress. It was about five hundred paces from the place where I had had my fall to the gate at which I entered the city.

As soon as I got in, some mastiff dogs came up, and bit me severely: finding that they persisted to worry me I took my dagger

and gave one of them so severe a stab, that he set up a loud howling; whereupon all the dogs in the neighbourhood, as it is the nature of those animals, ran up to him; and I made all the haste I could to crawl towards the church of St. Maria Transpontina. When I arrived at the entrance of the street that leads towards the Castle of St. Angelo, I took my way from thence towards St. Peter's gate; but, as it was then broad daylight, I reflected that I was in great danger, and happened to meet with a water-carrier, who had loaded his ass, and filled his vessels with water, I called to him and begged he would put me upon the beast's back, and carry me to the landing-place of the steps of St. Peter's church. I told him, that I was an unfortunate youth, who had been concerned in a love-intrigue, and had made an attempt to get out at a window, from which I had fallen, and broken my leg; but as the house I came out of belonged to a person of the first rank, I should be in danger of being cut to pieces if discovered. I therefore earnestly entreated him to take me up, and offered to give him a gold crown; so saying, I clapped my hand to my purse, which was very well lined. The honest water-man instantly took me upon his back, and carried me to the steps before St. Peter's church, where I desired him to leave me and to run back to his ass.

I immediately set out, crawling in the same manner I had done before, in order to reach the house of the duchess, consort to Duke Ottavio, natural daughter to the emperor, and who had been formerly married to Alessandro, the late duke of Florence. I knew that there were several of my friends with that princess, who had attended her from Florence; as likewise that I had the happiness of being in her excellency's good graces. This last circumstance had been partly owing to the constable of the castle, who, having a desire to befriend me, told the Pope that when the duchess made her entry into Rome, I prevented a damage of above a thousand crowns, that they were likely to suffer by a heavy rain; upon which occasion, when he was almost in despair, I had revived his drooping courage, by pointing several pieces of artillery towards that tract of the heavens where the thickest clouds had gathered; so that when the shower began to fall, I fired my pieces, whereupon the clouds dispersed*, and the sun again shone out in all its brightness. Therefore it was entirely owing to me that the above day of rejoicing had been happily concluded. This coming to the ears of the duchess, her excellency said, that Benvenuto was one of those men of genius, who loved the memory of her husband Duke Alessandro, and she should always

* Query, Will this round assertion of Cellini's be borne out by the testimony of Dr. Franklin and others?—Ed.

remember such, whenever an opportunity offered of doing them services. She had likewise spoken of me to Duke Ottavio her husband. I was, therefore, going directly to the place where her excellency resided, which was in Borgo Vecchio, at a magnificent palace. There I should have been perfectly secure from any danger of falling into the Pope's hands; but as the exploit I had already performed was too extraordinary for a human creature, and lest I should be puffed up with vain-glory, God was pleased to put me to a still severer trial than that which I had already gone through.

What gave occasion to this was, that whilst I was crawling along upon all four, one of the servants of Cardinal Cornaro knew me, and running immediately to his master's apartment, awakened him out of his sleep, saying to him, "My most reverend Lord, here is your jeweller, Benvenuto, who has made his escape out of the castle, and is crawling along upon all four, quite besmeared with blood: by what I can judge from appearances, he seems to have broken one of his legs, and we cannot guess whither he is bending his course." The cardinal, the moment he heard this, said to his servants, "Run, and bring him hither to my apartment upon your backs." When I came into his presence, the good cardinal bade me fear nothing, and immediately sent for some of the most eminent surgeons of Rome to take care of me; amongst these was Signor Giacopo of Perugia, an excellent practitioner. This last set the bone, then bandaged my leg, and bled me. As my veins were swelled more than usual, and he wanted to make a pretty wide incision, the blood gushed from me with such violence, and in so great a quantity, that it spirted into his face, and covered him in such a manner, that he found it a very difficult matter to continue his operation. He looked upon this as very ominous, and was with difficulty prevailed upon to attend me afterwards; nay, he was several times for leaving me, recollecting that he had run a great hazard by having any thing to do with me. The cardinal then caused me to be put into a private apartment, and went directly to the Vatican, in order to intercede in my behalf with the Pope.

CHAPTER XXIV.

General surprise caused by the Author's escape.—Account of a similar escape of Pope Paul III. in his youth.—Pier Luigi endeavours to prevent his father from liberating Cellini.—Cardinal Cornaro is induced to deliver him up to the Pope.—He is a second time committed close prisoner to the Castle of St. Angelo, and treated with utmost severity.

MEANWHILE the report of my escape made a great noise all over Rome, for the long string of sheeting fastened to the top of the lofty tower of the castle had excited attention, and the inhabitants ran in crowds, to behold the strange sight. By this time the frenzy of the constable had risen to its highest pitch: he wanted, in spite of all his servants, to fly from the same tower himself, declaring that there was but one way to re-take me, and that was for him to fly after me. Signor Roberto Pucci, father to Signor Pandolfo, having heard the rumour, went in person to see whether it was as fame had reported. He then repaired to the Vatican, where he happened to meet with Cardinal Cornaro, who told him all that had passed; that my wounds were dressed, and that I was at his apartments. These two worthy men threw themselves upon their knees before the Pope, who, before they could begin their supplication, cried out, "I know what you want." Signor Roberto Pucci answered, "Most holy father, we come to intercede for that poor man, who, on account of his extraordinary abilities, deserves some compassion. He has displayed such courage, and exerted such extraordinary efforts of ingenuity, as seem to surpass human capacity. We know not for what offences your Holiness has so long confined him; if his crimes, however, are enormous, convinced as we are of your piety and wisdom, we leave him to your decision; but if they are of a pardonable nature, we beg you will forgive him at our intercession." The Pope, in some confusion, replied that "he had detained me in prison by the advice of some persons at court, because I had been too presumptuous; that, in consideration of my extraordinary talents, he had intended to keep me near his person, and to confer such favours upon me that I should have no occasion to return to France. "I am concerned to hear of his sufferings; however," added he, "bid him take care of his health, and when he is thoroughly recovered, it shall be my study to make him some amends for his past troubles."

The two great personages then came to me from the Pope with

this good news. In the mean time I was visited by the nobility of Rome, by young and old, and persons of all ranks. The constable of the castle, quite out of his senses, caused himself to be carried into his Holiness's presence; and when he was come, began to make a terrible outcry, declaring that if the Pope did not send me back to prison, it would be doing him great injustice. He added, that I had made my escape in violation of my word; for that I had promised him upon my honour that I would not fly away, and had flown away notwithstanding. The Pope answered him, laughing, "Go, go, I will restore your prisoner by some means." The constable said to the Pope, "Send the governor then to examine him concerning the accomplices of his escape. If any of my people had a hand in it, I will have them hanged from the same battlement from which Benvenuto flew."

As soon as the constable was gone, the Pope sent for the governor of Rome, and said to him, laughing, "This Benvenuto is a brave fellow: the exploit he has performed is very extraordinary; and yet, when I was a young man, I descended from the very same place." In this the Pope spoke the truth, for he had himself been a prisoner in the Castle of St. Angelo, for forging a papal brief, when he was abbreviator in the pontificate of Pope Alexander, who kept him a long time in confinement; and afterwards, as his offence was of a very heinous nature, determined to have him beheaded. But as he chose to defer the execution till after Corpus Christi day, Farnese, having discovered the design, got Pietro Chiavelluzzi to come to him with some horsemen, and bribed several of the guards; so that whilst the Pope was walking in procession on that day, Farnese was put into a basket, and with a cord let down to the ground. The precincts of the castle wall had not then been erected, but the tower only, so that he had not so many difficulties to encounter in making his escape as I; besides, he was a prisoner for a real crime, and I upon an unjust accusation. He meant to boast to the governor only of his having been a brave and gallant fellow in his youth; but instead of that, he inadvertently discovered his own villainy. He then said to the governor, "Go to Benvenuto, and desire him to let you know who assisted him in making his escape; let him be who he will, Benvenuto may depend upon being pardoned himself, and of that you may freely assure him."

The governor, who had two days before been made Bishop of Jesi, came to me in consequence of the order from the Pope, and addressed me in these terms: "My friend Benvenuto, though my office is of a nature that terrifies men, I come to encourage you and dispel your fears, and that by authority of his Holiness, who has

told me that he made his escape himself out of the Castle of St. Angelo; but that he had been assisted by several associates, otherwise he could not have effected his purpose. I swear to you by the sacrament that I have just now received (and it is but two days since I was consecrated bishop), that the Pope has liberated and pardoned you, and that he is sorry for your sufferings. Therefore, endeavour to recover your health, and you will find that all has happened to you for the best, and that the confinement which you have suffered, though innocently, will be the making of you for ever; for you will thereby emerge from your poverty, and not be obliged to return to France, or to endure any distresses in foreign countries. So, freely tell me how the whole affair passed, and who assisted you in your escape; then be comforted, indulge yourself in repose, and endeavour to recover your health." I thereupon began my story from the beginning, delivered a circumstantial account of the whole affair exactly as it happened, and gave him all the tokens of the truth of my narrative that I could possibly think of, not forgetting even the poor waterman that had taken me upon his back. The governor, having heard my story to the end, said, "You have achieved too many great things for one person; at least, you are the only man deserving of the glory of such an exploit." So, taking me by the hand, he said to me, "Be of good cheer; by this hand you are free, and shall be a happy man."

He thereupon withdrew, and left me at liberty to see a considerable number of nobility and gentry, who had been waiting, for they were every day coming to see me as a man that had performed miracles. Some of them made me promises, whilst others made me presents.

In the mean time, the governor of Rome repaired to the Pope, and related to him all that he had heard from me. Signor Pier Luigi, the Pope's son, happened to be then present, and both he and all who heard the story expressed the utmost astonishment. The Pope said, "This is certainly one of the most extraordinary events that ever happened." Signor Pier Luigi then interposing, said, "Most holy father, if you liberate this man, he will do something else still more daring, for he is one of the boldest and most audacious of mortals. I must tell you of another exploit of his, which you have not heard of. This favourite of yours, Benvenuto, happening before his confinement to have some words with a gentleman belonging to Cardinal Santo Fiora, occasioned by some expression of that gentleman's, Benvenuto answered with the utmost audacity, and seemed bent on quarrelling. The gentleman having informed Cardinal Santa Fiora of all that had passed, the latter said that if he once took

Benvenuto in hand, he would soon find means to tame him. After Benvenuto heard of this, he always kept in readiness a fowling-piece, with which he can hit a farthing. The cardinal happening one day to look out at a window (the shop of Benvenuto being under his palace), the latter took his fowling-piece, levelled it at the cardinal, and was about to fire, when the latter, being apprised of his intention instantly quitted the place. Upon this, Benvenuto, in order to conceal his purpose, took aim at a pigeon, which was hatching its eggs in a hole upon the roof of the palace, and shot it through the head; a feat almost incredible. Your Holiness may now act as you think proper with respect to the man. I thought it a duty incumbent on me to tell you what I knew. He may possibly one day, in a persuasion that he was imprisoned unjustly, take it into his head to have a shot at your Holiness. He is a man of too fierce and audacious a spirit. When he killed Pompeo, he gave him two stabs with a dagger in the throat, though he was surrounded by ten of his friends; and then made his escape, to the disgrace of those ten, though they were men of worth and reputation." Whilst he was saying this, the gentleman belonging to the Cardinal Santa Fiora, with whom I had had the dispute, happened to be present, and confirmed to the Pope all that his son had related. The Pontiff swelled with indignation, but said nothing.

I should be sorry to omit giving a true and impartial account of the affair thus alluded to. This gentleman belonging to Cardinal Santa Fiora one day came to me, and put into my hands a little gold ring, which was all over sullied with quicksilver, saying, "Clean me that ring, and make haste about it." As I had then upon my hands several works of the utmost importance, both in gold and jewels, and was irritated at being commanded in that peremptory manner by one whom I had never seen or spoken to before, I told him I had no time to do it, and advised him to go to somebody else. Upon this, without further ceremony, he called me an ass. I told him that he was mistaken, for I was in every respect a better man than himself, and that if he provoked me too far, he should find I could kick worse than any ass. He immediately told the cardinal the affair in his own way, describing my behaviour as most outrageous. Two days after, I shot behind the palace at a wild pigeon, that was hatching its eggs in a hole at a great height. I had several times before seen one Giovanni Francesco della Tacca, a Milanese goldsmith, shoot at the same pigeon without killing it. The day that I shot at it, the pigeon happened just to show its head, being suspicious and in fear from having so often been fired at before. As Giovanni Francesco and I were rival marksmen, some gentlemen and friends of mine, who were in my shop, showed me the pigeon, and said, "Yonder is the bird

which Giovanni Francesco has so often shot at, and always missed;
do but observe, the poor creature is so timorous and suspicious, that
it scarce ventures to show its head." Looking up at it, I said, "That
head is mark enough for me to level at and kill the pigeon; if I had
but just time to take aim cleverly, I should be sure of bringing it
down." The gentlemen then said, "that the very inventor of fowling-
pieces would not hit such a mark." I answered, "Go for a pitcher of
our good host Palombo's Greek wine, and just stay till I charge my
broccardo (so I called my fowling-piece), and I will engage to hit
that little bit of a head which peeps out of yonder hole." I that instant
took aim, and performed my promise, without thinking of the car-
dinal or any body else; on the contrary, I took it for granted that the
cardinal was my patron and friend. It appears from hence, what a
variety of means fortune has recourse to, when she is bent on a
man's destruction.

The Pope, who was provoked and angry at what he had heard
from his son, revolved it seriously in his mind. Two days after,
Cardinal Cornaro went to ask his Holiness for a bishopric for one of
his gentlemen, named Signor Andrea Centano. It is true the Pope
had promised him the first bishopric that should become vacant: he
did not therefore offer to retract, but, acknowledging that he had
made such a promise, told the cardinal he would let him have the
bishopric on condition of his doing him one favour, which was,
that he would again deliver Benvenuto into his hands. The cardinal
cried out, "What will the world say of it, since your Holiness has
pardoned him? And as you have consigned him over to my care,
what will the people of Rome say of your Holiness and of me?"
The Pope replied, "I must insist upon having Benvenuto, if you have
a mind to the bishopric; and let people talk as they will." The good
cardinal desired that his Holiness would give him the bishopric, and
rely upon his doing afterwards as his Holiness should think proper.
The Pope, appearing to be almost ashamed of the violation of his
faith, said, "I will send to you for Benvenuto, and, for my own
satisfaction, put him into certain apartments of the privy gardens,
where he may recover at leisure, take proper care of his health, and
his friends shall be at liberty to visit him. I will myself bear all his
expenses till he is thoroughly recovered from this little affair."

The cardinal came home, and sent me word by the person in
whose behalf he had applied for the bishopric, that the Pope would
fain have me again in his hands; and that he intended to keep me in
one of the ground-floor apartments belonging to the privy garden,
where I might receive the visits of the nobility and gentry, and of all
my friends, in the same manner I had done at his house. I then

requested Signor Andrea to desire the cardinal not to surrender me to the Pope, but to leave the matter to me; adding, that I intended to get myself wrapt up in a mattress, and carried to a place of safety at a distance from Rome; for in delivering me up to the Pope he would consign me to certain destruction. The cardinal, when he heard this, was upon the point of complying with my desire; but Signor Andrea, who was to have the bishopric, discovered the whole affair.

In the mean time the Pope suddenly sent for me, and caused me to be put into one of the ground-floor apartments belonging to his privy garden, as he had said he would. The cardinal sent me word not to eat any thing dressed in the Pope's kitchen, for he would supply me from his own table: at the same time he assured me that he could not possibly avoid acting as he had done, begged I would make myself entirely easy, and promised that he would contrive to procure me my liberty by some means or other.

Whilst I was in this situation, I was every day visited by many persons of distinction, and received from them several valuable presents and offers of service. Victuals were sent me by the Pope, but these I would never touch, instead of which I ate of those sent me by the Cardinal Cornaro: this rule I constantly observed. Amongst my other friends, there was a young Greek, about five-and-twenty years of age: he was an active, gay youth, and the best swordsman at that time in Rome. He was somewhat deficient in point of courage, but faithful, honest, and very credulous. He had heard what the Pope had said at first in my favour, about repaying me for my past sufferings, but perhaps did not know that he had afterwards spoken in a very different style. I therefore resolved to trust this young Greek, and spoke to him in the following manner: "My dear friend, these people are resolved to take away my life, so that now is the time to assist me. What! do they think I cannot perceive that whilst they show me such external acts of civility, it is all with an intention to betray me?" The good youth answered; "My friend Benvenuto, a report prevails all over Rome, that the Pope has given you a place worth five hundred crowns a year: I therefore entreat you not to let your groundless suspicions deprive you of so great an emolument." But all this made no impression on me: still I most earnestly besought him to take me out of that place, being thoroughly convinced that, though the Pope had it in his power to do me great favours, he secretly intended to injure me as much as he could, consistently with his reputation. I therefore urged him to be as expeditious as possible in rescuing me from such a formidable enemy; adding, that if he would release me from my

confinement in the manner I should point out, I should always consider myself as indebted to him for the preservation of my life; and would, when occasion offered, gladly venture it in his service. The poor young fellow replied, with tears in his eyes, "My dear friend, you are bent on your own destruction, but I cannot refuse complying with your desire; so tell me how you would have me proceed, and I will do whatever you require, though much against my inclination." Thus we at last agreed, and I told him in what method to proceed, and what measures to adopt; so that we should have found it a very easy matter to carry our design into execution. When I thought he was upon the point of performing all that he had promised, he came to tell me, that for my own sake he must disobey me; adding, that he had been informed by those who were near the Pope's person of the real state of my case. Having no other means of effecting my purpose, I now remained forlorn and in despair. This happened on Corpus Christi Day, in the year 1539.

Our dispute being over, and night approaching, a great quantity of provisions was brought me from the Pope's kitchen, and at the same time I received an ample supply from Cardinal Cornaro. Several of my friends happening to be with me, I invited them to stay to supper: they consented, and I spent the evening cheerfully, keeping my leg wrapped up in the bed-clothes. About an hour after sunset, they took their leave of me; and two of my servants having put me to bed, retired to the antechamber.

I had a shock dog, as black as a mulberry, who had been of great use to me when I went a-fowling, and now would never quit me a moment: as he happened that night to be under my bed, I called to the servants to take him away, because he kept howling most hideously. When the servants came, the dog flew at them like a tiger: they were frightened out of their wits at this, and under terrible apprehension that the creature was mad, from its incessant howling. This lasted till one in the morning.

As soon as the clock struck the hour, the captain of the city-guards entered my apartment with a considerable number of his followers: the dog then came from under the bed, flew at them with great fury, tore their cloaks and their hose, and so terrified them, that they thought he was mad. But the captain, being a man of experience, said, "Such is the nature of faithful dogs, that they, by a sort of instinct, foreknow and proclaim any misfortune that is to befall their masters. Two of you take sticks, and defend yourselves from the dog: let the rest seize Benvenuto, bind him fast to that seat, and carry him you know where." As I have said, it was the last day of Corpus Christi, at one in the morning. The guards

obeyed their order: I was covered and wrapped up, while four of them walked on before the rest, to disperse the few people who might happen to be still walking in the streets.

In this manner they conveyed me to a prison called the tower of Nona, and putting me into that part of it assigned to condemned criminals, laid me upon a piece of a mat, and left one of the guards to watch me. This man all the night lamented my hard fate, saying, "Alas! poor Benvenuto, what have you done to offend these people?" Hence I quickly conjectured what was to be my lot, as well from the circumstance of my being confined in such a place, as because my guard had apprised me of it. I continued part of that night in the utmost anxiety of mind, vainly endeavouring to guess for what cause it had pleased God so to afflict me; and not being able to discover it, I beat my breast with my despair. The guard did the best he could to comfort me: but I begged of him, for the love of God, to leave me to myself, and say no more; as I should sooner and more easily compose myself by my own endeavours: he promised he would do as I desired.

I then turned my whole heart to God, and devoutly prayed that it would please him to afford me his Divine aid; though I could not help lamenting my hard fate, considering my escape justifiable according to all laws, both divine and human; and though I had sometimes been guilty of manslaughter, yet as God's Vicar upon earth had recalled me from my own country, and confirmed my pardon by his authority, and all that I had done was in defence of the body which heaven had given me, I did not see how I could in any sense be thought to deserve death. My case, indeed, appeared to be much the same with that of those unfortunate persons, who, whilst they are walking the streets, are killed by the falling of a stone upon their heads; in the same manner as is often owing to the influence of the stars, not that they conspire to do us either good or mischief, but it proceeds from their conjunctions, to which we are all said to be subject. Although I know I have free-will, and that if my faith were as strong and lively as it should be, angels would be sent from heaven to deliver me out of this prison, and to relieve me from all the distresses I groan under: yet as I am unworthy of being so highly favoured by the divine power, the stars are permitted to shed all their baleful influence on my devoted head. Having continued in this agitation of mind some time, I at last composed myself and fell asleep.

As soon as it was morning my guard awaked me, and said, "O unfortunate, though virtuous man! this is no time for you to sleep, for here comes the messenger of dismal tidings." To this I answered,

"The sooner I am delivered from the prison of this world the better, especially as I am sure of salvation, being unjustly put to death. The glorified and divine Jesus makes me a companion to his disciples and friends, who suffered death without cause; and I return thanks to the Almighty for the favour. Why does not the person come who is to pronounce my sentence?" The guard replied, "He is grieved on your account, and even now weeps your approaching fate." I then called to him by his name, which was Benedetto da Cagli: "Draw near, my good Benedetto, now that I am ready and prepared for my fate: it is much more for my glory that I should die innocent, than if I were to suffer for my crimes. Come hither, and let me have a priest to talk with for a while before my departure, though I have indeed but little occasion for such assistance, as I have already made my confession to the Almighty. I desire it merely in compliance with the will of our Holy Mother, the Church; for though she has cruelly wronged me, I freely forgive her. Therefore approach me, my dear Benedetto, and despatch me whilst I am resigned and willing to receive my sentence." When I had uttered these words, honest Benedetto bade the guard lock the door, which, without his authority, could not be done.

He went directly to Pier Luigi's lady, who was in company with the duchess above mentioned, and as soon as he was come into their presence, he addressed her thus: "I implore you, most illustrious patroness, for the love of God, to send to the Pope, to desire him to appoint another person to pronounce Benvenuto's sentence, and do the office that I was to have done; for I renounce it, and nothing shall ever prevail on me to comply with such orders." Having thus delivered his sentiments, he departed with the greatest demonstrations of sorrow and concern. The duchess exclaimed, with an air of indignation, "Is this the justice administered in Rome by God's Vicar upon earth? The duke, my first husband, greatly patronised this man, on account of his abilities and his virtues, and would not let him return to Rome, because he took great delight in his company." Having spoken thus, she left the place murmuring, and expressing the highest disapprobation of the Pope's proceedings. Pier Luigi's lady, who was called Signora Jeronima, then repaired to his Holiness, and falling upon her knees in the presence of several cardinals, pleaded my cause with such eloquence, that the Pope was covered with confusion, and said, "For your sake, madam, we will proceed no farther against him,—not that we were ever bent on his destruction." The Pope expressed himself thus, because the cardinals, who were present, had heard the words of that noble-spirited lady.

I continued in prison in the most dreadful agitation, my heart beating violently with terror; and even the men, who were to perform the cruel office of executioners, were in some disorder. At last dinner-time approached, when all present departed, and I had my victuals brought me: at this sight I said with surprise, "Now, indeed, truth has been too powerful for the malignant influence of the stars! I therefore entreat the Almighty to deliver me from this danger, if it be His divine pleasure." I then began to eat; and as I had at first resolutely made up my mind to my expected death, I now cordially entertained the animating hope of my deliverance. Having dined heartily, I remained without seeing or hearing any thing farther till an hour after sunset, when the captain of the city-guards came with a considerable number of his followers, who put me again upon the same seat in which I had been conveyed the evening before to that prison. He spoke to me in the most kind and obliging manner, and bidding me banish all fear, commanded his followers to take care of me, and in particular to avoid touching my broken leg. Thus they carried me to the castle from whence I had made my escape; and when we had ascended pretty high, to a little court, there for a short time they set me down.

CHAPTER XXV.

Account of the barbarities which the Author undergoes during his confinement. —His great resignation under his afflictions.—Wonderful vision denoting his speedy deliverance.—He writes a sonnet upon his distress, which softens the heart of the Constable of the Castle towards his prisoner.—Death of the Constable.—Signor Durante attempts to poison Cellini, who escapes death in an extraordinary manner, through the avarice of an indigent jeweller.

SOON after the constable of the castle, though diseased and afflicted, caused himself to be carried to the place where I was confined, and said to me, "So, have I caught you again?"—" 'Tis true, you have," answered I; "but you see I escaped, as I told you I would; and if I had not been sold, under the papal faith for a bishopric, by a Venetian cardinal to a Roman of the Farnese family, both of whom, in so doing, violated the most sacred laws, you never would have had this opportunity of retaking me; but since they have thus mis-used me, you also may do your worst, for I now care for nothing more in this world." The poor gentleman then began to make terrible exclamations, crying out, "So, so! life and death are equally indifferent to this man, who is more daring and presumptu-

ous in his present condition than when he was well. Put him there under the garden, and mention not his name any more to me, for he is the cause of my death." I was accordingly carried to a very dark room under the garden, where there was a great quantity of water, full of tarantulas and other poisonous insects. A mattress was thrown me covered with a blanket, and that evening I had no supper, but was fast locked in, and so I continued till the next day. At three in the afternoon my dinner was brought, and I desired those who came with it to let me have some of my books, that I might amuse myself with reading. They made me no answer, but mentioned my request to the poor constable, who was desirous to know every thing I said.

The next morning they brought me a Bible of mine in the vulgar tongue, with another book, containing the Chronicles of Villani. Upon my asking for some other books, I was told that I should have no more, and that I had too many already. Thus wretchedly did I drag on my time, lying upon the rotten mattress above mentioned. In three days every thing in the room was under water, so that I could hardly stir an inch, as my leg was broken; and when I wanted to get out of bed, I was obliged to crawl along with great difficulty. For about an hour and a half of the day I enjoyed a little of the reflected light of the sun, which entered my wretched cell by a very small aperture; and that was all the time I had to read. I passed the remainder both of the day and night patiently in the dark, revolving in my mind the most serious thoughts on God, and on the frail condition of human nature. I had scarce any doubt but I should there in a few days end my miserable life. However, I made myself as easy as I could, and was comforted with the reflection, that it would have been much worse to feel the excruciating pangs of being flayed alive*: whereas, in my circumstances, at that time I passed away my life in a sort of dose, which was much more agreeable than my former situation. Thus by degrees I found my spirits so far broken that my happy temperament became habituated to this purgatory.

When I found myself thus reconciled to my condition, I formed a resolution to bear up under my unhappy lot as well as I could. I commenced the Bible from the beginning, and perused it every day with so much attention, and took such delight in it, that if it had been in my power I should have done nothing else but read; but as soon as the light failed me, I felt all the misery of my confinement, and grew so impatient that I several times was going to lay violent

* It appears that when in the tower of Nona he was under apprehensions of being flayed alive.

hands upon myself. However, as I was not allowed a knife, I had not the means of carrying my design into execution. I once, notwithstanding, contrived to place a thick plank of wood over my head, and propped it in the manner of a trap, so that if it had fallen upon me, it would instantly have crushed me to death; but when I had put the whole pile in readiness, and was just going to loosen the plank, and let it fall upon my head, I was seized by something invisible, pushed four cubits from the place, and terrified to such a degree that I became quite insensible. In this condition I remained from break of day till three in the afternoon, when my dinner was brought me. The persons that attended me must have been with me several times before I heard them; for when I recovered my senses, I heard Captain Sandrino Monaldi enter the cell, exclaiming, "Unfortunate man, what a pity it is that such merit should have such an end." Upon hearing these words, I opened my eyes, and saw several priests in their sacerdotal robes, who cried out aloud, "How came you to tell us that he was dead?" Bossa made answer,—"I said so, because I found him lifeless." They immediately removed me from the place where I lay, and threw the mattress, which was quite rotten, out of the cell. Upon telling the constable what they had seen, he ordered me another mattress. Having afterwards reflected within myself, what it could be that prevented me from carrying my design into execution, I took it for granted that it was some divine power, or, in other words, my guardian angel.

Afterwards at night there appeared to me in a dream a wonderful being, in form resembling a beautiful youth, who said to me in a reprimanding tone, "Do you know who gave you that body, which you would have destroyed before the time of its dissolution?" My imagination was impressed as if I had answered, that I acknowledged to have received it from the great God of nature. "Do you then," replied he, "despise his gifts, that you attempt to deface and destroy them? Trust in his providence, and never give way to despair whilst his divine assistance is at hand:" with many more admirable exhortations, of which I cannot now recollect the thousandth part. I began to reflect within myself that this angelical apparition had spoken the truth: so having cast my eyes round the prison, I perceived a few rotten bricks, which I rubbed together, and made of them a sort of mash. I then crawled along as well as I could to the door of the prison, and gnawed with my teeth till I had unloosed a splinter: this done I waited for the time that the light shone into my cell, which was from half an hour past four till half an hour past five, and then I began to write as well as I could with the composition above mentioned upon one of the blank leaves of my Bible; and reproved my

soul, which scorned to continue any longer in this world, and it answered my body, excusing itself; the body then suggested hopes that all would be well. Thus did I write a sort of dialogue between my soul and body, the purport of which was as follows:—

BODY.

Say, plaintive and desponding soul,
Why thus so loth on earth to stay?

SOUL.

In vain we strive 'gainst Heaven's control;
Since life's a pain, let's haste away.

BODY.

Ah, wing not hence thy rapid flight,
Content thyself, nor fate deplore:
New scenes of joy and pure delight
Heaven still for thee may have in store.

SOUL.

I then consent to stay a while,
Freedom once more in hopes to gain;
The rest of life with ease beguile,
And dread no more the rattling chain.

Having at length recovered my strength and vigour, after I had composed myself and resumed my cheerfulness of mind, I continued to read my Bible, and so used my eyes to that darkness, that though I was at first able to read only an hour and a half, I could at length read three hours. I then reflected on the wonderful power of the Almighty upon the hearts of simple men, who had carried their enthusiasm so far as to believe firmly that God would indulge them in all they wished for; and I promised myself the assistance of the Most High, as well through his mercy, as on account of my innocence. Thus turning constantly to the Supreme Being, sometimes in prayer, sometimes in silent meditations on the divine goodness, I was totally engrossed by these heavenly reflections, and came to take such delight in pious meditations, that I no longer thought of past misfortunes; on the contrary, I was all day long singing psalms and many other compositions of mine, in which I celebrated and praised the Deity. At this time nothing gave me so much pain and torment as my nails, which grew to a most immoderate length. I could not touch myself without being cut by them; neither was I able to put on my clothes, because they pricked and gave me the most exquisite pain. My teeth likewise rotted in my mouth, and this I perceived,

because the foul teeth being pushed forward by the sound ones, and at last obstructing the gums, the stumps came beyond their sockets: when I saw this, I pulled them as it were out of a scabbard, without any pain or effusion of blood: in this manner I got them out pretty easily. Then being reconciled to my other sufferings, one time I sang, another time I played, and sometimes wrote with the compound of brick-dust. I began a few stanzas in praise of the prison, in which I related all the accidents that had befallen me: these stanzas shall be inserted in their proper place.

The constable of the castle sent several times privately to inquire how I went on. On the last of July I expressed great joy, recollecting the festival which is generally celebrated at Rome on the first of August; and I said within myself, "Hitherto have I kept this delightful holiday in worldly vanity, this year I will keep it with the Almighty:" at the same time I reflected, how much happier I was at this festival than at any of the former. The spies who heard me express these sentiments, repeated them to the constable, who said, with surprise and indignation, "Good God! this man triumphs, and lives happily in all his distress, while I am miserable in the midst of affluence, and suffer death on his account! Go directly and put him into the deepest subterranean cell of the castle, in which the preacher Fojano* was starved to death; perhaps when he sees himself in so wretched a situation, he may at last come to himself."

Captain Sandrino Monaldi accordingly entered my cell, attended by about twenty of the constable's servants, who found me upon my knees praying. I never once turned about, nor took any notice of them; on the contrary, I worshipped God the Father, surrounded with a host of angels, and Christ rising victorious over death, which I had drawn upon the wall with a piece of charcoal that I had picked off the ground. After four months that I had been obliged to keep my bed with my broken leg, and so often dreamed that angels came to cure it, it had at length become quite sound, as if it had never been broken at all. Hence it was that a band of armed men rushed in upon me at once, seeming nevertheless to dread me as a poisonous dragon. The captain said to me, "You see there is a strong body of us, and we have made noise enough upon entering the cell; why then did

* Benedetto da Fojano, a popular preacher, was imprisoned in the Castle St. Angelo, by order of Clement VII., in 1530. His offence consisted in being too popular a preacher at Florence, in the struggle against the power of the Medici, in 1528, exciting the citizens to arms in defence of the republic from the pulpit.

The description that Varchi gives of his sufferings and lingering death is truly appalling. He, in vain, appealed to the mercy of the Pope, offering to dedicate his future life to a confutation of Luther's heresies. He was esteemed one of the most learned and eloquent ecclesiastics of his times.

you not turn about? At these words I guessed the worst that could befall me, and being long inured to sufferings, I made this answer; "To God, the King of heaven, have I turned my soul, my contemplation, and all my vital spirits; and to you I have turned exactly what suits you; for what is good in me you are neither able to see nor touch: so do whatever you please to that part of me which is in your power." The captain then, quite frightened, and not knowing what I intended to do, said to four of the boldest of his followers, "Throw your arms on one side." As soon as they had done so, he cried out to them, "Fall on him quickly, and seize him; is he the devil himself, that we should be so much afraid of him? hold him fast, and do not suffer him to escape." I being thus roughly handled and ill-treated, expected much worse than what afterwards befell me: I therefore lifted up my heart to Christ, and said, "O just God! thou who upon that high tree didst expiate all our sins, why is my innocence to suffer for offences that I am ignorant of? Nevertheless thy will be done." Whilst they were carrying me off with a lighted torch, I thought they intended to throw me into the sink of Sammalo: that is the name of a frightful place, where many have been swallowed up alive, by falling from thence into a well under the foundations of the castle. As this happened not to be my lot, I thought myself very fortunate: they however put me into the dismal cell in which Fojano was starved to death, and there they left me without doing me any farther harm. As soon as I found myself alone, I began to sing the following psalms:

"Out of the depths I have cried unto thee, O Lord," &c.

"Have mercy upon me, O God, according to thy loving kindness," &c.

"Truly my soul waiteth upon God," &c.

That whole day, which was the first of August, I solemnised with God; and my heart continually exulted with faith and hope. In two days they took me out of that dungeon, and carried me again to the cell where I had drawn the figures above mentioned: when I came there, the sight of the images on the wall made me weep with joy and gladness of heart. The constable, after that, wanted every day to know what I did, and what I said. The Pope having heard all that had passed, and that the physicians had already despaired of the constable's recovery, said, "Before my constable departs this life, as Benvenuto is the cause of his untimely fate, I shall be pleased to hear of his putting that fellow to death in what manner he thinks proper, in order that he may not die unrevenged."

The constable, having been informed of this speech by Pier Luigi, said to him, "Is the Pope then willing that I should wreak my

revenge on Benvenuto; and does he put him into my power? If he does, leave me to manage him, I shall know how to wreak a proper revenge." As the Pope had borne me the utmost malice and ill-will, so the anger and resentment of the constable were now turned with equal fury against me. Just at this juncture, the invisible being that had prevented my laying violent hands upon myself, came to me, still invisible, but spoke with an audible voice, shook me, made me rise up, and said, "Benvenuto! Benvenuto! lose no time, raise your heart to God in fervent devotion, and cry to him with the utmost vehemence!" Being seized with a sudden consternation, I fell upon my knees, and said several prayers, together with the whole psalm,

"He that dwelleth in the secret place of the most High," &c.

I then, as it were, spoke with God for awhile, and in an instant the same voice, altogether clear and audible, said to me, "Take your repose, and now fear nothing."

The reason of this was that the constable had given cruel and bloody orders to have me put to death, but all on a sudden revoked them, saying to himself, "Is not this Benvenuto whose cause I have so often espoused, whom I know with certainty to be innocent, and to have suffered all that has been inflicted on him unjustly? How can I expect that God should have mercy upon me, and forgive me my sins, if I do not show mercy to those that have offended me? And why should I hurt a man of worth, who has served me and done me honour? Go, tell him that, instead of putting him to death, I grant him his life and liberty; and shall direct in my will, that no one shall sue him for the expenses he has been at in this place." When the Pope heard this, he was highly offended.

I continued to put my usual prayers, kept writing my stanzas, and began to have every night the most joyful and encouraging dreams imaginable. I likewise constantly thought myself visibly in the company of this divine person, whom I had often heard whilst invisible. I asked but one favour of him, that he would carry me where I could see the sun, telling him that was of all things what I desired most, and that if I could see it but once I should die contented, and without repining at any of the miseries and tortures I had gone through; for I was now inured to every hardship, all were become my friends, and nothing gave me any farther uneasiness. Some of the constable's over-zealous servants had been in expectation that he would have hanged me, as he himself had threatened, from the very same battlement which I had descended; but when they saw that he had entirely altered his mind they were highly mortified, and were continually trying, by one artifice or another, to put me in fear of my life. But, as I have already observed, I was now so

familiarised to these things that none of them terrified me in the least, or had any effect upon my mind: the strongest and almost the only desire which animated my breast was an earnest longing to see the sphere of the sun, the golden orb of day! So continuing to pray with the same earnestness and fervour of devotion to Jesus Christ, I thus expressed myself: "O thou true son of God! I beseech thee by thy birth, by thy death upon the cross, and by thy glorious resurrection, that thou wouldst deem me worthy to see the sun in my dreams at least, if it cannot be otherwise! but if thou thinkest me worthy of seeing it with these mortal eyes, I promise to visit thee at thy holy sepulchre!" These vows did I make, and these prayers did I put up to God on the second of October, 1539.

When the next morning came, I awoke at daybreak, almost an hour before sunrise; and having quitted my wretched couch, I put on a waistcoat, as it began to be cool, and prayed with greater devotion than ever I had done before. I earnestly entreated Christ that he would be graciously pleased to favour me with a divine inspiration, to let me know for what offence I was so severely punished; and since his divine majesty did not think me fit to behold the sun even in a dream, I besought him by his power and his goodness that he would at least deem me worthy of knowing the cause of such rigorous chastisement. When I had uttered these words, some invisible being hurried me away like a whirlwind to a place where he unveiled himself to me in a human form, having the figure of a youth with the first down upon his cheeks, and of a most beautiful countenance, on which a particular gravity was conspicuous. He remained with me, and showed me what was in that place, saying, "Those numerous men whom you see are all who have hitherto been born and died." I then asked him why he brought me thither? To this he answered, "Come forward, and you will soon know the reason." I had in my hand a dagger, and on my back a coat of mail: he led me through that spacious place, and showing me those who travelled several ways to the distance of an infinite number of miles, he conducted me forward, went out at a little door into a place which appeared like a narrow street, and pulled me after him. Upon coming out of the spacious apartment into this street, I found myself unarmed, and in a white shirt, with my head uncovered, standing at the right of my companion. When I saw myself in this situation I was in great astonishment, because I did not know what street I was in: so lifting up my eyes, I saw a high wall in the front of a house, on which the sun darted his refulgent rays. I then said, "O my friend, how shall I contrive to raise myself so as to be able to see the sphere of the sun?" He thereupon showed me several steps

which were upon my right hand, and bade me ascend them. Having gone to a little distance from him, I mounted several of those steps backwards, and began by little and little to see the approaching sun. I ascended as fast as I could in the manner above mentioned, so that I at last discovered the whole solar orb: and because its powerful rays dazzled me, I, upon perceiving the cause of it, opened my eyes, and looking steadfastly on the great luminary, exclaimed, "O brilliant sun! whom I have so long wished to behold; henceforward I desire to view no other object, though the fierce lustre of thy beams quite overpowers and blinds me." In this manner I stood with my eyes fixed on the sun, and after I had continued thus gazing for some time, I saw the whole force of his united rays fall on the left side of his orb; and the rays being removed, I with great delight and equal astonishment contemplated the body of the glorious luminary, and could not but consider the concentring of its beams upon its left as a most extraordinary phenomenon. I meditated profoundly on the divine grace which had manifested itself to me this morning, and thus raised my voice: "O wonderful power! O glorious influence divine! How much more bounteous art thou to me than I expected!" The sun divested of his rays appeared a bath of purest melted gold. Whilst I gazed on this noble phenomenon, I saw the centre of the sun swell and bulge out, and in a moment there appeared a Christ upon the cross formed of the self-same matter as the sun; and so gracious and pleasing was his aspect, that no human imagination could ever form so much as a faint idea of such beauty. As I was contemplating this glorious apparition, I cried out aloud, "A miracle! a miracle! O God! O clemency divine! O goodness infinite! what mercies dost thou lavish on me this morning!" At the very time that I thus meditated and uttered these words, the figure of Christ began to move towards the side where the rays were concentrated; and the middle of the sun swelled and bulged out as at first. The protuberance having increased considerably, was at last converted into the figure of a beautiful Virgin Mary, who appeared to sit with her son in her arms in a graceful attitude, and even to smile; she was between two angels of so divine a beauty, that imagination could not even form an idea of such perfection. I likewise saw in the same sun a figure dressed in sacerdotal robes: this figure turned its back to me, and looked towards the blessed Virgin, holding Christ in her arms. All these things I clearly and plainly saw, and with a loud voice continued to return thanks to the Almighty. This wonderful phenomenon having appeared before me about eight minutes, vanished from my sight, and I was instantly conveyed back to my couch. I then began to make loud exclamations, crying out thus: "It has

pleased the Almighty to reveal to me all his glory in a splendour which perhaps no mortal eye ever before beheld: hence I know that I am free, happy, and in favour with God. As for you, unhappy wretches, you will continue in disgrace with him. Know that I am certain that on All Saints' Day (on which I was born in 1500, the night of the first of November, exactly at twelve o'clock), know, I say, that on the anniversary of that day you will be obliged to take me out of this dismal cell; for I have seen it with my eyes, and it was prefigured on the throne of God. The priest who looked towards Christ, and had his back turned to me, was St. Peter, who pleaded my cause, and appeared to be quite ashamed that such cruel insults should be offered to Christians in his house. So proclaim it every where, that no one has any farther power to hurt me and tell the Pope that if he will supply me with wax or paper to represent the glorious vision sent to me from Heaven, I will certainly convince him of some things of which he now appears to doubt."

The constable, though his physicians had entirely given him over, had recovered a sound mind, and got the better of all those whims and vapours which used to torment him yearly; so he gave his whole attention to the salvation of his soul: and as he felt great remorse of conscience on my account, and was of opinion that I had been from the beginning, and still continued to be, most cruelly injured, he informed the Pope of the extraordinary things which I declared I had seen. The pontiff (who neither believed in God, nor in any other article of religion) sent him word that I was mad, and advised him to think no more about me, but mind his own soul. The constable, having received this answer, sent some of his people to comfort me, and likewise ordered me pen, ink, paper, and wax, with the proper implements to work in wax, as well as his best respects and most courteous expressions of kindness, repeated to me by some of his servants who were my well-wishers. These people were, indeed, in every respect the very reverse of his wicked domestics and others who were for having me put to death. I took the paper and the wax, fell to work, and at my leisure wrote the following sonnet, inscribed to the worthy constable:

SONNET TO THE CONSTABLE OF THE CASTLE OF ST. ANGELO.

Could I, my lord, convey in labour'd strain
 Some emanation of that light divine
Which late illum'd my soul, I more should gain,
 Approved by thee, than were an empire mine.

Would heaven it were but to our Pontiff told,
 How to my eyes his glory Christ reveal'd,
Glory which human tongue can ne'er unfold!
 Glory from mortal view by clouds conceal'd!

Soon Justice would unbar her iron gate,
 Soon thou would'st see vile impious Fury bound,
Would'st hear her rave at Heaven and cruel fate,
 And with her cries make all th' expanse resound.

Did I alas! enjoy the light of day,
 Or were my limbs but free and unconfined:
I then could Heaven's unbounded love display,
 Smile at my pain, to death and fate resign'd:
The cross I bear would then appear more light,
And freedom's rays dispel the gloom of night.

The day following, when that servant of the constable's who was
my well-wisher came with my breakfast, I gave him the sonnet: the
good man, unknown to his malicious fellow-servants, my enemies,
showed it to the constable, who would gladly have released me, being
of opinion that the injury done me was in a great measure the cause
of his death. He took the sonnet, and having read it several times
over, said, "These are not the expressions or thoughts of a madman,
but of a worthy and virtuous person." He then ordered his secretary
to carry it to the Pope, and put it into his own hand, at the same
time requesting him to set me at liberty. Whilst the secretary was
carrying this sonnet to the Pope, the constable sent me candles, both
for day and night, with all the conveniences that could be wished for
in such a place: I thereupon began to recover of my indisposition,
which had increased to a very high pitch. The Pope read the sonnet,
and sent word to the constable that he would soon do something that
would please him; and I make no doubt but he would have been
willing to release me, had it not been for his son Pier Luigi, who
caused me to be detained against his father's inclination. Whilst I
was drawing a design of the late wonderful miracle, the constable,
sensible of the approach of death, on the morning of All-Saints'
Day, sent his nephew Piero Ugolino to me, in order to show me some
jewels. As soon as I saw them, I said within myself, "this is a
proof that I shall shortly be at liberty." When I expressed myself
to that effect, the young man, who was a person of few words, said
to me, "Think no more of that, Benvenuto."—"Take away your
jewels," replied I, "for I am under so strict a confinement, that I
see no light but what glimmers in this gloomy cell, so that I cannot

distinguish the quality of precious stones; but with regard to my release from this prison, before this day expires you will come to deliver me from it. This will positively happen as I tell you, and cannot be otherwise." The young man left the cell, having first ordered me to be locked up; he stayed away above two hours, and then returned, without any armed men, attended only by two boys to support me; and in that manner he conducted me to the large apartments* which I occupied at first (I mean in 1538), at the same time allowing me all the conveniences and accommodation I could desire.

A few days after, the constable, who thought I was released, being quite overpowered by the violence of his disorder, departed this life: he was succeeded by Signor Antonio Ugolini, his brother, who had made the deceased constable believe that he had discharged me from my confinement. This Signor Antonio, as far as I could understand, was ordered by the Pope to keep me a sort of a prisoner at large, till he should let him know how I was to be disposed of. Signor Durante of Brescia, who has already been spoken of, had entered into a conspiracy with that soldier, now a villain of an apothecary of Prato, to mix some poisonous infusion amongst my food, which was not to operate suddenly, but to produce its effect in about four or five months.

They at first thought of mixing with my meat the powder of a pounded diamond: this is not a poison of itself, but is so excessively hard, that it retains its acute angles, differing from other stones, which, when they are pounded, entirely lose the sharpness of their particles, and become round. The diamond alone preserves the acuteness of its angles: hence it follows, that when it enters the stomach with the meat, and the operation of digestion is to be performed, the particles of the diamond stick to the cartileges of the stomach and the bowels; and as the newly received food is impelled forward, the minute parts of the diamond which adhere to those cartilages, in process of time perforate them; and this causes death: whereas, every other sort of stone or glass, when mixed with meat, is incapable of sticking to the coat of the stomach, and of consequence is voided with the food. The rascal Durante gave for this purpose a diamond of little value to one of the guards belonging to the castle. I was informed that one Lione of Arezzo, a goldsmith, and my inveterate enemy, was employed to pound the diamond but, as this fellow was very indigent, and the diamond was worth several scores of crowns, he made the guard believe that a certain dust, with

* Where he had been before confined, in 1538.

which he supplied him, was the pounded diamond designed for my destruction.

On the day that it was administered to me, being Good Friday, they put it into all my victuals, into the salad, the sauce, and the soup. I ate very heartily, as I had had no supper the night before, and it happened to be a holiday. I indeed felt the meat crash under my teeth, but never once dreamt of the villanous designs of my enemies. When I had done dinner, as there remained a little of the salad on the dish, I happened to fix my eyes on some of the smallest particles remaining. I immediately took them, and advancing to the window, upon examining them by the light, recollected the unusual crashing above mentioned; then viewing the particles with attention, I was inclined to think, as far as my eye could judge, that a pounded diamond had been mixed with my victuals. Immediately upon this discovery, I concluded myself to be a dead man, and with the most heartfelt sorrow had recourse to my devotion. As I thought my death inevitable, I made a long and fervent prayer to the Almighty, thanking his divine Majesty for so easy a death: and, as my stars had so ordered it, I thought it a great happiness that my life was to terminate in that manner. I therefore composed myself with the most perfect resignation, and blessed the world and the time that I had lived in it; for I hoped that I was then departing to a better place by the grace of God, which I thought I had perfectly secured. Whilst I revolved these thoughts in my mind, I had in my hand some of the little grains of the supposed diamond.

But as hope is never totally extinct in the human breast, I had still some glimmering of it left; I therefore laid hold of a little knife, and taking some of the small particles above mentioned, put them upon one of the irons of the prison, then pressing upon them with the point of the knife as hard as I could, I heard the little grains crack: upon this I examined them attentively with my eye, and found that it was really so. Hence I conceived new hopes, and said within myself, "This is not the stone which was intended for me by the villain Durante: it is a small brittle stone, which is not likely to do me any manner of injury:" so though I had at first formed a resolution not to have recourse to any remedy, but to die in peace, I now altered my mind. But I first returned thanks to God, and blessed poverty, which, though it often causes death, was on this occasion the preserver of my life; for Durante, my mortal enemy, having given a diamond, worth above a hundred crowns, to Lione* to pound,

*Leon Lioni, a very distinguished artist in Cellini's own line, and like him afterwards a distinguished sculptor. He resided in Rome, where in 1540 he was imprisoned and condemned to lose a hand, for having made an assault and battery

his poverty made him keep it for himself, and in lieu of it he pounded for me a counterfeit diamond, not worth above twenty pence, thinking, as that was a stone as well as the other, it was equally likely to do the business.

At this very time the bishop of Pavia, brother to the count of St. Secondo, called Monsignor Rossi, of Parma, was prisoner in the castle. I called to him with a loud voice, telling him that a parcel of villains had given me a pounded diamond with a murderous intention. I then got one of his servants to show him part of the dust which was left on my plate; yet I did not let him know that what they gave me was no diamond, but maintained that they had certainly poisoned me, knowing that my good friend the constable was dead. I moreover requested him that for the short time I had to live, he would supply me with bread from his table, being determined to eat nothing that came from them for the future. He thereupon promised to furnish me every day with provisions. This bishop was prisoner in the castle on account of certain plots and intrigues which he had been concerned in at Pavia; and, as he was my friend, I used to call to him through the grate of my prison. Signor Antonio, the new constable, who certainly was not an accomplice in the design upon my life, made a great stir on the occasion, and desired to see the pounded diamond himself, in a persuasion that it was a real diamond; but thinking that the Pope was at the bottom of the affair, he chose to take no farther notice of it. I was now so circumspect as to eat only of the victuals which were sent me by the bishop, and I continued my stanzas on the prison, setting down every day such new events as befel me. Signor Antonio always sent me my victuals by one Giovanni, of whom mention has already been made, who had been a journeyman apothecary at Prato, and was then a soldier upon

upon the Pope's jeweller, one Pellegrino di Leuti. By the intercession of Cardinal Archinto, and Monsig. Durante, he got his sentence commuted for the galleys; but after some labour, he was also enabled when at Genoa to obtain his liberty, on the recommendation of Pietro Aretino to the famous Andrea Dorea. Thus, though poor, it appears he had already met with friends and acquired some reputation. Entering into the service of Charles V. he cast several noble statues in bronze, as well as many beautiful medals, and was very liberally rewarded by that monarch, who gave him the title of Chevalier, and a house in Milan. He presented this city with those grand models, which he obtained by collecting many statues of rare value, and casts of the masterpieces of antiquity, forming an excellent school, at his own house, for the future artists of the Duomo of Milan. The bronze figures on the mausoleum of Gian Giacopo de' Medici, designed by Michel Angelo for the said Duomo, are also the work of Leoni. The house of Leoni still remains with the noble ornaments in the front, and with those fine colossal statues which gave a name to the great road *Degli Omenoni*. He died in the height of his reputation, in 1586.

Pompeo Lioni, his son, inherited his father's extraordinary genius for medals and casts, with which he enriched the court of Spain. See Lettere Pittoriche and Vasari.

duty at the castle. This man was my inveterate enemy, and it was he that had brought me the pounded diamond. I told him that I would eat nothing that came through his hands, unless he first performed the ceremony of tasting it: but he answered me with an air, that this ceremony was only for Popes. To this I replied, that as gentlemen are obliged to perform the office of tasting for the Pope, so he who was a soldier, a journeyman apothecary, and a low fellow from Prato, was in duty bound to taste for a Florentine of my character. High words thereupon ensued between us.

After this, Signor Antonio, in some confusion for his past conduct, but intending to make me pay the fees, and other expenses, which his brother had forgiven me, chose another of his servants, who was my friend, to carry me victuals; and the man readily tasted them for me, without any dispute. This servant told me every day, that the Pope was constantly solicited by Mons. de Monluc, in the name of the king his master, and that his Holiness seemed to be very unwilling to part with me: he added, that Cardinal Farnese, who had formerly been so much my friend and patron, had declared that I must not think of being released from my confinement in haste. Upon hearing this I affirmed, that I should recover my liberty in spite of them all. The worthy youth advised me to be quiet*, and attempt nothing; but above all, to avoid speaking in that style, as it might prove highly prejudicial to my interest, if it came to be known: he at the same time exhorted me to trust in God, and to depend on his divine Majesty for my deliverance. I made answer, "That the goodness of God secured me from all fear of my prosecutors."

CHAPTER XXVI.

The Cardinal of Ferrara returns to Rome from the Court of France.—At a banquet where he is entertained by the Pope, he prevails on his Holiness to set the Author at liberty.—Verses called the Capitolo, which Cellini wrote in his confinement.

AFTER I had led this melancholy life a few days longer, the Cardinal of Ferrara made his appearance at Rome. Upon going to pay his respects to his Holiness, he was detained to supper; and the

* Cellini's best friends were also of the same opinion, as we gather from a letter of Caro to Luca Martini, dated the 22d of November, 1539, in which he says, "Benvenuto still remains prisoner in the castle; and although we make use of earnest and constant solicitation, and indulge some hope, yet there is no knowing how far the harshness and rage of this old fellow (Paul III.) will proceed. We are

Pope, being a person of great taste and genius, chose to converse with him concerning all that he had seen curious and worthy of observation in France. The cardinal in the heat of conversation discovered several things which he would otherwise have concealed; and as he knew how to conform himself to the French king's taste, and was equally possessed of the art of pleasing his Holiness, the latter took a much greater liking to him than he was aware of himself, and seemed to be in high spirits, as well on account of this engaging conversation, as of the debauch he committed on the occasion, which he repeated every week, and vomited after it. When the cardinal saw the Pope in a good humour, and likely to grant favours, he applied in my behalf, in the name of the king his master, in the most urgent manner imaginable, and expressed himself in such terms as demonstrated that the French monarch was very solicitous to obtain his request. The holy father thereupon perceiving that his time of vomiting was at hand, and that the great quantity of wine he had poured down his throat was upon the point of operating, said to the cardinal laughing, "Take Benvenuto home with you directly, without a moment's delay." Thus having given proper orders in the affair, he rose from the table, and the cardinal sent for me that very moment, before the affair could come to the knowledge of Signor Pier Luigi, who would never have consented to my release.

The Pope's order was brought to the prison by two of the Cardinal of Ferrara's gentlemen, in the dead of night: they took me out of the castle, and conducted me to the cardinal, who gave me the kindest reception imaginable. I was well lodged at his house, and enjoyed all the happiness which recovered liberty can bestow.* Signor Antonio, brother to the governor, and who was then possessed of his place, insisted upon my paying all my expenses, as well

to consider, that the interest made for him is great, and his offence no more than what he has amply expiated by his sufferings. If his own perverse nature, therefore, certainly very obstinate, does not stand in his way, I entertain good hopes. Even since his imprisonment, he has not been able to restrain himself from uttering some things, which in my opinion must injure him in the mind of the prince, perhaps more from suspicion of what he may dare to say or do for the future, than from any faults either of word or deed committed before. Let us take some means of convincing him of this; the results of which, if there be any, you shall farther know."

* Caro wrote word of Cellini's liberation to his friend Varchi, the 5th December, 1539, in the following terms: "You will, perhaps, have heard the news respecting Benvenuto, who is out of prison, and once more in the house of the Cardinal of Ferrara. In a little time, I doubt not, his affairs will do well, if he would let them, with that unmanageable head of his, which would make one doubt whether there be any thing fixed and certain in the world. We are continually holding up his own interest before his eyes, but he will not see it: the more we say, the less he is inclined to hear." Luigi Alamanni also wrote to Varchi, in an inedited letter given by Mazzuchelli;—"I have got Benvenuto safe and sound in my room. He owes his life to Cardinal Ferrara and his friends."

as the fees and gratifications required by the officers of justice, and others of that stamp: in short, he was resolved to act in every respect contrary to the will of the deceased governor. This affair cost me many a score of crowns. The cardinal encouraged me, bidding me take care of myself, if I valued my life; adding, that if he had not that evening got me out of prison, I should, in all probability, have ended my days in confinement; as he was informed that the Pope had already repented his having set me at liberty. I must, therefore, look back a little, to recollect some circumstances that occur in the verses which I composed when a prisoner. During the time that I passed in the apartment of the cardinal, and afterwards in the Pope's privy garden, amongst other friends that visited me, there came a cashier of Signor Bindo Altoviti, whose name was Bernardo Galluzzi, whom I had entrusted with the value of several hundred crowns. This young man came to the privy garden with an intention to settle accounts, and restore to me all that I had deposited with him. I told him, that I could not put my property into the hands of a dearer friend, nor into any place where it could be more secure. My friend, upon this, seemed to decline keeping it, and I, by a sort of violence, obliged him to continue his trust. When I was liberated from the castle this last time, I understood that poor Bernardo Galluzzi was a bankrupt, and that I had consequently lost all my money.

During my confinement I had, moreover, a terrible dream, in which a person appeared to write certain words of great importance upon my forehead with a reed, at the same time strictly charging me not to divulge what he had been doing; and when I awoke in the morning I perceived that my forehead was actually marked. In the verses composed during my confinement there are several events of a similar nature. I likewise received a circumstantial account, without knowing to whom I owed my intelligence, of all that afterwards happened to Signor Pier Luigi; and it was so clear and express in every article, that I have often thought I received it from a heavenly angel.

Another circumstance I must not omit, which is one of the most extraordinary things that ever happened to any man, and I mention it in justice to God and the wondrous ways of his providence towards me. From the very moment that I beheld the phenomenon, there appeared (strange to relate!) a resplendent light over my head, which has displayed itself conspicuously to all that I have thought proper to show it to, but those were very few. This shining light is to be seen in the morning over my shadow till two o'clock in the afternoon, and it appears to the greatest advantage when the grass is moist with dew: it is likewise visible in the evening at sunset. This

phenomenon I took notice of when I was at Paris, because the air is exceedingly clear in that climate, so that I could distinguish it there much plainer than in Italy, where mists are much more frequent; but I can still see it even here, and show it to others, though not to the same advantage as in France. I shall now lay before the reader the verses which I composed during my confinement and in praise of the prison. I shall then relate all the good and evil which befel me upon a variety of different occasions, as likewise the various events of the subsequent course of my life.

These verses I inscribe to Luca Martini.

THE CAPITOLO:

WRITTEN DURING THE AUTHOR'S IMPRISONMENT IN THE CASTLE OF
ST. ANGELO.

He who would sound the depths of power divine,
Should for a time in gloomy dungeon dwell,
Where grief corrodes and harrows up the soul.
Domestic care should prey upon his mind,
To sorrow and to crosses long inured,
By various troubles and by tempests toss'd.
Would you improve in virtue's rigid lore
By sad imprisonment? Your lot should be
Unjust confinement, long in grief your chain
You comfortless should drag, and no relief,
No kind assistance from a friend receive.
You should, by gaolers, of your property
Be cruelly deprived, and roughly used,
Nor ever hope for liberty again.
Frantic with rage you should your prison break,
Urged by some fell oppressor's cruel wrongs,
And then in deeper dungeon be confin'd.
Dear Luca, listen with attentive ear,
Whilst I my dire calamities relate:
What sufferings could be worse? To break leg,
In moist, damp, noisome cell to be confined,
Without a cloak to shelter me from cold!
Think what I suffer'd in these cells immured
Lonely, from human converse quite debarr'd,
My daily pittance brought me by a slave,
A surly monster silent and severe.
Think to what ills ambition does expose,
What dangers threaten an aspiring soul.
Think what it was to have no place to sit,
Or rest my head on, but a corner foul;

At every hour of tedious night and day
By cares unceasing to be kept awake.
O think how dismal that, to this sad cell,
None should approach but mutes in silence wrapp'd,
Who sternly frown'd, nor e'er an answer deign'd.
How sad it was that in such horrid cave
The poet's fancy won' to soar, to rove
In sprightly sallies, now should be confined
To pine the solitary hours away!
How sad to be restrain'd from pen and ink,
Nor e'en allow'd, the poet's sad relief,
To scrawl with charcoal on my prison walls!
But hold, my sorrows make me deviate far
From the first purpose of my moral song.
I mean a prison's praises to proclaim,
To show what useful lessons may be learn'd
In deep distress and sharp affliction's school:
Few inmates of such dreary solitudes
Were ever equal to this arduous task.
In those receptacles of guilt and vice
The man of virtue seldom is immured,
Except when fallen a victim to the hate
Of ministers and servile tools of power:
Except through envy, anger, or despite.
Confined in dungeon deep, in gloomy cell
The prisoner oft invokes God's awful name,
Yet feels within the torments of the damn'd.
Howe'er traduced and blacken'd by the tongue
Of calumny, to reputation lost,
Pass two unhappy years in prison pent,
You'll then come out reform'd; with manners pure,
The world will love you, will forget the past,
Imprisonment will all your faults atone.
Within the darksome round of prison walls—
Relentless walls where comfort never dwells!
The mental powers, the faculties decline,
The body like its covering decays;
Yet here, too, grossest wits by constant woe
Are sharpen'd, sublimated, and refined.
Genius 'midst sufferings imps her wings and soars,
And from these gloomy cells, in prospect bright,
Though distant, heaven's blest regions are descried.
Here how invention's aid our wants supplies,
And greatest difficulties can surmount.
Staring aghast I stalk about the room,
My hair with horror bristling on my head,
Like quills upon the fretful porcupine;

Next from a panel of the door I tear
A splinter with my teeth, expedient strange!
Cruel necessity such means suggests.
A brick reduced to powder than I mix
With water, kneading both into a mash.
Poetic genius fill'd my labouring breast,
And all my soul was by the muse inspired.
But to resume the subject of these lays:
He who desires to know and to enjoy
The good that Heaven bestows upon our kind,
Should first be practis'd in the train of ills,
Which in his wisdom God inflicts on man.
A prison prompts and teaches every art:
If medical assistance you require,
Through ev'ry open'd pore it makes you sweat.
With some strange virtue are its walls endued
To make you learned, eloquent, and brave.
And by enchantment wonderful its power
Your raptured fancy ever can delight
With florid, gay ideas, fairy scenes.
Though wisdom is in prison dearly bought,
Happy the man who there is taught her lore;
The genius is not by confinement cramp'd,
But spreads untutor'd its advent'rous wings
To treat of gravest subjects, war or peace:
His efforts always with success are crown'd,
What steadiness the mind in durance learns!
No more elate by fortune's wantom smiles,
Nor sunk dejected and depress'd with woe.
Perhaps you'll tell me all these years are lost,
That wisdom never was in prison learn'd.
I speak but what I feel: experience shows,
That e'en a dungeon may be wisdom's school.
But would to heaven our laws were so contrived
That guilty men no longer had the power
To 'scape that prison which their crimes deserve.
The man of low degree, by fortune doom'd
To drudge for a subsistence, there should gain
Experience, there should learn to act his part.
He thus would be less liable to err,
Less prone to stray from reason's equal path;
The world would then no longer be a stage
Of dire confusion, and a chaos wild.
Whilst in a gloomy dungeon's dark recess
Monks, priests, and men of rank I saw confined,
But fewest still of those who for their deeds
Seem'd most deserving of that rigid lot.

What poignant grief pervades a prisoner's breast,
When some sad partner of his dire distress,
Loose from his chain, first sees the prison door
Op'd to admit him to bless'd liberty!
What cruel anguish wrings his tortured breast!
He wishes that he never had been born.
Though long corroding grief upon my heart
Relentless prey'd, though oft my labouring brain
Has almost grown distracted with my woes,
'Midst all my ills some comfort strange I found.
Unknown to those who slumber life away
Upon the down of ease, whose happy lids
Were never sullied with a gushing tear.
 What raptures would transport my ravish'd breast
Should some one say to me with friendly voice,
Hence, Benvenuto, go, depart in peace;
How often has a deadly pale o'erspread
My livid cheeks, whilst in a dungeon deep
I pinned and sigh'd my hapless hours away!
Deprived of liberty I now no more
To France or Florence can at will repair!
Though were I even in France, I might not there
Meet tender treatment to relieve my woe.
I say not this against that noble soil,
Whose lilies have illumined heaven and earth;
But amidst roses thistles often grow.
I saw an emblem from the heavens descend
Swiftly amongst the vain deluded crowd,
And a new light was kindled on the rock:
He who on earth and in high heaven explains
The truth, and told me that the Castle bell
Should, ere I thence could make escape, be broke.
Then in a vision mystic I beheld
A long black bier on every side adorn'd
With broken lilies, crosses, and with plants;
And many persons I on couches saw
Diseased and rack'd with anguish and with pain
I saw the demon, the tormenting fiend
That persecutes the souls of mortal men,
Now with his horrors these, now those appal:
To me he turn'd, and said, I'll pierce the heart
Of whosoever hurts or injures thee.
Herewith upon my forehead words he wrote
Obscure, profound, with Peter's mystic reed,
And silence solemnly enjoin'd me thrice.
I saw the power divine, who leads the sun
His great career, and checks him in his course,

Amidst his court celestial brightly shine.
The dazzled eyes of mortals seldom see
A vision with such various glories fraught.
 I heard a solitary bird of night
Sing on a rock a dismal fun'ral dirge;
I thence inferr'd with certainty, this note
To me announces life, but death to you.
My just complaint I then both sang and wroth
Implored God's pardon and his friendly aid;
For sight began to fail me, and I felt
The iron hand of death upon my eyes.
Never was lion, tiger, wolf, or bear
Of human blood more thirsty, than the foe
That now with furious rage attack'd my life;
More poisonous never was the viper's bite:
The foe, I mean a cruel captain, came
Attended with a band of ruffians vile.
Just as rapacious bailiffs haste to seize
A trembling debtor with relentless hands,
So rush'd those sons of brutal force upon me.
'Twas on the first of August that they came
To drag me to a dismal dungeon, worse
By far than that in which so long I'd groan'd:
A cell in which the most abandon'd crew,
The refuse of the prison are confined.
Yet in this sad distress I soon received,
Though unexpected, succour and relief.
My foes, when thus their hellish spite they saw
Defeated, to fell poison had recourse;
But here again th' Almighty interposed,
For first I ever turned my thoughts to God,
And loud his grace and aid divine implored.
 My poignant anguish being thus assuaged,
Whilst I prepared to render up my soul,
Resign'd to pass unto a better state,
I saw an angel from the heav'ns descend
Holding a glorious palm-branch in his hand
With looks then joyous, placid, and serene,
He promised to my life a longer date.
The angel spoke to me in terms like these;
"Thy foes shall all be humbled to the dust,
And thou shalt lead a life of lasting bliss,
Favour'd by heaven and earth's eternal sire."

CHAPTER XXVII.

The Author being set at liberty pays a visit to Ascanio, at Tagliacozzo.—He returns to Rome, and finishes a fine cup for the Cardinal of Ferrara.—Account of his Venus and Cupid, his Amphitrite and Tritons, with other performances.—He enters into the service of the French King Francis I. and sets out with the Cardinal of Ferrara for Paris.—Affray with the postmaster of Camollia.—He arrives at Florence, where he stays four days with his sister.

WHILST I lodged in the palace of the Cardinal of Ferrara I was universally respected, and received more visits than even at first; every body expressing the highest surprise at my having emerged out of such distress, and struggled through such a variety of hardships and miseries. As I was recovering by degrees, I exerted my utmost efforts to become again expert in my profession, and took great delight in copying out the above verses. The better to re-establish my health, I rode out to take the air, having first asked the good cardinal's leave, and borrowed his horses. Upon these occasions I was generally accompanied by two young Roman citizens, one of whom was bred to my own business, the other not. When I was out of Rome, I steered my course towards Tagliacozzo, thinking to meet with my pupil Ascanio, of whom mention has so frequently been made. Upon my arrival, I found Ascanio there, with his father, his brothers, his sisters, and his mother-in-law. I met with so kind a reception, and was so greatly caressed during a stay of two days, that I am unable to give the reader an adequate idea of their civilities. I then set out for Rome, and carried Ascanio with me. By the way we talked of business; and such an effect had this conversation upon me, that I grew quite impatient to be again at Rome, in order to resume my trade.

Upon our return to that capital I fell to work with the utmost assiduity; and happening accidentally to find a silver basin, which I had undertaken for the cardinal just before my imprisonment, (at the time that I set about this basin, I likewise began a fine cup, of which I was robbed, with several other things of great value,) I set Paolo, who has been spoken of above, to work on the basin; and I myself took in hand the cup, which consisted of round figures in basso relievo. In like manner the basin contained little round figures and fishes in basso rilievo; and it was so rich, and the workmanship so exquisite, that all who saw it were in the utmost surprise, as

well on account of the force of genius and invention in the design, as of the admirable polish, which the young artists had displayed in the execution of the work. The cardinal came at least twice every day to see me, accompanied by Signor Luigi Alamanni and Signor Gabbriello Cesano: upon these occasions we passed an hour or two merrily, though I had a great deal of business, which required despatch. He at the same time put several other works into my hands, and employed me to make his pontifical seal, which was about the size of the hand of a child twelve years old. Upon this seal I carved two little pieces of history, one was John preaching in the Wilderness, the other was St. Ambrosio routing the Arians, represented on horseback, and with a whip in his hand. The design of this seal was so bold and admirable, the workmanship so exquisite, and the polish so fine, that every body said I had surpassed the great Lautizio, whose talents were confined to this branch alone; and the cardinal, in the joy of his heart, ostentatiously compared it to the other seals of the Roman cardinals, which were almost all by the above-mentioned artist.

At the same time that the cardinal gave me the other two works, he employed me to make a model of a salt-cellar, but desired it should be in a different taste from the common ones. Signor Luigi said many excellent things concerning this salt-cellar; Signor Gabbriello Cesano likewise spoke admirably upon the subject; but the cardinal, who had listened with the utmost attention, and seemed highly pleased with the designs which these two ingenious gentlemen proposed, said to me, "Benvenuto, the plans of Signor Luigi and Signor Gabbriello please me so highly, that I am in doubt which to give the preference to: I therefore leave it to you to make a choice, as you are charged with executing the work." I then said, "Gentlemen, do but consider of what importance the sons of kings and emperors are, and what a wonderful splendour and emanation of the Godhead is conspicuous in them; yet ask but a poor humble shepherd, which he has the greatest love and affection for, these children of emperors and kings, or his own; he will, doubtless, answer you that he loves his own offspring best. In like manner, I have a strong paternal affection for my own child; so that the first model I intend to show you, most reverend patron, shall be my own work and invention: for many plans appear very plausible when delivered in words, which have but an indifferent effect when carried into execution." I then turned about to the two virtuosi, and said, "O gentlemen, you have given us your plans in words, but I will show you mine in practice." Thereupon Signor Luigi Alamanni, with a smiling countenance, spoke a long time in my favour, and that in the most complaisant

manner imaginable: in doing this he acquitted himself with extraordinary grace, for he had a pleasing aspect, an elegant figure, and an harmonious voice. Signor Gabbriello Cesano was quite the reverse of him,—as ill-shaped in his person as ungracious in his manner,—and when he spoke he acquitted himself awkwardly. The plan proposed by Signor Luigi was, that I should represent a Venus with a Cupid, and several fine devices round them suited to the subject. Signor Gabbriello was for having me represent Amphitrite, the spouse of Neptune, and the Tritons, Neptune's attendants, with other ornaments, very fine in idea, but extremely difficult to be carried into execution.

I designed an oval, almost two-thirds of a cubit in size; and upon this oval, as the sea appears to embrace the earth, I made two figures about a hand high, in a sitting posture, with the legs of one within those of the other, as some long branches of the sea are seen to enter the land; and in the hand of a male figure, representing the ocean, I put a ship, contrived with great art, in which was deposited a large quantity of salt; under this, I represented four sea-horses, and in the right hand of the ocean I put his trident. The earth I represented by a female figure, the most elegant and beautiful I could form an idea of, leaning with one hand against a grand and magnificent temple; this was to hold the pepper. In the other hand I put a cornucopia, adorned with all the embellishments I could think of. To complete this idea, in that part which appeared to be earth, I represented all the most beautiful animals which that element produces. In the part which stood for the sea I designed the finest sort of fish and shells which so small a space was capable of containing; in the remainder of the oval I placed several grand and noble ornaments. Having then waited till the cardinal came with the two virtuosi above mentioned, I in their presence produced my model in wax. The first who spoke was Signor Gabbriello Cesano, who made a great stir upon the occasion, and said, "This is a work that the lives of ten men would be hardly sufficient to execute; and you, most reverend cardinal, who desire to have it finished in your life-time, are never likely to see it. Benvenuto has, indeed, thought proper to show you some of his offspring; but he has not done like us, who proposed only such things as were feasible; he has brought you a plan which it is impossible to finish." Upon this Signor Luigi Alamanni took my part. The cardinal, however, said, that he did not choose to be concerned in so great an undertaking. I thereupon turned to them, and replied: "Most reverend cardinal, I must beg leave to tell you, that I expect to complete this work at all events, and you will see it, when finished, a hundred times more luxuriant in ornaments than its model. I even

hope to have more than sufficient time to bring works of much greater consequence to perfection." The cardinal said, in a passion, "If you do not make it for the King of France, to whom I intend to introduce you, there is no likelihood of your finishing it for any other person." He then showed me the letters, in which the king wrote to him to return directly, and bring Benvenuto with him. Seeing this, I lifted up my hands to heaven, and exclaimed, "When will that *directly* come?" He bid me lose no time, but settle my affairs at Rome in ten days.

The time for our departure being arrived, the cardinal made me a present of a fine horse, to which he gave the name of Tournon, because it was a present from a cardinal of that name.* Paolo and Ascanio, my apprentices, were likewise provided with horses. The cardinal divided his retinue, which was very considerable: the chief part of it he took with him, following the road to Romagna, in order to visit our Lady of Loretto, and then to proceed to his own house at Ferrara; the other part he sent towards Florence,—this was superior in number to the former, and made a grand appearance, on account of the beauty of the horses. He desired me to keep him company, if I had a mind to travel in security, telling me that if I did otherwise, my life would be in danger. I gave him to understand that I proposed to follow his direction; but, as what is decreed by Heaven, must necessarily come to pass, it pleased God to recall to my memory my poor sister, who was so much concerned for the great misfortunes I had undergone. I, at the same time, thought of my cousins, who were nuns at Viterbo, one of them abbess, and the other treasurer, insomuch that between them they governed that rich monastery. As they had suffered so much on my account, and prayed for me so fervently, I took it for granted that I had obtained the grace of God by virtue of the prayers of these good women. These things occurring at once to my memory, I took the road to Florence. Thus, though I might have had all my charges borne by travelling with the cardinal and his retinue, I chose to perform the journey at my own expense, taking with me as a companion an excellent clockmaker named Cherubino, who was my intimate friend. As we happened to meet accidentally upon the road, we chose to perform this agreeable journey together. When I set out for Rome, on Monday in Passion Week, I was attended only by my two apprentices: at Monterosi I came up with the company above men-

* Francesco di Tournon, who was related by affinity to the king of France, and had been created cardinal in 1530, was one of the greatest ministers of state in that age. Francis I., in acknowledgment of his having been in a great measure indebted to this prelate for his enlargement from captivity, intrusted him with the most important affairs of his kingdom.

tioned; and as I had signified my intention of travelling with the cardinal, I did not imagine that any of my enemies would have thought of waylaying me. But I met with an unlucky disaster at Monterosi; for a body of men well armed had gone before us to that town, with a design to attack me; and so it happened that, whilst we were at dinner, these men, who had discovered that I had quitted the cardinal's retinue, lay in ambush for me, and were preparing to perpetrate their villainous designs. Just at this juncture the retinue of the cardinal came up, and with it I travelled joyfully to Viterbo, without any sort of danger. I went on several miles before, and the bravest men in the cardinal's retinue had a high esteem for me.

Being, by God's providence, arrived safe and in good health at Viterbo, I was received with the utmost kindness by my sisters and the whole monastery. After leaving that city with the company above mentioned, we rode on sometimes before and sometimes behind the retinue of the cardinal, so that by six o'clock on Holy Thursday evening we were come within a stage of Siena. Perceiving that there were some returned horses at the inn, and that the postmaster waited an opportunity to give them to travellers to ride back to Siena, I instantly dismounted from my horse Tournon, and putting my saddle and stirrups upon him, gave a piece of money to one of the postboys; then leaving my horse to the care of my apprentices, I spurred on, in order to get to Siena half an hour before the rest, that I might have time to visit my friends and transact some business in the town. Though this horse carried me with tolerable speed, I did not, however, ride it too hard. As soon as we arrived, I took rooms at a good inn for five persons: the horse I sent back by the ostler to the posthouse, which was without the gate that leads to Camollia; and upon it I had, through forgetfulness, left my stirrups and saddle. We passed the night very merrily on Holy Thursday.

The next day, which was Good Friday, I recollected my stirrups and saddle. Upon my sending for them, the postmaster made answer that he would not return them, because I had overworked his horse. Several messages passed between us, but he persisted in refusing to return them, and that with much opprobrious and abusive language. The innkeeper at whose house I lay, said to me at the same time, "It is well for you if he does not do something worse than keep your saddle and your stirrups: he is one of the most insolent men that has ever had the place of postmaster in this city and he has two sons, who are soldiers, desperate fellows, and more insolent than their father himself." He, therefore, advised me to make all the haste I could in buying whatever I might stand in need of, and leave the place directly, without entering into any contest with him. I there-

upon bought a pair of stirrups, thinking to recover my saddle by fair means; and as I was extremely well mounted, armed with a coat of mail, and had an excellent piece at the pommel of the saddle, I was not in the least intimidated by this report of the insolence and brutality of the postmaster. I had likewise used my apprentices to wear coats of mail under their clothes; and I had great confidence in my young Roman, who seemeth never to have neglected this defence whilst we were at Rome. Even Ascanio, though in his tender years, wore a coat of mail; and, as it was Good Friday, I imagined that the folly of these wretches would for that day subside.

We soon arrived at the posthouse at Camollia; and I immediately saw and knew the postmaster, by tokens that had been given me, particularly by his being blind of an eye. I went up to him, and leaving my two young fellows and the rest of the company at a little distance, said mildly, "Mr. Postmaster, when I assure you that I have not ridden your horse very hard, why do you make a difficulty of restoring me my saddle and stirrups?" He answered with all the violence and brutality I had been prepared for. I thereupon said to him, "What! are you not a Christian, and do you intend to bring a scandal both upon yourself and me this Good Friday?" He answered, that he cared neither for Good Friday nor the devil's Friday, and that if I did not get about my business, he would soon, with his long pike, lay me sprawling upon the ground, musket and all. Upon his speaking to me thus roughly, there came up an old gentleman of Siena, a very polite, worthy man, who was just come from performing the devotions usual on that day. Having, though at a distance, heard what I had to say for myself, and perceiving that I was in the right, he boldly reproved the postmaster, took my part, and reprimanded the two sons for behaving rudely to strangers, by swearing and blaspheming, and thereby bringing a scandal upon the city of Siena. The two young fellows, sons to the postmaster, shook their heads, and without returning any answer retired. The incensed father, exasperated by what was said by the worthy gentleman that interposed in my behalf, ran at me with his long pike, cursing and blaspheming, and swore he would instantly be the death of me. When I saw him thus determined, I, to keep him off for a while, presented the muzzle of my piece at him. He, notwithstanding, flew at me with redoubled fury; and the gun which I held in my hand, though in a proper position for my own defence, was not rightly levelled at him, but, the muzzle being raised aloft, it went off of itself. The ball hit against the arch over the street-door, and having rebounded, entered the postmaster's windpipe, who instantly fell dead upon the ground. His sons thereupon rushed out of the house, and one having taken

down arms from a rack, whilst the other seized his father's pike,
they both fell upon the young men in my company: the son who had
the pike wounded Paolo, the Roman, in the left breast; and the other
fell upon a Milanese in our company, a foolish fellow, who would
not ask quarter or declare that he had no connection with me, but
defending himself against a partisan with a short stick which he had
in his hand, he found himself unable to parry his adversary's
weapon, so as to prevent his being slightly wounded in the mouth.
Signor Cherubino was in the habit of a priest, and though he was
an excellent clockmaker, as I observed before, he had several bene-
fices conferred on him by the Pope, which produced him a consid-
erable income. Ascanio was well armed and stood his ground bravely,
instead of offering to fly like the Milanese, so that these two received
no manner of hurt.

I spurred my horse, and whilst it was in full gallop, quickly
charged my piece again: then I returned back in a passion, thinking
that what I had done was but a trifle; for, as I thought my two young
men were killed, I advanced with firm resolution to die myself. My
horse had not gone many paces back, when I met them both coming
towards me. I asked them whether they were hurt, and Ascanio
made answer that Paolo had received a mortal wound with a pike.
I thereupon said to the latter, "My dear Paolo, how comes this?
Could a pike force its way through a coat of mail?" He then told me
that he had put his coat of mail into his cloak-bag. I replied, "What,
this morning? It seems then that coats of mail are worn at Rome to
make a show before the ladies; but in times of danger, when they
might be of use, they are put into the cloak-bag! You deserved all
you have suffered, and what you have done is the cause of my de-
struction also." Whilst I uttered these words, I continued to ride
back resolutely. Ascanio and the other earnestly entreated me that
I would for the love of God endeavour to save my life, as well as
theirs, for that I was hurrying on to death. Just then I met Signor
Cherubino and the Milanese, the former of whom reproved me for
my vain fears, telling me that none of my people had been hurt, that
Paolo's wound had only grazed the skin, and had not gone deep, and
that the old postmaster lay dead upon the ground. He added, that
the sons had got themselves in readiness, and being assisted by sev-
eral other persons, would certainly cut us all to pieces: "therefore,
Benvenuto," continued he, "since fortune has saved us from their
first fury, let us tempt her no more, for she will not save us twice."
I then said, "Since you are satisfied, I am content;" so turning to
Paolo and Ascanio, I bid them spur their horses hard, and gallop on

to Staggia* without ever once stopping, observing that when we
were there we should be in safety. The wounded Milanese then said,
"A plague of this unlucky adventure; this mischief was owing to a
little soup which I ate yesterday, when I had nothing else for my
dinner." Notwithstanding our great distress, we could not help
laughing at the fool, and at his silly expressions. We clapped spurs
to our horses and left Signor Cherubino and the Milanese, who were
for riding on gently, to follow us at their leisure. In the mean time
the sons of the deceased repaired to the Duke of Amalfi†, and re-
quested him to grant them a troop of light horse to pursue and take
us. The duke, being informed that we belonged to the retinue of
Cardinal of Ferrara, would not grant their request.

In the mean time we arrived at Staggia, where we were in per-
fect security: upon our arrival we sent for the best surgeon that
could be found in the place, who, examining Paolo's wound, de-
clared that it did not pass the skin, and there was no danger: we then
ordered dinner to be got ready. Soon after, Signor Cherubino made
his appearance with the fool of a Milanese, who was constantly ex-
claiming, "A plague of all quarrels and disputes!" adding that he had
incurred excommunication, because he had not had time to say his
paternoster that blessed morning. This man was hard-favoured, and
had naturally an ugly wide mouth, but by the wound he had received
it was enlarged above three inches. These circumstances, with his
ludicrous Milanese jargon, and his foolish sayings, made us so
merry, that instead of lamenting our ill-fortune, we could not help
laughing at every word he uttered. As the surgeon wanted to sew
the wound in his mouth, and had already made three stitches in it,
he desired him to stop, telling him he would not upon any account
have him sew it up entirely. He then took up a spoon, and desired it
might be left so far open as to leave room for such a spoon to enter,
that he might return alive to his companions. These words, which
he uttered with many nods and ludicrous gestures, made us so

* Staggio, or Staggia, is ten miles from Siena.

† The republic of Siena, which was under the protection of Charles V., was
then governed by Alfonso Piccolomini, Duke of Amalfi, who had been created
captain-general of the Sienese in 1529. He was descended from Nanni Tedeschini
da Sarteano, who, in consequence of his having married a sister of Pius II., had
been, together with his descendants, reckoned amongst the family of Piccolomini.
Having distinguished himself in arms under the emperor, and being under the pro-
tection of the Spanish Court, as well as in favour with a powerful popular party,
he might with ease have made himself sovereign of Siena. But Alfonso, abandon-
ing himself to pleasures, and the love of popularity, did not profit by these favour-
able circumstances; carried away by the love he bore Agnes Salvi, he was induced
to leave unpunished the misconduct of her family, and thus gave occasion to many
disorders and repeated accusations against his government, the result of which was,
that he was, in 1541, banished from Siena by the order of the Emperor Charles V.

merry, that instead of bewailing our ill fortune, we never ceased
laughing, and in this manner continued our journey to Florence.

We dismounted at the house of my poor sister, where we were
most kindly received, and very much caressed by her and my cousin.
Signor Cherubino and the Milanese went where their respective af-
fairs called them: we stayed four days at Florence, during which
Paolo was cured. The most diverting circumstance was, that when-
ever the fool of a Milanese became the subject of discourse, we all
laughed as heartily as we lamented our other misfortunes, insomuch
that we were constantly laughing and crying in the same breath.

CHAPTER XXVIII.

The Author arrives at Ferrara, where he is caressed by the sovereign of that
duchy, and employed to make his statue in marble.—The climate disagrees with
him, and he is taken ill; but recovers by eating wild peacocks.—Misunderstanding
between him and the duke's servants, attended with several unpleasant circum-
stances.—After many difficulties and delays, he resumes his journey, and arrives
safe at Lyons, from whence he proceeds to Fontainebleau, where the Court at that
time resided.

AFTER we had stayed four days at Florence, we took the road to
Ferrara, and there found the cardinal, who having heard all the acci-
dents that had befallen us, said with concern, "God grant that I may
carry you alive to the king, according to my promise to his majesty!"
The cardinal assigned me an apartment in a palace of his at Ferrara,
a magnificent building, called Belfiore, contiguous to the walls of the
city; and there he caused tools and all things necessary to be pro-
vided for me, that I might work at my business. He then ordered
his retinue to set out for France without me, and seeing me very
melancholy at being left behind, he said to me, "Benvenuto, all I
do is for your good; for before you leave Italy I should be glad you
were upon a certainty with regard to your employment in France.
In the mean time proceed as fast as you can with the basin and the
little cup; and I will leave orders with my steward to supply you
with whatever money you may want."

Upon his departure I remained highly dissatisfied, and often
thought of leaving the place: the only consideration that prevented
me was my being then out of the power of Pope Paul; for in all
other respects I was highly discontented, and very much a sufferer.
I however assumed those sentiments of gratitude which the favour
seemed to deserve, endeavoring to wait with patience and see how

this adventure would end. I fell therefore hard to work with my two apprentices, and went surprisingly forward with my basin and cup. In the part of the city where we lodged the air was rather unwholesome, and on the arrival of summer we were all somewhat indisposed. During this our indisposition we made a discovery of a great waste, about a mile in extent, that belonged to the palace in which we lived, and where several pea-hens came like wild fowl to hatch their eggs. When I perceived this I charged my piece with powder, and lying in wait for the young peacocks, I every day killed one of them, which served us plentifully to live upon; and such was the effect of this food that it entirely cured our disorder. Thus we continued our work with alacrity for several months that we had to stay, and went forward with the basin and the cup—works that required considerable application.

About this time the Duke of Ferrara accommodated his differences with Pope Paul, relative to Modena and some other cities; and as the claims of the Church were just, the duke made this peace by dint of money: the sum given upon the occasion was considerable, and I think it exceeded three hundred thousand ducats. The duke had at that time an old treasurer, who had been brought up at the court of the duke his father, and whose name was Signor Girolamo Gigliolo: this old man could not bear that so great a sum should be given to the Pope, so that he ran about the streets crying out aloud, "Duke Alphonso, our present duke's father, would rather have taken Rome with his money than have given it to the Pope;" and he would obey no order for paying it. The duke having, however, at last forced him to pay the money, the old man was attacked with a flux so violent that it brought him almost to the brink of the grave. Whilst he lay ill, the duke sent for me and desired me to take his likeness; I accordingly drew his portrait upon a round black stone, about the size of a little dish. The duke was greatly pleased with my performance, and with some agreeable conversations which passed between us: the consequence was, that he generally stayed at least four or five hours a day to have his likeness taken, and sometimes he made me sup with him at his own table. In a week's time I finished this portrait: he then ordered me to make a reverse; the design of it was a female figure that represented peace holding in her hand a small torch, with which she set fire to a trophy of arms. This female figure I represented in a joyous attitude, with garments of the thinnest sort, which flowed with the utmost grace; under her I designed a fury in despair, and bound with heavy chains. In this work I exerted the utmost efforts of my art, and it gained me great honour: the duke repeatedly expressed the highest satisfaction at my performance, and

gave me the inscription for the head of his excellency as well as for the reverse. The words intended for the reverse were *"Pretiosa in conspectu Domini:"* this intimated that the peace had been dearly purchased for a large sum of money.

Whilst I was busy about this reverse, the cardinal wrote to me to get ready, for the king insisted upon my coming directly, and that the next time I heard from him I should receive an order for all he had promised me. I caused my basin and cup to be packed up, having before shown them to the duke. A gentleman of Ferrara, Signor Alberto Bendidio, was agent to the cardinal: this person had remained twelve years without ever stirring out of his house, on account of a lingering disorder. He one day sent for me in a great hurry, and said that I must that instant take post, and use the utmost expedition to wait upon the king, who had inquired for me with the greatest eagerness and solicitude, thinking I was in France. The cardinal, to excuse himself, had told the monarch that I had stopped at an abbey of his at Lyons, being somewhat indisposed, but that he would take care I should be shortly with his majesty: therefore I must take post and repair to the court of France with all speed. This Signor Alberto was a very worthy man, but haughty, and his disorder rendered his pride and humour insupportable: he told me that I must without delay prepare to ride post. I made answer that it was not customary with men of my calling to ride post; but that if I were to proceed to the court of France I should choose to go by easy stages, and to carry with me Ascanio and Paolo, my companions and artificers, whom I had brought from Rome; adding that there must likewise be a servant with us on horseback to attend us, and that I expected to be supplied with a sum sufficient to defray the charges of the journey. The infirm old man then proudly made answer, that "the duke's sons travelled in the very manner I had described." I instantly replied, "that the sons of the art which I professed travelled in the manner I had mentioned; and that as I had never been the son of a duke I did not know how such gentry appeared on their journeys; therefore I would not go to France at all, as well because the cardinal had broken the promise he had made me as that I had now received such insulting language." I then formed a resolution to have no more dealings with the people of Ferrara, and turning my back on him, I departed, murmuring my discontent, whilst he continued to bully and insult me.

After this, I waited on the duke with his medal finished: his reception of me was the kindest imaginable, and no man was ever more caressed by a prince. He had given orders to Signor Girolamo Gigliolo, who was then recovered, to look out for a diamond ring

worth above two hundred crowns as the reward of my labour, and put it into the hands of Fraschino one of the gentlemen of his bed-chamber, who was to give it to me: these orders were obeyed. Fraschino, on the same evening that I had given him the medal, put a ring into my hands, with a diamond set in it, which made a great show, and told me from the duke, that my masterly hand, which had acquitted itself so admirably in consecrating the memory of his ex-cellency, well deserved to be adorned with such a diamond. The day following I examined the ring, the diamond of which was an incon-siderable one, not worth above ten crowns and as I could not con-ceive that the duke could use such grand expressions in giving so trifling a reward, or that he imagined he had properly recompensed me, I took it for granted that the rogue of a treasurer had played me a trick. I therefore gave the ring to a friend, desiring him to contrive some way or other to return it to Fraschino, the gentleman of the bedchamber. This friend was Bernardo Saliti, who performed the commission admirably. Fraschino immediately came to me, and made a terrible stir, telling me that if the duke should discover that I had been so rude as to return a present, which he had made me in so kind and gracious a manner, he would certainly resent it, and I might very possibly repent my having taken so indiscreet a step. To this I answered, that the ring which his excellency had sent me, was not worth above ten crowns, and the work which I had done for him came to above two hundred; but to show his excellency that it was his favour alone I set a value upon, he might send me one of those English crab-rings*, which are worth only tenpence, and I would keep it in remembrance of him as long as I lived; at the same time retaining in mind those honourable expressions of his excellency con-cerning my genius and abilities: for I considered my labour as abundantly rewarded by the honour of having served so great a prince, whereas a jewel of so little value disgraced me. These words occasioned the duke so much displeasure, that he sent for his treasurer, and reproved him most severely: he at the same time sent me orders not to leave Ferrara, without apprising him of my depar-ture, and commanded his treasurer to give me a diamond worth three hundred crowns. The avaricious treasurer found one, the value of which was not above sixty crowns, and maintained that it was worth considerably more than two hundred.

In the mean time Signor Alberto had taken the right method of proceeding, and furnished me with all I had desired for my journey. I had resolved by all means to quit Ferrara directly, but the duke's

* One of those metallic rings which are considered useful for that muscular contradiction called the cramp.

careful chamberlain had so concerted matters with Signor Benedetto, that I could not that day provide myself with horses. I had loaded a mule with my baggage, and with it I packed up the basin and the cup which I had made for the cardinal. Just at this juncture came in a gentleman of Ferrara, whose name was Signor Alfonso de' Trotti: he was advanced in years, exceedingly affable, and delighted greatly in talents and genius; but at the same time he was one of those that are very hard to be pleased, and who, if they happen to see any thing which strikes them, represent it to their imaginations as so admirable, so divine, that they never expect again to see any thing equal to it. Signor Alfonso, as I before observed, happening to enter the room just at this time, Alberto said to him, "It happens unluckily that you are come too late, for the cup and basin that we are sending to France to the cardinal are now packed up." Alfonso hearing this, said, he did not care; and upon beckoning to his servant, the latter went to his house, and brought from thence a white bowl, made of clay, from Faenza, the workmanship of which was admirable. Whilst the servant was going on his errand, Alfonso said to Alberto, "I will tell you why I have no longer any curiosity to see cups or vessels of any other sort. I once beheld an antique silver cup of such extraordinary beauty, that human imagination is incapable of forming an adequate idea of its excellence. Since that time, I am indifferent about seeing any thing else of the same kind, lest it should destroy the idea that I had formed in my imagination. It was in the possession of a person of condition, of great taste, who happening to go to Rome about some business, this antique cup was shown him secretly, and be by dint of money having corrupted the person who had the custody of it, brought it away with him; but he takes care to keep it from the knowledge of the duke, for he is afraid he should be deprived of it, if his excellency should once come to know of his being possessed of so valuable a treasure." Whilst Alfonso was telling this long story, he never once took notice of me, though I was present all the time. In the meanwhile, this fine earthen model made its appearance, and was displayed with such pomp and ostentation, that I no sooner set my eyes upon it, than I turned to Alberto, and said: "I am happy in having seen this great curiosity." Alfonso then answered me with great contempt: "Who are you? You seem not to know what you are saying." To this I replied, "Listen to me, and you will see which of us knows best what he is saying." Then turning to Signor Alberto, who was a man of great gravity and uncommon genius, I spoke thus: "This is copied from a little silver cup of such a weight, which I made at such a time for that mountebank Jacopo, a surgeon of Carpi, who came to Rome, stayed there six

months, and by means of a quack medicine took in several noblemen and poor gentlemen, whom he defrauded of many thousands of ducats: at that time I made this cup for him, and another of a different sort, and he paid me very ill both for the one and the other. At present all the unfortunate gentlemen who used his nostrum are at Rome, crippled, and in a most wretched condition. It is a great honour to me that my works have acquired so high a degree of reputation amongst men of fortune like you; but I must tell you, that for many years past I have laboured with the utmost assiduity to learn and improve; so that I cannot but be of opinion that the cup which I am carrying to France will prove much more worthy of the cardinal and the king, than the other did of the quack doctor." As soon as I had delivered myself to this effect, Alfonso appeared to be in the utmost impatience to see the basin and cup, and I persisted in refusing to gratify his curiosity. This contest having lasted for some time between us, he declared that he would go to his excellency, and by his means contrive to get a sight of it. Thereupon Alberto Bendidio, who, as I have already observed, was a very proud haughty man, said, "Before you leave this place, Signor Alfonso, you shall see it without being under the necessity of making any application to the duke." I quitted the room, and left Ascanio and Paolo to show it to them: they afterwards told me that the gentlemen had paid me a great many compliments, and spoke highly in my favour. Signor Alfonso then expressed a desire of contracting an intimacy with me, so that I began to grow quite impatient to leave Ferrara.

The only valuable or useful acquaintance I made there, were Cardinal Salviati and the Cardinal of Ravenna, with some of the eminent musicians*: for the gentry of Ferrara are not only exceedingly avaricious, but rapacious after the property of others, and endeavour to get possession of it by every expedient they can think

* It will not appear strange, that Cellini should here mention the musicians of Ferrara, in company with two eminent cardinals, Accolti and Salviati, when it is considered that music then flourished, and was held in high estimation in this city. This art, which was revived in the dominions of the house of Este about the year 1050, by the labours of the famous Guido Aretino, monk of Pomposa, always found great supporters amongst the Ferrarese. Not to mention the particular protection granted by that court to the celebrated Flemish musicians, Josquin de Près. Adrian Willaert, and Ciprian de Rore, who were the greatest masters of the sixteenth century: it will be sufficient here to notice, that in that very year (1540) there lived in Ferrara many professors so eminent as to leave their names famous in the annals of music. Such were Ludovico Fogliani, and Don Nicolo Vicentino, a priest, both writers on new musical theories; the Canon Afranio de' Conti, Albonesi di Pavia, the reputed inventor of the Fagotto; and Giacopo Fogliano, an excellent organist. Anna and Lucrezia, the two daughters of Duke Ercole II., who made great progress in the most profound studies, cultivated music also with such success as to merit the particular praise of Ricci, Giraldi, Calcagnini, and Patrizi, concerning whom see the dedication of the *Deca Istoriale*.

of : this is the general character of them all. About ten o'clock Fras-
chino came and delivered me the diamond, which was worth above
sixty crowns ; desiring me with a melancholy countenance, and in few
words, to wear it for his excellency's sake. I answered that I should
do so. I then mounted my horse, and set out upon my journey,
trusting myself to Providence. The treasurer took notice of all my
gestures and words, and gave information thereof to the duke, who
seemed to be incensed with what he heard to the highest degree, and
was very near ordering me to be brought back.

Before night I had travelled above ten miles, trotting all the way,
and upon finding myself the day following out of the district of
Ferrara I was highly rejoiced; for I had never met with any thing
good in that country, except the peacocks, by which I had recovered
my health. We steered our course by mount Cenis, taking particular
care to keep clear of Milan on account of the suspicion above men-
tioned, and soon after I arrived safe and in health at Lyons with
Paolo, Ascanio, and a servant : we were four in all, pretty well
mounted. Upon our arrival at Lyons we stopped for several days to
wait the coming of the muleteer, who was charged with the silver
basin and the cup, as likewise with part of my baggage : we were
lodged in an abbey belonging to the cardinal. The muleteer being
arrived, we packed up every thing belonging to us very safe in a
chest, and in this manner continued our journey to Paris, by the way
we met with some little impediments, which were not of much con-
sequence.

CHAPTER XXIX.

The Author meets with a most gracious reception from the French King, and
attends him in his tour to Dauphiny.—Grand retinue of that prince.—The Cardinal
proposes to Cellini to work for an inconsiderable salary.—He is highly disgusted at
this, and goes off abruptly upon a pilgrimage to Jerusalem.—He is pursued and
brought back to the King, who settles a handsome salary on him, and assigns him a
house to work in at Paris.—He sets out for that capital, but meets with great oppo-
sition in taking possession of the house, which however he at last completely
overcomes.

WE FOUND the court of the French monarch at Fontainebleau,
where we directly waited on the cardinal, who caused apartments to
be assigned us : we spent the night very agreeably, and were well
accommodated. The next day the waggon came up, so we took out
what belonged to us, and the cardinal having informed the king of

our arrival, he expressed a desire to see me directly. I waited on his majesty accordingly, with the cup and basin so often mentioned: being come into his presence I kissed his knee, and he received me in the most gracious manner imaginable. I then returned his majesty thanks for having procured me my liberty, observing that every good and just prince like his majesty was bound to protect all men eminent for any talent, especially such as were innocent like myself; and that such meritorious actions were set down in the books of the Almighty before any other virtuous deeds whatever. The good king listened to me till I had made an end of my speech, and expressed my gratitude in terms worthy of so great a monarch. When I had done, he took the cup and the basin, and said: "It is my real opinion that the ancients were never capable of working in so exquisite a taste. I have seen all the masterpieces of the greatest artists of Italy, but never before beheld any thing that gave me such high satisfaction." This the king said in French to the Cardinal of Ferrara, at the same time paying me several other compliments greater even than this. He then turned about and said to me in Italian: "Benvenuto, indulge yourself and take your pleasure for a few days; in the mean time I shall think of putting you into a way of making some curious piece of work for me." The Cardinal of Ferrara soon perceived that his majesty was highly pleased with my arrival, and that the specimens he had seen of my abilities had excited in him an inclination to employ me in other works of greater importance.

Whilst we followed the court, we may justly be said to have been in great straits, and the reason is that the king travels with upwards of twelve thousand horses, his retinue in time of peace being eighteen thousand. We sometimes danced attendance in places where there were hardly two houses, were often under the necessity of pitching very inconvenient tents, and lived like gypsies. I frequently solicited the cardinal to put the king in mind of employing me: he made answer, that it was best his majesty should think of it himself, advising me to appear sometimes in his presence, when he was at table. This advice I followed, and the king one day called me to him whilst he was at dinner. He told me in Italian, that he proposed I should undertake some pieces of great importance; that he would soon let me know where I was to work, and provide me with tools and all things necessary; at the same time he conversed with me in a free easy manner, on a variety of different subjects.

The Cardinal of Ferrara was present, for he almost always dined with the king: the conversation being over, his majesty rose from table, and the cardinal said in my favour, as I was informed afterwards; "May it please your Majesty, this Benvenuto has a great

desire to be at work, and it would be a pity to let such a genius lose his time." The king answered, that he was very right, and desired him to settle with me all that concerned my subsistence. The cardinal, who had received the commission in the morning, sent for me that night after supper, and told me from the king that his majesty had resolved I should immediately begin to work; but that he desired first to know my terms. To this the cardinal added, "It is my opinion that if his majesty allows you a salary of three hundred crowns a year, it will be abundantly sufficient. Next I must request it of you, that you would leave the whole management of the affair to me, for every day I have opportunities of doing good in this great kingdom, and I shall be always ready to assist you to the best of my power." I answered, "Without my ever soliciting your reverence, you promised upon leaving me behind you in Ferrara, never to let me quit Italy, or bring me into France, without first apprising me upon what terms I was to be with his majesty. But instead of acquainting me with the terms, you sent me express orders to ride post, as if riding post was my business. If you had then mentioned three hundred crowns as a salary, I should not have thought it worth my while to stir for double the sum. I notwithstanding return thanks to Heaven and to your reverence, since God has made you the instrument of so great a blessing as my deliverance from a long imprisonment. I therefore declare that all the hurt you can do me, is not equal to a thousandth part of the great blessing for which I am indebted to you. I thank you with all my heart, and take my leave of you; and in whatever part of the world I shall abide, I shall always pray for your reverence." The Cardinal then said in a passion, "Go wherever you think proper, for it is impossible to serve any man against his will." Some of his niggardly followers then said: "This man must have high opinion of his merit, since he refuses three hundred crowns:" others amongst the connoisseurs replied; "The king will never find another artist equal to this man, and yet the cardinal is for abating his demands as he would bargain for a faggot of wood." It was Signor Luigi Alamanni that said this, the same who at Rome gave the model of the salt-cellar, a person of great accomplishments, and a favourer of men of genius. I was afterwards informed, that he had expressed himself in this manner before several of the noblemen and courtiers. This happened at a castle in Dauphiny, the name of which I cannot recollect; but there we lodged that evening.

Having left the cardinal, I repaired to my lodging, for we always took up our quarters at some place not far from the court, but this was three miles distant. I was accompanied by a secretary of the Cardinal of Ferrara, who happened to be quartered in the same place.

By the way, this secretary, witn a troublesome and impertinent curiosity, was continually asking me what I intended to do with myself when I got home, and what salary I had expected. I, who was half angry, half grieved, and highly provoked at having taken a journey to France, and being afterwards offered no more than three hundred crowns a year, never once returned him any answer: I said nothing more to him, than that I knew all. Upon my arrival at our quarters, I found Paolo and Ascanio, who were waiting for me. I appeared to be in great disorder, and they knowing my temper, forced me to tell them what had happened. Seeing the poor young men terribly frightened, I said to them, "To-morrow morning I will give you money enough to bear your charges home, for I propose going by myself about some business of importance: it is an affair that I have long revolved in my mind, and there is no occasion for your knowing it."

Our apartment was next to that of the secretary, and it seems very probable that he acquainted the cardinal with all that I intended, and was firmly resolved to do; though I could never discover whether he did or not. I lay restless the whole night, and was in the utmost impatience for the approach of day, in order to put my design in execution. As soon as morning dawned, I ordered my horses should be in readiness, and having got myself ready likewise, I gave the young men all that I had brought with me, with fifty gold ducats over, and kept as many for myself, together with the diamond, which the duke had made me a present of; taking with me only two shirts, and some very indifferent clothes to travel in, which I had upon my back. But I could not get rid of the two young men, who were bent upon going with me by all means. I did my utmost to dissuade them, and said, "One of you has only the first down upon his cheeks, and the other has not even that; I have instructed you to the utmost of my poor abilities, insomuch that you are become the two most expert young men in your way in Italy. Are you not then ashamed that you cannot contrive to help yourselves, but must be always in leading-strings? This is a sad affair, and if I were to dismiss you without money, what would you say? Be gone directly, and may God give you a thousand blessings! so farewell."

I thereupon turned my horse about, and left them both bathed in tears. I took a delightful path through a wood, intending to ride at least forty miles that same day, to the most remote corner I could possibly reach. I had already ridden about two miles, and in the little way I had gone formed a resolution to work at no place where I was known, nor did I ever intend to work upon any other figure but a Christ, about three cubits high, willing to make as near an approach

as possible to that extraordinary beauty which he had so often displayed to me in visions. Having now settled every thing in my own mind, I bent my course towards the Holy Sepulchre, thinking I was now got to such a distance, that nobody could overtake me.

Just at this time I found myself pursued by some horsemen, which occasioned me some apprehensions, for I had been informed that these parts were infested by numbers of freebooters, called *Venturieri,* who rob and murder passengers, and who, though many of them are hanged almost every day, do not seem to be in the least intimidated. Upon the near approach of the horsemen, I perceived them to be one of the king's messengers accompanied by Ascanio. The former upon coming up to me said, "I command you, in the king's name, to repair to him directly." I answered, "You come from the Cardinal of Ferrara, for which reason I am resolved not to go with you." The man replied, that, since I would not go by fair means, he had authority to command the people to bind me hand and foot like a prisoner. Ascanio at the same time did his utmost to persuade me to comply, reminding me that whenever the king of France caused a man to be imprisoned, it was generally five years before he consented to his release. The very name of a prison revived the idea of my confinement at Rome, and so terrified me, that I instantly turned my horse the way the messenger directed, who never once ceased chattering in French, till he had conducted me to court: sometimes he threatened me, sometimes he said one thing and sometimes another, by which I was almost vexed to death.

In our way to the king's quarters, we passed before those of the Cardinal of Ferrara, who being at his door called me to him and said, "Our most Christian King has of his own accord assigned you the same salary that he allowed Liornardo da Vinci the painter, namely seven hundred crowns a-year. He will pay you over and above for whatever you do for him: he likewise makes you a present of five hundred crowns for your journey; and it is his pleasure that they should be paid you before you stir from hence." When the cardinal ceased speaking, I answered that these indeed were offers worthy of so great a monarch. The messenger who did not know who I was, seeing such great offers made me in the king's name, asked me a thousand pardons. Paolo and Ascanio said, "It is to God we owe this great good fortune."

The day following, I went to return his majesty thanks, who ordered me to make him models of twelve silver statues, which he intended should serve as candlesticks round his table. He desired they should be the figures of six gods and six goddesses, made exactly of his own height which was very little less than three cubits.

When he had given me this order, he turned to his treasurer and asked him whether he had paid me five hundred crowns: the treasurer answered that he had heard nothing at all of the matter: at this the king was highly offended, as he had commanded the cardinal to speak to him about it. He at the same time desired me to go to Paris, and look out for a proper house to work at my business, telling me I should have it directly. I received the five hundred gold crowns and repaired to Paris, to a house of the Cardinal of Ferrara's, where I began to work zealously, and made four little models two thirds of a cubit high, in wax, of Jupiter, Juno, Apollo, and Vulcan.

At this juncture the king coming to Paris, I waited on his majesty, and carried my models with me, as likewise the two young men, Ascanio and Paolo. When I perceived that the king was pleased with my performance, and had ordered me to make the silver Jupiter of the height above mentioned with all possible expedition, I informed his majesty that I had brought those two young men with me from Italy for his service, and as they were my pupils, they were likely to be of much greater use to me, who had instructed them in the principles of my art, than any of the working artists of Paris. The king, in answer to this, desired me to settle on the two young men such a salary as should appear to me handsome and sufficient to support them. I then told him, that a hundred gold crowns a-piece would do, and I would take care that they earned their salary. So it was agreed. I then told the king that I had found a place very proper for carrying on my business. The place I meant belonged to his majesty, and was called the Petit Nesle: it was then in the hands of the provost of Paris, to whom his majesty had granted it; but as the provost made no use of it, his majesty might give me leave to work in it for his service. The king answered directly: "The place you mention is a house of mine; the person to whom I have granted it does not inhabit or make any sort of use of it: you may therefore take it for the purpose you mentioned." He thereupon ordered one of his officers to put me in immediate possession of the Nesle. The officer declined this at first, telling the king that it was not in his power to obey him. The king replied in a passion, that he would give things to whomsoever he thought proper, and to such men as were of use to him and served him; for with regard to the provost, he was of no use to him at all: he therefore desired to hear no more objections or demurs. The officer rejoined, that it would be necessary to have recourse to violence. The King then said, "Go thither directly, and if a little force be not sufficient, you must exert yourself." The officer immediately conducted me to the place, and I was obliged to proceed to violence, before I could take possession of it: he then

bade me take care of myself, assuring me that my life was in imminent danger. I entered my new habitation, and immediately hired servants and purchased different weapons. My situation there was very uneasy during several days; for my adversary was a gentleman of Paris, and many other gentlemen were likewise my enemies, insomuch that I constantly received fresh insults. I must not omit that his majesty took me into his service in the year of our Lord 1540, and I was then exactly forty years old.

When I found myself liable to these daily affronts, I again waited upon the king and requested him to place me somewhere else. The answer he made me was: "Who are you, and what is your name?" At so strange a reception, I was quite disheartened, and could not possibly guess his majesty's meaning: as I remained in silent astonishment, he repeated his question a second time. I then answered, that my name was Benvenuto. The king said thereupon; "If you are the same Benvenuto that has been described to me, act like yourself: I give you free permission." I told his majesty that it was sufficient for me to continue in his good graces, and then it was impossible for any thing to hurt me. The king replied with a smile: "Go your ways, and depend upon it that my favour shall never be wanting."

Immediately upon this he ordered one of his secretaries, whose name was Mons. de Villeroy, to see me properly accommodated, and provided with every thing necessary. This Villeroy was an intimate friend of the provost of Paris, in whose possession the place called Nesle had been for some time. It was a large old castle of a triangular form, contiguous to the walls of the city, but had no garrison. Mons. de Villeroy advised me look out for some other building, and at all events to leave that, for as the person to whom Nesle had belonged was a man of great power, he would certainly get me assassinated. To this I made answer, that "I was come from Italy to France from no other motive but to serve their great monarch: with regard to dying, I was sensible that death is the common fate of all men, and whether it happened a little sooner or a little later, was a matter of perfect indifference to me." This Villeroy was a man of excellent understanding, of most extraordinary qualifications and endowments, and exceedingly rich; he would have done any thing to hurt me; but artfully concealed his malice: he had a grave deportment, a good aspect, and spoke deliberately. On this occasion he employed another gentleman, named Mons. de Marmande, who was treasurer of Languedoc. The first thing that this person did was to look out for the best apartments in the building, and get them fitted up for himself. I told him that the king had given me the place to work in

for his majesty, and that I was resolved it should be inhabited only by myself and my servants. Whereupon this man, who was proud and audacious, declared that he would do as he thought proper; that contending with him would be the same thing as running my head against a wall; and that he had Villeroy's authority for all he did. I then replied, that I claimed the place by the king's authority, and that neither he nor Villeroy had any right to act in that manner. When I had expressed myself to this effect the haughty treasurer grossly abused me in French: whereupon I told him in my own language that he was a liar. At this he was incensed with rage, and by his gestures seemed just going to draw his hanger. I instantly clapped my hand to a large cutlass, which I constantly wore by my side for my defence, and said to him: "If you offer to draw that hanger, I will instantly kill you." He had with him two servants, and I had my two apprentices. Whilst Mons. de Marmande remained thus in suspense, without determining upon any thing and rather inclined to mischief than otherwise, he muttered to himself: "I will never put up with this treatment." As I saw that he had bad intentions, I determined directly what conduct to pursue, and said to Paolo and Ascanio: "As soon as you see me draw my cutlass fall upon those fellows and kill them if you can; for I will begin with destroying that villain, and then we shall make our escape with the assistance of God." When Mons. de Marmande perceived that I had formed this resolution, he thought himself happy in getting out of the place alive.

I wrote an account of all that had happened, in the most modest terms I could think of, to the Cardinal of Ferrara, who immediately acquainted the king with the whole transaction: his majesty, highly provoked at this affair, put me under the care of another of his worthless courtiers, who was called Mons. d'Orbech. This gentleman provided me with every thing necessary for my business, and that with the most complaisant officiousness.

CHAPTER XXX.

The King employs our Author to make large silves statues of Jupiter, Vulcan, and Mars.—He presents his Majesty with a fine basin and cup of silver, together with a salt-cellar of the same metal of admirable workmanship.—The King's generosity defeated by the avarice of the Cardinal of Ferrara.—His Majesty, accompanied by Madame d'Estampes and the whole court, pays the Author a visit.—The King orders a considerable sum of money to be given him.—As he is going home, he is attacked by four armed ruffians, whom he repulses.—Dispute between him and the French artists, whom he makes sensible of their error.

As soon as I had made all the necessary preparations in my house and shop, in the most convenient and most creditable manner, I began to make three models exactly of the size that they were to be executed in silver: these were Jupiter, Vulcan, and Mars. I made them of earth well supported with iron, and then repaired to the king, who, as nearly as I can recollect, ordered I should have three hundred pounds of silver to enable me to begin my work. Whilst I was making these preparations, the cup and the golden basin, which had been several months in hand, were finished: as soon as this was done, I got them well gilt. This appeared to be the finest piece of work that had ever been seen in France. I carried it directly to the Cardinal of Ferrara, who thanked me, and waited on the king to make him a present of it. His majesty was highly pleased, and lavished greater praises upon me than had ever been before bestowed upon any artist. In return for this present, he gave the Cardinal of Ferrara an abbey worth seven thousand crowns a year; at the same time he was for making me a present, but the cardinal prevented him, telling his majesty it was too soon, as I had not yet finished any work for him. This confirmed the king, who was one of the most generous of men, in his resolution; and he said, "For that very reason I will encourage him to exert himself, and make something masterly for me." The cardinal in the utmost confusion replied, "Sire, I beg you would leave it to me, for I propose settling a pension of at least three hundred crowns a year upon him, as soon as I have taken possession of my abbey." These I never received; but I should tire the reader's patience if I were to relate all the diabolical tricks of that cardinal: I shall therefore proceed to subjects of greater consequence.

I returned to Paris, and being thus become a favourite of the king, I was universally admired. As soon as I received the silver

which had been promised me, I began to work at the above-mentioned statue of Jupiter; and took into my service several journeymen. We worked day and night with the utmost assiduity, insomuch, that having finished Jupiter, Vulcan, and Mars, in earth, and Jupiter being pretty forward in silver, my shop began to make a grand show. Just about this time the king made his appearance at Paris; and I went to pay my respects to him. When his majesty saw me, he called to me in high spirits, and asked me whether I had any thing curious to show him at my shop, for he intended to call there. I told him of all I had done, and he expressed an earnest desire to see my performances. After dinner he made a party, consisting of Madame d'Estampes*, the Cardinal of Lorraine, and some other great men (as the King of Navarre, cousin to King Francis,) and the quen his sister†; the dauphin and dauphiness‡ came likewise; in a word, that day all the nobility belonging to the court of France repaired to my shop.

I had just got home, and was beginning to work, when the king made his appearance at my castle gate: upon hearing the sound of so

* Francis I., previous to his imprisonment, was the admirer of the Countess de Chateaubriant, who had the temerity to contend in magnificence and power with the queen-mother herself, Louise of Savoy. This princess, unwilling to endure such conduct, on the return of her son from Spain, contrived to draw his attention to Anne de Piseleu, one of her maids of honour, who, by means of her beauty, her gracefulness, and her highly cultivated talents, succeeded in making a great impression on the mind of that monarch. Anne, thus became the favourite of the king, and the arbitress of France, was not ungrateful to the Queen Louise, to whom she always continued submissive: and she also acquired the friendship of the Queen of Navarre, sister of Francis. In 1536, she married Jean de Brosse, to whom, in consideration of the marriage, were restored the confiscated estates of his father, and who was also created Duke d'Estampes. This favourite, who was called the most beautiful amongst learned ladies, and the most learned amongst the beautiful, was a great patroness of literature and the arts.

† Margaret de Valois, sister of Francis I. and widow of the duke d'Alençon, was married to the King of Navarre in 1526. She received the appellation of the Fourth Grace and the Tenth Muse—uniting to gracefulness of form and sweetness of character, a cultivated genius, and a decided inclination for every species of literature.

‡ Catharine de' Medici, called by the French historians the ornament and the scourge of France, was born in Florence, in 1519. She was the daughter of Lorenzo, son of Piero de' Medici and of Madeleine de la Tour, a relation of Francis I. She was the only legitimate descendant of Lorenzo the Magnificent, and would have inherited the Florentine dominions, if Leo X. and afterwards Clement VII. had not given the preference to the illegitimate male children of that family. This princess, who was reputed one of the most beautiful women of the age, and was three times regent of France, carried the ambition and political sagacity of her race to the highest pitch. Placed in the midst of civil and religious factions, it was her sole aim to rule them, and to render them subservient to her own purposes. Without being zealous for the Catholic religion, she was the principal contriver of the celebrated massacre of 1572, which commenced on St. Bartholomew's Day, and continued for seven days throughout France, and in which perished more than forty thousand Huguenots. She died at the age of seventy years, in 1589.

many hammers, he commanded his retinue to be silent. All my people were at work, so that the king came upon us quite unexpectedly. As he entered the saloon, the first object he perceived was myself, with a large piece of plate in my hand, which I had not yet placed, and which was to make the body of Jupiter; another was employed on the head, another again on the legs, so that the shop resounded with the beating of hammers. Whilst I was at work, as I had a little French boy in the shop, who had some way or other offended me, I gave him a kick which drove him above four cubits forward towards the door, so that when the king entered, the boy fell against him; the good monarch laughed heartily, and I was in the utmost confusion. His majesty began to ask me what I was about, and expressed a desire that I should proceed with my work, telling me that he should be much better pleased if I would never harass myself with my business, but take as many men as I thought proper into my service, for it was his desire I should take care of my health, that I might be the longer able to serve him. I answered his majesty, that if were to discontinue working I should not enjoy my health, and that my performances would then no longer be worthy of so great a prince. The king, thinking that I said this through vanity, and did not speak my real sentiments, ordered the Cardinal of Lorraine to repeat to me what he had himself proposed; but I explained myself so fully to the cardinal, that he acquiesced in my reasons, and advised his majesty to let me act as I thought proper.

The king, when he had taken a sufficient view of my work, returned to his palace, after having conferred so many favours on me, that it would be tedious to enumerate them. The day following he sent for me immediately after dinner: the Cardinal of Farrara was present, and dined with him. I came just when they were at the second course: his majesty immediately began to talk to me, saying, that since he had so beautiful a cup and basin of my making, he must have a handsome salt-cellar to accompany such fine things; that he wanted me to draw a design of one, and the sooner the better. I answered that his majesty should see such a design much sooner than he expected; for that whilst I saw employed about the basin and the cup, I thought a salt-cellar would be a necessary companion to them, and therefore had already made one, which I should show to his majesty in a few moments. The monarch turned about with great vivacity to the noblemen present, to the King of Navarre, the Cardinal of Lorraine, and the Cardinal of Ferrara, and said to them: "This is so obliging a man, that whoever has heard his character, would be desirous to know him:" he then told me he would be glad to see my design.

I went for it, and soon returned, for I had nothing to do but to cross the Seine: I brought with me a model of wax, which I had made at Rome at the request of the Cardinal of Ferrara. Upon showing it to the king, he expressed great surprise, and said, "This is a much finer design than I expected; it is a most noble production; such a genius should never be unemployed." He then turned to me, and said with great cheerfulness, that he was highly pleased with my model, and should be glad to have a salt-cellar made according to it in gold. The Cardinal of Ferrara winked at me, giving me to understand that he knew this to be the same model I had made for him in Rome. I thereupon repeated what I had before told him, that I had made it for one who would pay for it. The Cardinal recollecting these words was nettled, and had a mind to take his revenge: he therefore thus addressed the king; "Sire, this is certainly a great undertaking: I have only one objection to make, namely, that I never expect to see it finished; for men of genius, who have noble and sublime ideas in their own art, are very ready to engage in grand enterprises, without duly considering when they can bring them to a conclusion; therefore, if I were to order works of such importance, I should be glad to know how soon they could be executed." The king made answer, that he who was so anxiously solicitous about the finishing of works, would never begin any; and this he said in such a manner, as intimated that he did not consider such undertakings as suitable to men of narrow minds. I then said, "When princes give their servants such noble encouragement, as your Majesty does both by words and deeds, they are sure of succeeding in all great undertakings; and since God has blessed me with so munificent a patron, I flatter myself that I shall be able to execute many great and admirable works for your Majesty." "I do not doubt but you will," answered the king, rising from table. He sent for me to his apartment, and asked me how much gold the making of the salt-cellar would require. I immediately answered him, a thousand crowns. The king called for his treasurer, Mons. d'Orbech, and commanded him to give me directly a thousand old gold crowns, good weight.

I quitted his majesty and sent for the two clerks, who had caused the money to be given me for the statue of Jupiter, and many other things; and having crossed the Seine, I took with me a little basket, which I had from a nun, a cousin-german of mine, in a convent at Florence; by good luck I took this basket, and not a wallet. I thought to do the business by day, as it was then early, and did not care to disturb my journeymen, nor did I even mind to take a servant with me. I came to the treasurer's house, who had the money ready

before him, and had chosen the pieces according to the **directions of** the monarch. It appeared to me that the villain had recourse to all the little artifices and stratagems he could think of, to delay paying me the money till late at night. I was by no means wanting in diligence, but sent for some of my journeymen to come to me about business of the utmost consequence. When I found that they did not appear, I asked the messenger whether he had obeyed my orders: the scoundrel told me that he had, and that they answered him they could not come; but he would carry the money for me with pleasure: I replied that I chose to carry it myself. In the mean time the writing was drawn up, and the money being brought, I put it all into the basket, then thrust my arm through the two handles; as it entered with great difficulty, the money was well secured, and I carried it with much greater ease than if I had made use of a bag. I was armed with a coat of mail, and having my sword and dagger by my side, I set out directly for my own house. Just then I took notice of some of the servants who were whispering to one another: but they soon quitted the house, and seemed to turn down quite a different street from that which I had entered. I, being in great haste, passed the bridge of the Change, and went up by a little wall in the marshes, which carried me to my own house at Nesle.

When I was just at the Augustins, a very dangerous place, though within five hundred paces of my own house, where, if I had attempted to call out, my voice would not have been heard by any body, I suddenly found four swords drawn against me. I quickly formed my resolution, and covering my basket with my cloak, I clapped my hand to my sword, and perceiving that they were eager to surround me, I told them there was nothing to be won from a soldier but his cloak and sword: these I was resolved not to resign tamely, but to defend them at the risk of my life. Whilst I bravely opposed the villains, I several times opened my arms wide, that in case they had been set on by the servants who saw me receive the money, they might have some reason to think I could not have any such sum about me. The combat did not last long, for they began gradually to retire. Some of them said in French, "This Italian is a brave fellow; he certainly cannot be the person we wanted, and even if he be the man, he has no money about him." I spoke Italian, and dealt my blows with such dexterity that I was near killing some of them. As I appeared to be an excellent swordsman, they thought it most likely that I was a soldier; so they crowded close together, and gradually drew off from me, muttering all the while in their own language. I at the same time continued to say coolly, and without any sort of rhodomontade, that he who wanted to possess himself of

my arms and cloak, must purchase them dearly. I began to mend my pace, and they followed me slowly; my fear thereupon increased, and I was filed with apprehensions of falling into an ambush of other villains who might surround me. But when I got within a hundred paces of my own house, I mended my pace as fast as I could, and cried out with a loud voice, "Help, help, or I am assassinated!" Immediately four of my young men sallied out with long pikes, and offered to pursue the fellows that had attacked me and were still in sight; but I stopped them, saying aloud, "Those four cowardly dogs have not been able to take from a single man a booty of a thousand gold crowns, the weight of which has almost broken his arm: let us therefore first go and lay them up, and then I will attend you with my great two-handed sword wherever you will." While we were putting up the money, the young men expressed great concern for the danger I had been exposed to, and said to me in a reprimanding tone, "You have too much confidence in your own courage, which will bring you one day into some scrape, and make us all lament your unhappy fate." I had a long chat with them, and they told me that my adversaries were gone off; so we all supped cheerfully, and were very merry, making a jest of the various turns and changes of fortune, which, whether prosperous or adverse, can affect us but for a time. I own it is a common saying, that every reverse of fortune teaches us how to behave on another occasion; but that is not true, as the circumstances which attend each event are different, and such as could not be foreseen.

The next morning I began the great salt-cellar, and caused that and other works to be forwarded with the utmost expedition. I had by this time provided myself with several journeymen, as well for sculpture as for the goldsmith's business: these journeymen were Italians, French, and Germans, and sometimes I had a considerable number of them. When I happened to meet with able artificers, (for I almost every day changed them, taking into my shop such as were most expert and skilful,) I hurried them in such a manner, that, unable to bear the constant labour as I did, who had received a happy constitution from nature, they endeavoured to restore and keep up their spirits by eating and drinking. Some of the Germans, who were more skilful and experienced than the rest, strove to keep pace with me, but could not bear the fatigue; so that the attempt cost them their lives.

Whilst I went on with the silver statue of Jupiter, seeing that I had plenty of that metal, over and above what the statue required, I, without the king's knowledge, set about making a large silver vessel with two handles, about a cubit and a half high. I had likewise

a fancy to cast in bronze the grand model which I had made for the silver Jupiter. I immediately began this arduous undertaking, which was of a nature that I had never attempted before; and having entered into a conversation upon the subject with some of the old experienced artists of Paris, I mentioned to them all the methods used in Italy to bring such a work to bear. They told me that they had never made use of that process, but that if I would let them take their own way, they would cast me the model of bronze as fine and as exact as the earthen one. I chose to make a bargain upon employing them; and thinking their demand moderate, promised them several crowns more than they asked.

They set about the work, but I soon perceived that they did not take the right method: I therefore began a head of Julius Cæsar, the breast covered with armour, much bigger than the life, which I took from a little model I had brought with me from Rome, representing an antique head of admirable workmanship. I likewise began another head of the same size, which was the likeness of a fine girl of my acquaintance. I gave her the name of Fontainebleau, from the seat which the king had chosen for his favourite residence. Having made a proper furnace to melt the bronze, and arranged and baked our figures, they their Jupiter, and I my two heads, I said to them, "It is my opinion that your Jupiter will not come out, as you have not blown enough under it for the wind to play, so that you labour in vain." To this they answered, that in case their work did not succeed, they would return me the money and make good all my expenses; but they at the same time maintained that the fine heads, which I wanted to cast in the Italian manner, would never succeed according to my expectation. There were present at this dispute the treasurers and other gentlemen who came to me from the king, and who related to his majesty all that was said and done upon the occasion. The two old artists, who proposed casting the model of Jupiter, occasioned some delay in the preparations for that purpose: they said they would gladly adjust the two moulds of my heads, it being impossible that they could succeed according to my process, and it would be a thousand pities that two such fine pieces should be spoiled. As they had informed his majesty of this, he desired they would endeavour to learn, and not take upon them to teach a person who was a master of the business.

They with great laughter and merriment put their work into the mould; and I, without any sort of emotion, without either laughing or discovering any uneasiness, put my two heads on each side of the figure of Jupiter. When our metal was thoroughly melted, we poured it out with great satisfaction: the mould of Jupiter was there-

upon cleverly filled, as were likewise those of my two heads at the same time. The two old artists were highly rejoiced, while I was very well pleased with my success; in short, it was an equal triumph to us both that we had been mistaken with regard to our opinion of each other's performance. They then were in high spirits, and desired to drink, according to the French custom; which I granted, and readily entertained them with a collation. The next thing they asked me for was the money I had agreed to give them, and what I had promised them over and above. I answered, "You have been very merry, whereas I suspect you should have been sad; for I have taken it into consideration that there has been a greater consumption of metal upon this work than should have been, so that I am determined not to let you have any more money till to-morrow morning." The poor men began to reflect seriously on this speech of mine, and without making any answer returned home. When they came again in the morning, they without any stir began to take the figures out of the moulds; and because they could not get at their own great figure, without first taking out my two heads, they did so accordingly, and placed them in such a manner that they appeared to the utmost advantage. Soon after they set up so loud a cry, that I thought it was a shout of joy, and immediately ran to the workshop from my own chamber, which was at a considerable distance. I found them exactly in the attitude of those who guarded Christ's sepulchre, in sorrow and astonishment. I cast my eyes upon the two heads, and seeing that they made a very good appearance, I was partly pleased and partly vexed, while they excused themselves by saying, "We have been unfortunate." I answered, "You have been very fortunate, but you have shown little skill; if I had but instructed you with a single word, the figure would have come out admirably, which would have been greatly to my honour and your advantage; but as to my honour, I can easily find an excuse, therefore another time learn to work, and not to banter and make sport of others."

They begged I would take compassion upon them, acknowledging that I was in the right, and that if I did not show them indulgence, in not obliging them to make good all that great expense, they must be reduced to beggary as well as their families. My answer was, that should the king's treasurers compel them to pay what they had agreed, I would pay it for them for I saw that they had done their best. By acting in this manner I greatly conciliated the good graces of the king's treasurers and ministers. A full account of the whole affair was given to his majesty, who was so generous as to order that I should be satisfied in all my demands.

CHAPTER XXXI.

The Author obtains a grant of naturalisation, *motu proprio,* from the King, and is made lord of the house he resides at, called Petit Nesle.—The King pays him another visit, accompanied by Madame d'Estampes, and orders him to commence superb ornaments for the fountain of Fontainebleau.—In obedience to the King's commands he makes two beautiful models of the ornaments for the fountain, and shows them to his Majesty.—Description of those ornaments.—Remarkable conversation between him and the King upon this occasion.—Madame d'Estampes is offended with the Author for not taking notice of her in any of his designs.—To recover her favour he waits upon her, intending to make her a present of a fine vase of silver, but is refused admittance.—He presents it to the Cardinal of Lorraine, who behaves most generously to him.—He involves himself in a scrape by turning out of his house a favourite servant of Madame d'Estampes, who had taken up his quarters there for some time.—Madame d'Estampes endeavours to alienate the King from him, but the Dauphin interposes in his favour.

JUST at this time arrived at court the great Piero Strozzi*, who having put the king in mind of his letters of naturalisation, his majesty gave orders that they should be made out directly. He at the same time said, "Prepare letters of naturalisation for Benvenuto likewise, *mon ami,* carry them to his house, and let him pay no fee whatever." Those of the great Piero cost him several hundred ducats; mine were brought me by one of the king's first secretaries, whose name was M. Anthony Masson.† This gentleman put the letters into my hands with many expressions of kindness from the

* Piero Strozzi, son of Filippo, of whom mention has already been made, had at first entered into the ecclesiastical career, and had been many times flattered by Clement VII. with the expectation of a cardinal's hat, the only dignity wanting to his powerful family; but finding his hopes of attaining this object defeated by the jealousy which had already begun to display itself between the Medici and the Strozzi, he betook himself to the profession of arms, and being cousin-german of Catharine de' Medici, entered into the service of the French in Piedmont, where he distinguished himself in 1536, in battle, as a colonel under the Count Guido Rangoni. In the following year, the Duke Cosmo having been just raised to the government of Florence, Piero Strozzi placed himself at the head of the banished Florentines, who were desirous of making a last attempt to re-establish the ancient form of government in their country; but having advanced with too much temerity, and being obliged to engage with a smaller force than that of his adversary, he was completely defeated at Montemurlo, where his father remained a prisoner. In spite of so many misfortunes Piero does not appear to have abandoned Italy immediately, but to have lived for some years in retirement at Rome and Venice.

† Antonio le Maçon was the private secretary of the Queen of Navarre. He was the author of a romance entitled *"Gli Amori di Fidia e di Gelasina,"* and was the first person who translated into the French language the Decameron of Boccacio, which he did at the instance of his patroness.

king, and said, "His majesty makes you a present of these to encourage you to serve him with a greater zeal; they are letters of naturalisation." He at the same time told me that letters of the like nature had been granted on much solicitation, and as a great favour, to Piero Strozzi; but that the king gave me these of his own accord—a mark of distinction which had never been shown before to any foreigner in that kingdom. I returned my royal benefactor thanks with all possible demonstrations of gratitude, and requested the secretary to inform me, what those letters of naturalisation meant. The secretary was a very polite, well-bred man, who spoke Italian incomparably well: he first laughed heartily, and then resuming his gravity, told me in my own language the meaning of letters of naturalisation; that it was the highest honour that could be conferred on a foreigner, and something of much greater consequence than being made a Venetian gentleman. Having quitted me and returned to the king, he related to his majesty all that had passed between us: the monarch laughed a good while, and said, "He shall know presently why I sent him the letters of naturalisation. Go and make out his patent of lord of the castle of Nesle, which is a part of my demesne: he will understand this much more easily than he did the letters of naturalisation." A messenger came to me from the king with the above patent, and I was for giving him a gratification, but he refused it, telling me that he had his majesty's express orders to the contrary. The above-mentioned letters of naturalisation, together with those of the grant of the castle, I took with me, when I returned to Italy; and wherever I reside, or wherever I am to finish my days, I shall always endeavour to have them with me.

I now resume the thread of my narrative. Having upon my hands the works of which I have already spoken, I mean the silver Jupiter, which was begun, the golden salt-cellar, the great silver vase, and the two heads of bronze, proceeded with expedition, and gave orders to have a base cast for the statue of Jupiter. This I caused to be made very magnificently of bronze, enriched with a variety of ornaments, amongst which I carved in basso rilievo, the Rape of Ganymede, and on the other side, Leda with her Swan; the latter I cast in bronze, and it had surprising success. I made another of the same sort, intending to place upon it the statue of Juno, expecting soon to begin that likewise, if the king furnished me with silver for such an undertaking. Continuing to work with the utmost assiduity, I had already completed the silver Jupiter, and had also cast the golden salt-cellar; the cup was very forward, and the two heads of bronze were finished. I had likewise executed several little pieces for the Cardinal of Ferrara, and moreover, a small silver vase of very

rich workmanship, which I designed as a present to Madame d'Estampes. At the same time, I had done some works for several Italian noblemen, as for Signor Piero Strozzi, the Count d'Anguillara, the Count of Pitigliano, the Count of Mirandola*, and many others.

When I was pretty forward with these works for my gracious monarch, he returned to Paris, and three days after came to my house, with a number of the chief nobility of his court. They all expressed great surprise at my being so forward with so many performances; and as Madame d'Estampes was with him, they began to talk of Fontainebleau. The lady advised his majesty to order me to make some fine ornament for his favourite residence. The King instantly answered, "What you say is very just; I will presently determine upon something handsome for him to execute:" then turning to me, he asked me what I thought would be a proper ornament for that charming fountain. I proposed some of my fancies; his majesty likewise told his opinion: he mentioned at the same time, that he intended going to take his pleasure, for fifteen or twenty days, at St. Germain-en-Laye, which was twelve leagues distant from Paris, desiring that I would in the mean while make a model for his seat at Fontainebleau, with the finest inventions I could think of, that being the most delightful place of recreation in his whole kingdom. He concluded with ordering me to exert my utmost efforts to produce something masterly: I promised to do my best. The king,

* The city of Mirandola, about the beginning of the 14th century, passed from the government of the Modenese to that of the family of Pico, which had for two centuries been the masters of the neighbouring territory of Quarantoli, and after many vicissitudes, in the year 1499 fell into the possession of Gio. Francesco Pico, nephew of the celebrated Giovanni Pico. This prince, whose great piety and learning are sufficiently testified by his numerous works, as well as by the eulogy pronounced upon him by Tiraboschi, not having been able to satisfy his younger brothers in the division of their paternal inheritance, became exposed to the most terrible reverses. In 1502, he was expelled by his brother Luigi, who had obtained assistance from Gian Giacome Trivulzi, his father-in-law, at that time general of all the French troops in Italy; and although he recovered possession of Mirandola in 1511, by means of Julius II., who took it by assault in person, and himself entered at the breach, yet he was compelled in the following year to abandon it anew to the French, in consequence of the celebrated victory obtained by them at Ravenna.

Two years afterwards, the French power having declined in Italy, Gio. Francesco, for the third time, regained possession of Mirandola, and his brothers being dead, retained it, and passed his time in the midst of his studies when Galeotto Pico, the son of Luigi, having attained the age of 25 years, in the night of the 15th October, 1533, entered into Mirandola with 40 assassins, killed his uncle, then at the age of 63 years, together with his eldest son, imprisoned the rest of the family, and declared himself lord of the fief. Charles V. deeply resented this act, and Galeotto, finding himself in danger of losing his sovereignty and his life, in 1536 threw himself under the protection of Francis I., delivered his sons to him as hostages, and became reduced to a situation little more than that of a French general in Italy.

seeing such a number of works so far advanced, said to Madame d'Estampes, "I never knew a man in his way that pleased me more, or that deserved to be more encouraged: we must endeavour to keep him here: he spends a great deal of money; is a good companion, and works hard. I am, indeed, under a necessity of thinking of him myself, for in all the times that he has been with me, or that I have been here, he has never asked for any thing; his mind seems to be entirely taken up with his business. I must confer some favour on the man, for fear of losing him." Madame d'Estampes replied, "I will take care to put you in mind." They went away, and I proceeded with the utmost expedition in the works I had begun; at the same time I set about the model of the fountain, and used all dispatch in bringing it to perfection.

In about six weeks the king returned to Paris, and I, who had worked night and day, waited on his majesty with my model: the figures were so elegantly executed, that it was a very easy matter to understand the design. The fatal disputes between the King of France and the emperor being already renewed, I found him very pensive; and therefore addressed myself to the Cardinal of Ferrara, telling him, that I had brought some models which the king had employed me to make; and I requested him to take the first opportunity of mentioning them to his majesty, as I was inclined to think they would afford him pleasure. The cardinal complied with my request, and spoke of the models to the king, who quickly repaired to the place where I kept them.

First of all I had designed the palace gate of Fontainebleau; and made as little alteration as possible in the form of it, which, according to the whimsical taste of the French, seemed to be an an odd mixture of greatness and littleness; for its form was almost square, with a semicircle over it bent like the handle of a basket, in which the king was desirous of having a figure to represent Fontainebleau. I gave a beautiful proportion to the gate, and over it I put an exact semicircle, with some agreeable projections on each side: instead of two pillars, which the order of architecture seemed to require for their support, I placed two satyrs: one of these, something above half-relief, appeared to sustain with one arm that part of the pile which touched the columns; in the other it held a large massive club; the countenance was so stern and fierce as to strike terror into the beholders: the other satyr had the same attitude, but differed from the former in the head, and some other parts; it held in its hand a whip, with three balls fastened to certain chains. Though I call these figures satyrs, they had nothing in common with those sylvan gods but certain little horns and heads resembling that of a goat: in all

other respects they were of the human form. In the same circle I represented a female figure in a reclining attitude, with her left arm upon the neck of a hart, which was a device of the king's: on one side of her I designed, in half-relief, little goats, boars, and other wild beasts; and on the other, in stronger relief, greyhounds, and other dogs of different sorts, such as are to be seen in the delightful woods where the fountain rises. I drew the whole plan in an oblong form, and at each corner I designed a victory in basso-rilievo, holding little torches in their hands, as they are represented by the ancients. On the top I placed the figure of a salamander, the king's own emblem, with several other ornaments pleasing to the eye, and adapted to the nature of the work, which was of the Ionic order.

The sight of this model raised the king's spirits, and diverted him from that disagreeable conversation in which he had been engaged above two hours. Finding him in this good humour, I showed him another model, which he little expected, for he imagined he had seen ingenuity enough in the first. This model was above two cubits in size: it represented a fountain in the form of a complete square, with fine steps round it, which intersected each other—a thing almost unexampled in any country whatever. In the midst of this fountain I placed a solid mass, which rose a little above its brim: upon this mass stood a naked figure of a most graceful shape. It had a broken lance in its right hand, raised aloft in the air, and the left it kept upon the handle of a cimetar, the form of which was exceedingly beautiful. It rested upon the left foot and held the right upon the crest of a helmet, the workmanship of which was the richest and most elegant that could be conceived. At the four sides of the fountain, I had designed a high raised figure, seated, with many ingenious devices and ornaments to each. The king began to interrogate me about the fancy of this elegant work, telling me, that he had himself understood my whole plan of the gate, without asking a single question; but as for my present design, though it appeared to him exceedingly beautiful, he could not so much as form a conjecture concerning its meaning. He added, that he was very sure I had not acted like some foolish artists, who produced works which had some beauty and elegance in them, but which were notwithstanding void of signification.

As I had had the good fortune to please his majesty by my performance, I prepared to give him a second pleasure by my explanation of it, which was couched in the following words: "May it please your majesty, this little work was designed on a small scale, but when it is carried into execution there will be the same symmetry and exactness in great as in miniature. That figure in the middle is

of fifty-four feet." At this the king appeared to be greatly surprised. "Next," continued I, "is represented the god Mars: those other four figures are made for the Virtues, in which your Majesty so highly delights, and which you so much favour. The figure upon the right hand is the emblem of Science: observe its symbol, that denotes philosophy with all its train of attendant virtues. That other signifies the art of designing, which comprises sculpture, painting, and architecture. That next figure represents Music, a proper companion for all the other sciences. This, which appears so kind and courteous, is intended for Liberality, since without her aid none of those virtues or talents given us by the Almighty can ever become conspicuous. The great statue in the middle represents your Majesty, who are the Mars of this age, the only valiant prince in the world, a prince who exerts that valour in supporting and asserting the glory of his crown."

Scarce had he the patience to hear me out, when he exclaimed aloud, "I have at last found a man after my own heart." He immediately sent for his treasurer, and ordered him to supply me with all I required, however great the expense. He then clapped me on the shoulder, and said to me in French, "Mon ami, I do not know which pleasure is the greatest, that of a prince who meets with a man after his own heart, or that of the artist who finds a prince that gives him all the encouragement necessary to carry his great and sublime ideas into execution." I made answer, that if I was the artist meant by his majesty the happiness was entirely on my side. He answered laughing, "Let us then reckon it equal on both sides." *

I left the monarch in high spirits, and returned to my work. It happened unluckily for me that I had not been apprised to act the same farce with Madame d'Estampes, who having in the evening heard all that passed from the king himself, conceived so deep a resentment at the neglect, that she said with the utmost indignation, "If Benvenuto had shown me his fine works I should have had reason to remember him at the proper time." The king endeavoured to excuse me, but without success. Having received this information about a fortnight after, when the court, after making a tour through Normandy to Rouen and Dieppe, was returned to St. Germain-en-Laye, I took with me the fine piece of plate which I had wrought at the desire of Madame d'Estampes herself, in hopes that, by making her a present of it, I might recover her good graces. Accordingly I carried it to her, and having mentioned my intention to her waiting-

* It is said in "The Art of Verifying Dates," in speaking of Francis I., "This prince had an extraordinary manner of evincing a coolness. When he called any one *father, son* or *friend,* the appellation was the precursor of disgrace."

woman, showed her the cup which I proposed presenting to her lady. She received me in the kindest manner imaginable, and said she would just speak a word to Madame d'Estampes, who was not yet dressed, but that as soon as ever she had apprised her of my coming she would introduce me. Upon acquainting her lady with my arrival, and the present I had brought, the latter answered disdainfully, "Tell him to wait." Having heard this, I armed myself with patience, and continued in suspense till she was going to dinner. Perceiving that it grew late, hunger provoked me to such a degree, that unable to resist its cravings any longer, I gave the lady a hearty curse, and going directly to the Cardinal of Lorraine, made him a present of the cup, begging he would stand my friend with the king, and prevent me from being deprived of his good graces. He made answer, that I did not want a friend at court, and in case I had, he would have espoused my cause without being solicited; then calling to his steward, he whispered something in his ear.

The steward, having waited till I had quitted the cardinal's presence, said to me, "Benvenuto, come this way, and I will treat you with a bottle of good wine." As I was not well aware of his meaning, I made answer, "For God's sake, good Mr. steward, do but give me a single glass of wine, and a bit of bread, for I am ready to sink for want of sustenance. I have waited fasting since the morning early at Madame d'Estampes' door, with an intention to make her a present of that fine gilt cup; and when I sent her word that I was there, she, to drive me to distraction, ordered me to be told to wait. At present hunger attacks me, and I find my powers begin to fail; so, as it was God's will, I have bestowed my property and my work on one that deserved it much better, and all I desire of you is to give me something to drink; as I am of a temper rather impatient, and hunger also pinches me to such a degree that I am almost ready to faint." Whilst I uttered these words with great difficulty, a servant brought in some excellent wine and other delicacies for a collation. I refreshed myself very well, and having recruited my spirits thoroughly, my peevishnes and impatience subsided. The worthy steward having put into my hands a hundred gold crowns, I declined accepting them on any account. Upon this he went and told the cardinal, who reprimanded him very severely, and commanded him to force them upon me, or not appear again in his presence. The steward came back highly offended, declaring that the cardinal had never rated him so before: he then endeavoured to persuade me to accept of his master's bounty: and upon my making some resistance, he said in a passion, that he would compel me to take the money. I at length accepted it, and proposed going to return

the cardinal thanks; but he gave me to understand by one of his secretaries that whenever he had it in his power to befriend me he should do it with pleasure.

I returned to Paris the same evening: the king was informed of all that had passed, and Madame d'Estampes was very much rallied upon the occasion; but this only increased her resentment against me, whence my life was afterwards in danger, as the reader shall be informed in due time.

I should however, first take notice of my having acquired the friendship of one of the most learned and most amiable acquaintances that I ever had in my life. This was Signor Guido Guidi, an excellent physician, and eminent citizen of Florence. On account of the calamities in which adverse fortune had involved me, I deferred speaking of him before, but I thought that neglect excusable, as he was always next my heart. Having afterwards taken it into consideration that my life was never agreeable without him, I have inserted an account of him amidst that of my greatest crosses, that as he constantly comforted and assisted me, I may in this narrative dwell upon the remembrance of the happiness I enjoyed in his friendship. Signor Guido Guidi* came to Paris while I resided in that capital. Upon our first acquaintance I conducted him to my castle, and assigned him an apartment in it, so that we enjoyed each other's company several years. Thither also came the Bishop of Pavia, Monsignor de Rossi, brother to the Count of St. Secondo. I made this prelate leave his inn, and took him with me to my castle, where I gave him an apartment in which he was handsomely accommodated, with all his retinue, during several months. Upon another occasion I accommodated Signor Luigi Alamanni and his sons for some months; and the Almighty was so favourable to me as to put it into my power to serve some other persons of distinction, and men of genius.

I enjoyed the friendship of Signor Guido as many years as I resided at the castle, and we often boasted to each other that we had acquired some improvement in our respective professions at the expense of the great and munificent king who had invited us to his capital. I can say with truth, that if I have any reputation, or have ever produced works deserving of notice, it was owing to the encouragement of that generous monarch. I therefore resume the thread of my narrative concerning him, and the great works in which I was employed by his majesty. My castle had a tennis-court, from which

* Guido Guidi went to France a short time previous to the year 1542. He was in that year created first professor of medicine in the Royal College, and tutor to Francis I.

I derived great benefit; at the same time that I used it for exercise there were many habitations in it, occupied by several men of different trades, amongst whom there was an excellent printer. Almost his whole shop was within the precincts of my castle, and it was he that first printed the excellent medical treatise published by Signor Guido. As I had occasion for the shop, I made him quit it, but not without some difficulty. There was likewise in the same place a person who made gunpowder: I wanted the habitation he occupied for some of my German artists, but the powder-maker would upon no account dislodge, though I several times civilly desired him to let me have the apartment, which was really necessary for some of my men employed in the king's service. The more humble my remonstrances, the more insolently the brute answered me. At last I allowed him three days to remove; but he laughed and told me that he would begin to think of it in about three years.

I did not know at first that this fellow was a domestic of Madame d'Estampes: and if it had not been that the above affair between that lady and myself had made me particularly cautious, I should instantly have dislodged him; but I thought it advisable to have patience for the three days: these being expired, I took with me several armed men, Germans, Italians, and French, as likewise some menial servants, who in a short time cleared the house, and threw all he had in it into the streets. I treated him with this particular rigour, because he had told me that he did not think any Italian had the courage to move the least thing belonging to him out of its place. In consequence of his having made such a boast I behaved to him in that manner; and then said to him, "I am the least of all the Italians, but I have done nothing to you yet, in comparison of what I find myself disposed to do, and what I certainly shall perform, if you speak another word," with many more angry and menacing expressions. The man, in the utmost terror and astonishment, gathered up his effects as well as he could, and ran to Madame d'Estampes, to whom he gave a most terrible account of the whole transaction. That grand enemy of mine, an enemy the more dangerous in proportion to her greater influence and credit, represented the affair in the worst light to his majesty. The monarch, as I have been informed, flew into a violent passion, and was upon the point of giving very severe orders against me; but as his son Henry the dauphin, now King of France, had received many affronts from that presumptuous lady, which had been also the case of the Queen of Navarre, sister to King Francis, they both espoused my cause so warmly, that the king turned the whole affair into ridicule; so that with the assistance of the Almighty I had a fair escape at this critical juncture.

CHAPTER XXXII.

Madame d'Estampes encourages Primaticcio, otherwise called Bologna the painter, to torment and rival the Author.—He is entangled in a troublesome lawsuit by a person whom he had turned out of his apartments at Petit Nesle.—Description of the French courts of justice.—The Author, finding himself very much persecuted and distressed by the chicanery and delays of the law, puts an end to the suit by the sword, which greatly intimidates his adversaries.—His domestic troubles.

AFTER I had thus got rid of my Frenchman, I found myself obliged to proceed in the same manner with another tradesman, but did not demolish the house; I only caused the goods to be thrown out of the window. This provoked Madame d'Estampes so highly, that she said to the king, "I believe this outrageous fellow will one day ransack the city of Paris." The king answered, in a passion, that I did very right in ridding myself of a rabble which would have prevented me from executing his orders. The fury of this cruel woman rising every day to a higher pitch, she sent for a certain painter, who lived occasionally at Fontainebleau, the king's place of residence. This painter was an Italian and a native of Bologna, by which name he was universally known; but his real name was Francesco Primaticcio. Madame d'Estampes bade him apply to the king for the work which he had resolved to put into my hands, and said she would second him to the utmost of her power: this was agreed upon between them. Bologna was highly rejoiced, looking upon himself as sure of success, though the business was quite out of the sphere of his profession. But as he was master of the art of designing, and had agreed with certain workmen who had learned their business under Rosso, our celebrated painter of Florence, who must be acknowledged to have been a man of great genius and as Primaticcio himself, in whatever he had produced of any degree of merit, had followed the excellent manner of that Rosso, who was at this time no more; these very plausible reasons had such weight, being backed by Madame d'Estampes, and conspiring with the continual dinning in the king's ears day and night, either by Primaticcio or the lady, that this great prince at last began to listen to their suggestions.

They said to him, "How is it possible that your sacred Majesty, while employing Benvenuto to make you twelve statues of silver, of

273

which he has not yet finished one, can think of engaging him in so great an undertaking? You must resolve to give up the other plans which you are so much bent upon, because a hundred men of first-rate talents would be unable to finish all the great works which this one enterprising genius has taken in hand. It is obvious, at the same time, that he exerts himself too much, and is indefatigable in the business, which may very probably be the cause of your losing both him and the works he is employed in." These and many other arguments of the like sort, by being urged at a proper time, produced their effect upon the mind of the king, so that he complied with their desires; and yet he had not hitherto seen any designs or models by Primaticcio.

Just at this very juncture, the second person whom I had driven out of the precincts of my castle, had commenced a law-suit against me at Paris, affirming that I had robbed him of several of his effects at the time that I dislodged him. This suit occasioned me a great deal of trouble, and took up so much of my time, that I was frequently upon the point of forming a desperate resolution to quit the kingdom. It is customary in France to make the most of a suit which they commence with a foreigner, or with any other person who is not used to law-transactions; as soon as they have any advantage in the process, they find means to sell it to certain persons who make a trade of buying lawsuits. There is another villanous practice which is general with the Normans, I mean that of bearing false witness; so that those who purchase the suit immediately instruct five or six of these witnesses, as there happens to be occasion: by such means, if their adversary cannot produce an equal number to contradict and destroy their evidence, and happens to be ignorant of the custom of the country, he is sure to have a decree given against him. Both these accidents having happened to me, I thought the proceeding highly dishonourable. I therefore made my appearance in the great hall of the Palais at Paris in order to plead my own cause; where I saw the king's lieutenant for civil affairs, seated upon a grand tribunal. This man was tall, corpulent, and had a most austere countenance: on one side he was surrounded by a multitude of people; and on the other with numbers of attorneys and counsellors, all ranged in order upon the right and left; others came one by one, and severally opened their causes before the judge. I observed that the counsellors, who stood on one side, sometimes spoke all together. To my great surprise, this extraordinary magistrate, with the true countenance of a Plato, seemed by his attitude to listen now to one, now to another, and constantly answered with the utmost propriety. As I always took great pleasure in seeing and contemplating the

efforts of genius, of what nature soever, this appeared to me so wonderful, that I would not have missed seeing it for any consideration. As the hall was of a prodigious extent, and filled with a great multitude of persons, particular care was taken that none should enter such as came about business; so the door was kept locked, and the avenues were guarded by door-keepers; these men, in opposing those who were for forcing in, sometimes made such a noise, that the judge reprimanded them very severely. I stooped down several times to observe what passed: the words which I heard the judge utter, upon seeing two gentlemen who wanted to hear the trial, and whom the porter was endeavouring to keep out, were these, "Be quiet, be quiet, Satan, get hence, and leave off disturbing us." The terms in French were, *Paix, paix, Satan, allez, paix.* As I had by this time thoroughly learnt the French language, upon hearing these words, I recollected what Dante said, when he with his master, Virgil, entered the gates of hell; for Dante and Giotto, the painter, were together in France, and visited Paris with particular attention, where the court of justice may be considered as hell. Hence it is that Dante, who was likewise perfect master of the French, made use of that expression; and I have often been surprised, that it was never understood in that sense; so that I cannot help thinking, that the commentators on this author have often made him say things which he never so much as dreamed of.

To return to my suit: I found that when verdicts were given against me, and there was no redress to be expected from the law, I must have recourse to a long sword, which I had by me, for I was always particularly careful to be provided with good arms. The first that I attacked was the person who commenced that unjust and vexatious suit; and one evening I gave him so many wounds upon the legs and arms, taking care, however, not to kill him, that I deprived him of the use of both his legs. I then fell upon the other, who had bought the cause, and treated him in such a manner, as quickly caused a stop to be put to the proceedings: for this and every other success, I returned thanks to the Supreme Being, and began to conceive hopes that I should be for some time unmolested. I earnestly entreated my young journeymen, especially the Italians, to be attentive to their business, and to work hard for a time, till I could finish the works I had undertaken; for I proposed to return to Italy as soon as ever they were completed, not being able any longer to bear the villany of the French; at the same time seriously considering, that if the monarch should once happen to be angry with me, I might probably meet with severe treatment for having revenged myself in the manner I had done.

These Italian journeymen were as follow:—The first and highest in my favour was Ascanio, born in the kingdom of Naples, at a place called Tagliacozza: the second was Paolo, a Roman, a person of mean birth, who did not so much as know his own father: these two I had brought from Rome, where they had lived with me. The third was likewise a Roman, who came from Italy, on purpose to enter into my service: his name was also Paolo, and he was son to a poor Roman gentleman of the Maccherani family. This young man had made but little proficiency in the business; but he was brave, and an excellent swordsman. The fourth journeyman was a native of Ferrara, whose name was Bartolomeo Chioccia. The fifth was a Florentine, named Paolo Micceri, who had a brother, surnamed Gatta, a very able clerk, but guilty of extravagance when he managed the business for Tommasso Guadagni, a rich merchant; he afterwards kept my books, which contained my accounts with his most Christian Majesty, and others by whom I was employed. Paolo Micceri, having learnt his brother's method of book-keeping, continued to follow it, and I allowed him a good salary: he appeared to me to be a very pious youth, and discovered a great turn to devotion, sometimes singing psalms, sometimes telling his beads, so that I conceived great hopes from such an appearance of virtue. I therefore called him aside, and spoke to him thus: "My dear friend Paolo, you see how happily you are settled with me, and may remember you were before out of business: you are a Florentine, which makes me confide in you; and what gives me high satisfaction is to see you so devout, and so regular in all acts of religion. I therefore, putting more trust in you than in the others, make it my request to you, that you would give your attention to two things, in which I am in a particular manner concerned: one is, that you would carefully watch over my property, and be always upon your guard to prevent any body from meddling with it, as likewise that you avoid touching it yourself. At the same time you see the poor girl Caterina, whom I keep in the house chiefly on account of my business, and without whom it would be impossible for me to conduct it. Now I have particular reasons for wishing that she should be extremely circumspect in her conduct; therefore I desire you to watch her attentively, and inform me of any improprieties you may observe. I have no desire to provide for other people's children, nor would I tamely put up with such a thing. Were I to detect so scandalous an outrage, I would sacrifice both to my insulted honour. Therefore be prudent, and obey my injunctions; let me know if you observe any thing wrong, and I will dismiss both her and her mother with disgrace." This traitor crossed himself from head to foot;

and made the most solemn asseverations, that such an idea as that of injuring so great a benefactor in the smallest particular could never enter his mind. His appeals to all that was sacred and apparent devotion to me, completely imposed upon me. Two days afterwards my countryman Maltio de Nasaro invited me and all my establishment to partake of his hospitality at his country-house. When I proposed to take Paolo with me to enjoy himself, he observed how dangerous it would be to leave the house unprotected, and such gold, silver, and jewels lying all about; and that there were thieves on the look-out day and night. "Go then, and enjoy yourself, dear master," he added, and "I will keep watch." So taking Ascanio and Chioccia with me, I set out and spent the greater part of the day with infinite satisfaction. But towards evening I began to feel uncomfortable and out of humour; the words used by Paolo kept recurring to my mind; I could not master my uneasiness, and at last I took horse, and with two of my attendants returned to my castle. I had very nearly taken the villain by surprise for as I entered the court I heard the wretch of a mother crying, "Pagolo, Caterina; here is the master." Soon they both appeared, terror and confusion depicted in every feature, scarcely knowing what they said or did; and evidently guilty. Overpowered by momentary rage, I seized my sword, resolved to kill them upon the spot: one fled, the other fell at my feet beseeching mercy, a movement that allowed me time to recover my reason. I determined then to turn them both out of the place: turning to Paolo; I exclaimed, "Thou basest of wretches, had my eyes been a little sharper, I would have passed this weapon through thy craven heart. Now thank thy stars, up and away;" and with every opprobious epithet, cuffs and kicks, I chased both mother and daughter out of my castle.

In conjunction with a low attorney, a Norman, these wretches entered into a foul conspiracy against me, which caused me the greatest uneasiness, and compelled me to seek redress in a court of justice. Thus the more I sought for peace to pursue my occupations the more I encountered tribulation, as if fortune were bent on finding new modes of persecuting me. I began to think of adopting one of two alternatives, either to quit France altogether or to exhaust her full vengeance, and see what strange destiny heaven had yet in store for me. I persevered, and having threatened to appeal to the king, my enemies took the alarm, and I came off victorious out of this fresh sea of troubles. By meeting it manfully I cleared my character and saved five hundred crowns, the forfeit of my non-appearance in the court. So returning thanks to God, I returned joyfully to my castle, with my young assistants, who had appeared in my behalf.

Still I had suffered great anxiety, and I resolved no longer to tempt my evil fortune in France; though I could not abandon the prospects I had in view without extreme regret. I began to make arrangements for such property as I could not carry with me. I sat alone in my little studio to consider over the matter, having requested those of my young men who advised me to take my departure to leave me awhile to my own thoughts; though aware at the same time that they had taken a correct view of the subject. For notwithstanding I had escaped imprisonment, and subdued the fury of my adversaries, I knew that I could much better justify myself to the king by letters, and thus prove their malignant and assassin-like design than by any other method, and as before said, I decided accordingly. No sooner, however, had I done so than it seemed as if some one slapped me on the shoulder, and exclaimed in a cheering voice: "Courage Benvenuto! Do as you are wont, and fear nothing." Such an effect had this upon my mind that I recovered all my confidence, and determined to put off my journey for a time. The first vengeance I took on my persecutors was to compel Paolo to marry Caterina, thinking so infamous a couple well suited to each other. This hypocritical fellow undertook what I requested, with such solemn assurances of fidelity and devotion to my interests, that I was induced to place implicit confidence in him. Nevertheless, he very soon betrayed me; and having unquestionable evidence of his guilt as well as Caterina's, and of her mother's connivance, I drove them all from my house. They then invented a horrible accusation against me, which according to the laws of France, endangered my life; but their detestable conspiracy failed, and my innocence was clearly established. I afterwards compelled Paolo to marry Caterina, thinking this infamous couple well suited to each other.

CHAPTER XXXIII.

Open rupture between Cellini and Primaticcio the painter, the latter having, at the instigation of Madame d'Estampes, undertaken to execute some of the designs of the former.—Primaticcio is intimidated by the Author's menaces, and gives up the point.—Cellini waits upon the King with a salt-cellar of the most exquisite workmanship.—Birth of his daughter Constantia.—The King again visits the Author, and finding the silver statues in great forwardness, orders him a considerable sum of money, of which he is deprived, as before, by the Cardinal of Ferrara.—His Majesty, discovering how the Author had been wronged, orders his ministers to give him the first abbey that becomes vacant.

WHEN once adverse fortune, or the influence of our ill-stars, if that expression be more correct, begins to persecute a man, it is

never at a loss for means to distress him. When I thought myself extricated from one troublesome and dangerous affair, and flattered myself that my evil genius would leave me at rest for a while, I was involved again in most perplexing difficulties, and in the space of a few days two accidents befel me, by both of which I was in the most imminent danger of my life. This happened as follows: I was obliged to go to Fontainebleau to wait upon the king, who had written me a letter, desiring me to undertake to strike the coins for his whole kingdom: in the letter he had inclosed some little designs the better to explain his mind, but at the same time he left me at liberty to follow the dictates of my genius. In compliance with his majesty's orders, I had drawn new designs, in my own taste, and with the utmost elegance of art. Upon my arrival at Fontainebleau, one of the king's treasurers, who had received orders to provide me with whatever I wanted, and whose name was Monsieur de la Faye, said to me: "Benvenuto, Primaticcio the painter has been ordered by the king to make your colossal statue; and all the other great works which had been put into your hands, his majesty has now taken from you, and given to him. We are all very sorry for it, and think that this countryman of yours has acted very presumptuously, and behaved extremely ill to you; for you had been entrusted with the works on account of the excellence of your models, and your masterly performance; but this man has supplanted you merely through the interest of Madame d'Estampes. It is now several months since he undertook those works, and he has not yet so much as begun a stroke." Hearing this, I exclaimed with surprise, "How is it possible I should never have heard a word of all this?" He answered me, that Primaticcio had kept the affair as secret as possible, and obtained his request with the utmost difficulty, the king being very unwilling to grant it; but that Madame d'Estampes had been so earnest in her solicitations, as to extort, in some measure, his compliance.

Finding myself so cruelly wronged, so unjustly treated, and deprived of a work which was due to me in consideration of the pains I had taken, I resolved to perform some signal feat of arms, and went with the most eager haste in quest of Signor Primaticcio. I found him in his chamber, quite absorbed in study; he bade me come in, and with some of his Lombard civilities asked me what was the best news, and what had brought me thither: I answered, an affair of the last importance. He thereupon ordered his servants to bring wine, and said, "Before we talk about business we must drink together, for that is the custom here in France." "I must inform you," replied I, "Signor Francesco, that there is no occasion

for the conversation, which is to pass between us, to be ushered in with drinking—that, perhaps, may come afterwards." I then continued thus: "All those who profess themselves to be men of worth and virtue show by their actions that they are such; and when they behave otherwise they can no longer be considered in that light. I am sensible that you were not ignorant of the king's having employed me to make the colossus, which has been talked of these eighteen months, and neither you nor any body else said any thing about it during that time. I had by my labours made myself known to that great prince, who was so pleased with my models as to commit this grand undertaking to me, and for many months I heard nothing of his having a different intention: it was not until this morning that I heard it was given to you, and that you had basely undermined me, though I had obtained the work by my successful performances, and you have taken it from me by empty words." "My friend Benvenuto," answered Primaticcio, "every man endeavours to do the best he can for himself; and if it be the king's pleasure, what objection can you make? Say what you will, you will only lose your labour in talking against the grant; it has been made to me, and cannot be disputed: now speak as much as you please, and I will listen to you in my turn." I thereupon replied to him thus: "I have a great deal to say to you, Signor Francesco, and could by many strong and convincing arguments make you confess, that such methods of acting and reasoning as yours are not customary amongst rational animals; but I will be brief, and come directly to the point: listen attentively, for what I am going to say is of great consequence." He was ready to rise from his seat, seeing that I changed colour, and discovered great symptoms of emotion; but I told him it was not yet time for him to stir, and bade him sit still and attend to what I had to say. I then proceeded thus: "Signor Francesco, you know very well that the work was at first put into my hands, and that, according to the practice of the world, it was no longer a proper time for any other person to apply for it: I now declare to you, that I am willing you should make a model, and I will make a new one; we then will carry them both to our great monarch, and he who upon that occasion acquits himself best, shall be looked upon as entitled to the honour of making the colossus. If it should happen to be your lot, I will lay aside all resentment of the injury you have done me, and bless your hands as more worthy than mine of so great an honour. Let us therefore make this agreement, and we shall be friends; otherwise we must be enemies; and God, who always assist the just cause, and I, his instrument, will find means to convince you of your error." Signor Francesco answered, "The

work is mine; and since it has been given me, I do not choose to run any farther risk." To this I replied: "Signor Francesco, since you will not accept of the alternative proposed, which is both just and reasonable, I will offer another to you, which will resemble your own proceeding in its harshness and deformity. I must tell you plainly, that if I ever hear you mention a word of this work of mine, I will kill you as I would a mad dog; and as we are now neither in Rome, Florence, Naples, nor Bologna, and the manner of living in this country is quite different, if I ever hear you drop a word about it to the king, I will instantly put you to death without mercy: think therefore seriously which proposal you choose to accept, the first which is fair, or the last which exposes you to destruction."

The man was at a loss what to say, or how to act, and I was almost preparing to put my design instantly in execution, rather than defer it to some other occasion. He said nothing farther than this, "So long as I behave like a man of honour and principle, I shall be free from all fear and apprehensions." To this I replied, "What you say is very just; but when you act in a contrary manner, you have reason to be afraid: remember my words." I thereupon instantly left him to wait on the king, and had a long conference with his majesty concerning the coins, in which we could not agree; for his privy council being there present, persuaded him that money should still be coined in the same manner as it always had been before that time in France. I answered, that his majesty had invited me from Italy to work for him, so as to deserve approbation; and even if he should give me contrary directions, I could never find it in my heart to obey him. Farther conversation upon the subject was deferred to another opportunity, and I returned to Paris. I had hardly dismounted, when one of those busy personages, who delight in spreading mischief, came to inform me that Paolo Micceri had taken a house for his new lady and her mother, and that he made use of the most injurious and contemptuous expressions towards me. "Poor Benvenuto; he paid the piper while I danced; and now he goes about boasting of the exploit. He thinks I am afraid of him; —I who can wear a sword and dagger as well as he; but I would have him to know my weapons are as keen as his.—I, too, am a Florentine, and come of the Micceri, a much better house than the Cellini any time of day." In short the vile informer painted the things in such colours to my disadvantage that it fired my whole blood. I was in a fever of the most dangerous kind. And feeling it must kill me without it found vent, I had recourse to my usual means on such occasions. I called to my workman, Chioccia to accompany me, and told another to follow me with my horse. On

reaching the wretch's house, finding the door half open, I entered abruptly in. There he sat with his *"chère amie,"* and his boasted sword and dagger beside him, in the very act of jesting with the elder lady upon my affairs. To slam the door, draw my sword, and present the point to his throat, was the work of a moment, giving him no time to think of defending himself. "Ah! thou vile poltroon, recommend thy soul to God; thou art a dead man." In the excess of his terror, he cried out thrice, in a feeble voice, "Mamma, Mamma, Mamma!—help! help me!" At this ludicrous appeal, so like a girl's, and the ridiculous manner in which it was uttered, though I had a mind to kill, I lost half my rage, and could not forbear laughing. Turning to Chioccia, however, I bade him make fast the door; for I was resolved to inflict the same punishment upon all three. Still with my sword point at his throat; and pricking him a little now and then; I terrified him with the most desperate threats; and, finding that he made no defence, was rather at a loss how to proceed. It was too poor a revenge—it was nothing; when suddenly it came into my head to do it effectually, and make him espouse the girl upon the spot. "Up! and off with that ring on thy finger, villain!" I cried, "marry her this instant; and then I shall have my full revenge." "Any thing; any thing you like, provided you will not kill me," he eagerly answered. Removing my sword a little: "Now then," I said, "put on the ring;" and he did so trembling all the time. "This is not enough; go and bring me two notaries to draw up the contract." Then addressing the girl and her mother in French: "While the notaries and witnesses are coming I will give you a word of advice. The first of you that I know to utter a word about my affairs, I will kill you—all three—so keep it in mind." I afterwards said in Italian to Paolo: "if you offer the slightest opposition to the last thing I choose to propose, I will cut you up into mincemeat with this good sword." "It is enough," he interrupted in alarm, "that you will not kill me. I will do whatever you wish." So this singular contract was duly drawn out and signed; my rage and fever were gone. I paid the notaries, and went home.*

The next day Primaticcio came to Paris, and sent Mattio del Nasaro for me: I waited upon him accordingly, when he begged I would consider him in the light of a brother, and declared he would not mention a word concerning the great work to the king, as he was sensible that I must be in the right.

Whilst I was going on with this work, I set apart certain hours of the day to continue the salt-cellar, about which several hands had

* There here follow some details in the Italian text which it is impossible to give in full.

been employed, for I could not otherwise conveniently work upon the statue of Jupiter. About the time that I had completely finished it, the king was returned to Paris: I paid him a visit, carrying the salt-cellar with me, which, as I have observed above, was of an oval figure, and in size about two thirds of a cubit, being entirely of gold, and admirably engraved by the chisel. Agreeably to the account already given of the model, I had represented the sea and the earth both in a sitting posture, the legs of one placed between those of the other, as certain arms of the sea enter the land, and certain necks of the land jut out into the sea. The manner in which I designed them was as follows: I put a trident into the right hand of the figure that represented the sea, and in the left a bark of exquisite workmanship, which was to hold the salt: under this figure were its four sea-horses, the form of which in the breast and fore feet resembled that of a horse, and all the hind part from the middle that of a fish; the fishes' tails were entwined with each other in a manner very pleasing to the eye, and the whole group was placed in a striking attitude. This figure was surrounded by a variety of fishes of different species, and other sea animals. The undulation of the water was properly exhibited, and likewise enamelled with its true colours. The earth I represented by a beautiful female figure holding a cornucopia in her hand, entirely naked, like the male figure; in her left hand she held a little temple, the architecture of the Ionic order, and the workmanship very nice; this was intended to put the pepper in. Under this female figure, I exhibited most of the finest animals which the earth produces, and the rocks I partly enamelled and partly left in gold. I then fixed the work on a base of black ebony of a proper thickness; and there I placed four golden figures in more than mezzo rilievo: these were intended to represent Morning, Noon, Evening, and Night. There were also four other figures of the four principal winds, of the same size, the workmanship and enamel of which were elegant to the last degree.

When I showed the king this piece of work, he burst into an exclamation of surprise, and could never sufficiently admire it; he then bade me carry it home, telling me he would soon let me know what to do with it.

Having taken it back, I immediately invited several of my most intimate friends to dinner, and put the salt-cellar upon the table: thus we were the very first to make use of it, and spent the day very cheerfully. After this I continued to work upon the statue of Jupiter, and the great silver vase already mentioned, on which were engraved several pretty mottos, with a variety of different figures.

About this time the Bolognese told the king, that it would be

proper for his majesty to send him to Rome, and give him letters of recommendation, that he might take designs of the first-rate antiques of that city, the Laocoon*, the Cleopatra*, the Venus†, the Commodus‡, the Apollo§, and the Zingara‖; which are indeed the finest

* This statue, which was in Parian marble, was purchased by Julius II. It represents Ariadne abandoned by Theseus in Naxos, at the moment when she is overcome by sleep, and a short time before the arrival of Bacchus. It was once supposed to represent Cleopatra perishing under the bite of the asp, because it bears a bracelet in form of a serpent, but the learned Visconti exposed this error, and the inanimate figure of the asp is now no less universally acknowledged than the life and evident sleep of Ariadne. This beautiful piece of workmanship stood on the border of a fountain, in the garden of Belvedere and underwent the fate of the Laocoon.

† This Venus, which was a greater object of admiration in Rome in the times of Cellini, than it has been since the discovery of the Venus de' Medici and the Capitoline Venus, is seen standing naked, and apparently just ascended from the bath. She extends the hand toward a napkin to dry herself. This statue then stood in the garden before mentioned of Pope Julius, and was afterwards placed in the museum of Pius Clementinus, where it remains at present. It is, according to the Signor Visconti, a copy of the famous Venus of Cnidus, the chef-d'œuvre of Praxiteles.

* This group, justly denominated by connoisseurs the miracle of the arts, was the work of three sculptors at Rhodes, probably of one family, though at what period exactly is not known. It was transported to Rome about the beginning of the vulgar æra. In the time of Pliny, it stood in the baths of Titus, upon the Esquiline Hill, but in the terrible vicissitudes which followed, and which overthrew, as it were from its foundation, that capital of the world, it remained buried in ruins, and was not again restored to light until the more favourable times of Julius II., when it was fortunately discovered by one Felice de Fredis, and placed by that Pontiff in the courtyard of the Vatican, which was then an orange garden, and deservedly called the garden of Belvedere. It was afterwards placed in the museum of Pius Clementinus, and thence was transported to Paris, in 1797, and deposited in the Museum Napoleon.

‡ This is the Hercules with the lion's skin, and a child in his arms. It is particularly admired for the beauty of the head, which was long thought to have represented Commodus under the character of that god: but Winkelman has demonstrated the physiognomy to be ideal, and to represent no other than Hercules with the infant Ajax Telamon; although others believe it to be his own son Telephus. This statue, which was discovered in the time of Julius II., was placed near the Laocoon, and followed its fate.

§ The Apollo Pizio, commonly called the Belvedere, and the most beautiful and sublime of the ancient statues, represents that god, at the moment when he has struck the serpent Python with his spear. It is not known of whose workmanship it is, nor to what age it belongs. It was discovered about the end of the fifteenth century, in the ruins of Antium, and was at first placed in the house of Julius II., then in the gardens of the Vatican, and afterwards in the Museum Napoleon.

‖ An ancient statue of white marble, with the head, hands, and feet, of bronze, has long been famous under the name of Zingara or Zingarella. From the injuries which its beautiful garments have sustained by length of time, it has been supposed to be clothed in ragged apparel, and to represent a female in the act of divination. It is now, however, with more reason considered to be intended for a Diana, robed, as it still preserves the belt to which probably was attached the quiver, and that the mutilated parts have been restored in bronze, in more modern times. It stood in the Villa Pinciana, and was carried away, with the whole of the Museum Borghesi, to Paris in 1808.* (See Collection of Statues of Paolo Alessandro Maffei, and the beautiful Description of the Borghese Statues, by the Signor Car. Luigi Lamberti.)

* On the restoration of the Bourbons these works were restored to Italy.

things in Rome. He at the same time told the monarch that his majesty, by seeing those admirable masterpieces, would be able to form a judgment of the art of drawing; for all the works of modern artists that had been shown him were infinitely inferior to the masterly performances of the ancients. The king approved of his proposal, and gave him all the encouragement he desired. So the fool went off in this manner, and not having the spirit to rival me, had recourse to this artifice, worthy of a Lombard, of pretending to praise the works of the ancients in order to depreciate mine; but though he took excellent drawings of them, his success proved quite the reverse of what he had flattered himself it would, as we shall inform the reader in due time.*

Having entirely discontinued my connection with that wretch Catharine, and the poor unfortunate young man who had conspired with her to wrong me being gone from Paris, I intended to have my ornament for Fontainebleau, which was of bronze, properly cleaned, as likewise to get the two figures of Victory, which extended from the side angles to the middle circle of the gate, furbished up. For this purpose I took into my house a poor girl about fifteen years of age: she was extremely well-shaped, lively, and of a complexion rather swarthy; and as she was somewhat rustic, spoke little, walked fast, and had a sort of wildness in her eyes, I gave her the name of Scozzona; but her own name was Gianna. With her assistance, I completely finished my Fontainebleau and the two Victories intended for ornaments to the gate. By this Gianna I had a daughter, on the seventh of June, as three in the afternoon, in the year 1544, when I was precisely in the forty-fourth year of my age. I gave this child the name of Constantia, and she was held upon the font by Signor Guido Guidi, physician to the king, and one of my most intimate friends. He alone stood godfather; for the custom of France is, that there should be but one godfather and two godmothers. One

* Vasari, Malvasia, Davila, Felibien, Mazzuchelli, Tiraboschi, and Milizia, in speaking of Primaticcio and Vignola, assert that the former was despatched by Francis I. between the years 1537 and 1541, and whilst Rosso was still living, to Rome, to purchase some ancient marbles for him, and to obtain copies of the heads of the statues above mentioned. Malvasia also, on the authority of Vidriani, adds, that Rosso himself had been induced by the jealousy he felt at the applause obtained by Primaticcio at the court of France, to procure this commission for him in order to effect his absence, and that Rosso destroyed himself for no other reason than the mortification he experienced at finding Primaticcio his rival in France, which was particularly the case in January 1540, on occasion of the preparations for the reception of Charles V. in Paris. This supposition would in a great measure remove the imputation of malignity here attributed by Cellini to Primaticcio. But Bottari, in a note to Vasari, citing this passage, shows this mission of Primaticcio to Rome to have taken place in 1543, and to be therefore inconsistent with these accusations against Rosso.

of these was Signora Maddalena, wife to Signor Luigi Alamanni, a gentleman of Florence, and an admirable poet, the other god-mother was a French lady of good family, wife of Signor Riccardo del Bene, also citizen of Florence, and an eminent merchant. This was the first child that I ever had to the best of my remembrance. I assigned the mother such a maintenance, as satisfied an aunt of hers, into whose hands I put her; and never had any acquaintance with her afterwards.

I continued my works with all possible expedition, and by this time they were in great forwardness: the Jupiter was as good as finished, so was the vase, and the gate began to display its beauties. Just at this time the king arrived at Paris; and though I have spoken of the birth of my daughter as having happened in 1544, at the time now under consideration the year 1543 was not quite elapsed. This was owing to my having occasion to speak of my daughter: however, to avoid interrupting the relation of affairs of greater importance, I shall drop the subject at present, and resume it in its proper place. The king came to Paris as I have said already, and immediately repaired to my house, where my works were in such forwardness that they gave great satisfaction to the eye: the monarch was as much pleased with them, as an artist could wish, who had bestowed great pains on his productions. He recollected, of himself, that the Cardinal of Ferrara had given me none of the money that he had promised me: so, talking in a low voice to his admiral, he said that the Cardinal of Ferrara had done very wrong in not paying me; but that he himself would see justice done me; for he perceived that I was a man of few words, and would leave the kingdom, if I were not satisfied. Without adding a word more, they withdrew, and the king after dinner bade the cardinal tell the treasurer to pay me, with all possible expedition, seven thousand gold crowns at three or four disbursements, according as he found it convenient, and not to fail at his peril. He then concluded with these words, "I had put Benvenuto under your care, and you have quite forgotten him." The cardinal assured the king, that he would punctually obey his orders; but the natural malignity of his temper made him stay till the monarch's fit of generosity and good-nature was over.

In the mean-time France was threatened more and more with the calamities of war, and the emperor with a numerous army seemed to be on the point of marching to Paris. The cardinal, perceiving that money was very scarce in the kingdom, took occasion one day to speak of me to the king in these terms: "I thought it best not to give Benvenuto the money your majesty ordered him; and one of my reasons was, that you now stand but too much in need of it

yourself; the other, that so generous a present would have deprived us of him the sooner, for if once he had found himself rich, he would have purchased an estate in Italy, and when the whim took him would certainly have left you. So I have considered with myself that it is most advisable your Majesty should assign him some settlement in your own dominions, if you desire that he should continue any considerable time in your service." The king seemed to approve of what was said: however, with a greatness of soul worthy of such a monarch, he took it into consideration that the cardinal had acted as he had done, rather to gratify his own temper, than because he had so long before had the sagacity to foresee the distressed state of so great a kingdom. Thus, though the king appeared to assent outwardly to the reasons assigned by the cardinal, his private sentiments were very different; for he soon returned to Paris, and the day after his arrival came of his own accord to my house, when I conducted him through several apartments, in which there was a variety of works of different sorts.

Beginning with those of least value, I showed him several pieces of bronze, which surpassed any thing of the kind he had ever beheld. I then led him to the silver Jupiter, and he was pleased to find it almost finished, with all its beautiful ornaments. This indeed he admired much more than any other man would have done, on account of an unlucky accident which had happened to him a few years before, when the emperor, intending an expedition against the town of Tunis, passed through Paris with the consent of the French monarch. Francis, being desirous of making Charles a present worthy of so great an emperor, caused a silver Hercules to be cast for that purpose, exactly of the same size with my Jupiter. This Hercules was a most ordinary piece of work; and when the king found fault with it, the artists whom he had employed, and who pretended to be the greatest masters in the whole world, maintained that nothing more complete could be made of silver, insisting upon two thousand ducats for their bungling piece of work. For this reason, when his majesty saw my performance, he was surprised at the admirable finish of it, which he could never have conceived. To such a degree was he pleased with my statue of Jupiter that he valued it at two thousand crowns and said, "Those ignorant artists received no recompense from me: for this I will give a thousand crowns, and it is well worth the money." I then took his majesty to see some other performance, both in silver and gold, and many other models of new works. At last when he was upon the point of departing, I conducted him through the castle garden, where I showed him my statue of the great giant.

The king discovered the greatest astonishment imaginable, and turning about spoke thus to the admiral, who was Mons. d'Annebaut*: "Since the cardinal has not yet supplied this man with money, and the latter is so backward to ask it, I must without more delay take care to provide for him myself; for when artists are too modest to ask any recompense, their works seem sufficiently to claim it. Therefore give him the first abbey that becomes vacant, the revenue of which amounts to two thousand crowns a year, and in case you cannot let him have it in one benefice, give it him in two or three: it will be the same thing to him." I was present, heard all that was said, and immediately returned thanks to his majesty, as if I had the abbey already in my possession; telling him, that I intended when that work was finished to serve his majesty without any other reward, salary, or recompense for my labour, till old age should render me incapable of working, when I might be allowed to retire to necessary repose, happy in the remembrance of having served so great a monarch. To this the king with great alacrity answered, "So be it;" and left me in high spirits.

CHAPTER XXXIV.

Madame d'Estampes, with a view of farther persecuting the Author, obtains leave from the King for a perfumer to take possession of a tennis-court within his premises.—The perfumer is opposed by Cellini, notwithstanding the King's grant, and obliged at length to quit the tennis-court.—The Author triumphs on meeting with the King's approbation.—He set out for Fontainebleau with the silver statue of Jupiter.—Primaticcio the painter, upon his return from Rome, endeavours to traduce the Author.—Madame d'Estampes' partial behaviour to the Bolognese painter.—Cellini's spirited resentment.—The King's gracious and generous behaviour to the Author.—Adventure of Ascanio.

MADAME D'ESTAMPES, having heard of my encouragement, was more provoked against me than ever, and said, "I govern the whole kingdom, and yet this insignificant fellow sets my power at defiance." In a word, she left no stone unturned to effect my destruction. A gerat distiller happening to fall in her way, gave her certain odoriferous waters of an extraordinary virtue for the skin, which had never been used in France before that time: this man she introduced

* Claude d'Annebaut, one of the greatest favourites of Francis I., with whom he had been made prisoner at Pavia, was created marshal in 1538; and after the disgrace of the constable Anne de Montmorency, which happened in March, 1541, was entrusted with the administration of the finance; and finally, on the 5th February, 1543, was created admiral of France.

to the king, to whom he showed certain operations in distilling, with which his majesty was highly delighted. During these amusements she made the distiller apply to the king for a tennis-court at my castle, with certain little apartments belonging to it, of which he said I made no use. The king, who knew with whom this application originated, returned no answer whatever. Madame d'Estampes, thereupon, began to solicit him, and made use of all those insinuating arts with which women know how to work upon men; and so successful did she prove, that happening to find the king in an amorous mood, to which he was very subject, he granted the lady all she desired.

Thereupon the distiller came, accompanied by the treasurer Glorier*, one of the first nobility of France, who understood Italian incomparably well. In this language he talked to me at first in a jocular manner, and then coming to the point, told me, that in the king's name he put the other man in possession of that tennis-court, and the little apartments adjoining to it. To this I answered, "His sacred Majesty is master of this house, and of every thing in it: you might therefore enter with the utmost freedom. But this manner of taking possession in the manner of notaries and courts appears to be rather a trick than the order of so great a monarch: I therefore protest to you that instead of going to complain to his majesty, I will defend myself in the manner that he commanded me the other day; that is, I will throw this man whom you have placed here out of the window, if I do not see a commission signed with his majesty's own hand."

Upon my expressing myself thus, the treasurer went away menacing and muttering to himself, and I remained in equal ill humour, but made no farther stir in his presence. Soon after he was gone, I went in quest of the notaries, who had put the man in possession. These, being my intimate acquaintances, gave me to understand that it was a ceremony performed by the king's authority, but not of much consequence; and if I had made ever so little resistance, the

* Jean Grolier, of Lyons, was regarded as the Mæcenas of his time. He was sent to Milan in 1515 by Francis I. as his principal treasurer, where he gained the esteem and affection of all the Italians by his integrity, and the generous protection he afforded to men of letters, towards whom he was so liberal, that having one day invited a considerable number to dinner with him, at the conclusion of the repast he presented to each of his guests a pair of gloves, which was found to be filled with gold. Celio Rodigino, Battista Egnazio, and the Aldi, on many occasions avowed their gratitude to Grolier, who on his return to France being created Intendant of the Finance, enjoyed a high reputation until 1565, when he died at the age of eighty-six years, leaving behind him the richest collection of books and medals which had till then existed in France. Cæsar Grolier, natural son of Jean, who published a history of the sacking of Rome in 1528, in the Latin language, latinised his name into Glorierus, as Cellini has here done.

man would not have taken possession as he did; adding that these were acts and customs of the court, which did not concern the obedience due to the king, insomuch that, if I thought proper to dispossess him in the same manner as he had taken possession, I should do very well, and need not be under any apprehensions with regard to the consequences. Being thus sufficiently instructed, I the next day had recourse to open violence. Though there were some difficulties in the way, I took pleasure in contending with them, and every day made some assault with stones, pikes, or musquets: I however fired without ball; but even so, struck such terror into my adversary's adherents, that nobody chose afterwards to stir to his assistance. One day, therefore, finding his resistance feeble, I entered the house by force, and drove him out, throwing all his goods and furniture after him. I then repaired to the king, and told him that I had done what he had commanded me, and defended myself against all those that offered to impede me in his majesty's service. The king laughed, and caused new letters to be issued, to secure me from being molested for the future.

In the mean time having with the utmost diligence finished the beautiful statue of Jupiter, with its gilt pedestal, I placed it upon a wooden socle, which scare made any appearance, and within that socle I fixed four little globes of wood, which were more than half hidden in their sockets, and so admirably contrived, that a little child could with the utmost ease move this statue of Jupiter backwards and forwards, and turn it about. Having adjusted it properly, I took it with me to Fontainebleau, where the king then resided. Just about this time Primaticcio had brought the figures already mentioned from Rome, and caused them to be cast in bronze with the utmost care. I knew nothing at all of the matter, for he had transacted the business with great secrecy, and Fontainebleau is above forty miles from Paris. Upon my inquiring of the king, in the presence of Madame d'Estampes, where I was to place the statue of Jupiter, the latter told his majesty that there was not a more proper place than his beautiful gallery. This is what we might call a portico, or rather a corridor: it might indeed be most properly distinguished by the latter name, because we give the appellation of portico to those walks which are open on one side. This place was about two hundred paces long, adorned and enriched with pictures by the admirable Rosso of Florence, intermixed with several pieces of sculpture, some detached and others in basso rilievo: the breadth about twelve paces. Here it was that Primaticcio had assembled all his bronze figures, and placed them in the most regular order upon their pedestals. As I have observed above, there were amongst them some of the finest imita-

tions of the antique statues of Rome. Here also I introduced my Jupiter; and when I saw this great display of the wonders of art, I said to myself, "This is like passing between the pikes of the enemy; Heaven protect me from all danger!" Having put the statue into its place, and fixed it in the most advantageous situation I could, I awaited the coming of the great monarch.

This figure of Jupiter had a thunderbolt in his right hand, and by his attitude seemed to be just going to throw it: in his left I had placed a globe, and amongst the flames I had with great dexterity put a piece of white torch. Madame d'Estampes had detained the king till night, with a design to make mischief, either by preventing his coming or contriving to make my work appear unfavourably in the night. As God, however, has promised to befriend such of his creatures as put their trust in him, it happened quite contrary to her expectations for, on the approach of night, I lighted the torch in the hand of Jupiter, and as it was raised somewhat above his head, the light fell upon the statue, and caused it to appear to much greater advantage than it would otherwise have done. The king came, accompanied by Madame d'Estampes, the Dauphin his son, now King of France, and the Dauphiness, the King of Navarre his cousin, the Princess Margaret his daughter, and several great lords and noblemen, who had all been instructed by Madame d'Estampes to speak against me. When I saw his majesty enter, I ordered my boy Ascanio to push the statue of Jupiter before him, and this motion being made with admirable contrivance, caused it to appear alive: thus the abovementioned bronze figures were left somewhat behind, and the eyes of all the beholders were first struck with my performance. The king immediately cried out, "This is one of the finest productions of art that ever was beheld: I who take pleasure in such things and understand them, could never have conceived a piece of work the hundredth part so beautiful." The noblemen who had been directed to rail at my performance, seemed now to vie with each other in praising it; but Madame d'Estampes said, with the utmost confidence, "It appears to me that you are very much at a loss for something to commend, when you lavish encomiums upon that statue. Don't you see those beautiful antique figures which stand a little beyond it? In these the utmost perfection of art is displayed, and not in those modern pageants." The king then advanced, as did the rest likewise, and cast an eye upon the other figures, which appeared to a great disadvantage, the light being placed below them. His majesty observing this, said,—"Those who have endeavoured to hurt this man, have done him the greatest service imaginable; for, from a comparison with these admirable figures, it is evident this statue is in every

respect vastly superior to them. Benvenuto is, therefore, worthy of the highest esteem, since his performances, instead of being barely upon a par with those of the ancients, greatly surpass them." In answer to this, Madame d'Estampes observed that my statue would not at another time appear a thousandth part so well as it did by night; and that it should be farther taken into consideration that I had thrown a veil over the figure to conceal its blemishes. This was an exceedingly thin drapery, which I had placed so gracefully, that it gave additional majesty to the figure. Upon hearing the above words, I took hold of the veil, and pulling it away discovered the parts it was intended to conceal. The lady thought I had done this out of contempt. The king perceived her resentment; and I, being overcome with passion, was just going to speak, when the wise monarch uttered these words deliberately in his own language: "Benvenuto, I must interrupt you—therefore be silent,—and you shall have a thousand times more treasure than you could wish." Not being allowed to speak, I discovered my emotion by my contortions: this caused the lady to be more highly incensed than ever, and made her mutter her indignation to herself. The king left the place much sooner than he otherwise would have done, declaring aloud, for my encouragement, that he had brought over from Italy one of the ablest men that the world had ever produced, and one who was endowed with the greatest variety of talents.

I left my statue there, and as I chose to quit the place that morning, the king ordered me a thousand crowns, partly as a recompense for my labour, and partly in payment of sums, which appeared from my accounts to have been disbursed by myself. Having received the money, I returned to Paris, and immediately upon my arrival made merry at my own house. After dinner I caused all my clothes to be brought me, which were of the finest furs, or the very best cloth: out of these I made presents to all my workmen, distributing them according to their deserts, and even giving some to the maids and the stable-boys; thereby encouraging them to assist me with alacrity. I set about finishing my statue of Mars, which I had made of pieces of wood well fastened together, over which the flesh was represented by a covering, in thickness about equal to the eighth part of a cubit, made of plaster, and of the most elegant workmanship. I afterwards formed a resolution to make up the figure of several different pieces, and to put them together according to the rules of art; and this I with great ease effected.

I must not omit to mention one circumstance that attended this great work, a thing, indeed, highly laughable. I had given strict orders to all those who lived with me not to bring any women into

my castle, and was particularly careful to see my orders obeyed. My boy Ascanio was in love with a girl of extraordinary beauty, who answered his passion with equal ardour. The girl, having on that account fled from her mother, came one night to Ascanio, and not caring afterwards to return home, he was at a loss where to conceal her; but necessity sharpening his wit, he bethought himself of the odd expedient of hiding her in my Mars, and let her sleep in the head of the statue. There he stayed to watch her, and in the night he took her out sometimes, without making any noise. I had almost finished that head, and vanity prompted me to leave it uncovered, so that it was every day exposed to the view of the inhabitants of Paris. The neighbours began to climb upon the roofs of their houses to see it, and great numbers of people went thither on purpose to indulge their curiosity. At the same time a report became current at Paris, that my old castle was haunted by a ghost; but, for my part, I could never perceive any thing to induce me to think it was well founded. This ghost was universally called Zemmonio Boreo through the city of Paris. Now, as the girl who was concealed in the head could not but be sometimes seen to move, while her eyes were more or less apparent, some of the foolish and credulous populace affirmed that the ghost had entered the body of the great statue, and that it made the eyes and mouth move as if it was just going to speak. Accordingly many went away frightened out of their wits; and some persons of penetration and sagacity, who came to see the figure, could not doubt the truth of what they had heard, when they contemplated the fire and brightness of the eyes of the said figure. So they declared in their turn that there was a spirit within it; not being aware that there was not only spirit in it, but likewise good flesh and blood. In the mean time I was busy in putting together my fine gate, with all the ornaments described above.

CHAPTER XXXV.

A war breaking out with the Emperor Charles V. the Author is employed to fortify Paris.—Madame d'Estampes, by constant artifices, prejudices the King against Cellini.—His Majesty's expostulation with the latter.—Madame d'Estampes continues her ill offices.—Cellini has another conference with the King, in which he declares his desire of returning to Italy.—He obtains his Majesty's permission, by means of the Cardinal of Ferrara.

As I do not mean to relate in this narrative of my life things which do not concern me but the writers of chronicles, I have passed

over the arrival of the emperor on the French frontiers with a numerous army, and the king's drawing together a considerable body of troops to oppose him. His majesty about this time consulted me concerning the means of expeditiously fortifying Paris*: he came purposely to my house in quest of me, led me all around the city, and perceiving how judiciously I spoke on the subject of fortifications, he empowered me by an express commission to cause all I proposed to be instantly carried into execution. At the same time, he signified to his admiral, Sieur Annebaut, to order the people to obey me upon pain of his displeasure. The admiral was a man of no genius, who owed his exalted dignity to the favour of Madame d'Estampes, and not to any merit of his own; though well-deserving his name, which they pronounced Ane-et-bo, *ass and ox*. This blockhead having told Madame d'Estampes of all that had passed between the king and me, she commanded him to send for Girolamo Bellarmato† directly: the latter was an engineer of Siena, who lived not above a day's journey from Paris. He instantly came, and had recourse to the most slow and tedious method of fortification. I concerned myself no longer in the affair; and if the emperor had advanced briskly to Paris, that city might have been easily taken. It was said with great truth, that in the treaty afterwards concluded, Madame d'Estampes, who was the person most concerned in negotiating it, had betrayed the king, and exposed him to the enemy.‡ I shall say nothing farther concerning this matter, because it does not enter into my plan, nor is it connected with the main subject of my narrative.

I then set about finishing my gate of bronze with the utmost assiduity and expedition, as likewise my great vase, and two other middle-sized ones, made of my own silver. The good king, after all his various distresses, came to rest himself for a while at Paris;

* Towards the end of August 1554, the Imperialists, by means of a fictitious letter, procured the surrender of the castle of St. Disier, in Champagne, to which they had laid siege, and advancing along the Maine, surprised the magazines and city of Epernay and of Chateau-Thiery, situated only nineteen leagues from Paris. It was then that the Dauphin withdrew his troops into the neighbourhood of Meaux, in order to defend the capital, and that Francis I. strengthened the walls of the city.

† Girolamo Bellarmati, at that time a very eminent professor of mathematics, of military architecture, and of cosmography, was banished from his country for political reasons, and having retired to France, was created by Francis I. his principal engineer; he was employed in building the city and port of Harve-de-Grace.

‡ There is great reason to believe, that on this occasion Madame d'Estampes betrayed the interests of France; for being the decided enemy of Diana of Poictiers and of the Dauphin, who favoured Diana, she contrived that the bridge of Epernay should not be broken down in sufficient time, by which means the Imperialists were enabled to advance, and the King was obliged to consent to the proposals of peace, which had been already set on foot by Queen Eleanora, through the medium of her confessor, and that of the Emperor her brother.